Deborah Kass, *Subject Matters*
Jewish Museum, New York. *Courtesy of Art Resource, New York*

Feminist Art Criticism
an annotated bibliography

A
Reference Publication in
ART HISTORY
Herbert Kessler, Editor
Medieval Art and Architecture

Feminist Art Criticism
an annotated bibliography

CASSANDRA LANGER

REFERENCE PUBLICATIONS
IN
ART HISTORY

G.K. Hall & Co.
An Imprint of Macmillan Publishing Company
866 Third Avenue
New York, NY 10022

Copyright © 1993 by Cassandra Langer
Published by G. K. Hall & Co.
An Imprint of Macmillan Publishing Company
866 Third Avenue
New York, NY 10022

Library of Congress Cataloging-in-Publication Data

Langer, Cassandra L.
 Feminist art criticism : an annotated bibliography / Cassandra Langer.
 p. cm. — (A Reference publication in art history)
 Includes indexes.
 ISBN 0-8161-8948-X
 1. Feminism and art—Bibliography. 2. Feminist art criticism—Bibliography.
 3. Women artists—Biography—History and criticism—Bibliography. I. Title.
 II. Series.
 Z5956.F44L36 1993
 [N72.F45]
 016.7'0118'082—dc20 93-822
 CIP

The paper used in this publication meets the minimum requirements of American
National Standard for Information Sciences—Permanence of Paper for Printed
Library Materials. ANSI Z39.48-1984. ∞™
MANUFACTURED IN THE UNITED STATES OF AMERICA

dedicated to I.F.R.J.,
to Jephthan's daughter,
to the forgotten sages and dreamers,
and to all those who humanize our lives

Contents

The Author

Cassandra (Sandra) Langer is an independent historian/art critic who has published and lectured widely on a variety of subjects in nineteenth- and twentieth-century art. Her books include *Feminist Art Criticism: An Anthology* (coauthored with Joanna Frueh and Arlene Raven), *Mother and Child in Art*, and, in press, *New Feminist Art Criticisms: Art, Identity, Action* (coauthored with Joanna Frueh and Arlene Raven). She is currently codirector of the Psych Arts Society and head of Langer Fine Arts and Appraising Services in New York City.

Foreword

During the planning of this series of critical bibliographies it quickly became clear that modernity was not merely an extension of the temperament of the past projected without alteration into the present. Discontinuities would have to be accounted for as well as the the old engines of history. What mainly distinguishes contemporaneity is history's voice – formerly the authoritarian and self-justifying thunder of the victor, now a chorus of the losers and winners, the underclass everywhere and the conquered, the helpers and the nobility. In this more complex telling of the past the largest of all the vacancies was women's place in making our world. Once it was decided to produce a volume on women's role in fashioning modern art I had to decide on the proper author. G. K. Hall acceded, wisely for all of us it turns out, in the suggestion of Cassandra Langer. She has done her work passionately well.

Each person recreates the universe and every observer creates a universe. In the long history of human evolution from rank mammal sentience to self-configuring creatures whose fate relies on the course of reason, we have moved from being shaped by instincts to rationally channeled feeling. Now it seems that the deflection of the female half of human perception to covert cultural paths was an unnecessary price for the climb from mammal society to modern culture. We are beginning to chronicle those ages before both males and females were offered the reins of evolution.

Merely to consider female suppression would be glib or extreme. Neither males nor females lived very well or very long until recently. Only with the economic surplus afforded by industrialization – when we could do more work than could be generated by human or animal muscle – could suffrage evolve. First freeborn landholders, then white males, then male citizens, then female citizens were recognized; then the suppressed and dispersed national identities were returned lands from colonizers: Indians (riven by Moslem-Hindu schism), Jews, Vietnamese, the African nations one

by one emerged. Not a nation, women are participants in this universal quest for liberation.

The twentieth century has busied itself fulfilling the dream of the eighteenth, the enfranchisement of the debased. There have been horrible detours, full of slaughter, political madness, and times of great troubles. As the different groups of disenfranchised emerged from shadows to become peoples, nations, or unions, the place of women in the world has been difficult. To gain purchase on this situation Langer points out Ariel Dougherty's statistical survey of the progress.

The past featured heroic figures (themselves now lost, or their acts distorted), contributors to every aspect of human betterment whose only "blemish" barring them from fame was being female. Among these were were artists, women of virtuosity and accomplishment whose names and careers never attained the luster of those of their male conterparts. Thanks to Langer we discover Margaret Middleton's study of Henrietta Johnston, the first American of either sex to work in pastel. In Langer's volume we can begin to see artistic personalities accrue facts, biographical and art-historical, in a process paralleling the original process of art history. For example, Langer directs us to Ellen C. Clayton's pathfinding two-volume work of 1876, *English Female Artists*.

As if the first art history were being reenacted with a new "national style" (akin to establishing the lineaments of a French, Italian, or German style), some authors argued for a "female" sensibility. To so fashion this viewpoint implied an underlying similarity, or the possiblility of such, a femaleness, whose characteristics were fugitive at best, and possibly subversive if they existed as disqualifiers to male-generated aesthetics. We can, by closely reading these pages, discover the possiblility of a counter-aesthetic, a womanly aesthetic consisting of a pertinent subject matter of female imagery–not necessarily "feminist." Then a more recent reconstructed universal imagery subsumed male/female sensibilities.

Now–in that parade of new reporters, new sensibilities, and viewpoints streaming to enrich the record of human experience–appears the great voice of the formerly silent half of human nature. However else women were defined–as commodity (a situation shared with men in different societies) or by a talent: beauty–their universal job has been motherhood. Numerous citations of motherhood as a theme are found in Langer's work.

Langer presents evidence of gender rivalries; she treats definitions of sexuality. Men and women examine and struggle with the seductive fictions of societal forms that assigned a place to all, but made that place uncomfortable for the majority. Discussions about the domestic and other workplaces for artists can be consulted. Here is a key to debates about representations of the female body by men and women. The patriarchy of the artistic canon has been presented from all facets: as a warranted and genuine artifact of past society, and as an expression of continuing oppressive manipulation. Both viewpoints can be tracked in the literature Langer has gathered. It is to her

credit that in the following pages she is both vehement and rhetorically balanced; the reader is her beneficiary.

Until now there was no coherent record to consult on the feminist discussion in the arts; Cassandra Langer has ameliorated that lack. We can trace the history of questions and answers, new questions and new answers. But the debate really has no beginning and certainly no end in sight.

Harry Rand
Smithsonian Institution

Preface

My debts are great, and my sense of gratitude is very deep to those women and men who struggled before me in service of women's liberation.

The staffs of several institutions – in particular the New York Public Library – have helped me in my research efforts. During the early stages of this project my search of the standard databases revealed that little had been done in the field of feminist art criticism. Shockingly, this initial survey of the field produced entries listing traditional categories (i.e., woman, art, etc.). Only after an extensive computer survey (using a series of rather unusual headings) did sufficient data emerge; from that list I made my selections. Despite new technologies, a number of significant documents slipped through the net. Many of the articles dealing with multicultural, race, and gender issues were published in alternative journals, small museum and gallery catalogs, and feminist papers and/or circulated informally through the women's studies network.

I encountered additional problems when I got to sensitive issues such as pornography, rape, essentialism, incest, battering, women's spirituality, censorship, homophobia, ageism, and other topics in the field of feminist art criticism. The failure of the majority of traditional and even feminist researchers to consider the possibility of lesbian meaning was directly related to their inability to see lesbians at all and to their habitual failure to see relationships among women as significant. My own research – which involves more than twenty years in the women's art movement – enabled me to overcome these stumbling blocks and provide counterbalancing entries.

Librarian Claire Gabriel's nimble mind unlocked the combinations to the vaults of various computer data banks, including Art Bibliographies Modern, Dialog, and RILA, which yielded up their treasures reluctantly. I would also like to thank Ferris Olin of Rutgers, Paula Chiamonte, and most especially Ann C. S. Benton of the New York Public Library for the many valuable hours she spent on the book section of this bibliography. Without the support of the many women and men art historians, art educators,

theorists, artists, and critics who met the challenge of a new historical situation, as well as those who resisted it, I would not have been able to document the rapid social and cultural changes that took place during this exciting period in the development of a feminist art and criticism. I owe an enormous debt to the anonymous reviewers who serve on the staffs of various publications in the humanities for their assessments, which helped me evaluate some of the entries I selected to represent debates that shaped my own theory and practice as an emerging activist art critic during the late 1960s and to the present day.

I would like to express my personal and professional gratitude to Harry Rand of the Smithsonian Institution and Borgna Brunner and Helen Ronan at G. K. Hall for their support throughout the production process. I can only inadequately convey appreciation to the many people who have helped me in the face of what seemed like an insurmountable task. The contributions of my two spunky assistants, Catherine Morris and Kathy Finley, were essential.

Some of the ideas for this book grew out of conversations with friends and colleagues such as Emma Amos, Ferris Olin, Robert Preato, Jill Morris, Diana Kruz, Berenice D'Vorzon, Margo Machida, Cynthia Navaretta, Lois Fink, and Linda Nochlin. I would like to thank them all for their patience and blessings.

Introduction

Beyond a regard for feminist art criticism itself, this book originated in two watershed movements while I was developing a methodology of art history and criticism that wouldn't evade engagement in the real world as a feminist and art historian/critic.

The first of these milestones was a meeting of the College Art Association of America in San Francisco in 1972, at which Ann Sutherland Harris and Paula Harper spoke of the need to focus art-historical attention on women's contributions and then smartly passed the hat to finance the formation of the Women's Caucus for Art. On that fateful day, I was one of an audience of young women. We were to change the face of our discipline and, in turn, our own lives and career possibilities. I recall this as a period when the WCA began to deal with sexual politics by struggling to introduce at the annual meetings of the College Art Association sessions that dealt with women's realities in the arts professions.

In 1977, Ann Sutherland Harris and Linda Nochlin opened their now celebrated exhibit documenting women's contributions to art, *Women Artists: 1550 to 1950*. In their catalog essays they gave a comprehensive overview of women's artistic opportunities (or lack of them), education, lives, and careers. The questions they posed – "What is the place of women in the history of various movements, to what degree has prejudice resulted in the neglect or inadequate appreciation of their work? Is the relative silence on their work a just reflection of their merits, do any of these women deserve a place in the standard surveys?" – became the basis for the revisionist movement in art history.

Meanwhile, by the mid-1970s I had already been responsible for a number of activities in the southeast focusing on women artists. I also read everything that was available on women artists and criticism, discussed the emerging issues with other feminists, wrote on various cultural activities, and supported newly emerging journals, for instance *Woman and Art* (1971), *Feminist Art Journal* (1972-1977), *Womanspace Journal* (1973; published only

three issues), *Womanart* (1976-1978), *Chrysalis* (1977-1980), and *Women Artists News* (1975-1991). My experience paralleled that of many other activists worldwide.

In 1974, I became a contributing officer of *Women in Art: It's Time* and initiated the first "Women and Art" course in the state of Florida, at Florida International University. By 1975, I, like many of my regional sisters, had become very much a part what some scholars have termed "the first wave" of the American art movement in Women's Studies.

The magazines mentioned earlier and other short-lived publications contributed greatly to the field of women's studies. During this era, feminist art criticism was only a faint glimmer on the horizon of sexual politics. Universities and art institutions were not cordial to the efforts of feminists, looking upon them as "foreign bodies" within the organism of the university. Putting women into the picture required enormous energy and commitment.

The budding movement was nourished by a number of newsletters, privately published broadsheets, and assorted other alternatives that encouraged self-awareness, multiculturalism, experimentation, and humility. Judith Brodsky, Mary Garrard, Judy Loeb, Elsa Fine, Jean Gillies, Lee Ann Miller, and many others were all champions in forwarding the cause of women in art.

In the 1970s American writers including Lawrence Alloway, Cindy Nemser, Pat Mainardi, Ellen Lubell, Arlene Raven, and Lucy Lippard were to emerge as feminist art's problematic beacons, shortly followed by dissimilar feminist publishers. These included Cynthia Navaretta of *Women Artists News*, Elsa Fine of the more conservative and art-historically oriented *Woman's Art Journal*, and later the radical editions of the *Heresies* collective.

Revisionist art historians, some of whom called themselves feminists, including Ann Sutherland Harris, Linda Nochlin, Eleanor Tufts, Norma Broude, Mary Garrard, and Alessandra Comini, to mention only a few, were all busy filling in the gaps, hence providing a basis for emerging theories in feminist sexual politics. Artists, especially Judy Chicago and Miriam Schapiro, quickly established beachheads with their feminist art programs. I remember how boldly Womanhouse's explorations of such issues as consciousness-raising, self-expression, violence toward women, sexuality, feminist community, and a host of related topics became the basis for my own teaching and critical practices. Younger art historians/critics like Arlene Raven, Moira Roth, and Joanna Frueh, as well as myself, became transformed by the realities of sexism, and the personal as the political. We became sprouting American feminist art critics whose writings would unremittingly struggle to change the face of the discipline and the society in which we lived.

I recall those heady days and the exhilarating spirit of possibility we all felt with a certain sense of mixed satisfaction because I have lived long enough to see the harvest of those seeds flower into the difficulties feminists face as we edge toward the millennium. We thought we could change the

world; we did, and we are still in the process of transforming cultural and social values.

By the late 1970s a feminist critique of class, race, gender, and sexuality was being employed worldwide. American feminists were aware of the Canadian, English, German, French, and emerging Italian women's movements, although they appeared marginal to our own activities at the time and unfolded at their own pace. International developments were relevant to our individual representations and analyses of the problems at hand. At that time, global networking was a germ floating in the intoxicating atmosphere of feminism. This was especially evident in the arts, where a pungent mixture of international scents flooded feminist praxis.

During the 1980s, women's studies experimented with a variety of postmodernisms. Many read British publications, including *Feminist Art News* and *Women Artists*, and found resource material in issues of *Block* and *Spare Rib*. In general this self-conscious and self-contradictory term, "postmodern," has come to stand for a body of feminist criticism that some label "second-wave" feminism and define as the allegedly more intellectual formulation of our practice. This system of masculine authority was, and still is, full of obligatory linguistic gymnastics centered in poststructuralism, French literary criticism, and psychoanalysis. In the hands of French feminists such as Luce Irigary, postmodernism's alluring mechanisms have been repossessed to raise serious critical questions concerning such issues as essentialism (the supposed valorization of the body by early feminists). In the United States many feminist art critics refused to be shackled by postmodernism's academic chains or bound by the irons of identity politics. Rather than submit to politically correct dogma, many continued to develop alternative theories based on a natural progression of ideas advanced by Mary Daly, Audre Lorde, and Adrienne Rich.

A number of English feminists, however, such as Griselda Pollock, embraced the psychoanalytic theories formulated by Jacques Lacan, whose ideas about the moment of our symbolic entry into language vis-à-vis gender (masculine or feminine) are operative in their thoughts about the relation of writing to images. Melding such ideas with an interest in Althusserian Marxism, this group created their own particular brand of academic feminist art criticism.

In general, the binary opposition raised by such theories ran counter to what American feminist art critics, as opposed to British feminist art historians, generally envisioned as a praxis. In fact, some American critics view these formulations, which converge on male authority, as part of the backlash that emerged during the 1980s. For them, a feminist critique must arise from the false universalization of male experience regardless of color, creed, or class. Consequently, this bibliography reflects conflicts within and without the feminist art movement, in the context of development of a prismatic and multitudinous model of feminisms.

My rites of passage as an American feminist art critic mirror growing up in the late 1950s, and entering the reality of women's experience during

the sixties and seventies shapes this selective overview. With Luce Irigaray, I believe that sexual difference represents the horizon of fertile worlds as yet unknown. This is why I am not ready to displace the masculine/feminine binary before the female side has succeeded to identity and subjectivity. For "to omit the question of the woman-as-subject and her identity in thought and culture," as Irigaray explains, "is to leave in place a tenacious and damaging imaginary structure. Woman's time, then, is not necessarily coincident with the chronology of the male subject" (*The Irigaray Reader*, ed. Margaret Whitford [Cambridge, Mass.: Basil Blackwell, 1991], p. 13.)

Doubtless, in gathering together this collection of resources, I have overlooked some valuable work due to lack of communication among feminists and of proper recording of such research in databases and general resources. Nonetheless, it is my sincere hope that the information collected here will serve as a basis from which to build a more comprehensive knowledge of feminist art criticism.

As it now stands, this bibliography is the first of its kind in existence and represents a tremendous first step toward filling an enormous vacuum that is still ongoing, toward the fulfillment of a desired something that has yet to be achieved – a praxis that encourages a consciousness free from previous models that are limited or biased. It is a personal and political dream I am still trying to make come true. For any curious mind that longs to grasp the field of feminist art and criticism as it has matured over the last twenty years – to locate a place within this landscape – I hope this publication will dispel any sense of estrangement and provide a level of entry that facilitates a move into political awareness and action. In the spirit of sisterhood, I welcome ideas and contributions that add to future editions of this bibliography.

Purpose

The purpose of this guide is to provide the first basic bibliographic information in one place on a rich harvest of publications in feminist culture, art, theory, and criticism that have been produced over the last hundred or so years and are of prime relevance to the study of the visual arts and the feminist critique of art history and art criticism. The major emphasis, however, is on English-language publications in contemporary art and criticism, with an occasional reference to French, German, Russian, Dutch, Italian, and other European writings that might be representative of the field.

In order to present a broad general overview and give some idea of the perspectives that feminist art criticism has developed in the last twenty-five years, including recent developments in postmodernism, I have omitted the arguments of any theorist, major or minor, whose contributions did not affect the overall framework of the field. The selections will at times seem arbitrary and will show that individual authors on the same side of an issue differ from one another, are inconsistent with themselves, and change their minds. In the final analysis, what will emerge is a general picture of a flourishing garden

that is blossoming into countless bouquets of heterogeneous flowers producing an abundance of fragrances.

The references examined include books, pamphlets, articles, periodicals, exhibition catalogs, reviews, newspapers, and unpublished manuscripts. The entries are organized alphabetically. In general, reference tools and books for which more than one person is responsible are listed by title; where several articles or chapters by the same author are cited, they are arranged chronologically giving the full name of the author when available, title, date, place of publication, publisher, and other data that may augment entries. There are some entries where publisher, complete name of the author, dates, and page numbers may not be given. This is especially true of catalog essays and self-published references where, because of the haphazard nature of the field itself and the sometimes arbitrary forms used by artists, critics, and art historians, the information is simply not easily found.

The difficulty of tracking down some of the important resources, which were not readily available, for example *Womanart*, *WARM Journal*, *Soho News*, *Womanspace Journal*, *Easy Magazine*, and other alternative publications, furnished additional hurdles in the struggle to provide a model picture. Many of these "marginal" periodicals, which I remember well from my own consciousness-raising, contained important transitional work that deconstructed traditional art-historical methodology. These declarations showed the impact of early feminist thinking on American artists, teachers, and critics of the era and on the art-historical canon itself.

It is in the pages of such publications and other more international outgrowths, for example, *Women Artists Slide Library Journal* (U.K.), that we ferret out feminist resistance to sexual politics. Whatever the confusion over definitions, terms, directions, territorial imperatives, and methodology, this bibliography reflects a consistent picture of the fluid frontiers of feminist art criticism's passage over time.

The subject index is a useful cross-reference for researchers seeking additional information regarding specific topics such as healing, ritual, religion and spirituality, essentialism, violence, rape, racism, sexism, lesbians and lesbianism, pornography, multiculturalism, and identity. In many cases, essays have been collected to form useful anthologies for research and study purposes. I have attempted to cite significant related work in these areas and whenever possible indicate that these resources exist and contain other interesting material.

Each entry has an explanation of the nature of the items included and their relevance to feminist culture, art theory, and criticism. Whenever possible, most references are annotated with comments identifying and evaluating their place in the history of feminist art theory and criticism. There are cross-references to works containing related or additional information. Many of these are to sepcific entries, others are general references to the works of a writer; in the latter case, only the last name is given except to distinguish between two people with the same surname, and their writings can be traced in the author index. I have also included a listing of books and

essays at the end of many entries that I think may be relevant to those new to this field and that raise issues relating to feminist theory in the arts.

Reference Tools

1 *Anthology of Contemporary African-American Women Artists*. Edited by Leslie King-Hammond. New York: Midmarch Art Press, forthcoming, illus.

Essays by art historians, educators, curators, and writers are accompanied by photographs of the artists and their work. Includes a section on emerging artists. This collection covers more than 100 artists, and is the first comprehensive book to focus exclusively on African-American women in the contemporary art world.

2 BACHMANN, DONNA G., and PILAND, SHERRY. *Women Artists: A Historical, Contemporary, and Feminist Bibliography.* Metuchen, N.J., and London: Scarecrow Press, 1978, 360 pp., 59 illus.

A chronologically arranged bibliography of books, articles, and exhibition catalogs relating to feminist art and women artists, with sections on general works and individual artists from the Middle Ages to the present. Includes a selected bibliography on needlework.

3 *Black Dimensions in Contemporary American Art*. Compiled and edited by J. Edward Atkinson. New York: New American Library, 1971, 127 pp., b&w illus.

Covers about twenty-five African-American women artists including Lois Mailou Jones, Lucille Roberts, Jewell Woodward Simon, and Alma Thomas. A valuable biographical resource giving information on the art, life, and careers of these creators.

4 CHADWICK, WHITNEY. *Women, Art, and Society*. London: Thames & Hudson, 1990, 383 pp., 243 illus., 50 in color.

Basing her analysis on two decades of feminist art history, Chadwick covers women artists from the Middle Ages to the present,

dividing their activities into art-historical periods. Though the book covers only Western society, it is densely packed with worthwhile information. Chadwick's interpretation of Romaine Brooks's lesbian self-portrait seems dubious, although her book is a great improvement over existing surveys and should be used to offset patriarchal histories of art currently used in the classroom.

5 CHIARMONTE, PAULA. *Women Artists in the United States.* Boston: G. K. Hall & Co., 1990, 997 pp.

Divided into sixteen sections by various experts dealing with topics including graphics, performance art, critics, special research collections on women artists, organizations, exhibition catalogues, minority artists, and a host of other subjects. Joanna Frueh's scan of feminist art criticism is a brief, pithy introduction to a neglected topic in the American art-historical conversation. Cynthia Navaretta's overview of women's art organizations gives a concise introduction to the subject. The short comments and crisp entries on reference tools, catalogs, and articles are a useful, quick guide to resources on women artists.

6 CLAYTON, ELLEN C. *English Female Artists.* 2 vols. London: Tinsley Brothers, 1876.

Volume one is a historical survey, and volume two concerns then-contemporary women artists. Contains biographic information on little-known or neglected British artists.

7 CLEMENT, CLARA ERSKINE. *Women in the Fine Arts from the Seventh Century B.C. to the Twentieth Century A.D.* Boston and New York: Houghton Mifflin Co., 1904. Reprint. Hacker Art Books, 1974.

A biographical dictionary focusing on women artists in all media and from many countries. Covers European and American artists, particularly of the nineteenth century. Gives brief biographical sketches; lists awards, exhibitions, and selected works.

8 COLE, DORIS. *From Tipi to Skyscraper: A History of Women in Architecture.* Boston: I Press Inc., 1973.

One of the first feminist surveys of architecture. Begins with early tipi forms and traces the development of women's architecture and aesthetics to modern times from a feminist perspective.

9 COLLINS, J. L., and OPITZ, G. B. *Women Artists in America: Eighteenth Century to the Present.* New York: Apollo, 1980, 966 pp., 226 illus.

An updated version of biographical listings of American women artists, divided into three sections for the lists compiled in 1973, 1975, and 1980.

10 DALY, MARY, and CAPUTI, JANE. *Websters' First New Intergalactic Wickedary of the English Language*. Boston: Beacon Press, 1987, 288 pp., 30 illus.

A witty, wacky, and defiant act of naming. This is a philosophical tool that is useful to theorists and critics.

11 DAVIS, G. LENTWOOD, and SIMS, JANET L. *Black Artists in the United States: An Annotated Bibliography of Books, Articles, and Dissertations on Black Artists, 1779-1979*. Westport, Conn., and London: Greenwood Press, 1980, 137 pp.

Treats the history of African-American art and artists, starting in the colonial period and running to 1979. Black artists have not been integrated into the history of American art. Provides references to books, major articles, publications including *Jet*, *Ebony*, *Opportunity*, and *Crisis*, and dissertations, and lists black artworks in various national archives.

12 *Directory of Hispanic Artists and Organizations*. Edited by Elba Cabrera Mondesire, David Crommett, and Guillermo Lucero. New York: Association of Hispanic Arts, 1981, 118 pp.

This publication includes an excellent section on the visual arts with brief biographical sketches on thirty-five women painters, sculptors, craft artists, illustrators, and photographers. Gives professional information and addresses and telephone numbers.

13 DUNFORD, PENNY. *A Biographical Dictionary of Women Artists in Europe and America since 1850*. Philadelphia: University of Pennsylvania Press, 1990, 380 pp., 26 color and b&w illus.

Offers information on important women artists. Explores a number of myths about them and demonstrates that although many of these women had as much talent as their male contemporaries, their opportunities were restricted. Shows the major influences and artistic associations that helped to shape them and their careers. Notes the type of art they produced and where it can be found.

14 ELLET, ELIZABETH FRIES LUMMIS. *Women Artists in All Ages and Countries*. New York: Harper & Brothers Co., 1859, 377 pp.

An international overview including painters, sculptors, miniaturists, landscape painters, and decorative artists. Arranged by nationality and century. Of particular note are the last two chapters, which are devoted to American women artists and sculptors, including Harriet Hosmer.

15 FINE, ELSA HONIG. *Women and Art: A History of Women Painters and Sculptors from the Renaissance to the Twentieth Century*. Montclair, N.J.: Allanheld & Schram, 1978, 240 pp., 180 illus.

Surveys the achievements of nearly 100 European and American artists from the Renaissance to the present. Among the first usable texts for classroom teaching in the history of art and women's studies. Each chapter opens with an introduction to the period examined.

16 FISTER, PATRICIA. *Japanese Women Artists, 1600-1900*. New York: Harper & Row, 1987, 208 pp., illus.

An excellent historical survey that gives us insights into gender relations and how they affected the production of Japanese women artists.

17 GARRARD, MARY. *Slides of Works by Women Artists: A Source Book*. Washington, D.C.: Women's Caucus for Art, 1974.

One of the first reference guides to come out of the women's movement in art. Remains a basically sound starting point for anyone interested in building a slide reference library in the history of women's art.

18 GREER, GERMAINE. *The Obstacle Race: The Fortunes of Women Painters and Their Work*. London: Secker & Warburg, 1979, 373 pp., 193 illus.

A sensational historical survey of women artists from the medieval cloister through the nineteenth century. Reinforces the notion of women as helpless victims of patriarchal society. Focuses on the world of women painters, demonstrating how the imposition of traditional social constraints deprived women of the chance to excel in their creativity. Examines the various kinds of obstacles encountered by women artists, including the family, love, the illusion of success, humiliation, and the problem of women's expression in the male mainstream.

19 *Guide to Women's Art Organizations: Groups, Activities, Networks, Publications*. Edited by Cynthia Navaretta. New York: Midmarch Art Press, 1979, 84 pp., 15 illus.

Guide to women's art organizations in the United States. Notes resources and provides addresses for each organization, with commentary on activities. Divided into sections on the visual arts, architecture, design, film and video, dance, music, theater, and writing.

20 HARMON FOUNDATION, NEW YORK. *Negro Artists: An Illustrated Review of their Achievements, including Exhibition of Paintings by the Late Malvin Gray Johnson and Sculptures by Richmond Barthe and Sargent Johnson*. 1935. Reprint. Freeport, N.Y.: Books for Libraries Press, 1971. 59 pp.

Part of the *Black Heritage Library Collection*, this publication includes essential information on a few women artists of color. The alphabetical directory, descriptions of educational backgrounds, and listing of works by artists make this work indispensable.

21 HEDGES, ELAINE, and WENDT, INGRID. *In Her Own Image: Women Working in the Arts*. Old Westbury, N.Y.: Feminist Press, 1980, 308 pp., 57 plates.

Divided into four sections: Everyday Use: Household Work and Women's Art; Becoming an Artist: Obstacles and Challenges; Their Own Images: Definitions and Discoveries; and Lend Me Your Hands: Women's Art and Social Change. A collection of writings ranging from African-American quilter Harriet Powers, impressionist Mary Cassatt, and authors Charlotte Brontë, Virginia Woolf, Jessamyn West, and May Sarton to feminist artist Miriam Schapiro.

22 HELLER, NANCY G. *Women Artists: An Illustrated History*. New York: Abbeville Press, 1987, 224 pp., 131 color, 47 b&w illus.

A (coffee-table) general survey of women painters and sculptors offering one illustration per artist.

23 JOHANNSEN, CHRISTINA B., and FERGUSON, JOHN P. *Iroquois Arts: A Directory of a People and Their Work*. Warnerville, N.Y.: Association for the Advancement of Native North American Arts and Crafts, 1983, 406 pp.

An invaluable biographical reference that includes each artist's Indian name, nation, birthdate, type of craft or art, materials used, training, and experience, and descriptions of their work. Arranged by chapters relating to a specific art or craft. Each part features names of artists listed by communities they belong to and by alphabetical order within their peoples.

24 JONES-WATSON, VIRGINIA. *Contemporary Women Sculptors*. Phoenix: Oryx Press, 1986, b&w illus.

A useful but somewhat incomplete and unrealistically priced survey of 328 living women sculptors, arranged alphabetically with a photo of almost every artist's work. This is a valuable research tool but its $125 price tag makes it too expensive for the average reader's home library.

25 KATZ, JANE B. *This Song Remembers: Self-Portraits of Native Americans in the Arts*. Boston: Houghton Mifflin Co., 1980, 207 pp.

Biographical sketches and personal stories of contemporary Native American women artists including Grace Medicine Flower, Helen Hardin, and Pitseolak.

26 KRAMARAE, CHERIS, and TREICHLER, PAULA A. *A Feminist Dictionary*. New York: Pandora Press, 1985, 587 pp.

A compilation of feminist terms and concepts. The book is a sometimes serious, sometimes humorous and downright eccentric demonstration that language, along with ourselves, can be liberated by a feminist approach. The authors were "particularly interested in the words of writers and speakers who have taken a self-conscious stand in opposition to male definition, defamation, and ignorance of women and their lives." Many of the entries are amplified quotations. Includes a lengthy bibliography.

27 *Lesbian Photography Directory*. Edited by Moran Gwenwald. Brooklyn, N.Y.: Print Center, 1982, 48 pp.

International in scope; lists 71 lesbian photographers, giving names, addresses, and phone numbers along with a short description of their work.

28 LEWIS, SMELLA. *Art: African-American*. New York: Harcourt, Brace, 1978, 246 pp., illus.

In five brief chronological chapters (ranging from 1619 to 1970), Lewis deals with the life and work of more than twenty-nine women artists of color (e.g., Elizabeth Catlett). Her descriptions of artists' styles, coupled with statements by the artists themselves, make these biographical sketches particularly rich.

29 MCQUISTON, LIZ. *Women in Design*. New York: Rizzoli, 1988, 144 pp., illus.

The first book to present an inventory of the lives and work of women designers. The forty-three women cited are an international collection of graphic, product, interior, furniture, and letterform designers. McQuiston also includes architects, filmmakers, animators, and design critics. Raises questions about design in relation to feminism: who benefits from design, what do the design professionals demand of women, and how do women cope with these demands? Includes Hedda Beese, Jane Priestman, Katrin Adam, Itsuko Haseawa, Nina Sabnami, and Susan Young.

30 MILLER, LYNN FIELDMAN. *The Hand That Holds the Camera*. New York: Garland, 1988, 200 pp.

A collection of interviews exploring the lives and works of women film and television directors. Includes Linda Yellen, Doris Chase, Michele Citron, and Kavery Dutta.

31 MOUTOUSSAMY-ASHE, JEANNE. *Viewfinders: Black Women Photographers*. New York: Dodd, Mead & Co., 1986, 201 pp., illus.

Overview of nineteenth- and twentieth-century black American photographers. Arranged into five historical periods with biographical narratives, bibliography, and historical information on the art and lives of these women.

32 MUNRO, ELEANOR. *Originals: American Women Artists*. New York: Simon & Schuster, 1979, 528 pp., 183 illus., 40 in color.

Traces historic traditions, from Mary Cassatt to the present, often with reference to interviews. Examines the lives of American women artists (i.e., Helen Frankenthaler, Lee Krasner, Joan Mitchell, Louise Nevelson, Georgia O'Keeffe).

33 *Mutiny and the Mainstream: Talk That Changed Art, 1975-1990*. Edited by Judy Seigel. New York: Midmarch Art Press, 1991.

Covers more than 250 "art talk" events – panels, discussions, presentations, and interviews – documenting the passionate debates raging in American art over the last fifteen years. Critics, dealers, artists, curators, art educators, and other arts professionals chart the unpathed waters at the edges of the so-called mainstream of art in the United States.

34 NAVARETTA, CYNTHIA. *Whole Arts Directory*. New York: Midmarch Art Press Series, 1980, 176 pp.

Covers art resources in the United States and Canada. Highlights organizations, alternative spaces, cooperative galleries, and special museums. Special focus on women and minorities, covering visual arts, photography, performance art, artists' books, film and video, crafts, and artists' colonies, retreats, and study centers. Also includes information on financial help, grants, arts management, legal assistance, and insurance. This is a crucial networking tool and a minihistory of the women artists' movement.

35 NEMSER, CINDY. *Art Talk: Conversations with Twelve Women Artists*. New York: Charles Scribner's Sons, 1975, xvi + 368 pp., 124 illus.

Nemser interviews Barbara Hepworth, Sonia Delaunay, Louise Nevelson, Lee Krasner, Alice Neel, Grace Hartigan, Marisol, Eva Hesse, Lila Katzen, Eleanor Antin, Audrey Flack, and Nancy Grossman. She explores the essential issues including the effect of the family on women artists, the extent to which each sees her work as different from that of men, and the evolution of each artist's basic concepts. She introduces the interviews with a text commenting on her awareness of sexist attitudes towards women artists, which led to "Forum – Women in Art," published in *Arts Magazine* (February 1971). The reasons for the particular selection of artists interviewed

are given, with comments on those who refused to be interviewed and on the reactions of those interviewed.

36 PALMQUIST, PETER E. *Shadowcatchers: A Directory of Women in California Photography before 1901.* New York: Midmarch Art Press, 237 pp., 104 illus.

The result of more than twenty years of research, this book documents the existence of some 850 women photographers working in California before 1901. Alphabetically arranged, each entry includes vital statistics, career chronology, a photograph of the woman, and selected examples of her work. Includes a list of selected readings and five essays written by or about women included in the book.

37 PETERSEN, KAREN, and WILSON, J. J. *Women Artists: Recogniton and Reappraisal.* New York: Harper & Row, 1976, illus.

One of the first scans of women artists to surface in the early years of women's studies. A set of slides was later made to go with the book and constituted one of the first teaching collections available in the United States. Now dated, this pioneering effort deserves mention for its place in the history of the women's art movement.

38 PETTEYS, CHRIS; GUSTOW, HAZEL; OLIN, FERRIS; and RITCHIE, VERNA. *Dictionary of Women Artists: An International Dictionary of Women Artists Born before 1900.* Boston: G. K. Hall & Co., 1985, 851 pp.

More than 21,000 citations for women artists and illustrators born before 1900, worldwide. Entries are arranged alphabetically and provide name, dates of birth and death, media and subject matter, place(s) of residence, education, a summary exhibition record, and bibliographical references.

39 PRATHER-MOSES, ALICE IRMA. *The International Dictionary of Women Workers in the Decorative Arts: A Historical Survey from the Distant Past to the Early Decades of the Twentieth Century.* Metuchen, N.J.: Scarecrow Press, 1981, 200 pp.

First-of-its-kind reference book, documenting the careers of 883 women who specialized in the decorative arts. Through a series of biographical sketches, examines the prevailing social and working conditions affecting the status of women in art manufacture.

40 RAVEN, ARLENE. *Picture This, or Why Is Art Important?* Houston: The Judy Chicago Word & Image Network, 1982.

This is Raven and Chicago's feminist manifesto. In many ways, it sets the tone for feminist art criticism in the United States. This innovative and creative text is made up of narrative units that

deconstruct androcentric representations of art and art history. Starting with Section I, "Picture," Raven gives us a word picture of patriarchal standards of measure and how they are constructed. Section II, "Picture-Framing," deals with the distinctions between women artists who are not supported in a patriarchal value system and males who are – the structures and distribution system. Section III, "What's Wrong with This Picture?" answers, "We're Not in It!" and sets the agenda for feminist consciousness and a feminist criticism. Section IV, "Picture the Question and Question the Picture," explores art's meaning in society, time, and culture. Section V, "Envision," pictures a woman before her own mirror creating her self. Section VI, "What Have Women Created? From A to Z," concludes with an alphabetic list of achievements. Section VII, "Why Is (Women's) Art Important (to Women)?" Feminist art is meant to change the world.

41 RUBENSTEIN, CHARLOTTE S. *American Women Artists: From Indian Time to the Present*. Boston: G. K. Hall & Co.; Avon, 1982, 574 pp., 283 illus.
 Politically naive and overblown, but full of good biographic material on a variety of American women artists. Chapters range from "Native American Artists" through "The Fifties: Women of The New York School" and "The Sixties: Pop Art and Hard Edge" to "The Feminist Movement." Useful lists of women holders of Guggenheim fellowships in art, women members of the American Academy of Arts and Letters, women sculptors and painters who exhibited at the Chicago World's Fair of 1933 and the New York World's Fair of 1939, and women artists in the National Academy of Design, 1825-1981. The revised edition includes contemporary artists such as Petah Coyne, Alison Saar, Betye Saar, Maya Lin, Jenny Holzer, and others working in the 1980s.

42 SPARROW, WALTER SHAW, et al. *Women Painters of the World*. London: Hodder & Stoughton, 1905. Reprint. New York: Hacker Art Books, 1976, 332 pp., 320 illus.
 A condescending survey that remains a classic in patriarchal stereotyping. Interesting from a historical point of view. The text is divided into chapters describing the work of different nationalities, written by various authors: "Women Painters in Italy since the Fifteenth Century," "Early British Women Painters," and "Women Painters in the United States of America" by Sparrow, "Modern British Women Painters" by Ralph Peacock, "Of Women Painters in France" by Leonce Benedite, "Women Painters in Belgium and in Holland" by N. Jany, "Women Painters in Germany and Austria, in Russia, Switzerland, and Spain" by Wilhelm Scholermann, and "Some Finnish Women Painters" by Helena Westermarck. Gives researchers

insights into how women were seen and what standards their achievements were measured by as compared with men.

43 STONE, WILBUR MACEY. *Women Designers of Bookplates*. New York: Published for the Triptych by Randolph R. Beam, 1902, 22 pp., b&w illus.

This brief book contains an international checklist of women designers of bookplates, including sixty American women artists. This valuable resource often gives information on neglected graphic artists and illustrators.

44 TUFTS, ELEANOR. *Our Hidden Heritage: Five Centuries of Women Artists*. London and New York: Paddington Press; Toronto: Random House, 1973, 256 pp., 137 illus.

Shows that despite the repression of women in the past and male biases of art and art history, women were consistently active in the art world, accepted as professionals, appointed as court painters, and appreciated. Presents a selection of work by outstanding women artists from the sixteenth to twentieth centuries, noting why women became adept at certain art genres rather than others. The section on the nineteenth century illustrates work by Sarah Peale, Rosa Bonheur, Edmonia Lewis, and Suzanne Valadon, and that on the 20th considers Kathe Kollwitz, Paula Modersohn-Becker, Gwen John, Natalia Goncharova, Germaine Richier, and I. Rice Pereira.

45 TUFTS, ELEANOR. *American Women Artists, Past and Present: A Selected Bibliographical Guide*. Vol. 1. New York: Garland, 1984, 340 pp., 12 illus.

An extremely useful research tool: contains primary and secondary materials on some 500 American women artists beginning with Henrietta Johnstone (ca. 1670-1728) and Patience Wright (1725-1786) and running through to the present.

46 TUFTS, ELEANOR. *American Women Artists, Past and Present: A Selected Bibliographical Guide*. Vol. 2. New York: Garland, 1989, 491 pp., 15 illus.

Includes more than 1,200 women artists and is as comprehensive a reference as one will find in the field. Tufts exhibits the meticulous research so valuable to scholars and students concerned with American women artists.

47 VAN WAGNER, JUDITH K. COLLISCHAN. *Women Shaping Art: Profiles of Power*. New York: Praeger, 1984, 302 pp., 19 illus.

Nineteen essays, based on interviews with women art critics and gallery owners who have been dominant in the art world in the United States since the Second World War: Emily Genauer, Marian

Willard, Katharine Kuh, Antoinette Kraushaar, Betty Parsons, Dore Ashton, Grace Borgenicht, Virginia Zabriskie, Lucy Lippard, Ileana Sonnabend, Grace Glueck, Paula Cooper, Rosalind Krauss, Cindy Nemser, April Kingsley, Holly Solomon, Monique Knowlton, Pam Adler, and Barbara Gladstone. The contributions of these women have largely been in the areas of supporting innovative artists against denunciation, founding art galleries, and contributing to art journalism. The book neglects African-American, Native American, Hispanic, and Asian women dealers and critics. The text serves to clarify issues that still need further investigation, such as the nature and politics of the art world, the role of dealers and gallery owners, and the position of women in the marketplace and their power in shaping taste. This volume tells us very little about power relations in these galleries or about various artists and their work.

48 WILLIAMS, O. *American Black Women in the Arts and Social Sciences: A Bibliographic Survey.* 2d ed. Metuchen, N.J.: Scarecrow Press, 1978, 197 pp., 28 illus.

This bibliography of creative work by or about black American women falls into two parts: the first provides a comprehensive listing of writings relating to literature and the visual arts, and the second gives individual bibliographies of writers and artists. The revisions consist of additional titles, merged sections, a list of significant dates, a list of some important ideas and achievements of black women, and photographs of artwork, artists, and authors.

49 YELDHAM, CHARLOTTE. *Women Artists in Nineteenth-Century France and England: Their Art Education, Exhibition Opportunities and Membership of Exhibiting Societies and Academies, with an Assessment of the Subject Matter of Their Work and Summary Biographies.* 2 vols. New York: Garland, 1984, 1165 pp., 198 illus.

Documents the lack of equal opportunities for women in art education in England and France prior to the twentieth century. Earlier there were four main types of art education available to women: 1) elementary instruction provided at school and at home; 2) education offered by schools of design, which was intended for women who had to earn a living through commercial art; 3) art education given at private art schools and ateliers, which, in France, was of an extremely high standard; and 4) academic instruction: after long efforts women were admitted to the Royal Academy Schools in 1860, and to the École des Beaux-Arts in 1897, but they were not allowed to study from the nude figure at these institutions until 1903 and 1900, respectively.

Books

Diaries, Letters, and Autobiographies

50 ALCOTT, ABIGAIL MAY (Mem. Nieriker). *Studying Art Abroad and How to Do It Cheaply*. Boston: Robert Brothers, 1879.

A witty little book giving insights into the differences in gender and opportunities for women studying art abroad in the nineteenth century.

51 BASHKIRTSEFF, MARIE. *Letters of Marie Bashkirtseff*. Translated by Mary Serrano. London, Paris, and Melbourne: Cassell & Co., n.d., 340 pp., illus.

Fighting against the environment, disease, and prejudice in the Paris of the 1880s, Bashkirtseff's letters vividly recount what it was like to be a woman artist struggling to be equal in a world where that was impossible for women.

52 BEAUX, CECILIA. *Background with Figures*. New York and Boston: Houghton Mifflin Co., 1930, 27 illus.

A look at Beaux's career from her point of view. Contains many observations on the forces that shaped women's lives at the turn of the century. Includes information on the de Kays, Van Gelders, and other important figures in the New York art scene at the turn of the century.

53 CHICAGO, JUDY. *Through the Flower: My Struggle as a Woman Artist*. Introduction by A. Nin. New York: Doubleday & Co., 1982, 226 pp., 63 illus.

One of the first contemporary feminist, autobiographical confessionals. Chicago describes her struggles – in private life and as

a woman artist – to be taken seriously. She discusses her rediscovery of neglected women artists and her growing conviction that female imagery itself has been excluded from the history of art. It is an inspiring read and serves as a model of feminist persistence.

54 HOSMER, HARRIET. *Harriet Hosmer, Letters and Memories*. Edited by Cornelia Carr. New York: Moffat, Yard & Co., 1912.

Written and compiled by a close friend and contemporary who based her book on the sculptor's correspondence with her patron Wayman Crow. This volume is full of interesting letters and useful information on Hosmer, her career, and her times. The short excerpts from her writings are particularly useful in giving insights into the problems encountered by women artists of the nineteenth century.

55 HOWITT, ANNA MARY. *An Art Student in Munich*. Boston: Ticknor, Reed, & Fields, 1854, 470 pp.

Personal account of a young woman's experience in an art school abroad during the mid-nineteenth century. Based on Howitt's letters home during her studies in Munich from 1850 to 1852. Describes the conditions under which female students persisted; she refutes claims that male art teachers thwarted the efforts of female students, but she does produce a quiet manifesto out of her understanding of a need for a union of women artists. She suggests a "Sisterhood in Art" in which "all should be bound to help each other."

56 MORISOT, BERTHE. *Berthe Morisot Correspondence*. Edited by Denis Rouart. Translated by Betty W. Hubbard. Introduction by Kathleen Adler and Tamar Garb. New York: Moyer Bell, 1987, 238 pp., 17 Illus.

Edited by Morisot's grandson, this collection includes statements on exhibitions, salons and events in Paris during the siege and Commune, travel impressions, invitations, and the important political events of Morisot's time. Gives insights into her position as an "exceptional" woman and the "feminine" delicacy attributed to her work by her contemporaries.

57 SHERMAN, CINDY. *Cindy Sherman: Untitled Film Stills*. Introduction by Arthur C. Danto. New York and Italy: Rizzoli, 1990, 120 pp.

This is a (coffee table) collection of forty photographs from the late 1970s. They were produced during the early period of Sherman's career, a period some critics think is her best. Sherman wrote, directed, shot, and starred in this provocative collection. Her staged photographic images (mainly of women) deal with male-constructed media presentations of women and with femininity as an act. She

often makes ironic fun of female stereotypes as portrayed by film, television, commercials, and art. Danto's essay manipulates the reader by overstating Sherman's importance.

58 SPENCE, JO. *Painting Myself in the Picture: A Personal, Political and Photographic Autobiography.* Seattle, Wash.: Real Comet Press, 1988.

A collection of articles, interviews, and photographic projects that examines the photographer as object from a feminist viewpoint. See "Sharing the Wounds: Jan Zita Grover Interviews Jo Spence," *Women's Review of Books* 7, nos. 10-11 (July 1990): 38-39.

Dissertations, Biographies, and Critiques

59 ALLEN, ELSIE. *Pomo Basketmaking: A Supreme Fine Art for the Weaver.* Healdsburg, Calif.: Naturegraph Publishers, 1972.

Details the life of Elsie Allen, a Native American woman who was born in 1899, but didn't begin basketweaving until she was 62 years old. The book describes the art of gathering materials and making baskets.

60 ALLEN, VIRGINIA MAE. *The Femme Fatale: Erotic Icon.* Rev. ed. Troy, N.Y.: Whitston, 1983, xviii + 209 pp., 48 illus., 10 text figs.

Examines the development of the "femme fatale" through the works of Goethe, Theophile Gautier, Charles Baudelaire, Gustave Moreau, Dante Gabriel Rossetti, Algernon Swinburne, and Edward Burne-Jones. Asserts that the meanings of the Eternal Feminine, for instance Mary/Eve, greatly emphasize the man-killer aspect of the feminine, transforming Eve from fallen woman to the mate of Satan. Concludes that the femme fatale is a mid-nineteenth century projection of the erotic fantasies and fears of a man-hating society and represents a hostile response to the sexual and other freedoms demanded by the emerging feminist movement. (Originally Allen's Ph.D. dissertation, 1979, Boston University, 479 pp.)

61 ANSCOMBE, ISABELLE. *A Woman's Touch: Women in Design from 1860 to the Present Day.* New York: Elisabeth Sifton Books, Viking; London: Virago Press, 1984, 75 b&w and 15 color illus.

Traces women's contributions to crafts and the arts, touching on their education, opportunities, and handicaps. Asserts that interpretation of twentieth-century design history has been distorted and narrow, overemphasizing theoretical writings in the field. She suggests that a shift in focus in design history to objects produced by designers will accent women's mastery in design. She pays serious attention to work of the Russian constructivist Stepanova and also

examines the influence of feminism on designers such as Paul Poiret. Includes index and bibliography.

62 *Art and Sexual Politics, Women's Liberation, Women Artists, and Art History.* Edited by Thomas B. Hess and Elizabeth C. Baker. New York: Art News Service, Collier Books, 1973, ix + 150 pp., illus.

A collection of essays by contemporary artists including Elaine de Kooning, Rosalyn Drexler, Bridget Riley, Louise Nevelson, Eleanor Antin, Suzi Gablik, Sylvia Stone, Marjorie Strider, Lynda Benglis, and Rosemarie Castoro and art critics Thomas Hess, Elizabeth Baker, Linda Nochlin, and Lee Hall. Reprints Nochlin's condemnation of institutional discrimination against women, "Why Have There Been No Great Women Artists?" (see entry 842).

63 *The Artist and the Quilt.* Edited by Charlotte Robinson. New York: Knopf, 1983, illus.

Based on an exhibition of twenty quilts curated by Charlotte Robinson, Dorothy Gillespie, and the late Alice Baber. Describes the nature of collaborations in the long-standing tradition of people working together to produce art. Quilts are organized in five groups and Lucy Lippard, Miriam Schapiro, Eleanor Munro, Bonnie Persinger, and Robinson have contributed essays that illuminate the background of these works.

64 *Art with Self-Will: Contemporary Art by Women.* Edited by C. Pichler and G. F. R. Locker. Vienna: Museum Moderner Kunst and the Museum des 20. Jahrhunderts, 1985, 301 pp., 156 illus.

Published in conjunction with an exhibition at the museums 29 March-12 May 1985. In addition to illustrating the performances and work in all media of the eighty-nine women artists who participated in the exhibition, contains thirteen texts, some previously published, examining the state and progress of feminist art, as well as separate sections and essays on films and videos made by women. RILA.

65 BAEHR, HELEN, and DYER, GILLIAN. *Boxed In: Women and Television.* New York: Pandora Press, 1987, 241 pp., illus.

Examines television's representation of women on the screen and behind the scenes. Discusses the medium as an important source of insights, assumptions, and beliefs about women and their place in culture.

66 BANKS, MIRA. *Anonymous Was a Woman.* New York: St. Martin's Press, 1979, 128 pp., illus.

Discusses samplers, quilts, and other objects produced by eighteenth- and nineteenth-century American women. Accompanied by excerpts from their diaries and letters.

67 BANTA, MARTHA. *Imaging American Women: Idea and Ideals in Cultural History*. New York: Columbia University Press, 1987, 844 pp., 500 illus.

Reflecting on American women as types, Banta charts the continuing currency of the turn of the century's iconography of the feminine. Banta's interpretations provoke a host of questions that are not addressed, for example the exclusion of Frederick Stuart Church's portraits of "ambiguous encounters between women and animals," thought to suggest women's underlying bestial/sexual nature. (See Bram Dijkstra, *Idols of Perversity* (entry 105), for comparisons.)

68 BARNES, DJUNA. *Ladies' Almanack*. 1928. Reprint. New York: Harper & Row, 1972.

A witty and amusing parody of lesbian and bohemian life. Character sketches based on role models such as Romaine Brooks and Natalie Barney, who Barnes knew and socialized with in Paris.

69 BARNEY, NATALIE. *Romaine Brooks: Portraits, Tableaux, Dessins*. New York: Arno Press, 1952.

Text in French. A volume of drawings and paintings by Barney's artist lover Romaine Brooks. It contains striking black and white reproductions of her works, including portraits of Barney, Una Lady Troubridge, Elisabeth de Gramont, Elsie de Wolfe, Ida Rubinstein, and Renata Borgati.

70 BARNEY, NATALIE. *Traits et portraits*. New York: Arno Press, 1963.

Text in French. A volume of Barney's portraits, published when she was 86. This includes a brilliant, biting twelve-page defense of lesbianism and male homosexuality as completely natural and normal life-styles, and includes references to Sappho, the Ladies of Llangollen, Renee Vivien, and Colette.

71 BAYLIS, SARAH. *Utrillo's Mother*. New Brunswick, N.J.: Rutgers University Press, 1988, 246 pp.

This is Baylis' first and last novel (she died in a tragic accident at the age of 31). Based on the life of French artist Suzanne Valadon, it attempts a hypothetical reconstruction. A fictionalized version of Valadon's life, the book captures rape and parenthood as a generational drama seen through a feminist lens. Treats the reader to a fascinating revisionist art history lesson as Baylis/Valadon deconstructs the sacred cows of late nineteenth century art. Valadon emerges as the heroic figure she was and we are able to fully appreciate her oeuvre in terms of innovative working-class female nudes and frank portrayals of the male nude.

72 BEHR, SHULAMITH. *Women Expressionists*. New York: Rizzoli International Publications, 180 pp., 40 illus.

A survey and discussion of the contributions of a select group of women artists to the expressionist movement, depicting work by women in Scandinavia, Holland, Austria, and Germany.

73 BELCHER, GERALD L., and BELCHER, MARGARET L. *Collecting Souls, Gathering Dust: The Struggles of Two American Artists, Alice Neel and Rhoda Medary*. New York: Paragon House, 1991, 304 pp., 31 illus.

Compares and contrasts the lives of painters Alice Neel, celebrated portraitist known as a collector of souls, and Rhoda Medary, who chose conventional roles as wife and mother and whose work fell into obscurity. Explores these different life choices and their outcomes.

74 BENSTOCK, SHARI. *Women of the Left Bank*. Austin: University of Texas Press, 1986, 566 pp., 48 b&w illus.

Details and describes the lives, relationships, and creative work of a community of extraordinary women in Paris. The book forces a redefinition of what modernism is, who is important in it and how we as feminists might go about defining it for ourselves. Includes many gay and bisexual women such as Margaret Anderson, Djuna Barnes, Natalie Barney, Sylvia Beach, Colette, Hilda Doolittle (H. D.), Janet Flanner, Jane Heap, Adrienne Monnier, Gertrude Stein, Alice B. Toklas, Renee Vivien, and Edith Wharton. By surveying the Paris expatriate experience from a feminist perspective, Benstock uncovers and clearly establishes the major role played by these gifted and autonomous women in forming the principles of modernism. Makes us take a harder and more skeptical look at postmodern sexual politics and the displacement of women.

75 BERGER, RENATE. *Malerinnen auf dem Weg Ins 20. Jahrhundert Kunstgeschichte als Sozialgeschichte*. Cologne: Du Mont Buchverlag, 1982, 51 b&w illus.

Examines problems in gender conflict. RILA.

76 BLANCHARD, PAULA. *The Life of Emily Carr (1871-1945)*. Seattle: University of Washington Press, 1988, 331 pp., illus.

Focuses on Canadian painter Emily Carr in the context of the social and psychological barriers that have prevented creative women in the past from achieving full expression and recognition. Blanchard gives us a sympathetic portrait of a woman who actively fought patriarchal standards to preserve her integrity and embodied deep spiritual principles in her art.

77 BRADLEY, PAULA W. "Miriam Schapiro: The Feminist Transformation of an Avant-Garde Artist." Ph.D. dissertation, University of North Carolina – Chapel Hill, 1983, 210 pp., 46 illus.

Provides a historical analysis of Miriam Schapiro's work and its impact on feminist politics in art. In the 1970s and 1980s, her work expanded the definition of art, revealing how the integration of feminist aesthetics into the so-called mainstream challenges hierarchical concepts in art, the political framework of the art world, and the nomenclature of "high art" and "craft." For a contrasting contemporary view see Arthur C. Danto, "Rosemarie Trockel," *The Nation* (October 7, 1991):420-423, in which he deflates Sidra Stich's troublesome interpretations of weaving and its feminist connotations.

78 BRESENHAN, KAROLINE PATTERSON, and PUENTES, O'BRYANT. *Lone Stars: A Legacy of Texas Quilts, 1836-1936*. Austin: University of Texas Press, 1986, 156 pp., 36 b&w and 110 color illus.

This book documents and examines more than sixty of the finest quilts made in or brought to Texas. The text describes the characteristics of each quilt, the family history behind it, and its size, fabric, colors, pattern name, etc.

79 BRETT, GUY. *Through Our Own Eyes: Popular Art and Modern History*. Santa Cruz, Calif.: New Society Publishers, 1987, 160 pp., 100 b&w and 40 color illus.

A selection of third-world art and artists. Highly political (Socialist/Marxist) in content.

80 *The Bride: Loved, Sold, Exchanged, Abducted – On the Role of Women in Different Cultures*. 2 vols. Edited by G. Volger and K. Von Welck. Ethnologica, n.s., vol. 11. Cologne: Rautenstrauch-Joest-Museum, 1985, 1:399 pp., 180 illus.; 2:497 pp., 217 illus.

Text in German. This book examines the role of women in different cultures and epochs through a study of brides and the ways in which they have been regarded both culturally and in the visual arts. Includes a study of the representation of the bride by twentieth-century women artists. RILA.

81 BROUDE, NORMA. *Impressionism: A Feminist Reading*. New York: Rizzoli, 1991, 192 pp., b&w and color illus.

In this publication Broude has taken full advantage of her feminist lens to scrutinize modern French science. Her text is accessible and reader-friendly and uses poststructuralism without becoming a slave to its theories. Her systematic examination of the field, particularly in "The Gendering of Art, Science, and Nature in the Nineteenth Century," reveals underlying patterns of gender discrimination

inherent in traditional French philosophy, which upholds Descartes's "I think therefore I am." Her examination of the social relations between art and science compels readers to take a harder, more skeptical look at the sexual politics of postmodernism, whose theory seems to be rooted within the French Cartesian tradition. Her book should be required reading for anyone interested in art, the feminine principle, and how it is treated in a male-oriented universe.

82 BROUN, ELIZABETH. "The Painting and Sculpture Exhibits in the Fine Arts and Woman's Building of the World's Columbian Exposition: 1893." Ph.D. dissertation, University of Kansas, 1983.

Describes and discusses the art created by a diverse group of nineteenth-century women.

83 BROWN, BETTY, and RAVEN, ARLENE. *Exposures: Women and Their Art*. Photographs by Kenna Love. Pasadena, Calif.: New Sage Press, 1989, 153 pp., 53 color photographs.

Both Brown and Raven, who collaborated with Kenna Love, are well-respected feminist critics who have written extensively on contemporary art. Their clearly written essays are entertaining (in jargon-free language) and succinctly characterize each artist and her work. This visual celebration features 50 contemporary artists: Kenna Love demonstrates her special gifts for composition and portraiture. Her emotionally intense portrayals capture women whose energies pulsate through this collection like electric charges. The feminist methodology that informs *Exposures* allows each artist's voice to emerge, speaking for itself and communicating directly with the reader.

84 BURGIN, VICTOR; DONALD, JAMES; and KAPLAN, CORA. *Formations of Fantasy*. New York: Methuen, 1987, 221 pp., illus.

Includes original articles, and republishes and critiques two classical psychoanalytic essays which demonstrate the crucial role of fantasy in the construction of sexual identity: Jean Laplanche and Jean-Bertrand Pontalis's "Fantasy and the Origins of Sexuality," and most importantly for feminists Joan Riviere's "Womanliness as a Masquerade."

85 *Camera Friends and Kodak Girls*. Edited by Peter Palmquist. New York: Midmarch Art Press, 1989.

Celebrates women of photography from 1840 to 1930. A selection of 50 writings recall the forgotten camerawomen of yesteryear. Included in this collection are commentaries by Julia Shannon, Annie L. Snelling, Lady Elizabeth Eastlake, Jabez Hughes, Julia Margaret Cameron, Eliza W. Withington, Richard Hines, Jr., Arthur W. Dow, Sadakchi Hartmann, Helen L. Davie, Emma Spencer, Alice

Boughton, Sara F. T. Price, Mary Carnell, Annie W. Brigman, Carmen Ballen, Flora Huntley Mascmedt, Laura Gilpin, and Ira W. Martin. Some of the women covered are Gertrude Kasebier, Zaida Ben-Yusuf, Abbie Cardozo, Annie Brigman, Imogen Cunningham, and Dorothea Lange.

86 CAMERON, VIVIAN. "Woman as Image and Image-maker in Paris During the French Revolution." 2 vols. Ph.D. dissertation, Yale University, 1983, 115 illus.

Examines how the French Revolution affected the lives of women, especially women artists. Begins with the activities and roles of women in society from before the Revolution to the Terror. Discusses the roles of women as mothers, virgins, and amazons in the festivals of the Revolution, and examines the imagery of armed Liberty and other female character types in the popular arts of the Revolution. Focuses on women's motivations for choosing artistic careers, their opportunities for education, their relation to the art schools and professional organizations of the establishment, the subjects they selected, the places they exhibited, and the nature of their political commitments.

87 CASTRO, JAN GARDEN. *The Art and Life of Georgia O'Keeffe.* New York: Crown Publishers, 1985, illus.

One of the most complete works on the artist to date. Examines O'Keeffe's art and life, her early feminism, her reputation as a modernist, and the myths surrounding her. Compares O'Keeffe to Louise Bourgeoise, Lynda Benglis, and Judy Chicago vis-à-vis sexuality.

88 *Caught Looking: Feminism, Pornography and Censorship.* Edited by Caught Looking, Inc. Seattle, Wash.: Real Comet Press, 1990, illus.

Feminist writers examine why restricting sexual speech and/or images is not the way to prevent pathological development in men and women. Surveys more than 200 erotic images dating from the 1890s to the present.

89 CHADWICK, WHITNEY. *Women Artists and the Surrealist Movement.* London: Thames & Hudson, 1985, 256 pp., 220 illus.

Examines the careers of the women who exhibited with the surrealists in the 1930s and 1940s. It includes Eileen Agar, Emmy Bridgwater, Leonora Carrington, Ithell Colquhoun, Nusch Eluard, Leonor Fini, Valentine Hugo, Frida Kahlo, Rita Kernn-Larsen, Jacqueline Lamba, Dora Maar, Lee Miller, Meret Oppenheim, Grace Pailthorpe, Alice Rahon, Edith Rimmington, Kay Sage, Dorothea Tanning, Toyen, and Remedios Varo. Traces their

struggles towards artistic maturity and their own "liberation of the spirit" within the context of the surrealist revolution.

90 CHICAGO, JUDY. *The Dinner Party*. New York: Anchor Press/Doubleday, 1979, b&w and color illus.

An extensive, emotional description and history of this monumental feminist retort to patriarchal history and art. *The Dinner Party* ignores the problems of racism and biology-as-destiny in both iconography and theory; nonetheless, Chicago's heroic efforts on behalf of women remain one of the most telling blows struck for women during the 1970s.

91 CIXOUS, HELENE. *The Book of Promethea*. Translated by Betsy Wing. Lincoln and London: University of Nebraska Press, 1991, 211 pp.

Cixous, born in Oran, Algeria, has made the phrase "writing from the body" one of the prime methodological concepts of feminism during the 1980s and currently. Many American, French, and Italian critics have incorporated her poetic praxis into their textual readings. Art critics including Lucy Lippard, Arlene Raven, Joanna Frueh, Moira Roth, and Mira Schor have attempted to make their writing agents of an empowered feminine rather than re-present a disempowering masculinity through their own lines. For these and other reasons, *Promethea* is a striking example of feminist identity and its possibilities as embodied in print. In embodying the pleasures and problems of love Cixous once again demonstrates that the personal is political.

92 COCKCROFT, EVA; WEBER, JOHN; and COCKCROFT, JAMES. *Toward a People's Art*. New York: E. P. Dutton & Co, 1977, illus.

A detailed account of the community mural movement including many black, Hispanic, and women's groups. Gives historical insight and political support to the many "people's" murals illustrated in the text.

93 COLE, DORIS, and TAYLOR, CORD. *The Lady Architects: Lois Lilley Howe, Eleanor Manning and Mary Almy, 1893-1937*. Edited by Sylvia Moore. New York: Midmarch Art Press.

Between 1913 and 1937 the architectural firm of Howe, Manning, and Almy designed more than 400 projects, most of which still survive. Pioneers in the field of residential design, these three women, graduates of MIT, became architects at a time when women were not encouraged to work outside the home. Their story is told through interviews with twenty past and present residents of the firm's houses, some of them the original clients.

94 CONSTANTINE, M. *Tina Modotti: A Fragile Life—An Illustrated Biography*. London and New York: Paddington Press; Toronto: Random House, 1973, 224 pp., 73 illus.

Life of Italian émigrée Tina Modotti, who escaped from a poverty-stricken childhood to a varied life as a Hollywood actress, the apprentice, model, and companion of photographer Edward Weston, and a political activist in Mexico, Russia, and Spain, during the Spanish Civil War. Seventy-three photographs of and by Modotti accompany the text, which contains information on her involvement with the women's suffrage movement and other social issues, describes her connections with artists and activists, and includes details of Weston's life and work as well as extracts from Modotti's correspondence. The relationship of her own photography to other aspects of her life is noted throughout.

95 COOPER, EMMANUEL. *The Sexual Perspective: Homosexuality and Art in the Last 100 Years in the West*. London: Routledge & Kegan Paul; New York: Pandora, 1986, 324 pp., illus.

This text claims to contribute to homosexual self-representation, and one applauds Cooper's ambitions, but because lesbians are collapsed into the general category "homosexual," Cooper's feminist politics (if any) remain controversial. Yet the book is valuable to those dealing with same-sex relations because it allows us to see how the feelings of homosexuals were depicted by the heterosexual world and by gay artists such as Donatello, Leonardo, Michelangelo, Alice Austin, Romaine Brooks, Gluck, Minor White, Francis Bacon, Harmony Hammond, Betsy Damon, Monica Sjoo, Jody Pinto, Fran Winant, Christina Berry, Robert Mapplethorpe, and Gilbert and George. For any lesbian feminist or feminist interested in gay and lesbian studies in art history, this is required reading. Of particular interest is "The Soul Made Flesh."

96 COURTNEY-CLARKE, MARGARET. *Ndebele: The Art of an African Tribe*. New York: Rizzoli, 1986, 208 pp., color illus.

Surveys South African women's mural traditions, showing many examples of painted houses and explaining the nature of their symbolism.

97 COURTNEY-CLARKE, MARGARET. *African Canvas: The Art of West African Women*. New York: Rizzoli, 1990, 204 pp., color illus.

Documents the central role women play in the decoration of vernacular architecture, by hand-painting, in Nigeria, Ghana, Burkina Faso, Ivory Coast, Senegal, Mauritania, and Mali. Also includes pottery and painted cloth.

98 DANIEL, PETE, and SMOCK, RAYMOND. *A Talent for Detail: The Photographs of Miss Frances Benjamin Johnston, 1889-1910.* New York: Harmony Books, 1974, 182 pp., illus.

A brief biographical sketch accompanies this partial catalog of the late nineteenth-century photographs of Frances Benjamin Johnston. Accomplished as a documentary press, architectural, and portrait photographer, she was also especially concerned with the role of women in American life. Johnston encouraged other women to find self-expression through the lens. For those interested in obtaining prints, the book includes an index to her photographs (with Library of Congress negative numbers) available through the Photo Duplication Division, Library of Congress, Washington, D.C.

99 DAVIDSON, CAROLINE. *Women's Worlds: The Art and Life of Mary Ellen Best 1809-1891.* New York: Crown, 1985, illus.

The English watercolorist Best first established her reputation in 1830, setting out to paint her autobiography early in her career. She was financially independent and was able to travel and paint in a variety of places on the Continent. She ceased painting in the late 1850s.

100 DAVIS, GAIL. R. "The Cooperative Galleries of the Women's Art Movement, 1969-1980." Ph.D. dissertation, Michigan State University, 1981, 262 pp.

A study of the historical, sociopolitical, and artistic significance of twelve women's cooperative galleries as they developed between 1972 and 1980: AIR Gallery (New York); Arc Gallery (Chicago); Center/Gallery (Chapel Hill, North Carolina); Central Hall Gallery (formerly Port Washington, New York); Floating Gallery (formerly New York); Front Range Women in the Visual Arts (Boulder, Colorado); Grandview Galleries I and II (formerly Los Angeles); Hera Gallery (Wakefield, Rhode Island); Muse Gallery (Philadelphia); Soho 20 Gallery (New York); and WARM Gallery (Minneapolis). Traces the early history of the collectives, relates their specific political and organizational developments to the changing national climate, and surveys and illustrates their artistic achievements.

101 DECKER, RUDOLF M., and VAN DE POL, LOTTE C. *The Tradition of Female Transvestism in Early Modern Europe.* New York: St. Martin's Press, 1989, 128 pp., illus.

Examines the female desire to assume male dress by such women as Sarah Emma Edmonds, Mary Read, Anne Bonney, Catalina de Erauso, and others in the context of cross-dressing and sexual politics. Discusses the Margaretha Link case in Germany where a lesbian who dressed and acted as a male was executed in 1721: the

trial is referred to in Salvatore J. Licata and Robert P. Petersen, eds., *Historical Perspectives on Homosexuality*, Haworth Press, 1980-81.

102 DE LAURETIS, TERESA. *Technologies of Gender*. Bloomington and Indianapolis: Indiana University Press, 1984, 151 pp.

Collection of eight essays. In these textual readings, influenced by the theoretical framework set in her *Alice Doesn't: Feminism, Semiotics and Cinema*, De Lauretis questions how to go beyond theories of sexual difference, confronting structuralist, poststructuralist, and postmodern theory through feminist interventions. She argues that women are active spectators and empowered by the way they gaze. Here she advances new theoretical approaches to film, narrative, and gender and catches the heterosexual blind spots of current debates.

103 *The Desert Is No Lady*. Edited by Vera Norwood and Janice Monks. New Haven and London: Yale University Press, 1987, 283 pp., 60 illus.

Looks at the ways in which women artists and writers of varying generations, ethnic backgrounds, and classes, including Georgia O'Keeffe, Nancy Newhall, Laura Gilpin, Carmen Rodriguez, Maria Vergagra-Wilson, Zoraida Ortega, Gloria Lopez, Pablita Velarde, Rosetta Huma, Nancy Holt, and Michelle Stuart expressed themselves through the images embodied in the landscapes of the American Southwest. Asks what the landscape has meant to these women and women in general in the context of identification and self-expression. The analysis is based on weaving, pottery, basketry, painting, photography, land art, etc.

104 DEWHURST, C. K.; MACDOWELL, B.; and MACDOWELL, M. *Artists in Aprons: Folk Art by American Women*. New York: E. P. Dutton, in association with the Museum of American Folk Art, 1979, 202 pp., 179 illus.

Based on an exhibition of the same title which focused on the art of American women who, without formal training and professional stature, exceeded the traditional expectations of society in producing their art. "The Needle Far Excels the Rest. ..." Describes the colonial period, 17th-18th centuries, with particular emphasis on needlework arts, especially samplers and quilts. "Beyond Expectations" analyses art created by nineteenth-century women in the context of the prevailing attitudes about women and their place in society. "The Women Have Leaped from Their Spheres" relates the artistic production of American women in the twentieth century to changes in political ideology which were sparked by the industrial revolution.

105 DIJKSTRA, BRAM. *Idols of Perversity: Fantasies of Feminine Evil in Fin-de-Siècle Culture*. New York: Oxford University Press, 1986, 453 pp., 300+ illus.

This text exposes the iconography of misogyny and other manifestations of antifeminine thought so prevalent at the end of the nineteenth century. At the time, evolutionary theories posited women, earthly and erotic, as threats to men's supposed spiritual progressions. Invalids, vampires, sirens, and other malevolent depictions of women are discussed at length.

106 DUBOIS, PAGE. *Sowing the Body: Psychoanalysis and Ancient Representation of Women*. Austin: University of Texas Press, 1988, 227 pp., 15 b&w illus.

Explores metaphors of the female body, using literary texts, ritual practices, and the graphic arts to expose ancient Greek views on gender. Also critiques psychoanalytic theories about gender. In conclusion, DuBois contrasts the twentieth-century psychoanalyzed female body, as represented as a symbolically castrated male, with the ancient Greek culture's figuration of the female body as fertile field.

107 DWORKIN, ANDREA. *Intercourse*. New York: Free Press (Macmillan, Inc.), 1987, 257 pp.

Using literature as a base, Dworkin brings to light the inherent sexism of patriarchal society through a feminist unmasking. Particularly telling are her examinations of Tolstoy's "Kreutzer Sonata," Joan of Arc's "Virginity," and "Dirt/Death."

108 *The Female Body in Western Culture: Contemporary Perspectives*. Edited by Susan Rubin Suleiman. Cambridge, Mass.: Harvard University Press, 1986, 389 pp., illus.

A collection of essays deconstructing representations of the female body in western art and culture. The essays by Mary Ann Caws, Miles, and Armstrong deal specifically with the visual arts and provocative postmodern examinations.

109 *Female Spectators: Looking at Film and Television*. Edited by E. Deidre Pribram. New York: Verso, 1989, 224 pp.

Essays by feminist filmmakers and theorists tackling the problem of female spectatorship and the contradictory identification with the camera's male "eye." Examines voyeurism and discusses the possibility of a "female or feminine" look. Includes writings by Linda Williams, Ann Kaplan, and Teresa de Lauretis.

110 *Feminism and Art History: Questioning the Litany*. Edited by Norma Broude and Mary D. Garrard. New York: Harper & Row; Toronto: Fitzhenry & Whiteside, 1982, 358 pp., illus.

Seventeen papers that reconsider, from a feminist perspective, some of the assumptions of art history. Twelve are reprinted, some with revisions, from earlier publications. Included are such subjects as matrilineal reinterpretation in Egyptian art, the Great Goddess and the palace architecture of Crete, mourners on Greek vases, the social history of women, social status and gender in Roman art, Eve and Mary, Artemisia and Susanna, Judith Leyster's "Proposition," history and its exclusions, happy mothers, the fallen woman, Degas's misogyny, virility and domination, and crafts.

111 *Feminist Aesthetics*. Edited by Gisela Ecker. Translated by Harriet Anderson. Boston: Beacon Press, 1986, 187 pp., 27 illus.

Eleven essays by Silvia Bovenschen, Elisabeth Lenk, Sigrid Weigel, Heide Gottner-Abendroth, Christa Wolf, Gertrud Kock, Jutta Bruckner, Christiane Erlemann, Renate Mohmann, and Gisela Breitling. Discusses aspects of the feminine aesthetic in art, history, writing, film, photography, music, and speech and its relationship to feminism. Argues against any "essentialist" position/and or female aesthetic due to sexual difference.

112 *Feminist Art Criticism: An Anthology*. Edited by Arlene Raven, Cassandra Langer, and Joanna Frueh. Forward by Donald Kuspit. Ann Arbor, Mich.: UMI Research Press, 1988, 200 pp., illus. Reprint. Harper/Collins, 1991.

Thirteen essays by critics, historians, and artists trace the course of feminist art criticism in America from 1970 to the present, demonstrating both the passion and the plurality of the movement. Arranged chronologically, demonstrating a continuity through essays dealing with sexuality, spirituality, the representation of women in art, women as art makers, ethnicity, language, the art world, and the practice of art criticism. Offers a critique on the theory and practice of feminist art and ways to reshape the art world and extend its values into the world at large.

113 *Feminist Collage: Educating Women in the Visual Arts*. Edited by Judy Loeb. Introduction by Joan Mondale. New York: Columbia University; London: Teachers College Press, 1979, 317 pp.

Contains twenty-eight provocative essays by Linda Nochlin, Lawrence Alloway, Jean Gillies, June Wayne, Mary Garrard, Cindy Nemser, Arlene Raven, and others that explore a wide range of educational, institutional, and societal changes. It is divided into three sections addressing changes inspired by the women's movement in the 1970s: "Feminist Reappraisals of Art and Art

History," "Feminist Reexaminations of Art, Artists, and Society," and "Feminist Restructuring of Art Education," and a concluding section, "Feminist Mandates For Institutional Change." Loeb argues that while positive changes affecting women in the visual arts have been initiated, the virtual absence of women heads of major art institutions and the failure of the most prestigious galleries and museums to offer exhibitions to women artists show that decisive actions by women in the arts were needed in the 1980s.

114 FERRERO, PAT; HEDGES, ELAINE; and SILBER, JULIE. *Hearts and Hands: The Influence of Women and Quilts on American Society*. Tennessee: Quilt Digest Press, 1987.
 Needlework as social criticism. A historical and biographical survey of quilts, letters, and diaries by women that parallels the growing pains of the country.

115 *Framing Feminism: Art and the Women's Movement, 1970-1985*. Edited by Rozsika Parker and Griselda Pollock. New York: Pandora Press, 1987, 288 pp., illus.
 A comprehensive history of the British women's art movement, covering major events and debates that have transpired over the last fifteen years. Discusses the various ways in which feminists have articulated their aims and ideas.

116 *Frauen in der Kunst*. Edited by Gislind Nabakowski. Frankfurt am Main: Suhrkamp, 1980.
 General anthology that discusses women and art. Includes work by Gloria Orenstein. RILA. *See also* entry 237.

117 GABOR, M. *The Pin-Up: A Modest History*. New York: Universe Books; London: Andre Deutsch; Pan, 1973, 272 pp., 500 illus.
 A comprehensive history of the exploitation of the female (and male) body from the fifteenth century to today. Pin-ups are discussed in the categories of "art" magazines, newspapers, cinema, calendars, posters, cigarette cards, and popular magazines. Both famous and obscure examples are included, and the psychology and sociology of the pin-up is examined.

118 GARRARD, MARY D. *Artemisia Gentileschi: The Image of the Female Hero in Italian Baroque Art*. Princeton, N.J.: Princeton University Press, 632 pp., illus.
 Divided into three parts – a biographical essay, a chapter on historical feminism, and a rigorously researched discussion of the theme of heroic womanhood that is so evident in Gentileschi's work. See Ann Sutherland Harris's review (entry 607).

119 GERZINA, GRETCHEN HOLBROOK. *Carrington: A Life*. New
 York: W. W. Norton, 1989, 329 pp., illus.
 Examines the Victorian taboos on female assertiveness that
 prevented this talented artist from achieving her full potential. Part
 of the mythic Bloomsbury set, Leonora Carrington traced her own
 problems regarding her creativity from her awful childhood. Her
 fifteen years with the homosexual Lytton Strachey are examined from
 a psychoanalytic point of view. The claustrophobic nature of her art
 is often seen as an expression of her inner world. Despite her relative
 neglect in texts on English art, Carrington exhibited widely and
 worked with Roger Fry's Omega Workshops and for the Woolfs'
 Hogarth Press. Between 1921 and 1924, she produced a striking
 series of landscapes that simply points to the fact that she is one of
 the most seriously neglected women artists of her time.

120 GILLESPIE, DIANE F. *The Sister' Arts: The Writing and Painting of
 Virginia Woolf and Vanessa Bell*. Syracuse, N.Y.: Syracuse University
 Press, 1988, 288 pp., illus.
 The first three chapters trace the interactions between these arts
 and in relation to the complex sisterhood of Woolf and Bell. The
 final three chapters explore ways in which Bell's portraits, still lifes,
 and landscapes complemented and inspired Woolf's writing.
 Examines, for the first time, the close artistic collaboration that
 existed between Bell and Woolf in the context of Bloomsbury, the
 Hogarth Press, sisterhood, and feminism.

121 GILPIN, LAURA. *The Enduring Navaho*. Austin: University of
 Texas Press, 1968, 321 pp., 221 b&w and 22 color photographs.
 A superb photographic survey of these disappearing Native
 Americans by an outstanding photographer of the Navaho. Using
 portraits of individuals and families, Gilpin conveys a unique sense of
 intimacy and serenity. Here she captures the daily life and spiritual
 essence of a tribe that continues to capture the imaginations of
 artists, psychotherapists, and ordinary people. Her dramatic images
 of the desert, mountain, and canyon landscapes that these people
 inhabit only underscore their way of life, which contrasts so sharply
 with the materialism of white people's lives.

122 *The Green Stubborn Bud: Women's Culture at Century's Close*. Edited
 by Kathryn F. Clarenbach and Edward L. Kamarck. Metuchen, N.J.:
 Scarecrow Press, 1987.
 Record of the proceedings of the Second National Conference on
 Women and the Arts, sponsored by the University of Wisconsin in
 June 1985. Documents the discussion papers and recommendations
 of the conference, which addressed cultural feminism. Of particular
 interest is Gloria Orenstein's focus on the reemergence of the

Goddess, which asserts that such work is shaped by self-conscious political analysis of both andro- and gynocentric visions of power over the world. Images of the Goddess represent a symbolic potential to alter both the consciousness of women and the dominant mythological perspectives of Western patriarchal culture. Includes essays by Tisa Chang, Sophie Rivera, Jean La Marr, Ruth C. Dean, Elizabeth Durbin, and Robin Morgan.

123 GRIFFIN, SUSAN. *Women and Nature: The Roaring Inside Her.* New York: Harper & Row, 1978, 263 pp.

A virtuoso piece of eco-feminist writing. The form is an intricate dialogue between a patriarchal voice and a chorus of women and nature. The patriarchal voice insists that we are separate from nature, and indeed superior to it, while the women's voices explain how we are all embedded in nature. Ultimately, the analogy between women and nature gives rise to a new way of seeing and is enunciated in a section entitled "Her Vision." These meditations laid essential groundwork for women artists and their expressions on the subject.

124 GROVER, JANE C. *The Positive Image: Women Photographers in Turn of the Century America.* New York: State University of New York Press, 1988, illus.

Examines high art and popular culture in the context of the period 1880 to 1920. Focuses on Gertrude Kasebier, Eva Watson-Schutze, Anne Brigman, Alice Broughton, Alice Austin, Jessica Tarbox Beals, and Frances Benjamin Johnston. Includes a chapter on the associations and clubs to which these women belonged.

125 GUNN, PETER. *Vernon Lee: Violet Paget, 1856-1935.* New York: Arno Press, 1964.

In this biography of the critic Violet Paget (pseud., Vernon Lee), the author fails to deal with her lesbianism and her lifelong attachment to the poet-novelist Agnes Mary Robinson. Lee's contributions as an art critic and aesthetic thinker have long been ignored by the patriarchy, particularly her concept of empathy, which differs sharply from that of the German critics. She is long overdue for a sensitive feminist treatment of her work.

126 HALE, NANCY. *The Life in the Studio.* Boston: Little, Brown & Co., 1969, 209 pp.

A daughter's fond reminiscences of her artist parents, Lilian Westcott Hale and Philip Hale. These accounts were sparked by a visit to and clearing out of her mother's studio after her death. Also comments on strains in artists' marriages produced by competition.

127 HALL, EVELYN B. *The Women of the Salons, and Other French Portraits*. New York: G. P. Putnam's Sons, 1926, 235 pp., illus.

Ten women and one man are described as "saloniers." Elisabeth Vigée-Lebrun is the only female artist represented here. A chapter on Madame Recamier sheds light on her role as model for several artists.

128 HAMMOND, HARMONY. *Wrappings: Essays on Feminism, Art and the Martial Arts*. New York: TSL Press, 1984, 110 pp., illus.

A collection of previously published writings including "Class Notes," "Horse Blinders," "Feminist Abstract Art," "A Sense of Touch," and others. See Hammond in articles and chapters section.

129 HAYDEN, DOLORES. *The Grand Domestic Revolution: A History of Feminist Designs for American Homes, Neighborhoods and Cities*. Cambridge, Mass., and London: MIT Press, 1981, 367 pp., 131 b&w illus.

Examines the material of feminists between the end of the Civil War and the beginning of the Depression. These were women who undertook the complete transformation of the spatial design and material culture of American homes, neighborhoods, and cities. They called for functional changes in physical structures and sought to relocate domestic activities in order to free women from unpaid, household labor.

130 HERRERA, HAYDEN. *Frida*. New York: Harper & Row Publishers, 1980, 256 pp., 32 b&w and 16 color illus.

A beautifully researched and written life of one of Mexico's best artists, Frida Kahlo. Packed full of original insights into Kahlo's relationships, including her lesbian adventures, and new information regarding the development of her art, surrealism, Communism, and the impact of Mexican culture and life on her mode of expression.

131 HOFRICHTER, FRIMA FOX. *Judith Leyster: A Woman Painter in Holland's Golden Age*. Doornspijk: Davaco, 1989, 303 pp., 159 b&w and 18 color illus.

Covers Dutch painter Leyster's career and the consequences of her obscurity, chief among these being incorrect attribution of much of her work to better-known artists. The catalogue raisonné arranges authentic, problem, lost, and incorrectly attributed works. Also included are biographical and legal documents, a 1688 household inventory (taken eight years after her death), and a selected bibliography. General, location, and subject indexes. (Hofrichter, Frima Fox. *Judith Leyster, 1609-1660*. Ph.D. dissertation, Rutgers University, 1979, 469 pp., typescript, microfilm, xerox.)

132 HSU CHUNG-P'EI. *The Position of Women in Free China: Chinese Women Show Their Mettle in the Arts*. Taipei: China Culture Publishing Foundation, 1953, 18 pp.

This description of the state of the arts in 1950s Taiwan journalistically records how women flourished through general encouragement and their aptitude. Painting became a vastly popular hobby for women of all classes. Madame Chiang Kai-shek is mentioned for publication of her accomplished paintings in *Life Magazine* after only a brief amount of study. Other women painters who attracted attention were Yuan Chu-chen and Sun To-sze (both exhibitors in the United States).

133 *In/sights: Self-Portraits by Women*. Compiled by Joyce T. Cohen. Boston: David R. Godine, 1978, 134 pp., 238 illus.

A collection of photographic self-portraits arising out of contemporary women artists' concern with autobiography. Includes 60 women, followed by six portfolios of photographs. Discusses self-transformation, explorations of sexuality through direct visual confrontation with one's body, incorporation of natural forms, nostalgia, unsettling images, dreams, fantasies, humor, and satire. An essay entitled "Self as Subject: A Female Language" by Patricia Meyer Spacks contributes a psychoanalytical explanation.

134 IRIGARY, LUCE. *Speculum of the Other Woman*. Translated by Gillian C. Gill. Ithaca, N.Y.: Cornell University Press, 1989, 364 pp.

Considered one of the major texts in post-1968 feminist inquiry in France, Irigary's essays were instrumental in transforming feminist art criticism. Casts light on the antifeminism inherent in Western philosophy and carrying over to psychoanalytic theory. The original publication of this book led the Lacanian faction to eject her from the Freudian School and her teaching position at Vincennes.

135 JEB. *Eye to Eye: Portraits of Lesbians*. Forward by Joan Nestle and historical introduction by Judith Schwartz. New York: GladHag, 1979, 80 pp., 38 b&w illus.

A book of photographic portraits of lesbians of many ages and races from all walks of life. This is one of the first collection to view lesbians as human beings (rather than erotic titillations or as victims to reassure the predominant mode of sexuality).

136 JOHNSON, BUFFIE. *Lady of the Beasts*. New York: Harper & Row Publishers, 416 pp., 165 b&w illus., 3 eight-page color inserts.

Discusses common and uncommon images of goddesses throughout world history and culture. The deep themes of fertility, death, and rebirth are brought to the forefront by Johnson's catalog

of beasts and figures crafted by humanity to describe the realm of nature as myth.

137 KAPLAN, JANET A. *Unexpected Journeys: The Art and Life of Ramedios Varo*. New York: Abbeville Press, 1988, 286 pp., 220 illus.

The author examines Varo's close association with surrealism, her deep belief in dreams and the power of the spiritual, and her interest in science, time and space, and creation itself. Born in Spain in 1908, Varo became an exile in 1939, when Franco closed the Spanish borders to those with Republican ties. Her life in Paris, her marriage to surrealist poet Benjamin Peret, and her relationship to Andre Breton are explored. Kaplan discusses Varo's fascinations with Bosch, El Greco, Goya, and mysticism. In 1941, the Nazi occupation forced her to flee to Mexico City where she remained until her death in 1963.

138 KAPLAN, LOUISE J. *Female Perversions*. New York: Doubleday, 1991, 580 pp.

Kaplan's discussion of perversion, castration, feminine stereotypes, masquerades, separation anxiety, and the codes that refer to these issues constitutes one of the most coherent discussions to date of the battle between the sexes. Of particular interest to art historians and critics is her first chapter, "What Is Perversion," in which she discusses the meaning of the term fetish, which originates in the French word *factice*, meaning "fictious" or "artificial." Her depiction of the inner genital world of women will force art historians and critics to rethink gender stereotypes and cultural constructions.

139 KEARNS, MARTHA. *Kathe Kollwitz: Woman and Artist*. New York: Feminist Press, 1976, 320 pp., illus.

Discusses Kollwitz's life and career in the context of her women, who are working-class mothers, revolutionary activists, grief-stricken widows, tender friends, prostitutes, militant pacifists, and defiant victims of an oppressive system of work that seldom rewards them with a decent standard of living. Sensitively written and generously illustrated, this book shows us many striking reproductions from private collections and demonstrates what a feminist reading can bring to the history of art.

140 KELLY, MARY. *Post-Partum Document*. Introduction by Lucy Lippard. London: Routledge & Kegan Paul, 1983, 212 pp., 131 b&w illus., diagrams and documentation.

Deals with provocative issues of sexual politics, specifically mother and child relationships, in terms of structure and process as represented in the public arena and through a postmodern matrix.

141 KEULS, EVA C. *The Reign of the Phallus: Sexual Politics in Ancient Athens*. New York: Harper & Row Publishers, 1985, 452 pp., illus.

Phallicism, as defined by the author, is a combination of male supremacy and the cult of power and violence. Keuls' study of phallicism chronicles events in Athens in the fifth century B.C., offering evidence of a shift from extreme phallicism to an emergent antimilitaristic, feminist period. Numerous artifacts, from Greek vase paintings to the (castrated) sculptures of the Herms, are used to support her argument. It is unfortunate, given Keuls' skillful methodology, that comparisons to our own culture are left for another scholar to explore.

142 KOLODNY, ANNETTE. *The Land before Her: Fantasy and Experience of the American Frontiers 1630-1860*. Chapel Hill: University of North Carolina Press, 1984, 293 pp., illus.

This text traces white women's narratives about the settlement of the western United States (excludes Native American experience). These "frontier fantasies" offered salvation and liberation to the many women who had found the prairie their home. Excerpts by Caroline Kirkland, Margaret Fuller, Alice Cary, and others present the female approach to the frontier of cultivation as opposed to the male domination or "rape of the virgin soil."

143 KUNZLE, DAVID. *Fashion and Fetishims: A Social History of the Corset, Tight-Lacing and Other Forms of Body Sculpture in the West*. Totowa, N.J.: Rowman & Littlefield, 1982, 359 pp., 95 illus.

Shows how corsetry and tight-lacing are central to the history of female emancipation and repression, exploring aspects of social history, the history of costume, and anthropological, sexological, and feminist elements in Western culture. Study extends from ancient Crete to the present, and draws upon such sources as medical literature, popular magazine articles, prints, and caricature.

144 KUSPIT, DONALD. *Bourgeois*. New York: Vintage Books, Elizabeth Avedon Editions, 1988, 109 pp., illus.

An interview conducted by Donald Kuspit with Louise Bourgeois. Gives insights into Bourgeois's upbringing, childhood, relationship with her mother and father, and other psychological considerations that Kuspit presumes influence her work.

145 LADUKE, BETTY. *Campaneras: Women, Art and Social Change in Latin America*. San Francisco: City Lights Books, 1985, 161 illus.

LaDuke traveled in Central and South America interviewing a variety of women artists. She discusses about fifty Latin American women, bringing their personal stories and recent work to a wider public. She explores in Haiti, Chile, and postrevolutionary Nicaragua,

Brazil, Bolivia, Guatemala, and Peru. The book does not pretend to be an exhaustive study and is marred by unclear organization and inconsistent and sometimes incorrect grammar and punctution, but it is a useful and much-needed resource.

146 LAUTER, ESTELLA. *Women as Mythmakers: Poetry and Visual Art by Twentieth-Century Women*. Bloomington: Indiana University Press, 1984, 288 pp., 16 illus.

Analyzes the work of six poets and artists: Anne Sexton, Kathe Kollwitz, Margaret Atwood, Remedios Varo, Diane Wakoski, and Leonor Fini.

147 LAVRENTIEV, ALEXANDER. *Varvara Stepanova: The Complete Work*. Edited by John E. Bowlt. Cambridge, Mass.: MIT Press, 1989, 192 pp., 335 b&w and 45 color illus.

A much-needed historical study of one of the outstanding women artists of Russia, who along with Nataliea Goncharova, Liubova Popova, and Olga Rozanova made remarkable contributions to the Russian avant-garde. During the experimental period, c. 1905-35, Stepanova extended art's range in a truly revolutionary fashion. She was a contributor to the famous 5 x 5=25 exhibition of 1921. Combines her designs, writings about her, and Alexander Rodchenko's photographs to document her life and art. Written and designed by the grandson of Stepanova and Rodchenko, who is also the curator of their archive. Includes a memoir by her daughter.

148 *Let Us Now Praise Famous Women*. Edited by Andrea Fisher. London: Pandora Press, 1987, 160 pp., illus.

The book presents the works of eight women photographers, among them Dorothea Lange and Marion Post Wolcott, who took part in the United States government's sweeping attempt to record American life from 1935 to 1944. Using these photographs as a footing, the author explores current sexual politics.

149 LIPPARD, LUCY. *Eva Hesse*. New York: New York University Press, 1976, 252 pp., 250 illus.

In this sensitive narrative reflection on the meaning of Eva Hesse's life and art, Lippard treads a fine and dangerous line between art and life. Uses extensive quotes from Hesse's own diaries, from past reviews, and from conversations with her friends and colleagues to discuss Hesse's artistic education, development, and mature work, including her battle with the brain tumor that finally killed her at the age of 34. Includes Lippard's own remembrances, which do much to dispel the myth of Hesse as a tragic artist.

150　LIPPARD, LUCY. *From the Center: Feminist Essays on Women's Art*. New York: E. P. Dutton, 1976, 314 pp., illus.

The first meaningful reflections on Lippard's unsettled development as a feminist within the context of emerging feminist art criticism. This collection of critical and theoretical essays includes some of the most provocative thinking to come out of the feminist 1970s, when according to some critics "nothing happened in art." What happened was that Lippard energized two generations of feminists by demanding that the visual arts establish new criteria of evaluation. Lippard's advantage, unlike most emerging feminist art critics, was her access to the art media. Her essays "Freelancing the Dragon," "Sexual Politics: Art Style," "What Is Female Imagery?" and "European and American Women's Body Art" dissented from the art-world mainstream and encouraged other artists and critics to deal with the inevitable contradictions between established conventions and racial activism. Lamentably, very few of the pluralists who became Lippard's fellow travelers were willing to pay the price demanded by a radical transformation of the value system. Includes two pieces of fiction.

151　LIPPARD, LUCY. *Overlay: Contemporary Art and the Art of Prehistory*. New York: Pantheon Books, 1983, 288 pp., 160 b&w and 8 color illus.

A provocative sociopolitical exploration of contemporary artists' renewed interest in ritual, myth, and civilization. A well-balanced application of "femmage" (which Lippard still tags collage: "the juxtaposition of two unlike realities combined to form an unexpected new reality") and fascinating expositions that raise questions concerning the meaning of the nature/culture debate in relation to spirituality from prehistoric times to the present day.

152　LIPPARD, LUCY. *Get the Message? A Decade of Art for Social Change*. New York: E. P. Dutton, 1984.

An intensely subjective and political collection of essays addressing the ills of contemporary society through art. Includes many feminist readings.

153　LIPTON, EUNICE. *Looking into Degas: Uneasy Images of Women and Modern Life*. Berkeley: University of California Press, 1987, 256 pp., 138 illus.

Lipton attempts to place Degas's images within the larger context of art, life, and politics in the France of the Third Republic. In four shifting chapters that form the core of her book she uses Marxist and feminist interpretations of racing themes, the ballet, bathers, laundresses, and ironers to argue that Degas's simultaneous longing for the past, with its aristocratic values and clearly defined social

classes, and rejection of it in favor of the turbulent excitement of modern life account for his location as a social nomad and perhaps explain the richly ambiguous and dialectical nature of his realism.

154 LISLE, LAURIE. *Portrait of an Artist: A Biography of Georgia O'Keeffe*. New York: Seaview Books, 1980. Rev. ed. New York: Washington Square Press, 1987.

The life and times of Georgia O'Keeffe by conjecture and careful research. Well-documented and intriguing depiction of O'Keeffe's personality including her development as an artist and in the context of early modernism. Fully examines the O'Keeffe myth and attempts to unravel the relationship between reality and fantasy.

155 LOMBARDI, M. "Women in the Modern Art Movement in Brazil: Salon Leaders, Artists, and Musicians, 1917-1930." Ph.D. dissertation, University of California – Los Angeles, 1977, 193 pp.

This study seeks to reestablish the significance of Brazilian women's contributions to modernism. The author argues that women were leaders in all the arts except literature at this time, and their paintings sparked the movement's beginnings and pointed the direction of successive phases within it. RILA.

156 *Looking On: Images of Femininity in the Visual Arts and Media*. Edited by Rosemary Betterton. New York: Pandora Press, 1987, 386 pp., 66 illus.

An anthology of essays organized around exploring representations of femininity from a feminist point of view and in relation to photography, advertising, magazines, fine art, and fashion. Arranged in four sections, *Looking On* first tries to represent the main theoretical questions and approaches shaped by feminist thinkers, with the notable neglect of psychoanalytic methodology. Section two examines the changing stereotypes of female sexuality and ranges from images of Asian women to the erotic nudes of art photography. The discussions of pornographic imagery in section three are particularly valuable, as are the reprints of Lisa Tickner's "The Body Politic: Female Sexuality Since 1970," Rosemary Betterton's "How Do Women Look?" and Laura Mulvey and Peter Wollen's "The Discourse of the Body."

157 LORDE, AUDRE. *Sister Outsider*. New York: Crossing Press Feminist Series, 1984, 176 pp.

Of particular theoretical interest are "An Open Letter to Mary Daly," "Uses of the Erotic," and "The Master's Tools Will Never Dismantle the Master's House," originally in *This Bridge Called My Back: Writings by Radical Women of Color*, ed. Cherrie Moraga and Gloria Anzaldua (New York: Kitchen Table Press), 1983.

158 LYNES, BARBARA BUHLER. *Georgia O'Keeffe*. Ann Arbor, Mich.: UMI Research Press, 1989. Reprint. University of Chicago Press, 1991.

Georgia O'Keeffe emerged from out of nowhere in the early twenties due to Alfred Stieglitz's enthusiasm for her work. In a study that reprints ninety responses to O'Keeffe's art published before 1930, Barbara Buhler Lynes argues that two contradictory images of O'Keeffe emerged – one promoted by Stieglitz and another by O'Keeffe herself. In six forcefully written chapters, the author loosely chronicles O'Keeffe's career, offering shifting views of her art. The identification with O'Keeffe's art as explicitly and implicitly sexual and unrepressedly female helped to establish her reputation as a free lover and sexually obsessed woman. It fostered a critical climate in which her art was treated as an extension of her body. Drawing parallels between O'Keeffe's art and her body became the standard approach between 1917 and 1923. Over the years O'Keeffe became increasing determined to recreate herself in an image closer to her heart – that of a serene artist who had withdrawn from the sexuality of life in order to seek spirituality.

159 MCBRIDE, HENRY. *Florine Stettheimer*. New York: Museum of Modern Art, 1946, 55 pp., 32 b&w and 3 color illus.

One of the most influential critics of his time, McBride examines Stettheimer's art and life from an insider's position. Full of amusing and insightful glimpses into the complex personality of one of America's most original artists.

160 MACKOWN, DIANA. *Dawns and Dusks: Louise Nevelson*. New York: Charles Scribner's Sons, 1976, 192 pp., illus.

An intimate portrayal of Louise Nevelson through a series of taped conversations with her longtime companion Diana MacKown. Particularly interesting are Nevelson's recollections of her Jewish childhood and her emerging feminism.

161 MANN, SALLY. *At Twelve: Portraits of Young Women*. Introduction by Ann Beatie. New York: Aperture, 1988, 54 pp.

Mann selected puberty as her theme. The thirty-six portraits explore what girls are like, what they look like, how they feel and act, when they "become women." Her unfortunately narrow vision concentrates on latent seduction or blatant sexuality; all sullen and sultry. There are class and economic distinctions that call into question Mann's selective renderings of what becoming a woman means.

162 MARK, MARY ELLEN. *Streetwise Photographs*. Philadelphia: University of Pennsylvania Press, 1988, 77 pp.

Mark's photographs explore the world of the runaway children of Pike Street in Seattle and were begun in 1983. The fifty-seven portraits concentrate on Lulu, Rat, Mike Shadow, Tiny and Dewayne, and their friends. At the time that these shots were taken Lulu was nineteen and had been on the street since she was 9 years old. The photographs are marked by Mark's committed approach to her work and respect for her subjects. Displays the remarkable compassion so evident in her other books—*Falkland Road*, about prostitutes in Bombay, and *Ward 81*, about a woman's ward in a mental hospital. Calls into question the objectives of photography from a feminist vantage point.

163 MARRIOTT, ALICE. *Maria: The Potter of San Ildefonso*. Norman: University of Oklahoma Press, 1945.

Illustrated by Margaret Le Franc. A personal reflection on the extraordinary legacy embodied by the Native American potter Maria Martinez. The book features illustrations of the famous Pueblo potter's traditional tribal art by artist Le Franc, who was also a personal friend.

164 MARSH, JAN. *The Pre-Raphaelite Sisterhood*. London: Quartet, 1985, 408 pp., 49 illus.

Explores the lives of the women who appear as models, wives, and dependents for the Pre-Raphaelite painters: Elizabeth Siddall, Emma Brown, Annie Miller, Fanny Cornforth, Jane Morris, and Georgiana Burne-Jones. Despite the fact that these women were artistically gifted and ambitious, their passive role with relation to the male artists they were connected with made artistic achievement difficult. The book traces those achievements, while detailing the domestic tribulations, drug addiction, childbirth traumas, and supportive roles that worked against their own artistic ambitions.

165 *Men in Feminism*. Edited by Alice Jardine and Paul Smith. New York and London: Routledge, 1989, 288 pp.

This collection of essays is organized into twenty-four chapters by authors including Elaine Showalter, Terry Eagleton, Jacques Derrida, and Craig Owens, who attempt to create a dialogue between feminists and their so-called male allies. Each essay tries to assess the benefits or damage of male participation in feminism.

166 MERCHANT, CAROLYN. *The Death of Nature*. San Francisco: Harper & Row, 1980, 339 pp., 24 b&w illus.

An important and complex book, exploring the historical connection between women and nature, men and science, from the middle ages to the present. A must for anyone interested in the eco-

feminist movement and the sexual politics of exploitation and gender when it comes to "Mother Earth."

167 MIDDLETON, MARGARET S. *Henrietta Johnston of Charles Town, South Carolina: America's First Pastellist.* Columbia: University of South Carolina Press, 1966, 88 pp., illus.

An eighteenth-century portraitist said to be the "first American of either sex to work in pastel" is described here. See Gerdts.

168 MILLER, LYNN F., and SWENSON, SALLY S. *Lives and Works: Talks With Women Artists.* Metuchen, N.J: Scarecrow Press, 1981, 255 pp., illus.

A collection of interviews with living women artists who work in a variety of media. Artists include Louise Bourgeois, Judith Brodsky, Radka Donnell-Vogt, Deborah S. Freedman, Cynthia Mailman, Alice Neel, Howardena Pindell, Faith Ringgold, Betye Saar, Susan Schwalb, Nancy Spero, and May Stevens.

169 MILLUM, T. *Images of Women: Advertising in Women's Magazines.* London: Chatto & Windus, 1975, 208 pp., 31 illus.

Examines the role of women and of advertising, the twin foci of this study. Discusses the way advertising presents women and its interpretation of the nature of woman. Special attention is paid to feminine psychology and the question of whether feminine characteristics are innate or culturally acquired.

170 MITCHELL, MARGARETTA K. *Recollections: Ten Women of Photography.* New York: Viking Press, 1979, 206 pp., illus.

Collection of photographs and statements by ten American photographers: Berenice Abbott, Barbara Morgan, Ruth Bernhard, Carlotta M. Corpron, Louise Dahl-Wolfe, Nell Dorr, Toni Frissell, Laura Gilpin, Lotte Jacobi, and Consuelo Kanaga.

171 MODERSOHN-BECKER, PAULA. *The Letters and Journals of Paula Modersohn-Becker.* Translated by J. Diane Radycki. Introduction by Alessandra Comini. Epilogue by Adrienne Rich and Lilly Engler. Metuchen, N.J.: Scarecrow Press, 1980, 344 pp., 16 illus. Originally published as *Die Briefe und Tagebuchblatter von Paula Modersohn-Becker* (Berlin: Kurt Wolff Verlag, 1920).

Extensively annotated translation using contemporary sources to delineate the artistic milieu and the relevant historical-social feminist situation in 1900. Provides a guide to the art capitals Berlin, London, and Paris as seen through the eyes of a woman studying art, and in light of the changing relationships between Becker and her friends, the poet Rainer Maria Rilke, the sculptor Clara [Rilke-] Westhoff, and Becker's husband, the painter Otto Modersohn. New light is

shed on the art education of Becker, who, like Kathe Kollwitz, was one of the first woman artists to come from a non-artistic background. The letters begin when Becker is in art school and end a month before her tragic death in 1907, at age 31. The epilogue consists of an English translation of Rilke's "Requiem" of 1908 and Rich's poem "Paula Becker to Clara Westhoff" (1975-76).

172 MODLESKI, TANIA. *Feminism without Women: Culture and Criticism in a "Postfeminist" Age.* New York and London: Routledge, 1991, 188 pp., illus.

Dedicated to women, this book deals with theory, methodology, masculinity and male feminism, race, gender, and sexuality. The most useful chapters for art historians and critics concerned with postfeminism and its operation in cultural practices are "Postmortem on Postfeminism," a survey of the field, and "Lethal Bodies," a discussion of sex, gender, and representation that pays particular attention to lesbian theorizing and pornography of the 1980s. Modleski's analysis of Susie Bright and Pat Califia's positions is of particular interest to anyone involved in deconstructing sexuality and censure.

173 MORROW, DEBORAH. *The Art Patronage of Maria de'Medici.* Ann Arbor, Mich.: UMI Research Press, 1982, 43 illus.

Examines Maria de Medici as a queen and patron and in the context of her body type from a feminist point of view. Discussed the artists and art she commissioned, the effects of political power plays, and the imagery she perpetuated in order to combat her foes and support the emergence of a heroic female imagery. See Mary Garrard's *Artemisia Gentileschi* (entry 118) for a comparison.

174 MOSER, CHARLOTTE. *Clyde Connell.* Austin: University of Texas Press, 1988, 96 pp., 15 b&w and 30 color illus.

The first full-length study devoted to this important sculptor from the Southern region. Explores her daily life in Louisiana, her spiritual commitment, and how she integrates these into her art.

175 MULLINS, EDWIN B. *The Painted Witch: Female Body – Male Art: How Western Artists Have Viewed the Sexuality of Women.* London: Secker & Warburg, 1985, 230 pp., illus.

A psychological reading of male painters' depictions of women. Arranged thematically, ranging from virgins to mistresses to sinners, as well as including mothers and heroines. Coverage through the nineteenth century leaves works from the twentieth century unexamined. See Dijkstra.

176 NEAD, LYNDA. *Myths of Sexuality: Representations of Women in Victorian Britain*. New York: Basil Blackwell, 1988, 240 pp., 50 illus.
 Discusses how the depiction of women in art defined and restricted women's role in Victorian England. Shows how paintings reinforced a distinct image of bourgeois morality.

177 NELSON, MARY CARROLL. *Pablita Velarde*. Minneapolis, Minn.: Dillon Press, 1971.
 Biography of the Tewa artist born in 1918 at Santa Clara Pueblo. Velarde became well known for her detailed, historically accurate paintings in casein of traditional Pueblo life, especially the work of the women of her tribe. The book discusses the conflicts between the artist's Native American heritage and the Anglo world. See Carleen Touchette, "Mother and Daughter Painting across Two Worlds," *Woman's Art Journal* 12, no. 2 (Fall 1991/Winter 1992).

178 NELSON, MARY CARROLL. *Maria Martinez*. Minneapolis, Minn.: Dillon Press, 1972, illus.
 Tells the story of the Native American potter, who was born around 1885 at San Ildefonso Pueblo. The book includes Indian history of the Southwest.

179 *No Bluebonnets, No Yellow Roses: Essays on Texas Women in the Arts*. Edited by Sylvia Moore. New York: Midmarch Art Press, 1988, 138 pp., 38 b&w illus.
 This is the second in a series of collected regional essays on United States women artists, artfully edited by Sylvia Moore. With this series Midmarch Art Press has started a campaign against our collective ignorance. The ten essays, written by artists, historians, critics, curators, and educators, explore art by Texans from the early pioneers to contemporary artists, collectors, and dealers. As a history the book makes no pretense at chronologically charting the development of art in the state of Texas, offering instead a prismatic model for future research into our nation's art. It is through the overlap and interplay of interactive voices that a sense of the region emerges.

180 NOCHLIN, LINDA. *Women, Art, and Power and Other Essays*. New York: Harper & Row, 1988, 181 pp., illus.
 A collection of seven essays written from 1971 to 1988. Includes such milestones as "Why Have There Been No Great Women Artists?" "Eroticism and Female Imagery in nineteenth Century Art," "Once More the Fallen Woman," "Some Women Realists," "Florine Stettheimer: Rococo Subversive," and "Morisot's Wet Nurse," and maps the battleground of female discourse in art history from a pioneering feminist vantage point. Nochlin's essay "Women, Art and

Power" insists on feminism's right to dissent, the reality of backlash, the necessity of persistence, and a sense of humor in attacking the discrimination that is so glaringly evident in the discipline of art history and the world in general. See Eunice Lipton's review (entry 770).

181 NUNN, PAMELA G. "The Mid-Victorian Woman Artist 1850-1879." Ph.D. dissertation, London University, 1981.

Between 1850 and 1879, female artists made progress toward being recognized as professionals within both the fine and applied arts. Concentrates on education, exhibitions, patronage and employment, and the pictorial type and style practiced by female artists. Leads to the conclusion that the generally accepted view of Victorian art must be corrected to include women's art.

182 ORENSTEIN, GLORIA F. *The Reflowering of a Goddess*. Athena Series. London: Pergamon Press, 1989, illus.

In this book Orenstein coins new "feminist-matristic" vocabulary and explores the way in which contemporary women artists and writers are both developing from and attempting to challenge the set of codes that constitute our consciousness of culture and society. The vast feminist matristic renaissance that Orenstein has mapped in this space changes the way we think about art and life.

183 PARKER, ROZSIKA, and POLLOCK, GRISELDA. *Old Mistresses: Women, Art, and Ideology*. 1st American ed. New York: Pantheon Books, 1981; London: Routledge & Kegan Paul, 1981, 184 pp., 97 illus.

Questions women's position in culture and the role of ideologies about creativity and the sexes in maintaining the hierarchical social definitions of masculinity and femininity. Argues that it is only in twentieth-century academic art history that the work of women artists has been eliminated from the historical record by omission or derision. In posing and answering the central questions of why this has happened and what it means, the authors expose the ideological character of art-historical practices. The goal of feminist art history should not be to add women to the existing sterile forms of the discipline of art history, with its narrow and restricted definition of art and the artist, but to challenge art history itself. Offers readings of the art made by women from the sixteenth century to the women's art movements of the 1970s.

184 *Patterns of Desire*. Introduction by Linda Nochlin. New York: Hudson-Hills Press, 1990, 88 pp., 64 color plates.

Artist Joyce Kozloff explores the erotic through an extraordinary suite of watercolors that incorporate sexual motifs and ornamental

details from the worlds of Eastern and Western art. By creating amusing juxtapositions of bodies woven together in various erotic configurations, Kozloff provides a basis for Nochlin's sophisticated musings on gender and fantasy.

185　PERRY, GILLIAN. *Paula Modersohn-Becker*. New York: Harper & Row Icon Edition, 1979, 192 pp., 124 illus.

First book in English on Paula Modersohn-Becker. One of the principal artists to assimilate the postimpressionist currents of Paris, Modersohn-Becker forged a very personal and powerful style. Based on the diaries and letters of this talented, determined, and courageous artist who died at 31, Perry's book is a synthesis.

186　*Pilgrims & Pioneers: New England Women in the Arts*. Edited by Alicia Faxon and Sylvia Moore. New York: Midmarch Art Press, 1987, 160 pp., illus.

The first survey of New England women in the arts. Sixteen art historians, artists, architects, curators, and critics examine the New England art scene from the art colonies of Italy to the art galleries of Boston. There is also descriptive analysis of contemporary art, much of which is political in nature. Part of a continuing regional series documenting women artists and the art scene in the United States over time.

187　POLLOCK, GRISELDA. *Mary Cassatt*. New York: Harper & Row, 1979, 119 pp., 92 illus.

Pollock uses a Marxist approach to argue that through her oeuvre, Cassatt, a woman painting women, reworked with increasing power and insight the traditional visual iconography of woman, questioning its basic assumptions.

188　POLLOCK, GRISELDA. *The Subversive Stich: Embroidery and the Making of the Feminine*. London: Women's Press, 1984, 247 pp., 106 illus.

Evaluates the way in which needlework has been identified exclusively as women's work and traces the relationship between the history of embroidery and changing ideas about femininity from the Middle Ages to the present day. Includes discussion of Victorian medievalism's rediscovery of medieval embroidery, different representations of needlework as a feminine activity in the nineteenth-century novel, changes brought about by the arts and crafts movement and by the invention of the sewing machine, and development of embroidery as a nationalist art form. Concludes with an analysis of the survival of embroidery in the women's liberation and women's peace movements.

189 POLLOCK, GRISELDA. *Vision and Difference: Femininity, Feminism, and the Histories of Art*. London: Routledge, 1988, 272 pp., 54 illus.

Pollock has collected seven essays written after the publication of *Old Mistresses* (1981) (entry 183), and before *Framing Feminism* (1988) (entry 115). "Vision, Voice, and Power" (see entry 891) gives a valuable analysis of relations between feminist and Marxist histories of art. In the other essays she uses a combination of semiotics and psychoanalytic theory. In "The Painter of Modern Life," her analysis differs from T. J. Clark's when she directs her attention to women impressionists and spaces of femininity in the modern city. In essays ranging from "Siddal in Pre-Raphaelite Literature\Biography," "Woman as Sign: Psychoanalytic Readings," and "Screening the Seventies," Pollock reevaluates how feminist strategies in culture have informed modernist/antimodernist and modernist/post-modernist debates.

190 *Postmodern Culture*. Edited by Hal Foster. London and Sydney: Pluto, 1985, 159 pp., illus.

First published as *The Anti-Aesthetic* by Bay Press, Port Townsend, Washington, in 1983. Collection of essays on postmodernism as resistance, one which seeks to both "deconstruct modernism and resist the status quo." Foster's preface is followed by essays by Jurgen Habermas, Kenneth Frampton, Rosalind Krauss, Douglas Crimp, Gregory L. Ulmer, Frederic Jameson, Jean Baudrillard, Edward Said, and, most provocatively for feminist critics, Craig Owens's "The Discourse of Others: Feminists and Postmodernism," in which he, a gay man, explores the intersection of the feminist critique of patriarchy and the postmodern critique of representation.

191 PRICE, S. "Women and Art in an Afro-American Society." Ph.D. dissertation, Johns Hopkins University, 1981, 293 pp.

Examines the development since the eighteenth century of women's arts, especially calabash carving and decorative sewing, among the Maroon women of Suriname. Explores these arts in terms of production, social uses, and aesthetic ideals. The author argues that an adequate understanding of the artistic expression of Maroon men and women must be based on a more general understanding of the artistic expression of Maroon men and women within these societies.

192 PUGH, SIMON. *Garden – Nature – Language*. New York: St. Martin's Press, 1988, 176 pp.

A useful study of the natural garden of eighteenth-century Britain as an index of class power. Issues of gender are evident in a textual reading of nature as culture.

193 RAVEN, ARLENE. *Crossing Over: Feminism and Art of Social Concern*. Ann Arbor, Mich.: UMI Research Press, 1988.

Sixteen compelling and passionately feminist essays. Beginning in the 1970s when women artists achieved unprecedented exposure and recognition, and concluding in the 1980s with her continuing search for purposeful change, the author confronts readers with the immediacy of being an activist critic. Raven never fails to put herself on the line, and consciously jettisons reason in confronting patriarchal violation in all its disguises. *Crossing Over* is not only a celebration of Raven's journey into the uncharted territory of feminist consciousness, but a significant record of a community that included Dottie Attie, Harmony Hammond, Lucy Lippard, Judy Chicago, Miriam Schapiro, May Stevens, Michelle Stuart, Nancy Spero, Suzanne Lacy, Faith Wilding, Mary Beth Edelson, Pat Steir, Joan Snyder, Cynthia Carlson, Ana Mendieta, Cheri Gaulke, and a sisterhood of racy, raging women who changed the history of culture, art history, and criticism.

194 *Reweaving The World: The Emergence of Ecofeminism*. Edited by Irene Diamond and Gloria Ferman Orenstein. San Francisco: Sierra Club Books, 1990, 324 pp.

Twenty-seven notable authors from diverse cultures on the cutting edge of thinking about the environment give us their views on the serious plight facing our planet. Includes Paula Gunn Allen, Starhawk, Susan Griffin, Carolyn Merchant, Arisika Razak, Irene Javors, Julia Scofield Russell, Catherine Keller, and Gloria Feman Orenstein. With the birth of the women's movement in the late 1960s, feminists took apart the basis used to justify men's control over women and by extension the earth. Explores alternatives to the traditional "woman is to nature as man is to culture" formulation, offering a more creative sense of identity which embraces all people and things. Of particular note is Irene Javors's essay on the urban goddess, subject of her forthcoming book.

195 RICHARDSON, DIANE. *Women and Aids*. New York: Methuen, 1988, 160 pp.

One of the first books to cover the effect of the AIDS crisis on women. It explains the nature of the disease, how it spreads, who is at risk, and how it might be avoided. Richardson challenges the racism, sexism, and homophobia surrounding the disease, pointing out that the problems that AIDS creates for women are not necessarily the same as those for men, gay or otherwise. She attacks

the special gender-specific problems related to women and AIDS, such as pregnancy. This book is a good contrast to Douglas Crimp's *AIDS*, a collection of essays originally published in *October*, no. 43 (Winter 1987).

196 ROBINS, CORINNE. *The Pluralist Era: American Art 1968-1981*. New York: Harper & Row; Toronto: Fitzhenry & Whiteside, 1984, 246 pp., 103 illus.

Traces the many influences on American art in the 1970s, discussing the decline of minimal and conceptual art and the creation and development of the Soho school in New York, including process and conceptual art, art and politics (the advent of the "art worker," the black artist, and women artists in the seventies and the feminist contribution), earth art, site sculpture, pattern painting, realism, abstraction, photography, video, and performance art.

197 ROBINSON, LILLIAN S. *Sex, Class, and Culture*. Bloomington and London: Indiana University Press, 1977, 349 pp.

A collection of provocative essays, featuring the principles of feminist criticism. "Dwelling in Decencies: Radical Criticism and the Feminist Perspective" and "Modernism and History," coauthored with Lise Vogel, are of particular interest to feminist art critics. On these issues Robinson is one of feminism's most articulate spokeswomen.

198 ROHRLICH, RUBY, and BARUCH, ELAINE HOFFMAN. *Women in Search of Utopia*. New York: Schocken Books, 1983, 380 pp.

Poems by Marge Piercy and Audre Lorde, dramatic selections by Ntozake Shange, cartoons by Mary Anne Shea, and essays by several others have been gathered to suggest heretofore little known alternatives.

199 ROSEN, MARJORIE. *Popcorn Venus: Women, Movies, and the American Dream*. New York: Coward, McCann, & Geoghegan, 1974, 416 pp., illus.

The author examines cultural trends in film as related to the treatment of women in film from Victorian times through the 1970s. She describes women in film as "Popcorn Venus, a delectable but insubstantial hybrid of cultural distortion."

200 ROSEN, RANDY, and BRAWER, CATHERINE C. *Making Their Mark: Women Artists Move into the Mainstream, 1970-1985*. Edited by Judith E. Stein and Ann Sargent Wooster. New York: Abbeville Press, 1989, 300 pp., 183 illus. (70 color).

Based on an exhibition of the same name, this book asserts that women artists, through their questioning, disruption, and

transfiguration, have changed an art world largely dominated by white men. Whether or not one agrees with this premise, *Making Their Mark* deserves to be read. The six essays in the book are provocative, especially Rosen's interpretation of the meaning of "mainstream" art in "Making Their Mark," Marcia Tucker's discussion of the strategies set in motion by women artists in their work, and Brawer and Ferris Olin's assembling of damning, if somewhat questionable (due to the way the statistics were gathered), information concerning how *underrepresented* and underpaid women are when it comes to the success of their mainstreaming. Their neglect of lesbian artists such as Harmony Hammond, who made courageous contributions to feminist art, theory, and practices during these crucial years, is puzzling.

201 ROTH, MOIRA. *The Amazing Decade: Women and Performance Art in America, 1970-1980.* Los Angeles: Astro Artz Press, 1983, 165 pp., illus.
 Contains a provocative section by Mary Jane Jacobs. This is an exciting and significant history of early feminist experiments with performance work by American women artists. Performance art was autobiographical, personal, transformational, ritualistic, and highly theatrical, dealing with the harsh realities of antifeminism in the worlds of art and life. Includes well-known artists such as Laurie Anderson, Eleanor Antin, Judy Chicago, Betsy Damon, Mary Beth Edelson, Joan Jonas, Meredith Monk, Yvonne Rainer, Martha Rosler, Carolee Schneemann, Faith Wilding, and Hannah Wilke.

202 SANDELL, RENEE K. "Feminist Art Education: Definition, Assessment, and Application to Contemporary Art Education." Ph.D. dissertation, Ohio State University, 1978, 270 pp.
 The study that defined and analyzed feminist art education and constructed a model of the women's art movement and its relationship to contemporary art education. Finally there is a discussion of the implications for the arts and education, as well as art education, stating that a nonsexist approach in art education could affect cultural change and help the field of education and the art world.

203 SANDWEISS, MARTHA A. *Laura Gilpin: An Enduring Grace.* Austin: University of Texas, 1986, 336 pp., 7 color, 120 tritone, and 40 duotone photographs.
 This is the first book devoted to one of America's most remarkable photographers, Laura Gilpin (1891-1979), who photographed the American Southwest for more than sixty years, creating an extraordinary document of the land and its people. Her work is a bridge between the sentimental studies of earlier

photographers and the supposedly objective documentation of later work. The book is supported by an excellent selection of her classically elegant work. Of particular interest is Gilpin's feminist approach to the western landscape as a significant influence on human development and the Navaho people.

204 SAYERS, DOROTHY L. *Are Women Human?* Grand Rapids, Mich.: William B. Eerdmans, 1971.

A hilariously biting essay, by one of England's best scholars and mystery writers. Sayers's vitality as a writer lends humor to her prose as she relentlessly points out the absurdity of gender discrimination.

205 SCHAEFER, CLAUDIA. *Textured Lives: Women, Art, and Representation in Modern Mexico.* Tucson: University of Arizona Press, 1992, illus.

Explores Mexican cultural history through the work of Frida Kahlo, Rosario Castellanos, Elena Poniatowska, and Agneles Mastretta by combining literary theory, cultural analysis, gender, aesthetics, and identity.

206 SCHOR, NAOMI. *Reading in Detail: Aesthetics and the Feminine.* New York and London: Methuen, 1987, 184 pp., 14 b&w illus.

Explores the conceptual space of "detail as negativity" in five freewheeling chapters. Deconstructs femininity as a representation of detail and raises the nagging postmodern question of whether detail has achieved its new prestige in our own century by being taken up by "a male-dominated culture."

207 *Setting the Place: The Women's Art Movement 1980-1983.* Edited by Jane Kent. Adelaide, Australia: Women's Art Movement, 1984, 118 pp., 150 b&w illus.

A general overview of the women's movement. RILA.

208 *Sex Differentials in Art Exhibition Reviews: Statistical Study and Selected Press Reaction.* Los Angeles: Tamarind Lithography Workshop, March 1972.

This ground-breaking study documents the scope of discrimination against women artists in reviews of their shows by the art press and other media furnished by June Wayne, Betty Fiske, and Rosalie Brautigan.

209 SHERMAN, CINDY. *Cindy Sherman.* New York: Pantheon Books, 1984, 89 color plates.

Contains a five-page introduction to Sherman's work by Peter Schjeldahl and an afterword by I. Michael Danoff. Sherman poses herself as the actress, the designer, the director, the producer, and

the photographer, all in one. Images from the 1950s and 1960s predominate. The interesting thing about the threat of victimization that Sherman implies is that the gaze is male. Her work is problematic for feminist critics because of its hyped-up exhibitionism, which plays with old-style voyeurism. The fact that the art world has declared it new and innovative, and set Sherman up as its token feminist, has also been questioned by feminist critics and art historians.

210 SHERMAN, CLAIRE RICHTER, and HOLCOMB, ADELE M. *Women as Interpreters of the Visual Arts 1820-1979*. Westport, Conn., & London: Greenwood Press, 1981, 512 pp., 29 illus.

Surveys the contributions of women to the criticism, scholarship, and interpretation of the visual arts. Divided into four sections: women as interpreters of the visual arts; nineteenth-century writers on the arts; art historians and archaeologists of the late nineteenth and early twentieth centuries; scholars active from the early twentieth century to 1979. The first section provides an overall view of the general character of women's participation in the study of art from 1820 to 1979, and the other three illustrate aspects in more detail by examining the lives and works of twelve eminent women scholars.

211 SISLER, REBECCA. *The Girls: A Biography of Francis Loring and Florence Wyle*. Toronto: Clark, Erwin, 1972, illus.

Offers an excellent overview of these two women living together and striving against conformity. Trained as traditional academics, these women produced an astonishing body of work.

212 SLATKIN, WENDY. *Women Artists in History: From Antiquity to the 20th Century*. Englewood Cliffs, N.J.: Prentice-Hall, 1985, 191 pp., illus.

A cursory and now dated survey covering antiquity to the twentieth century, inexpensively produced, and useful to first-time students in women's studies provided they are aware of the way the writer unwittingly devalues the achievements of women artists and fails to give equal representation to multicultural issues.

213 SMITH, MARGARET, and WAISBERG, BARBARA. *Pornography: A Feminist Survey*. Toronto: Boudicca Books, 1985.

This useful guide lists and annotates fifty-one articles, collections, and books on pornography from 1970 to 1985. Entries are divided into four sections: Sexuality, Social Construction of Perception (gender issues), Perspectives on Pornography (antiporn movement), and Control of Pornography (censorship).

214 SNYDER-OTT, J. *Women and Creativity.* Millbrae, Calif.: Les Femmes Publishing, 1978, 148 pp., 63 illus.

Analyzes the contributions made by women to the world of art. Derives from the author's personal involvement in the American feminist movement. She surveys the attitudes about women and their roles in past societies, with specific reference to the work of Trude Collison Baxter in compiling an iconographical collection on birth and its place within cultures. She also specifically discusses the work of Angelica Kaufmann and Chloe Dellaport. Discusses the development of a dance routine by students in response to an exhibition of the author's drawings, the replies given during an interview with students at a women's art college, the development of feminist art programs, and the Woman's Pavilion at the Chicago World's Columbian Exposition, 1893.

215 SOUHAMI, DIANA. *Gluck: Her Biography.* London: Pandora Press; Winchester, Mass.: Unwin Hyman, 1988, 325 pp., illus.

A full-length biography of Hannah Gluckstein, the "male-identified" lesbian painter who posed for lesbian artist Romaine Brooks's portrait of a young girl, *Peter.* Traces her life and work in the context of her lesbian life-style. "Gluck" died three years after Brooks and like her was rescued from neglect only a few years before her death. Lacks the critical edge and analysis that is needed to appreciate Gluck's work in light of other lesbian artists and in the context of developments in late nineteenth- and early twentieth-century modernism. See Tee Corinne's review (entry 484) and Meryl Secrest, *Between Me and Life* (Doubleday, 1972, a biography of Romaine Brooks).

216 STEIN, JUDITH E. "The Iconography of Sappho, 1775-1875." Ph.D. dissertation, University of Pennsylvania, 1981, 363 pp., 114 illus.

Identifies and analyzes the diverse manifestations of Sappho's image in the visual arts and in literature. In the late rococo and early neoclassicism periods, Sappho is represented as an active poet, often accompanied by her erotic muse. During and after the French Revolution, Sappho is frequently portrayed at the moment of her suicide leap. By the romantic period, as suffering became a conventional sign of creativity, Sappho was transformed into a genius, who is crippled by her devotion to a faithless boyfriend. As the late nineteenth century's fascination with Sappho as a woman of legendary passion and unbridled sexuality grew, it obscured her literary reputation. Erotic images of Sappho mushroomed but only in rare instances was she shown as a lesbian. The final chapter traces the historiography of Sappho's sexuality and its influence on her visual representations.

217 STONE, MERLIN. *When God Was a Woman*. New York: Harcourt
 Brace Jovanovich, 1976.
 A stunning achievement in scholarship that gives a fresh view and
 insights into matrilineal society and its displacement by the
 patriarchal revolution. Her deconstruction of the story of Adam and
 Eve gives feminists a rereading of the Genesis story in light of Jewish
 history and the context of religious manipulations by certain sects, i.e.
 Levite biblical writers. See David Rosenberg and Harold Bloom, *The
 Book of J* (New York: Grove Weidenfeld), 1990.

218 STUDLAR, GAYLYN. *In the Realm of Pleasure: Von Sternberg,
 Dietrich, and the Masochistic Aesthetic*. Urbana: University of Illinois
 Press, 1988, 242 pp., illus.
 The gaze isn't exclusively male, argues the author, challenging
 Laura Mulvey's theory ("Visual Pleasure and Narrative Cinema,"
 entry 819), in which Mulvey asserted that Hollywood films women as
 passive objects of male voyeuristic and sadistic impulses. Studlar
 instead argues for infantilization as a theory and masochism as the
 basis of pleasure and identification. The mother is central to this
 theory and Studlar is influenced by Gilles Deleuze's work.

219 TICKNER, LISA. *The Spectacle of Women: Imagery of the Suffrage
 Campaign 1907-1914*. London: Chatto & Windus, 1987, illus.
 A rigorous critical analysis of the political and aesthetic nature of
 high and applied art as mediated by gender. The book is smartly
 divided into segments that include "Production," "Spectacle,"
 "Representation," and "Epilogue." Suffrage artists created banner
 typefaces to depict political events, marches, parades, and
 stereotypes, using such leading phrases as the "working woman,"
 "modern woman," and "militant woman" to call attention to their
 cause. "Epilogue" summarizes the effects of World War I on the fight
 for the vote. A useful appendix is included. See Harper.

220 TUCKER, ANNE. *The Woman's Eye*. New York: Alfred A. Knopf,
 1973, 170 pp., 112 illus.
 Surveys the work of ten twentieth-century American women
 photographers. It begins with the romantic series on motherhood by
 Gertrude Kasebier and the eloquent turn-of-the-century reportage by
 Frances Benjamin Johnston, then proceeds chronologically to the
 photographs of Margaret Bourke-White, Dorothea Lange, Berenice
 Abbott, Barbara Morgan, Diane Arbus, Alisa Wells, Judy Dater, and
 Bea Nettles. Approaches the same material from two perspectives.
 Questions the relationship between artists' sex and their art from a
 feminist's point of view.

221 TUPAHACHE, ASIBA. *Taking Another Look: A Further Examination*. Great Neck, N. Y.: Spirit of January Publications, 1987, 294 pp., illus.

This self-published book (available from author, 4162 Old Village Station, Great Neck, N.Y. 11027) is divided into four major parts: "The Victim," "The Perpetrator," "The Facilitator," and "The Survivor." These are followed by five short sections dealing with techniques and strategies. Tupahache, like Adrian Piper, Howardena Pindell, Clarissa Sligh, and Margo Machida, applies a multicultural analysis to the problems of racism and sexism, suggesting ways of combatting and healing oneself from these illnesses. Her book stresses self-empowerment and accountability.

222 VAN WAGNER, JUDITH K. COLLISCHAN. *Lines of Vision: Drawings by Contemporary Women*. Foreword by Thomas W. Leavitt. Introduction by Judith Wilson. New York: Hudson Hills Press, 1989, 176 pp., 105 illus.

Brings together 135 female artists including emerging minority women. Presents representative examples from every decade since the 1940s with a major concentration on the seventies and eighties. An excellent resource. Includes short biographies.

223 *Visibly Female: Feminism and Art Today*. Edited by Hilary Robinson. London: Camden Press, 1987, 317 pp., 38 b&w illus.

An important, historically provocative, but uneven collection of feminist writings. For those familiar with feminist art and politics in America and England, it is somewhat dated. It reprints some important essays, including Griselda Pollock's "Women, Art and Ideology: Questions For Feminist Art Historians," Lippard's "Some Propaganda for Propaganda," May Stevens's "Taking Art to The Revolution," and Michelle Cliff's "Object into Subject: Some Thoughts on the Work of Black Women Artists."

224 *Voices of Women: 3 Critics on 3 Poets on 3 Heroines*. Edited by Cynthia Navaretta. New York: Midmarch Art Press, 1980, 54 pp., 21 illus.

This collection of essays is introduced by Lucy Lippard's "To the Third Power: Art and Writing and Social Change." She discusses "the three solid dimensions ... of the women's liberation movement: making poetry out of politics, making art from lives lived outside power, and making politics out of that art and poetry" as exemplified in this book, which is comprised of three critical essays and three previously published poems. Martha Kearns's appreciation of Muriel Rukeyser's poem "Kathe Kollwitz" states that it demonstrates the usefulness of approaching the artist and her work from a woman's point of view; Diane Radycki praises Adrienne Rich for choosing to

portray Paula Modersohn-Becker in conversation with her closest friend in the poem "Paula Becker to Clara Westhoff," and May Stevens writes on Jane Cooper's poem "Threads: Rosa Luxemburg from Prison."

225 WAHLMAN, MAUDE SOUTHWELL. "The Art of Afro-American Quilt Making: Origins, Development, and Significance." 2 vols. Ph.D. dissertation, Yale University, 1980. 421 pp.

Author argues that quilts made by African-American women in the United States are strikingly different in style from quilts made by Anglo-American or Amish women. Compares contemporary West African textile designs as an explanation.

226 WALTERS, MARGARET. *The Nude Male: A New Perspective*. London and New York: Paddington Press, distributed by Grosset & Dunlap, 1978, 352 pp., 150 illus.

By examining images of the male nude in Western art from Apollo to twentieth-century pin-ups, attempts to show that Western art has been created from a male viewpoint. Suggests that artistic depiction of the male nude provides clues to underlying social attitudes. Includes discussion of Michelangelo, Christian art, Renaissance attitudes, Durer, propagandist nudes, and contemporary women artists such as Sylvia Sleigh and Nancy Grossman.

227 WARNER, MARINA. *Monuments and Maidens: The Allegory of the Female Form*. Atheneum: New York, 1985, illus.

Offers a serious and provocative study of the aesthetic and symbolic meanings of the female form, from classic times to the present day. Draws on myth, poetry, painting, and sculpture to pose useful questions about images of women such as the Statue of Liberty or Britannia. Warner relates the legacy of Greece to the female presence in current popular culture, particularly in films.

228 WEIDNER, MARSHA; LAING, ELLEN JOHNSTON; and LO YUCHENG, IRVING. *Views from Jade Terrace: Chinese Women Artists, 1300-1912*. New York: Rizzoli International, 1988, 256 pp., 200 illus.

In conjunction with an exhibition, this book covers forty Chinese women artists spanning six centuries, showing that their work was influenced by famous fathers and that they often earned reputations that exceeded those of their relatives.

229 WEINMANN, JEANNE MADELINE. *The Fair Women*. Introduction by Alice Miller. Chicago: Academy Chicago, 1981, 611 pp., 437 illus.

Provides a detailed history of the Woman's Building at the World's Columbian Exposition, in Chicago, Illinois, in 1893. Among the contributors were the painter Mary Cassatt, the sculptors Vinnie Ream Hoxie and Harriet Hosmer, and the architect Sophia Hayden.

230 WHEELWRIGHT, JULIE. *Amazons and Military Maids: Women Who Cross-Dressed in the Pursuit of Life, Liberty, and Happiness.* London: Pandora Press, 1989, 207 pp.

An important theoretical resource with implications for the history of lesbianism. The author deals with this connotation in a cursory and defensive manner. Examines the history of criminality, social history, popular culture, the social origins of cross-dressing women, and data on popular attitudes toward gender and cross-dressing in relation to role-playing among women.

231 WICKES, GEORGE. *The Amazon of Letters.* New York: PopLib, 1976, 318 pp., illus.

A somewhat drab biography of Natalie Barney, the "wild girl from Cincinnati" who was the unquestioned lesbian cultural leader of her day and the lover of the lesbian artist Romaine Brooks.

232 WILDING, FAITH. *By Our Own Hands.* Santa Monica, Calif.: Double X, 1977.

The first comprehensive history of the women artists' movement in Southern California.

233 WILTON, N. C. "The Antecedents of Artistic Success: A Study of the Early Lives of Women Visual Artists." Ed.D. dissertation, Boston University, 1978, 227 pp.

Author examines the lives of thirty female visual artists to discover factors in their early lives that may have been related to artistic success in adulthood. Early childhood activities, family backgrounds and relationships, and critical incidents were compared in the early lives of "more successful" artists and "less successful" artists. Methods used for collecting data are described in detail. Concludes that early successes, lowered levels of self-criticism, and early commitments to visual modalities have been precursors of success in visual-art careers.

234 WOLFF, JANET. *The Social Production of Art.* London: Macmillan, 1981.

Discusses the interactions between gender and class, material conditions and ideological structures, and those who write and make things and their readers and viewers. Examines the complexity of the production and reception of art within a social context. Although her model rests in Marxist theory, unlike Griselda Pollock Wolff

manages to be remarkably flexible and nondogmatic. Of particular note to those wishing to practice a feminist critique of art is her chapter on art and ideology.

235 *Woman as Sex Object: Studies in Erotic Art, 1730-1970.* Edited by Thomas B. Hess and Linda Nochlin. Art News Annual 38. New York: Newsweek, Inc., 1972, 237 pp., 200 b&w and 21 color illus.

This collection of essays represented a vanguard analysis of erotic representations of women in art. The signification of woman as sexual, by male artists, for the male gaze, is assessed. Linda Nochlin, John L. Connolly, Jr., Marcia Allentuck, Robert Rosenblum, Beatrice Farewell, Gerald Needham, David Kunzle, Barbara Erlich White, Martha Kingsbury, Alessanda Comini, Thomas B. Hess, and Gert Schiff contribute greatly to our understanding of the politics of gender. Much of the focus is on fin-de-siècle artists and woman as dangerous or as victim (see Dijkstra). To bring us up to date, there is an essay on the pin-up and its incorporation into pop art and contemporary works.

236 *Women in American Architecture: Historic and Contemporary Perspective.* Edited by Susana Torre. New York: Watson-Guptill Publications, Whitney Library of Design, 1977, 224 pp., illus.

A critical survey examining the sexual politics that has shaped the architecture produced by American women. Evaluates women's roles in architecture in America. Aspects covered include women designing for and as workers in the home, professionalism and breadth of interests of women architects from the mid-nineteenth century through the 1960s, women as architectural critics, contemporary women in the profession, the effects of feminism, and women's spatial symbolism. A chart relates architectural projects to women's history and American history.

237 *Women in Art.* Volume 1. Edited by H. Sander. Frankfurt am Main: Suhrkamp, 1980, 343 pp., 71 illus.

Articles dealing with the contribution of women to the arts. Mainly concerned with the cinema, but Valie Export examines aspects of feminist "actionism" (performance and body art), Gloria F. Orenstein discusses the Mexican painter Frida Kahlo, and Gislind Nabakowski surveys the general issue of women in art. RILA.

238 *Women in Art.* Volume 2. Edited by P. Gorsen and Ulrich Kuder. Frankfurt am Main: Suhrkamp, 1980, 292 pp., 96 illus.

Surveys the historical roles of women and the image of woman in the history of art. Gorsen discusses the construction of feminine culture, the myths surrounding women and feminine opposition to them, and the steps taken towards the emancipation of women

artists. In concluding, Gorsen and Kuder survey the treatment of the theme of Adam and Eve in the history of art. RILA.

239 *Women's Culture: The Renaissance of the Seventies.* Edited by Gayle Kimball. Metuchen, N.J., and London: Scarecrow Press, 1981, 296 pp., 37 b&w illus.

A collection of feminist essays documenting various aspects of the women's movement, including interviews with Mary Beth Edelson, etc.

240 *Women See Men.* Edited by Yvonne Kalmus. Introduction and text by Ingrid Bengis. New York: McGraw Hill, 1977.

Asks "Do women really see men and how?" Answers are provided by the work of sixty-eight photographers.

241 *Women's Images of Men.* Edited by Sarah Kent and Jacqueline Morreau. Series editor, Frances Borzello. London: Writers and Readers Publishing, 1985, 199 pp., 103 b&w illus.

Collection of essays dealing with women's ideas concerning picturing men as erotic objects, as depicted by women, through the concept of masculinity, in the context of British feminism, through performance art, personal experience, and other dimensions.

242 *Women's Studies and the Arts.* Edited by Elsa Honig Fine, Lola B. Gellman, and Judy Loeb. New York: Women's Caucus for Art, 1978.

General discussions of topics relating to women and art, discrimination, art education, teaching women and art, and a host of other significant issues in sexual politics and education.

243 WOOLF, VIRGINIA. *Orlando.* 1928. Reprint. New York: Harcourt, Brace, Jovanovich, 1956.

A provocative and witty historical fantasy dealing with gender-switching and its effect on individual perceptions in changing society and over time.

244 WRIGHT, GWENDOLYN. *On the Fringe of the Profession: Women in American Architecture.* Edited by S. Kostof. Chicago: University of Chicago Press, 1979, 308 pp., 7 illus.

Examination of women's role in American architecture in the late nineteenth and early twentieth centuries. Kostof comments that women architects were generally connected with domestic architecture, such as housing, evidently because of the influence of contemporary social attitudes. Women who did become architects recognized the unstable nature of their position, and most persisted in their allegiance to the system, remaining individuals but falling into one of four groups. Some strove to become exceptional women,

more dedicated and prolific than their male colleagues; most were anonymous, tolerating discrimination against themselves; others became adjuncts to the profession as planners, writers, etc.; and finally some were reformers outside the profession, dedicated to creating alternatives.

245 WRIGHT, GWENDOLYN. *Moralism and the Model Home: Domestic Architecture and Cultural Conflict in Chicago, 1873-1913*. Chicago: University of Chicago Press, 1980, 382 pp., 52 illus.

Considers stylistic changes that Western domestic architecture underwent in the late nineteenth and early twentieth centuries, passing from Victorian complexities through Beaux-Arts formalities to modern minimalist forms. Studying one city, Chicago, it is possible to places aesthetic changes in a larger cultural context.

246 *Yesterday and Tomorrow: California Women Artists*. Edited by Sylvia Moore. New York: Midmarch Art Press, 1989.

This is a colorful collection of twenty-one essays (by artists, historians, and critics) from California. It is a vital, vivid cornucopia of information, spanning the history of mural and photographic art and touching on the diversity of art by women in California and in relation to the feminist movement. The black-and-white illustrations provide a provocative glimpse of women's art, including Works Progress Administration artists Maxine Albro, Suzanne Scheur, Helen Burton, Florence Swift, Jane Goodwin Ames, and Henrietta Shore; northern California muralists Jane Norling, Judy Baca, Juana Alicia, Susan Cervantes, and Rual Martinez (the lone male); California women artists of the nineteenth and early twentieth centuries Helena Dunlap, Donna Schuster, Gertrude Partington, and E. Charlton Fortune; Bay area artists Sylvia Lark, Roberta Loach, Viola Frey, Judith Linhares, and Joan Brown, and many, many others exploring photography, landscape, autobiography, spirituality, and ethnicity.

Exhibition Catalogs

247 *Adrian Piper: Reflections, 1967-1987*. New York: Alternative Museum, 18 April-30 May 1987, 40 pp., illus. Curator, Jane Farver.

Essays by Farver, Piper, and Clive Phillpot discuss the prevailing issue of self and others in Piper's work and examine xenophobia, the male other, mixed race issues, class, racism, and sexism. Includes "The Mythic Being," "Aspects of the Liberal Dilemma," "Funk Lessons," and other pieces.

248 *Agnes Martin*. Philadelphia: Institute of Contemporary Art, University of Pennsylvania, 22 January-1 March 1973, illus.

Lawrence Alloway's overview of the artist's development discusses her motifs including the grids, connection to the natural world, and time zones. Includes verbal texts and poetry by Martin.

249 *Alice Neel*. Fort Lauderdale, Fla.: Fort Lauderdale Museum of Art, 8-26 February 1978, 33 b&w and color illus.

Organized by George Bolge and Henry R. Hope. Hope's introductory essay is in partial interview form, capturing the zesty flavor of Alice Neel's talk. The development of her portrait style parallels the acute psychological insights of her mature period.

250 *All But the Obvious*. Los Angeles: Los Angeles Contemporary Exhibitions, 2 November-23 December 1990. Edited by Catherine Lord. Curators, Pam Gregg, Phranc, Cheri Gaulke, Liz Kotz, Adriene Jenik, et al.

Writing, visual art, performance, and video by lesbians is the subject of this exhibition catalog. The text is difficult to read because of the design and the fabrications it contains. The basic assumptions presented by this select group of younger lesbians is often in

contradiction with an older generation's perceptions; this is especially true of lesbian feminists who have much to take issue with in their deconstructions and re-representations of lesbian identity for the 1990s.

251 *American Women Artists: 1830-1930.* Washington, D.C.: National Museum of Women in the Arts, 10 April-14 June 1987, illus.

Essays by Gail Levin, Alessandra Comini, and Wanda M. Corn. Corn's "Women Building History" explores how art schools and exhibitions provided institutional support for women artists. Concentrates on the contributions by women to the Philadelphia Centennial of 1876 and the Woman's Building at the 1893 Chicago World's Columbian Exposition. Levin's "The Changing Status of American Women Artists, 1900-1930" delves into the relationship of women artists to the art world at large. She shows their connections to radical politics and interest in progressive centers such as 291, and reveals the antifemale bias present among many of the avant-garde men, for instance homosexual artists like Marsden Hartley. Comini traces the development of American women artists from a revisionist perspective, gives biographic information, and discusses comparisons, sometimes questionable, between Hosmer and Ney and focuses on medium and professionalism in a field often hostile to women.

252 *American Women of the Etching Revival.* Atlanta: High Museum of Art, 1988, 72 pp., illus. Curator, Phyllis Peet.

The catalog celebrates the 100th anniversary of two path-breaking shows by women etchers: "Women Etchers of America 1887" in Boston and another show at the Union League Club, New York. Commemorates the originality of women in the graphic arts, and includes many of the prints in the original exhibitions by such artists as Eliza Greatorx, Anna Lea Merritt, and Mary Nimmo Moran.

253 *Ana Mendieta: A Retrospective.* New York: The New Museum of Contemporary Art, 20 November 1987-24 January 1988, 85 pp., b&w and color illus.

In Spanish and English. Essays by guest curators John Perreault and Petra Barreras del Rio. Perreault's "Earth and Fire: Mendieta's Body of Work" discusses Mendieta's tragic death in 1985 at the age of 36 and her brilliant synthesis of earth, body, photo, and performance art as embodied in feminist themes in the context of her third-world roots. Barreras's historical overview traces Mendieta's development from the 1970s through the *Silueta* series, rape performance pieces, and *Ruperstrain* sculptures to a point in the early 1980s when the resonance of her art went beyond the actual objects to mythological "metaphors of Gaea, or Mother Earth, and Hades,

the dwelling of departed spirits"; she "relentlessly searched for images that would capture the power of nature."

254 *Art and Ideology*. New York: New Museum of Contemporary Art, 4 February-18 March 1984, 71 pp., 70 illus.

Five guest curators were invited to show the work of two artists, one lesser known, the other more established. They were asked to choose works that addressed feminist and antiwar issues in a provocative way. The selections included: Fred Lonidier and Allan Sekula (curator, Benjamin H.D. Buchloh); Nancy Spero and Francesco Torres (Donald B. Kuspit); Jerry Kearns and Suzanne Lacy (Lucy R. Lippard); Ismael Frigerio and Alfredo Jaar (Nilda Peraza); Kaylynn Sullivan and Hannah Wilke (Lowery Sims). Essays by each of the guest curators. Lowery Sims's "Body Politics: Kaylynn Sullivan and Hannah Wilke" considers the work of these two artists in the context of feminism, language as an instrument of social control, autobiography, female symbolism, sexuality, sexism, and transgression. Discusses Wilke's "cunt forms" and negative connotations of "pussy," "cunt," "box." What Wilke explains is "labeling people instead of listening to them." Sullivan's work centers on the themes of victimization within the context of murder; dispersal of elements, parts, inventory, etc.; the audience's consumerist greed and consumption; and the mechanisms of her own survival as a black woman in this world. Delving into her own past and basing her performances on television and media narratives, amplified by her own experiences, she works from her position as a black woman, creating transactions between victim and aggressor that entertainingly examine the shifting ground between the two states of being, fostering a problematic intimacy. See Frueh.

255 *The Artist and The Quilt*. San Antonio, Tex.: Marion Koogler McNay Art Institute, 25 September-29 October 1983. Organized by Charlotte Robinson. Contributions by Jean Taylor Federico, Miriam Schapiro, et al. Catalog by Eleanor Munro. New York: Alfred A. Knopf, 1983, 144 pp., 179 illus. (99 color).

This presentation of twenty contemporary quilts and twenty-three original artworks that inspired them represents a collaboration between eighteen American women artists and sixteen American quilters. Exhibition travels extensively in the United States.

256 *The Artist's Mother: Portraits and Homages*. Huntington, N.Y.: The Heckscher Museum, 14 November 1987-3 January 1988. Guest curator, Barbara Coller.

In her introductory essay, based on sixteen interviews with artists in the exhibit, Coller addresses the uniquely personal nature of artists' portraits of their mothers, discussing such complex issues as

the nuclear family and Freudian psychology and confronting style, motivation, and iconography. Essays by John E. Gedo and Donald Kuspit only confuse the initial clarity with which Coller approaches this project. Kuspit's "Representing the Mother: Representing the Unrepresentable?" is a psychoanalytic deliberation that focuses on the central role of the mother in the context of the Oedipus complex. He argues that the mother is a difficult subject "because it confronts the adult artist with the childish part of himself/herself." He claims that most of the portraits distance themselves from the mother. By contrast, Kuspit theorizes, women artists, e.g. May Stevens and Hannah Wilke, seem more willing to identify and empathize with the mother. His claims, based on androcentric psychoanalytic theories and/or his encounter with the mother in art, emerge as a kind of contest. One doesn't know whether he is discussing the artists or himself. His irritating analysis of Gorky's portrait of his mother is worth reading. In feminist art criticism we have not really undertaken the necessary work when it comes to the identity of the mother in art or society. Includes Eric Fischl, Arshile Gorky, Marisol, June Wayne, Ann Sperry, Daisy Youngblood, Faith Ringgold, and others. See Nancy Chodorow, *The Reproduction of Mothering: Psychoanalysis and the Sociology of Gender* (University of California Press, 1978), and Adrian Piper and Marni Reva Kessler's "Reconstructing Relationships: Berthe Morisot's Edma Series," *Woman's Art Journal* (Spring/Summer 1981): 24-28.

257 *At Home*. Long Beach, Calif.: Long Beach Museum of Art, 1983, 65 pp., illus. Reprinted in *Crossing Over*, by Arlene Raven (see entry 193), pp. 83-153, 24 illus. Guest curator, Arlene Raven.

The home and the family are subjects explored in this exhibition of contemporary feminist art by southern California women artists. Includes performances, environments, installations, diaries, notebooks, journals, and videotapes. The majority of the ninety-nine works were made especially for this exhibition. Artists represented include Eleanor Antin, Judy Chicago, Suzanne Lacy, Miriam Schapiro, and Faith Wilding. Raven's essay pictures the house we were born to, tells how we made it a home of our own, and envisions its rooms. Asks what is a home, where is it, who lives in our house, and what happens there? Discusses Womanhouse, a collaborative art environment created by twenty-three women of the Feminist Art Program at the California Institute of the Arts. Includes Lili Lakich's lesbian homages, Laurel Klick's explorations of suicide, Rachel Rosenthal's "Soldier of Fortune," Newton and Helen Harrison on working at home, and survival as poetic transcendence. Puts into perspective historical feminism and its passionate reevaluation of patriarchal society and culture.

258 *Autobiography: In Her Own Image.* New York: INTAR Latin American Gallery, 25 April-27 May 1988, 37 pp., 20 illus. (many in color). Guest curator, Howardena Pindell.

In her introduction to this neglected (by the New York critics) exhibition, Pindell attempts to probe some very rotten spots at the core of the Big Apple's restricted representation of the art scene, for instance, how it misrepresents multiracial art expressions by refusing to show or review them, and when it does by categorizing them into the dominant white-supremacist culture's system of understanding. Taking off from the late Ana Mendieta's question "Do we exist?" Pindell questions women's existence and awareness of self. Essays by Judith Wilson and Moira Roth make this a notable catalog. Wilson, an African-American art historian and critic, discusses her own reality as a woman of color growing up in a racist society. In her writing she exposes the pain of trying to come to terms with the images she saw and her own experiences in a woman-hating, white-supremacist America. Roth's "Diggings and Echoes" details issues of racism and sexism from the perspective of a serious gynergenic art historian and critic. Contains work by women of color including Lorna Simpson, Vivian E. Browne, Candida Alvarez, Yong Soon Min, Clarissa T. Sligh, Alison Saar, Kay Walkingstick, Adrian Piper, Pena Bonita, Pat Ward Williams, Emma Amos, Nina Kuo, Asiba Tupahache, Sophie Rivera, Marina Gutierrez, Camille Billops, Margo Machida, Ana Mendieta, Janet Olivia Henry, and Theresa Hak Kyung Cha.

259 *Barbara Kruger.* New Zealand: National Art Gallery, 5 March-1 May 1988, 73 pp., 47 illus. Contributions by Luit Bieringa, Jenny Harper, and Lita Barry.

Harper describes Kruger's development and her brand of feminist politics. Of particular note is Barry's "Beyond the Looking Glass: Your Truths Are Illusions." A postmodern psychoanalytical analysis based on French feminism, particularly Luce Irigaray. Woman is the negative of all that man is, his fear of castration, etc. Kruger appropriates images from the media to expose the consumption of the cultural construction of "femininity." Her work reads signs in reverse. This is a densely packed, jargon-filled discussion of Kruger's work from a poststructural theoretical perspective. Raises the question "Is this really necessary in order to discuss discrimination?"

260 *Coast to Coast: A Women of Color National Artists' Book Project.* Radford, Va.: Flossie Martin Gallery, Radford University, 14 January-2 February 1990, 79 pp., illus.

Formed in 1987 as a women of color national artists' project, "Coast to Coast" serves up a hot and spicy jambalaya stew of statements and images by women artists. Faith Ringgold, in

collaboration with Clarissa Sligh and assisted by Crystal Britton, gives a history of the "Coast to Coast" project and discusses her relationship with the Women's Caucus for Art, which enabled her to become a part of a national network of largely white middle-class women, and her longing for forming a successful network for women of color. Nashormeh N. R. Wilkie's "Stepping Into Beauty and Power" is a crucially important overview for anyone working on issues concerning women of color. Among artists of color included are Clarissa Sligh, Carole Byard, Miriam Hernandez, Tomie Arai, Lotus Do-Brooks, Mary Ting, Sharon Jaddis, Margaret Gallegos, Diosa Summers-Fitzgerald, and Deborah Willis.

261 *Committed to Print: Social and Political Themes in Recent American Printed Art.* New York: Museum of Modern Art, 1988, 120 pp., 34 illus. Curator, Deborah Wye.

Wye explores images of race, culture, gender, nuclear power, ecology, war, revolution, economics, class struggle, sexism, and the American Dream. She bases her essay on interviews with the artists.

262 *Connections.* New York: Museum of Contemporary Hispanic Art, 1987, 100 pp., illus. Contributions by Sabra Moore and Josely Carvalho.

Made up of nine volumes accompanied by a list of 150 women artists primarily from Brazil and the United States. Includes Josely Carvalho, Ana Castillo, Marina Gutierrez, Ana Medina, Catalina Parra, Liliana Porter, Judite Dos Santos, Josie Talamantez, Cecilia Vicuna, Jaune Quick-To-See Smith, Michiko Itatani, Kazuko, Emma Amos, Howardena Pindell, and Betye Saar.

263 *Cross/Cut.* Washington, D.C.: Washington Project for the Arts, 24 January-5 March 1988, 5 illus. Edited by Mel Watkin.

Maurice Berger's "Race and Representation: The Production of The Normal" discusses racial bias through a reexamination of works by Margo Machida, Jenny Holzer, and Edgar Heap-of-Birds among others. Using a deconstructive but rhetorically accessible analysis, Berger reveals the bigotry inherent in our centrist art system, and describes strategies to expose its racism and sexism. Advocates encouraging people to speak for themselves, rather than be spoken for, on issues of art and culture. But how to do this in an exclusionary art system remains a problem. Margo Machida's "Seoul on Soul: Asians Take On America" (pp. 19-21, 1 illus.) considers contemporary Asian-American artists, including herself, and their ambivalence concerning a sense of American identity against a background which often locates them as outsiders even in relation to other minority groups.

264 *The Dinner Party: Judy Chicago*. San Francisco: San Francisco Museum of Modern Art, 16 March-17 June 1979, 100 pp., 47 illus.

The catalog was the result of five years' work. It was conceived by a Jewish feminist with the help of Catholic nuns, the Ecclesiastical Stitchers Guild, Methodist, Baptist, and Episcopalian china painters, scores of researchers, and studio assistants. Hopkins explains in the introduction how Chicago uses "women's techniques" (stitching and china painting) in a "women's context" (*The Dinner Party*) in order to create a major feminist art statement. Brief information on the thirty-nine women at the table and the symbols on the floor, with a note on the specially designed and painted china plates, is included in the newspaper-format catalog, together with introductory remarks by Chicago on the development of the project.

265 *Dorothy Dehner and David Smith: Their Decades of Search and Fulfillment*. New Brunswick, N. J.: The State University of New Jersey, The Jane Voorhees Zimmerli Art Museum, 1984, 56 pp., 49 illus.

Joan Marter compares and contrasts the work of these two artists, demonstrating how gender affects exposure, and showing how collaborative interchanges between husband and wife (which are generally attributed to the male rather than the female) result in greater appreciation for his work than for hers. Despite the difficulties of the marriage, which ended in Dehner's divorce from Smith in 1952 and subsequent marriage to a man who was supportive of her art until his death in 1974, she remained on friendly terms with Smith. Their early interactions shaped Smith's work and nurtured Dehner's growing confidence as a mature artist. Judith McCandiess's "Dorothy Dehner: Life and Work" appraises Dehner's childhood, studies at UCLA, European experiences, interactions with the experimental dancer Mary Wigman, and her studies at the Art Students League of New York. She probes the impact of her marriage to Smith in 1927, her interaction with the avant-garde of the late twenties and thirties in New York, and the influences of surrealist and abstract expressionist theories on her art. She indicates that the WPA and Bolton Landing were discrete experiences that shaped her work during the forties, as well as her struggle with married life and making her art during the fifties, particularly the engravings she did at Stanley Hayter's Atelier 17 in New York, which stimulated her interest in making sculpture.

266 *Drawing Now: 10 Artists*. New York: The Soho Center for Visual Artists, 3-26 June 1976.

Corinne Robins discusses the decade of 1966 to 1976 and the radical changes it brought about, including the emergence of a large number of strong women artists who were leading innovators. Selects

some of the most critical female humanists of the decade: Dotty Attie, Natalie Bieser, Blyth Bohnen, Nancy Grossman, Phoebe Helman, Howardena Pindell, Deborah Remington, Nancy Spero, Michelle Stuart, and the token male Lucas Samaras. Statements and poems by the artists. Particularly powerful are those by Grossman, Remington, and Spero.

267 *Edith Altman*. Omaha: College of Fine Arts, University of Nebraska at Omaha, 1983.
 Joanna Frueh's "Love Poems for Edith Altman" is a three-part poem appearing as a catalog essay. The first part critiques "men the self-enablers" who "name themselves/Great (ones)/And write love letters in the pages of art history." The second part creates a mythic world from which women artists come to earth, and the third part is an homage to Altman, a conceptual artist and Holocaust survivor who lives in Chicago.

268 *Eight Southern Women*. Greenville, S.C.: Greenville Country Museum of Art, 1986, 58 pp.
 Essay by Margaret Lynne Ausfeld. Traces the careers of women working between 1900 and 1940, all of who were born in the South and raised during Reconstruction. This is an evenhanded assessment of art made by Josephine Marien Crawford, Anne Goldthwaite, Blanche Lazzell, Alice Ravenel, and Helen Turner among others.

269 *Elizabeth Nourse, 1859-1938: A Salon Career*. Washington, D.C.: National Museum of American Art, 14 January-17 April 1983. Introduction by William H. Truettner.
 Essays by Mary A. H. Burke and Lois M. Fink. Gives a detailed account of Nourse's life and career as an expatriate who traveled and painted extensively in Europe. Her sister, Louise, acted as her housekeeper and business manager. Includes a chronology, bibliography, and catalog raisonné.

270 *Ellen Jacobs: Metalwork and Glass*. Miami, Fla.: The Art Museum at Florida International University, 23 June-21 July 1989, b&w and color illus.
 In "Ellen Jacobs," Cassandra Langer considers twenty years of the artist's work, remarking on the organic, flowing forms, oriental influences, and intimate scale of the androgynous objects Jacobs makes. Drawing inspiration from the ancient world of female figures, she creates an art that centers on openness, flexibility, and growth.

271 *Ellen Lanyon – Strange Games: A Twenty-Five Year Retrospective*. Urbana-Champaign, Ill.: Krannert Art Museum, 7 March-12 April 1987, illus.

Donald Kuspit views Lanyon's art through his own eccentric psychoanalytic perspective and in the context of surrealism, realism, and feminism.

272 *The Emmets: A Family of Women Painters*. Pittsfield, Mass.: The Berkshire Museum, 6 August-26 September 1982, 63 pp., 51 illus.

Essay by Martha J. Hoppin. Discusses the remarkable careers of Rosina Emmet Sherwood, her sister Lydia Field Emmet, and their cousin Ellen Emmet Rand. Among the first truly professional women portraitists in the United States, these three women asserted their right to work for a living. The range of their interests and the stumbling blocks they encountered provide insights into the obstacles women artists faced in pursuit of a career.

273 *Events: En Foco, Heresies Collective*. New York: New Museum of Contemporary Art, 11 June-20 July 1983, 48 pp., 50 illus.

Essays by Marcia Tucker, Charles Biasiny-Rivera, and Frank Gimpaya. Second series of invitational exhibitions in which independent artists' groups organize exhibitions of their own choosing for the Museum. En Foco's "La Gran Pasion" curated by Biasiny-Rivera and Gimpaya, presents sixty-five photographs from the 1970s and 1980s by thirty Mexican-American photographers, which reflect the unique qualities inherent in the Latino experience. The Heresies Collective, a New York City-based feminist art group, presents "Classified: Big Pages from the Heresies Collective," a walk-around magazine of 6- x 8-foot pages made collaboratively by the women of the collective.

274 *Extended Sensibilities: Homosexual Presences in Contemporary Art*. New York: New Museum of Contemporary Art, 16 October-20 December 1982, 60 pp., 51 illus. Curator, Daniel J. Cameron.

Works shown by Charley Brown, Scott Burton, Craig Carver, Arch Connelly, Janet Cooling, Betsy Damon, Nancy Fried, Jedd Garet, Gilbert and George, Lee Gordon, Harmony Hammond, John Henninger, Jerry Janosco, Lili Lakitch, Ross Paxton, Jody Pinto, Carla Tardi, and Fran Winant. In his essay, Cameron attempts to set up some highly problematic categories regarding gay and lesbian sensibilities that threaten to collapse like a house of cards at every close reading. His representations are highly subjective and his cultural constructions regarding engendering his treatment of subjects, particularly lesbians, as objects intimate sadistic-masochistic readings similar to those of Pat Califia, viz. "rough trade" and other concepts that only serve to reinforce stereotypical, patriarchal, and sometimes heterosexist decoding of these works.

275 *Faith Ringgold: A 25-Year Survey*. Long Island, N.Y.: Fine Arts Museum of Long Island, 1 April-24 June 1990, illus. Curator, Eleanor Flomenhaft. Contributions by Lowery S. Sims, Thalia Gouma-Peterson, and Moira Roth.

This exhibition, which traces Ringgold's career from the early 1960s through the 1980s, commences a thirty-month tour of twelve culture institutions throughout the United States. Sims's discussion in "Race Riots, Cocktail Parties, Black Panthers, Moon Shots and Feminists" and Faith Ringgold's "Observations on the 1960s in America" highlight the political and social unrest that permeated race relations during this era. Gouma-Peterson's "Modern Dilemma Tales: Faith Ringgold's Story Quilts" focuses on the links among storytelling, performance, and pictures. Roth's "A Trojan Horse" highlights Ringgold's career, using the metaphor to underscore the artist's painful struggle to enter the mainstream art scene without being swallowed up in it.

276 *Faith Ringgold: Change Painted Story Quilts*. New York: Bernice Steinbaum Gallery, 13 January-7 February 1987, 28 pp., illus.

Essays by Thalia Gouma-Peterson and Moira Roth. Roth's "The Field and The Drawing Room" addresses Ringgold as a passionate black feminist. Bases the title of her essay on Amiri Baraka's article "Faith," written for *Faith Ringgold: Twenty Years of Painting, Sculpture, and Performance 1963-1983*, ed. Michele Wallace (New York: The Studio Museum in Harlem), 1984. Roth cites this catalog as the single best source on the artist because of articles by Terrie S. Rouse, Freida High Wasikhongo, Eleanor Munro, Lucy Lippard, Michele Wallace, and herself. Discusses Ringgold's class, status and bi-coastal life. Gouma-Peterson traces Ringgold's political activities from the early Civil Rights movements to her ongoing fight for women artists of all colors and talks about the artist's role as an activist. Her storytelling quilts allow her to amplify narratives, visual and verbal, for example, *Who's Afraid of Aunt Jemima*, *Slave Rape Story Quilt*, and *The Men*.

277 *Feministische Kunst Internationaal*. The Hague: Haags Gereentemuseum, 104 pp., illus.

Essays in Dutch, with summaries in English, by Marlite Halbertsma and others deal with themes of sexuality, collaboration, and the reevaluations of crafts. Presents a survey of works from America and Europe highlighting three dozen twentieth-century artists. RILA.

278 *Figures from the Background*. Ferrara: Padiglione D'Arte Contemporanea, 26 February-25 March 1984. Organized by Comune Di Ferrara, Assessorato Istituzioni Culturali, Gallerie Civiche D'Arte

Moderna, and Palazzo Dei Diamanti. Bologna: Grafis Industrie Grafiche, 1984, 146 pp., 106 illus.

An exhibition of work in all media done in the last thirty years by Italian women artists. M. Pasquali explains the title, suggesting that these artists should be considered as "figures" of art, operating in a complex ambience, but not bound by any other parameters than those of their artistic professionalism. She believes this gives a new view of a period in which women took on more and more roles in the art world, and a new perspective on the major art movements of the last thirty years. RILA.

279 *Five Winston-Salem Printmakers*. Winston-Salem, N.C: Southeastern Center for Contemporary Art, 1983, illus.

Essay by Sandra (Cassandra) Langer. Presents a historical survey. Langer's essay deals with five women printmakers, their art, and the contrast between this regional women's community and the competitive structures of patriarchal art systems in general.

280 *Florine Stettheimer*. New York: Museum of Modern Art, 1946, 53 pp., illus.

Essay by Henry McBride. Posthumous exhibition of the artist's work. In this essay written after Stettheimer's death in 1944, McBride comments on her relative obscurity, personality, circle of friends, and subject matter, including the *Cathedrals* series, *Beauty Contest*, *Spring Sale*, *Self-Portrait*, and other works. He discusses the "difficult Miss Stettheimer" and her collaboration in "Four Saints" as the set designer for this avant-garde production with music by Virgil Thompson, text by Gertrude Stein, and an African-American cast.

281 *Florine Stettheimer: Still Lifes, Portraits and Pageants, 1910-1943*. Boston: Institute of Contemporary Art, 4 March-27 April 1980, 23 illus. (2 color).

Essay by Elisabeth Sussman. Stettheimer's work defies classification and challenges our imagination. The thirty-two paintings exhibited are evocative in their symbolism. Drawing on Stettheimer's journals in the Beinecke Library (Yale University) and other resources, Sussman documents the artist's interest in Diaghilev's Ballets Russes and how its aesthetics influenced Stettheimer's own art.

282 *Forever Free: Art by African-American Women, 1862-1980*. Normal, Ill.: Centre for the Visual Arts Gallery, Illinois State University, 30 January-22 February 1981, 214 pp., 49 b&w and color illus. Edited by A. A. Bontemps.

Essays by Jacqueline Fonvielle-Bontemps, David C. Driskell, R. A. Walker, A. M. Gordon, J. Bertagnolli, and Arna Alexander

Bontemps. Co-curators Bontemps and Fonvielle-Bontemps present *Forever Free* as a counter to the bicentennials that neglected African-American women artist's contributions. Driskell's introduction examines the role played by black women in the evolution and maintenance of black culture in the United States during the nineteenth and twentieth centuries. He also considers the general lack of interest shown by Western society in women as artists. Bontemps and Fonvielle-Bontemps' "African-American Art History: The Feminine Dimension" traces the essential role of African-American women in developing and maintaining this African-American culture. Examines the racial attitudes which existed in America throughout the eighteenth and early nineteenth centuries and considers in particular how African-American women painters and sculptors like Edmonia Lewis achieved public prominence in the mid-nineteenth century. Charts this development into the late nineteenth and early twentieth centuries through the Harlem Renaissance of 1910-20, as exemplified by the career of Laura Wheeler Waring (1887-1962), the Depression years and the postwar era. The period 1950-80 saw a flowering of deeply felt and long-standing aesthetic attitudes in black culture and showed that artistic achievements were essential to the future development of modern black art. Other essays in the volume include Rosalyn A. Walker's "Woman as Artist in Sub-Saharan Africa" and Keith A. Morrison's "A Critic's Viewpoint." Biographies of each of the artists, together with short statements on their stylistic tendencies and thematic concerns, are included.

283 *For Splendor and for Glory*. New York: Yeshiva University Museum, 1976. Curator, Ita Aber.

Short history of traditional textile arts including the contributions of Jewish artisans. Includes examples, some by Ita Aber, who is a textile artist and producer of religious craft items.

284 *Frances Benjamin Johnston: Woman of Class and Station*. Long Beach, Calif.: The Art Museum and Galleries and the Center for Southern California Studies in the Visual Arts, California State University, 12 February-11 March 1979, 96 pp., 38 illus.

Organized by Constance Glenn, Anne E. Peterson, and Leland Rice. Gives a biographical survey, focuses critical attention on Johnston's technique and photographic vision, and examines her career in the context of her extraordinary photographs of some of Washington's most unorthodox women, including Alice Roosevelt, Frances Hodgson Burnett, Countess Marguerite Cassini, and Madame Wu.

285 *Frida Kahlo and Tina Modotti*. London: Whitechapel Art Gallery, 26 March-2 May 1982, 79 pp., 88 illus.

Essays by Laura Mulvey and Peter Wollen. Presents ninety works that catalog the lives and careers of the painter Frida Kahlo and the photographer Tina Modotti as seen in the context of Mexican culture and politics. Divided into eight sections that discuss Andre Breton in Mexico, his views on work by Frida Kahlo, "The Mexican Renaissance," women in art and feminist aesthetics, the Mexican revolution and the part Rivera and Siqueiros played in the cultural programs, the nature of the women's movement around the slogan "the personal is political," Frida Kahlo and the Mexican qualities of her paintings, and Tina Modotti's nomadic life. Concludes with a discussion of the basis of both artists' work in their bodies.

286 *Gabriele Munter: Between Munich and Murnau*. Cambridge, Mass.: Busch-Reisinger Museum, 25 September-8 November 1980.

Essay by Anne Mochon. Munter's first solo exhibition and retrospective in the United States took place when she was 83. Seventy-two works ranging from drawings done at the turn of the century in Arkansas and Texas, when she visited the Americas, through works of the 1950s were exhibited. Machon's essay shows that Munter chose to follow her own direction in art despite Vassily Kandinsky's influence.

287 *The Genius of the Fair Muse: Painting and Sculpture Celebrating American Women Artists, 1875-1945*. New York: Grand Central Art Galleries, Inc., 1 April-23 May 1987, 77 pp., 33 b&w illus., 40 color plates. Curator, Robert R. Preato.

Essay by Robert R. Preato, "The Genius of the Fair Muse: Academic and Other Influences on American Women Painters and Sculptors," contains details on many neglected American women artists including Pauline Palmer, Catherine Wiley, Ellen Day Hale, Alice Schille, Susan Watkins, and Johanna K. W. Hailman. This is an unusually sensitive discussion of the problems women artists faced during this period by a gay male art historian. Preato's approach sets a standard in methodology for male feminists. Artists' biographical sketches by Elyse Topallian.

288 *Gertrude Stein and Her Friends*. Greenvale, N.Y.: C. W. Post Center Art Gallery, School of the Arts, Long Island University, 11 April-11 May 1975, illus. Introduction by James R. Mellow.

This is a good example of how not to approach a lesbian subject. Nowhere in Mellow's brief introduction is there any mention of Stein's relationship with her life partner, Alice B. Toklas. Pictures, however, show them at home together in the studio at 27 Rue de Fleurs, Paris in 1922.

289 *Grace Woodworth (1872-1967): Photographer outside the Common Line*. Auburn, N.Y.: Schweinfurth Memorial Art Center, September-October 1984, 57 pp., illus. Edited by Lisa Johnson and Heather Tunis. Curators, Anthony Bannon and Mary Stanley.

Discusses Woodworth's career, her photographs of Susan B. Anthony, and the status of women in photography at the turn of the century.

290 *Growing Beyond: Women Artists from Puerto Rico*. Washington, D.C.: Museum of Modern Art of Latin America, Organization of American States, 5-28 May 1988, pp. 5-7, illus.

Susanna Torruella Laval reviews the history of this group of women artists. They all believe that public education is a high priority. Concludes that the most serious drawbacks to working on the island for these artists are the predominance of conservative tastes and training and the lack of role models, serious critics, and collectors. Presents the work of Maria De Mater Oneill, Yolanda Fundora, Lorraine De Castro, Susana Herrero, Nora Rodriguez Valles, Maria Antonia Ordonez, Clarissa Blaggi, Rita Fernandez Zavala, Carmen Ester Hernandez, Lisette Lugo, Myrna Baez, and Susana Espinosa, among others, to support points about identity, body image, transformation, fantasy, whimsy, and violence.

291 *Half the Sky: An Exhibition of Works on Paper by Australian Women Artists*. Adelaide, Australia: Art Gallery of South Australia, 1985, 289 pp., 44 illus. Foreword by D. Thomas.

Presents a traveling exhibition of photographs, drawings, prints, and etchings with a brief introduction by S. Clearihan, and short essays on photography in the 1920s, drawing, relief printing in the 1920s and 1930s, Sydney Harbor Bridge as an image, the work of Joy Hester in the 1940s and 1950s, lithography in the 1950s and 1960s, etching, postermaking in the 1970s, and contemporary photography.

292 *Hannah Wilke: A Retrospective*. Columbia: University of Missouri Press, 1989, 171 pp., more than 105 illus. Edited by Thomas H. Kochheiser.

Includes writings by Wilke. Joanna Frueh's "Hannah Wilke" is an innovative and risky essay paralleling Wilke's own approach by playing with words that recycle and interweave images, rather than use traditional art-historical systems of detecting and examining chronological developments. Frueh is one of a group of younger (so-called second wave) gynocentrically oriented feminist critics who believe that the form as well as the content of art criticism must change if art audiences are to think about art more expansively. Her approach is more erotic, corresponding to Wilke's art. Ultimately, she argues, Wilke's work is neither feminine nor masculine and thus

opens new avenues of expression and experimentation for feminist art critics.

293 *Harmonies: An Essay on the Work of Harmony Hammond*. Chicago: Klein Gallery, 1982. Reprinted in *Crossing Over*, by Arlene Raven (see entry 193), pp. 33-46.

Arlene Raven vividly illustrates autobiographical, first-person poetics in the feminist mode. Reading and writing her text as a play on the representation and meaning of harmony and conversation, Raven sets the standard for this kind of interpretation. Using the technique of weaving she creates a counterpoint that reveals the mixed shadows and lights of a loosely woven collaborative process that illuminates both feminist criticism and feminist art in the work of lesbian feminist Harmony Hammond.

294 *Harmony Hammond: Ten Years, 1970-1980*. Minneapolis: Women's Art Registry of Minnesota, 28 February-28 March 1981, 32 pp., 22 illus.

Miniretrospective of wrapped objects and installations by Harmony Hammond, a lesbian feminist artist. Lucy Lippard's insightful essay, "Towards a Politics of Abstraction," positions Hammond within a framework of popular concepts of feminist art and its relation to politics. Quotations from the artist are used to clarify her intentions and her feelings. Like Romaine Brooks, Hammond represents a self-identified lesbian feminist participation, as well as encoding and establishing a self-affirming lesbian presence in her art.

295 *Harriet Randdall Lumis: An American Impressionist*. Chicago: R. H. Love Galleries, Springfield Museum of Art, 4 December 1977-1 January 1978, 64 pp., 97 illus.

Art dealer Richard H. Love comments on Lumis's career but without the obligatory critical analysis of her talents. Mainly a marketplace production, but valuable for the biographical information it gives. It takes an astute and patient reader to make sense of this as a potential resource for feminist analysis from the point of view of class distinctions and the economic and other consequences women suffered in pursuit of artistic careers.

296 *Hedda Sterne: Forty Years*. New York: Queens Museum, 1985, pp. 6-23, 25 illus. (some in color). Contributions by Ileen Sheppard, Anna C. Nol, and Dore Ashton.

Ashton's "A Cosmopolitan of the Imagination" traces Sterne's career from Bucharest through her Jewish origins and the effects of anti-Semitism in her native Romania. Sterne escaped during the roundup of Jews by Romania's Iron Guard and fled to the United

States in 1941. Ashton considers Sterne in the context of abstract expressionism and contemporary art. What is striking is that no one ever seems to notice the fact that the women's movement helped to stimulate interest in Sterne's neglected art and life.

297 *Helen M. Turner 1858-1958*. Cragsmoor, N.Y.: The Cragsmoor Free Library, 2-17 July 1983, 40 pp., illus. Guest curator, Lewis Hoyer Rabbage.

Art-historical overview of a neglected woman artist who studied at the Art Students League of New York and the Women's Art School at Cooper Union, and taught at the Art School of the New York Y.W.C.A. Turner's career or lack of it serves as a model answer to the question of what happened to America's women impressionist artists when art historians began putting together the history of art in the United States. Rabbage has unwittingly given us a portrayal of the colonized woman artist and some of the reasons for her neglect. In examining Turner's development one can see all of the male peers she emulated in her attempt to succeed.

298 *Her Own Space*. Philadelphia: Muse Gallery, Moore College of Art, 1983, 34 pp., 38 illus. Contributions by Naomi Waksberg, Norma Broude, Mary D. Garrard, Lucy R. Lippard, Gayle Davis, and Barbara Zucker.

Examines alternative exhibition spaces for women since the emergence of the women's art movement in the early 1970s. Presents thirty-four works in a variety of media by American women artists–members of Muse and six guest artists (Carole Fisher, Suzanne Lacy, Sylvia Sleigh, Harmony Hammond, Faith Ringgold, and Barbara Zucker).

299 *Home Work: The Domestic Environment Reflected in Work by Contemporary Women Artists*. Seneca Falls, N.Y.: National Women's Hall of Fame, 1981, 35 pp., illus. Curator, Harmony Hammond.

A feminist exploration of women's roles and experiences in the domestic arena. Reflections by twenty-seven New York State artists on home life as a process of cooking, sewing, cleaning, and caregiving. Comments on the transformation of crafts into art and a renewed focus on still life. This show is an expansion of themes developed in *Out of the House* (Whitney Museum of American Art, Downtown Branch, Jan. 1978), and in *Womanhouse* (Hollywood, Ca., 1972). See Raven.

300 *Ida Applebroog*. New York: Ronald Feldman Fine Arts, Inc., 1987, 63 pp., illus. Texts by Carrie Rickey, Lucy Lippard, Applebroog, Linda McGreevy, and Carter Ratcliff. Foreword by Ronald Feldman.

301 *Ida Applebroog: Happy Families, A Fifteen-Year Survey*. Houston, Tex.: Contemporary Art Museum, 24 February-20 May 1990, University of Washington Press, 62 illus.

Essays by Marilyn A. Zeitlin, Thomas W. Sokolowsky, and Lowery S. Sims. Zeitlin makes a case for understanding Applebroog's work in a context similar to that of Nancy Spero and Sue Coe, and relating to a society that encourages inauthenticity and lack of intimacy. Sims addresses the "blond bombshell" image of Marilyn Monroe, labeling it "an icon for America." But in Applebroog's version of Monroe we see an aging, pudgy, wrinkled figure in a bathing suit. The assumed male gaze that creates such impossible images, i.e. ideal sex goddess, is represented by identical effigies of men behind steering wheels who are responsible for constructing a destructive system of social relationships and values.

302 *Images: 1980*. Montevallo, Ala.: Montevallo Art Gallery, 1980, 31 pp. Curator, Patricia A. Johnson.

A sociological and critical survey of Alabama women artists drawn from questionnaires filled out by 156 artists. Includes a systematic study of women's imagery in which Johnson concludes that it is impossible to tell if differences arise from inherent dissimilarities between the sexes or from unequal treatment in a patriarchal social order.

303 *Introduction to Art: A Woman's Sensibility*. Valencia, Calif.: Institute of the Arts, 1975, 84 pp., 150 illus.

Selected works by American women artists representing all contemporary styles. The text of the catalog consists entirely of letters. Deena Metzger notes that the focus is not necessarily each artist's work, but can be the letter by the artist accompanying and discussing her work. "To speak about her work is to affirm the consciousness and intelligence of the woman artist, and to create an environment appropriate to its statements."

304 *Invented Selves: Images of Asian-American Identity*. New York: Asian American Center, 1-21 December 1988. Guest curator, Margo Machida.

Machida, a Japanese-American artist, discusses ethnicity and self-imaging as a vehicle for achieving personal definition and exposing her own and other Asian artists' longing for a sense of place in a "perplexing, unstable, rejecting and indifferent environment." Cites works by Ken Chu, Y. David Chung, and Susan Suzuki to deal with the several components of identity.

305 *Irish Women Artists: From the 18th Century to the Present Day*. Dublin: National Gallery of Ireland, July-August 1987, 230 illus.

Edited by Wanda Ryan-Smolin. Curators, Elizabeth Mayer and Jeni Rogers.

Starting from the eighteenth century and running to 1943, this exhibition features more than eighty artists and tells us something of who these pioneers were. Includes Mary Swanzy, Mainie Jellett, Letitia Bushe, Mary Delany, Henrietta Dering, Mary Kate Benson, and Sarah Purser. The introductory essay by Anne Crookshank gives the broad sweep of the history of women artists in Ireland. Includes comprehensive bibliography and a dictionary of Irish women artists.

306 *Joan Snyder: Seven Years of Work*. Purchase, N.Y.: Roy R. Neuberger Museum, 17 January-4 March 1978, 40 pp., 30 illus.

In this text of paintings and collages completed by Joan Snyder between 1970 and 1977, Hayden Herrera focuses on the feminist influences that have appeared in Snyder's work since 1974. She also examines Snyder's early paintings and discusses the major transition which occurred in the artist's painting in 1964 (when she saw the work of Max Beckmann at an exhibition in New York), her use of non-art materials in her work, the influence of her European trip on her artistic development, her flock/membrane paintings, and her stroke paintings. The recent paintings show the connections between Snyder's artistic and personal growth.

307 *Jo Hanson: Crab Orchard Cemetery*. La Jolla, Calif.: Mandeville Art Gallery, 25 September-26 October 1975, pp. 1-13, illus.

In this interview Moira Roth questions Hanson about her concepts of life and death, how she began her rubbings of grave stones in Crab Orchard Cemetery, and her artistic recreation of mythical time through these images over seven decades of stones encoded with multiple human histories. Hanson sees her work as addressing the history of death and continuity.

308 *Joyce Kozloff: Visionary Ornament*. Boston: Boston University Art Gallery, 20 February-6 April 1986, 62 pp., illus.

Patricia Johnson's "Joyce Kozloff: Visionary Ornament" is a brief overview of the artist's continuing dialogue with the history of style and ornament. She examines work from the early 1970s to the present, the incorporation of Kozloff's feminism into her art, her co-founding of the Pattern and Decoration group, her installation pieces, and her shift to public art. Hayden Herrera's "A Conversation with the Artist" (pp. 27-43) took place in New York at P.S. 1 in December of 1984. Her deliberations focus on Kozloff's painting on tiles, public art, dialoguing with the audience, portrayals of cities, decorative intentions, and the political dimensions of Kozloff's art in relation to cultural history. Feminism, though implied, is not central to this particular conversation.

309 *Krasner/Pollock: A Working Relationship.* New York: Gray Art
 Gallery, 4 November-12 December 1981, 32 pp., 20 illus.
 Enez Whipple originated and organized the exhibit, which was
 first shown at Guild Hall, East Hampton, N.Y. Essay by Barbara
 Rose. Rose traces Lee Krasner's early influence on Jackson Pollock
 and maps the course of their avant-gardism, proving that the close
 and influential relationship between husband and wife, artist and
 artist, has been grossly understated and misrepresented by the art-
 historical establishment – including Rose herself in earlier writings on
 the subjects. Demonstrates that Krasner's little image paintings and
 assorted mosaic canvases influenced Pollock's work, turning him
 away from expressionistic modes, and confirms that the close
 interaction between the two artists advanced Pollock's career and
 disadvantaged Krasner.

310 *The Ladies, God Bless 'em.* Cincinnati: Cincinnati Art Museum, 19
 February-18 April 1976, 71 pp., 86 illus.
 An exhibition of 176 objects made and decorated by women artists
 in Cincinnati in the nineteenth century. C. Macht's "The Ladies, God
 Bless 'em – The Women's Art Movement in Cincinnati in the
 Nineteenth Century" examines the women's art pottery movement,
 which began in Cincinnati in the 1870s, peaked in the 1880s, and
 developed an underglaze process that became the basic technique of
 the well-known Rookwood art pottery. Founded by Mary Louise
 Mclaughlin, the world-famous Rookwood Pottery produced some of
 the finest ceramics in America. Mclaughlin's work is described with
 that of several other key figures in the movement. Macht
 demonstrates that as Rookwood pottery gained world renown, the
 women's art movement and its subsidiary group, the Pottery Club,
 were forced out of the production of pottery, and by 1890 Rookwood
 was an all-male, totally commercial operation. She comments on the
 part played by women artists and other women in Cincinnati's
 cultural life during the rest of the century. The catalog includes
 extensive notes about each pottery piece.

311 *Latina: Enfoco.* New York: City Gallery Department of Cultural
 Affairs of the City of New York, 25 April-3 June 1989.
 In Spanish and English. "Latina" concentrates on the art of four
 Latin American photographers: Sandra Eleta (Panama), Garciela
 Iturbide (Mexico), Marucha (Maria Eugenia Haya [Cuba]), and
 Frieda Medin (Puerto Rico). Curator Susanna Laval asks what
 imagery is real to Hispanic Americans, and considers the question
 "Who are we ourselves?" She believes a sense of self proves essential
 to the faculty of experiencing the self depicted by these artists.
 Concludes that individually and collectively, the work celebrates,

transmits and ultimately preserves the unique, irreducible traits of their respective Latin American cultures. See S. Goldman.

312 *Lee Krasner.* New York: Whitney Museum of American Art, 13 November 1973-6 January 1974, 44 pp., 18 illus.

Essays by Marcia Tucker and P. Adler. Concentrates on work done since 1950. Tucker declares that Krasner's work has been undervalued through being diminished by that of her husband Jackson Pollock and of other abstract expressionists for some years. She needed the change of attitude toward women artists of the late 1960s to be properly evaluated as a pioneer. Surveys Krasner's development and the evolution of her work from this perspective. From 1963-1965, the artist produced a group of works dominated almost entirely by the linear element which expressed her earlier fascination with calligraphy, rooted in her Jewish upbringing, and became fully orchestrated in larger works. After the transitional *Pollination* (1968), new works emerged, and her most recent paintings mark the beginning of a new phase in a long, often difficult, but distinguished career.

313 *Lee Krasner: A Retrospective.* Houston, Tex.: The Museum of Fine Arts; New York: The Museum of Modern Art, 1983, 184 pp., 139 b&w and 33 color illus.

Filling in the gaps, Barbara Rose pays attention to Krasner, who was unfairly neglected during her most productive years. Details her development as an artist and under the shadow of her husband and abstract expressionism. Traces her career to her rediscovery in the 1960s and shows her producing strongly original work, reflecting her own interpretation of aesthetics. See Marcia Tucker.

314 *Lilly Martin Spencer.* Washington, D.C.: National Collection of Fine Arts, 1973. Curators, Robin Bolton-Smith and William Truettner.

Texts describe the difficulties encountered by this self-taught professional artist. Lilly Martin Spencer's marriage appears to have been a revision of the traditional contract since it was she who supported herself and her family through her art. Her art was sentimental but it also had a serious side.

315 *Louise Bourgeois.* New York: Museum of Modern Art, 3 November 1982-8 February 1983, 124 pp., 153 illus. (4 color). Introduction by William Rubin.

Essay by Deborah Wye. Bourgeois only had to wait until she was 72 before the Museum of Modern Art thought she merited a retrospective. Here is a woman artist who has been creating deliberately feminist imagery since long before it came into vogue to do so. Wye traces the Bourgeois development from her early period

when she emigrated to America with her husband, art historian Robert Goldwater, through her latest developments.

316 *Louise Bourgeois: Drawings*. New York: Robert Miller Gallery; Paris: Daniel Lelong Gallery, 1988, 101 pp., 148 illus.

Limited edition with an intelligent and insightful preface by Robert Storr, writings by the artist, and reproductions of drawings from 1940 to 1987.

317 *Magdalena Abakanowicz*. Chicago: Museum of Contemporary Art, 6 November 1982-2 January 1983. Curator, Mary Jane Jacobs. New York: Abbeville Press, 172 pp., 153 illus.

In her introduction, Jacobs describes Abakanowicz's constant struggle against limitations. She is an artist who has always used the human body in her work. Her focus on vaginal and aggressive sexual shapes is noted, as well as her dialogue between abstract and representational concerns. Receptiveness to spiritual concerns in daily life is one of Abakanowicz's touchstones. The artist's verbal self-portrait reverberates with the heart-felt emotion that informs all her art. The "Nature" and "Coda" sections of this catalog are essential for anyone working with the nature/culture, mind/body debate.

318 *Making Their Mark*. New York: Abbeville Press, 1989, illus.

Contributors: Randy Rosen, Catherine C. Brawer, Ellen G. Landau, Thomas McEvilley, Ferris Olin, Judith Stein, Calvin Thomkins, Marcia Tucker, and Ann Wooster-Sargent. A selected overview of the evolution of the women's movement in art in the United States. This is a good introduction to the subject and it is packed full of valuable information. But it neglects the diversity of women in excluding Harmony Hammond, who was instrumental in bringing an out lesbian-feminist perspective to the development of sexual politics. Raises a question as to why the women's movement in art is so uncomfortable with its visionaries.

319 *The Male Nude: Women Regard Men*. New York: Hudson Center Galleries, 1986, 26 pp., illus. Curators, Elisa Decker and the Galleries.

Essay by Eleanor Munro. Works by twenty artists with images from 1933 to the present. Takes a hot topic and explores the sparse representation of the male nude in American art. Points out that there has not been a major exhibition on this theme since *Sons and Others* (1977). Deals with the implications of male nudity if not representations of masculinity in a patriarchal society and culture.

320 *Margaret Wharton*. Chicago: Museum of Contemporary Art, 12
 September-1 November 1981, 52 pp., 54 illus. Curator, Mary Jane
 Jacobs.

 Jacobs positions Wharton's sculpture squarely in the context of
 surrealism and pop art. Her life was profoundly affected by the
 women's movement and she helped to found Artemisia, the first
 women's cooperative gallery in Chicago. Wharton transforms her
 chair forms into "people with a believable spirit of their own."

321 *May Stevens: One Plus or Minus One*. New York: The New Museum
 of Contemporary Art, 19 February-3 April 1988.

 Stevens dedicated this unpaginated publication to the curator of
 this show, William Olander, who died of AIDS complications. "One
 Plus or Minus One" includes Lucy Lippard's "May Stevens," which
 discusses the work in the context of feminism and class (originally
 appeared in *Zeta Magazin* ["Z"], May 1988). Olander's short essay
 once again displays the sophisticated political consciousness that
 made his commitment to those classified as "others," for example,
 socialists and feminists, so extraordinary. Tracing Stevens's
 development, he shows the steps that led to the production of these
 two enormous photographs with their billboard-like constructions
 which he places not in the postmodern "campus" but instead in a
 provisionally modernist space that squarely confronts racist, sexist,
 and class attitudes. The footnotes refer to female authors, giving
 credit where credit is due. Olander gracefully takes on the daunting
 project of deconstructing patrilineal legitimation and placing women
 in culture and art as subjects.

322 *May Stevens' Ordinary Extraordinary–A Summation 1977-1984*.
 Boston: Boston University Art Gallery, 29 February-1 April 1984, 48
 pp., 12 illus.

 Essays by Donald Kuspit, Lucy Lippard, Moria Roth, Lisa
 Tickner, and Patricia Hills. Paintings and photocollages, with two
 previously published texts, "Visions and Re-visions" by Roth and
 "May Stevens" by Tickner; Lippard's "Masses and Meetings," which
 portrays Stevens's work as a feminist artist and the political nature of
 her photographs, for example the use of the image of Rosa
 Luxembourg; Kuspit's "May Stevens: Within the Self's Heroic and
 Unheroic Past," which asserts the personal rather than the political
 nature of her work, based on the author's preoccupation with
 psychoanalysis; and a foreword by Patricia Hills details some of the
 artist's recent themes.

323 *Miriam Schapiro*. La Jolla, Calif.: University of California,
 Mandeville Gallery, 1-27 April 1975 and 13 September-19 October
 1975, 28 works and illus.

Interview by Moira Roth. Articles by Dore Ashton, Paul Brach, and Schapiro. Includes an overview by Linda Nochlin, "The Recent Work of Miriam Schapiro."

324 *Miriam Schapiro: A Retrospective 1953-1980.* Wooster, Ohio: College of Wooster, 10 September-25 October 1980, 122 pp., 45 illus. (25 in color, including a fold-out page of *Anatomy of a Kimono*).
Contributors: Thalia Gouma-Peterson, Linda Nochlin, Miriam Schapiro, Norma Broude, John Perreault, Paula Bradley, and Ruth A. Appelhof. A retrospective of works by Miriam Schapiro, whose recent images raise the issue of feminism and art, and more specifically, of feminism in relation to abstract art. The collective essays ranging from 1973 to the present relate to Schapiro's use of the house as private and public image, feminism and formal innovation, patterning, and "femmage."

325 *Miriam Schapiro: Femmages, 1971-1985.* St. Louis, Mo.: Brentwood Gallery, 17 May-30 June 1985. Originally published in *Heresies*, no. 4 (1978).
Essay by Miriam Schapiro and Melissa Meyer includes a definition of the term "femmage" (coined by them). Discusses *Doll House, Connections*, and *Water is Taught by Thirst.*

326 *La Mujer en Mexico/Women in Mexico.* New York: National Academy of Design, 1990. Curators, Edward J. Sullivan and Linda Nochlin. Exhibition featured more than one hundred works by twenty-two women artists. Includes Maria Izquierdo, Frida Kahlo, Olga Costa, Remedios Varo, Leonora Carrington, Lola Alvarez Bravo, Graciela Iturbide, Tina Modotti.
In English and Spanish. Essays by Edward J. Sullivan and Linda Nochlin. Nochlin's introductory essay states that her first encounter with "a Mexican woman artist" was over twenty years ago. [This artist was Ramedios Varo, ironically not a Mexican.] Nochlin later discovered Frida Kahlo and others who have much to teach us about Mexico and difference. Sullivan's "Women in Mexico" is an extensive overview. It refers to the conditions under which women artists in Mexico produced art, the position of women in Mexican culture, and the savage realities depicted by these women. He gives an extended postmodern reading of the impact of Frida Kahlo's work on gay male artists. He does not mention women artists, gay or otherwise, but I am sure there are some because Kahlo is as much a cult figure among lesbians as Romaine Brooks. See Cassandra Langer's review (entry 734).

327 *Nancy Grossman*. Brookville, N.Y.: Hillwood Art Museum, C.W. Post Campus, Long Island University, 27 September-10 November 1991, 141 pp., 134 illus.

Essay by Arlene Raven. This is an audacious and spirited piece of writing that allows the disparate facets of Grossman's art to come into focus. Raven's text shows the influence of childhood events, mystical stories, farm life, garment manufacturing, and a host of other considerations on the development of Grossman's art. Grossman's emphasis on a human type and on the self-predicament "evoke fundamental questions about human limitation and potential." Her art is based upon the human body which she believes is the foundation for all human thinking–"all social constructions and perceptions of reality."

328 *Nancy Spero*. London: Institute of Contemporary Arts, 11 March-19 April 1987, 71 pp., b&w and color illus. Curator, Jon Bird.

Essays by Lisa Tickner and Jon Bird. Examines Spero's work in the context of women speaking as subjects and in their own language. The artist addresses the question of how to speak the female body through mythic, archaic, and classical prototypes. Questions of sexual violence are addressed and the state's use of images of women are brought into focus. Issues of gender, viz. masculine and feminine, are at the heart of Spero's art. Her interest in the "new French Feminism" is implied in her renderings.

329 *Nancy Spero: Works since 1950*. Syracuse, N.Y.: Everson Museum of Art, 18 December 1987-31 January 1988.

Considers Nancy Spero's activist and feminist art and includes essays by Dominique Nahas who organized and curated the show, Jo-Anna Isaak, Robert Storr, and Spero's husband Leon Golub. The writings incorporate the ideas of the Russian theorist Mikhail Bakhtin and the carnivalesque as the comic and sometimes shadowy side of human existence. Storr singles out the contribution of the "first" generation of feminist artists and remarks on Spero's "outsider" status and her choice of formats, graphic means, and disjunctive syntax. He concludes that Spero's "is an art of recovery–and always an art of resistance."

330 *Nevelson and O'Keeffe: Independents of the Twentieth Century*. Roslyn, N.Y.: Nassau County Museum of Fine Art, 30 January-10 April 1983, 40 pp., 56 illus. (9 color).

Essay by Constance Schwartz, who interviewed O'Keeffe. Works shown in two sections surveying the art of these two independent American women artists.

331 *Nevelson Wood Sculptures*. Minneapolis, Minn.: Walker Art Center, 10 November-30 December 1973, 79 pp., illus. New York: E. P. Dutton & Co., 1973.

Curator Martin Friedman discusses Nevelson's work as phantom architecture intended to lead the observer into sequences of visual and psychological free associations, but he doesn't discuss sexual politics and the implication of identity crisis in her work, although he does speak of their "utilitarian and virginal" qualities. Her boxes, zags, columns, and walls are illustrated, and what makes this catalog valuable are the many quotes indicating Nevelson's spirituality and the unwittingly feminist observations between the lines of Friedman's text.

332 *Newcomb Pottery: An Enterprise for Southern Women, 1895-1940*. Washington, D.C.: Smithsonian Institution, Renwick Gallery, 2 November 1984-24 February 1985, 160 pp., more than 100 illus.

Overview and analysis by Jessie J. Poesch. Presents approximately 204 works, mostly pottery with a few examples of needlework and metalwork. Recounts the history of Newcomb pottery, produced by the art school at H. Sophie Newcomb College, the women's unit of Tulane University, New Orleans (1895-1940). Investigates the pottery program as an experiment in graduate level training in decorative arts design, which led to the program's involvement with industry, commerce, and the arts and crafts movement in America.

333 *New York Society of Women Artists*. New York: ACA Galleries, 7-28 May 1987, illus.

Amy Wolf's useful resource on neglected women artists who belonged to the New York Society of Women Artists, including Theresa Bernstein, Lucille Blanch, Gladys Roosevelt Dick, Anne Goldthwaite, Minna Harkavy, Blanche Lazzell, Ethel Paddock, Marjorie Organ, Henrietta Shore, Concetta Scaravaglione, Agnes Weinrich, and Marguerite Zorach.

334 *Next Generation: Southern Black Aesthetic*. Winston-Salem, N.C.: Southeastern Center for Contemporary Art, 5 May-15 July 1990, 5 illus.

Lowery S. Sims, "Some Notions of the Decade: African-Americans and the Art World," refers to "Decade-itis." She discusses the 1980s as an era of AIDS, environmental malaise, political disequilibrium, moral and ethical challenges, and the possibility of global existence. Sims notes she's spent a lot of time during the decade looking at where women and so-called minority artists fit in. The African-American artists in the exhibition, she claims, will run the race quite differently than their colleagues of previous decades did. Addresses work by Tom Miller and Beverly Buchanan in some depth as well as

work by Winnie Owens-Hart and Arlene Burke-Morgan among others. Concludes that African-American artists cut across many strata and classes, and represent the richness and variety of artistic practices now. She hopes that we will not have to have this kind of exhibition in the year 2000. Adrian Piper's "The Triple Negation of Colored Women Artists" (pp. 15-21) reflects her beliefs, widely held among artists of color in the United States, that American society is now imposing a Euroethnic, Christian, heterosexual male aesthetic on all of us in order to maintain a uniquely American identity against the incursion of those called others. She cites Rosalind Krauss, the Whitney Biennial, and Donald Kuspit as maintaining the status quo. She takes particular note of Arlene Raven's review of Howardena Pindell's "Autobiography" show. Piper criticizes the fact that no colored woman artist has ever been defended from censorship in the way that Robert Mapplethorpe, Andres Serrano, or David Wojnarowicz have. She discusses postmodernism's attitude and how it has helped and hindered women artists of color. Comments on collusion, success, and how difficult it is not to play the game demanded by the art world in what amounts to a "zero-sum" equation. She is optimistic that women artists of color will be able to realize their creative potentials without loss of self-expression, creative integrity, or honest dialogue. This catalog also includes a panel discussion featuring Judith Wilson and Richard J. Powell.

335 *Old Mistresses: Women Artists of the Past*. Baltimore: Walters Art Gallery, 17 April-19 June 1972. Curators, Ann Gebhart and Elizabeth Broun.

 The first presentation dealing with women artists. Despite its cute, tiresome, and stereotypic title this is one of the earliest generative exhibitions in women's studies in the arts to deal with woman as subject. Considers forty-six works by artists from the sixteenth through the twentieth centuries. Deals with women's difficulty in combining the personal and professional. Includes Romaine Brooks, Artemisia Gentileschi, and Mary Cassatt.

336 *Original Sin*. Brookville, N.Y.: Hillwood Art Museum, Long Island State University, C. W. Post Campus, 16 January-3 March 1991, 48 pp., illus. Curator, Mary Ann Wadden.

 Cassandra Langer's "The Many Masques of Eve" examines feminist-influenced images of "the mother of us all" in the context of the Eve/Mary connection, linking the suppression of women's freedom first to masculine biblical narratives manufactured by orthodox Jewish sects (i.e., Levite), and then to Christian church fathers and a contemporary patriarchy. Theoretical deliberations on the meaning of the art are examined, as are the questions these artists may have raised regarding gender, difference, ethics, and

morality. Artists include Regina Corritore, Bessie Harvey, Miriam Hernandez, Mary Beth Edelson, Karen Finley, and Maureen Connor.

337 *Overview 1972-1977*. New York: A.I.R. Gallery. Corinne Robins's "The A.I.R. Gallery: 1972-1977," was previously published in a different form in *Womanart* (Winter 1977-78).

Documents the history of the gallery and some of the contributions to feminism of the twenty women artists who founded the institution. Robins comments on the aesthetic approach, professionalism, and stance of its members. Mentions various political activities, for example W.A.R. (Women Artists in Revolution), Art Workers Coalition, the New York Art Strike, and "X-12" and "Mod Donn" at the public theater, which began a tradition of all-women shows that changed the composition of the art world in America by the mid-seventies.

338 *The Paintings of Miss Catherine Wiley: American Impressionist*. Tenn.: The Dulin Gallery of Art, 17 May-12 June 12 1964, 4 b&w illus.

Earl D. Layman's short biographical overview focuses on Wiley's works in the context of her times. This little publication is important because it gives biographical information on this neglected and deserving American impressionist painter who very often made woman the subject of her art. Wiley's depictions should be engaging for feminist art historians and critics.

339 *The Pennsylvania Academy and Its Women, 1850-1920*. Philadelphia: Pennsylvania Academy of the Fine Arts, 3 May-16 June 1973, 48 pp., illus.

Christine Jones Huber's essay on American women artists of the mid-nineteenth and early twentieth centuries centers on their educational opportunities in art. She contends that the Pennsylvania Academy paved a broader way for women artists of the next generation by being a leader in providing serious professional training to women.

340 *Philadelphia Focus*. Philadelphia: April-May 1974.

Organized in conjunction with a variety of activities by the Women's Caucus for Art. A documentation of "Philadelphia Focuses on Women in the Visual Arts." This citywide exhibition generated an incredible controversy over Judith Bernstein's playful use of an contradictory object. Her hairy penis or screw was removed from this show by a male curator who was threatened by it. Feminist artists and free-thinking professionals in the field were shocked by this treatment, given Duchamp's criterion regarding the subjects of the artist. His action simply confirmed the discrepancy in power relations

for female artists. Ironically, the images were reproduced in the Philadelphia newspapers, thus reaching a much wider public than they would have in a museum.

341 *Physical Relief.* New York: The Bertha and Karl Leubsdorf Art Gallery at Hunter College, 7 November-13 December 1991, 21 pp., 5 illus.

Organized and with an essay by Susan Edwards. Brings together work by nine women artists who are trying to demystify the body. Deals with the possession of women's bodies in art and how to investigate the body not merely as a sight of representation, but also as a metaphor for physical, psychological, intellectual, and emotional integration. Work by Maureen Connor, Nancy Davidson, Jeanne Silverthorne, Orshi Drozdik, Helen Chadwick, Shelagh Keeley, Mira Schor, Shirley Irons, and Kiki Smith.

342 *The Politics of Gender.* Bayside, N.Y.: Queensborough Community College of the City University of New York, 1988, 37 pp., 27 b&w illus. Curator, Lenore Malen.

Working from an assumption that a selection of women artists including Louise Bourgeois, Nancy Fried, Nancy Bowen, Nancy Spero, Mira Schor, Joan Snyder, Ida Applebroog, Clarissa Sligh, Miriam Schapiro, Silvia Kolbowski, Lorna Simpson, Kathleen Gilje, and others share a common ground in French structural linguistics and psychoanalysis that shapes their art, Malen tries to show how their work "demystifies cultural attitudes about both femininity and masculinity." She argues, somewhat inconclusively, that because they are "other" or outsiders women have been allowed to produce the most powerful art of our time.

343 *Post Boys and Girls.* New York: Artists Space, 15 November 1990-5 January 1991, 32 pp., illus. Organized by Ken Aptekar.

Essays by Carol Zemel, Michael Kimmel, Renee Green, and James Saslow. This very provocative little catalog gathers together nine artists whose works explore formal strategies to disrupt assumptions concerning gender: Ken Aptekar, Greg Davidek, Nancy Davidson, Greg Drasler, Lee Gordon, Margo Machida, Holly Morse, Lillian Mulero, and Millie Wilson. Using a prismatic lens (a multifaceted approach derived from feminist criticism) to explore this subject, the participants throw various lights on issue of gender and politics.

344 *Provincetown Painters: A Woodcut Tradition.* Provincetown, Mass.: Art Association and Museum, 29 July-21 August 1983, 56 pp., 31 illus. (3 color).

Essay by Janet A. Flint. Includes biographical summary. Seventy-five works: woodcuts and some linoleum cuts, mostly color, by thirty-eight artists, twenty-eight of them women, all members of an artists' community known as the Provincetown Printers. Prints date from 1914 to 1965, with a concentration in the years 1916 to 1935.

345 *Race and Representation*. New York: The Hunter College Art Gallery, Hunter College of the City of New York, 26 January-6 March 1987.

Project co-directors, Maurice Berger and Johnnetta Cole. Exhibition: Maurice Berger and Lowery Sims. Film and video: David Goldberg. Artists included Pat War Williams, Barbara Kruger, Candace Hill-Montgomery, Margo Machida, Jenny Holzer, Ana Mendieta, Howardena Pindell, and Trinh T. Minh-ha. Berger's essay "Race and Representation: The Production of the Normal" is informed by his marginalization as a white gay male. His discussion of rhetoric collapsing into stereotypes deals with what Umberto Eco has defined as "codes of recognition" so that the picture of "Normal Norman the fascist ideal, and his equally impossible sister Norma Perfect," with which Berger begins his essay, characterizes the constructs that the artists in this show are trying to deconstruct. What he takes to task is the "irresponsibility of representation" that is central to postmodern debates now raging in contemporary art; as he notes, it is "difference" that most frightens bigots and at the same time cautions the ambitious "other" against the dubious promises of "making it" into the hierarchies of the mainstream. Lowery S. Sims' "Race, Representation, and Appropriation" considers appropriation in the context of other cultures in which the frame of reference may change dissolute "colonialism," which is defined as a state in which the non-white or non-European may be educated to the point where he or she can ape the dominant culture. The same can be said of certain sexual stereotypes. The point is that despite this, the economic and social factors that are the exclusive control of the reigning class will keep those that are different safely in their place and prevent them from participating fully in the promise of the system. At the same time these elites, seeking to escape from the sterility of their culture, turn to outsiders for what is fresh, vital, and excitingly transgressive – "slumming." Sims goes on to discuss the connections between racism and sexism through the works of various artists. In concluding she comes down hard on the art world for its unwillingness to recognize non-white artists really grappling "with the challenge of creating visual statements that are vigorous and original."

346 *Rape*. Columbus, Ohio: Ohio State University Gallery of Fine Art, 1985, pp. 5-12. Reprinted in *Crossing Over*, by Arlene Raven (see entry 193), pp. 157-166.

Arlene Raven's "We Did Not Move from Theory/We Moved to the Sorest Wounds" uses Ana Mendieta's performance "Rape/Murder" (Iowa City, 1973) as a point of departure from which she argues that such work draws the viewer into the arena of vulnerable, violated, female flesh and we are witnesses in the "art-of-crime-scene," which changes us. This essay examines all the aspects of rape as a political act, including the confusion and guilt the victim is made to feel by patriarchal society from the point of view of both spectator and victim, and as a "kind of exorcism."

347 *Reclaiming Paradise: American Women Photograph the Land*. Duluth, Minn.: Tweed Museum of Art, University of Minnesota, Duluth, 22 February-5 April 1987, 64 pp., 100 illus.

Introduction by Martha A. Sandweiss and essays by Gretchen Gardner and Elizabeth Hempsten. Gardner, who is the guest curator, concentrates on ecology and the vision suggested by Carolyn Merchant in *The Death of Nature*. She considers the underlying assumption of patriarchy that culture is superior to nature, arguing that women's relationship with the land has been motivated and lived differently. Gardner claims that two basic paradigms emerge in women's photography: metaphor, and nurture and interdependence. Mentions Anne Brigman, Laura Gilpin, Clara E. Sipprell, Berenice Abbott, Dorothea Lange, Marion Post Wolcott, Imogen Cunningham, Lynn Geesaman, Gail Skoff, Linda Connor, and Mary Beth Edelson. A similar methodology is used by Norma Broude in *Impressionism: A Feminist Reading* (see entry 81).

348 *Rediscovery: Canadian Women Photographers 1841-1941*. London, Ontario: London Regional Art Gallery, 13 May-27 June 1983, 36 pp., 14 illus. 59 works shown. Guest curator, researcher, and catalog designer, Laura Jones.

Photographs by twelve Canadian women photographers, both amateur and professional.

349 *Romaine Brooks, Thief of Souls*. Washington, D.C.: Smithsonian Institution, National Museum of American Art, 24 February-4 April 1971, pp. 15-30, 64 illus. Introduction by Joshua C. Taylor.

Essay by Adelyn Breeskin. Admirable as this essay is, it never refers to Brooks as a lesbian and so resists addressing the meaning of Brooks's lesbianism–that is, her experience, attitude, and representation of lesbianism, and the framework in which she constructed herself. Illustrates portraits of her friends and lovers, including the young lesbian painter Gluck (Hannah Gluckstein, who

posed as Peter), Natalie Barney, Una Troubridge, and Ida Rubinstien without ever really deconstructing traditional art-historical discourse, viz. Brooks, Barney, Troubridge, and others who frequented this circle. Despite its faults and heterosexual assumptions, it contains information that is valuable if read with a cautious eye. See Barney; Langer; Raven; Secrest; and Brooks's unpublished memoirs, "No Pleasant Memories" (NMAA).

350 *Rosa/Alice, May Stevens: Ordinary Extraordinary*. Gambier, Ohio: Olin Gallery, Kenyon College. Edited by Melissa Dabakis and Janis Bell. New York: Universe Books, 1988, pp. 12-33, 11 illus.

Melissa Dabakis, "Re-imagining Women's History": Since 1976, May Stevens "Ordinary Extraordinary" has engaged in a dialogue with history through paintings, collages, and artist's books in this series she juxtaposes images of Alice Stevens (1895-1985), the artist's mother, with those of Rosa Luxemburg (1871-1919), the Polish/German revolutionary. Discusses Stevens's revisioning of the personal as political in these works through appropriation and feminist deconstruction. The series synthesizes history, politics, sentiment, and experience in a powerful amalgam and works on many levels. Janis Bell, "Conversations with May Stevens," discusses Stevens's xerography, 4 illus. The artist finds common ground between her *Ordinary Extraordinary* and that of Harmony Hammond's *Cry* (1978) because of the spontaneous chance element in both. Bell examines Stevens's strong feminist and socialist values, working series, bringing together apparent opposites, her relationship to film, time, space and experience, the audience, her materials and aesthetics and the autobiographic elements involved in deconstructing the Rosa/Alice figures. See Matthews; Roth; Stevens.

351 *Rosemarie Trockel*. Berkeley, Calif.: University Art Museum, 12 June 12-8 September 1991, 152 pp., 100 illus. Edited by Sidra Stich.

Essays by Sidra Stich and Elisabeth Sussman. The authors discuss Trockel's contributions to contemporary issues concerning women and art in Germany. Her work challenges established theories about sexuality, culture, and artistic production. Her "knitted paintings," designed on a computer, attempt to rid knitting of its female/hobby/chore connotation in our sexist culture. Provocative juxtapositions of the Playboy bunny, the hammer and sickle, and the woolmark present serious questions about our gendered society.

352 *Russian Women Artists of the Avantgarde, 1910-1930*. Illus. Edited by K. Rubinger. 1979.

In Russian and German. Essays by John E. Bowlt and L. Vachtova. In "Russian Woman and Her Avant-Garde," Vachtova argues that women artists in Russia were able to be actively involved

in the avant-garde movement while women artists in the west were not taken seriously at all. Discusses the role of women in Russia and their social, political, and artistic evolution at the turn of the century. Bowlt's "Some Very Elegant Ladies" discusses the "Russian Amazons," trying to explain their emergence as a result of artistic precedents set by Russian aristocratic lady amateurs and a series of administrative reforms which gave women access to art education. Describes the birth of the Neo-Russian school in the 1890s, the women who were involved in this new movement, and the role of women artists, including Nataleia Goncharova and Alexandra Exter, in the suprematist and constructivist movements. See Bowlt; Hilton. RILA.

353 *Ruth Weisberg: Paintings, Drawings & Prints, 1968-1988*. Ann Arbor, Mich.: Jean Paul Slusser Gallery, 9 March-5 July 1988, 52 pp., illus. Curator, Marion E. Jackson.

Essays by Marion E. Jackson and Thalia Gouma-Peterson. Jackson's overview of Weisberg's work sets the stage for Gouma-Peterson's "Narrative Passages in Cyclical Time." Text considers what it means for Weisberg to be a woman artist and Jewish in America today. The long scroll and other pieces are examined in this context and in light of Weisberg's conscious reasoning regarding what theorist Irene Javors describes as "Jewish American women's experience of the diaspora." In returning to her roots, much like Letty Cottin Pogrebin, author of *Deborah, Golda, and Me* (Crown Publishers, 1991), Weisberg has modified her view of art to accommodate her most deeply held feminist and Jewish values.

354 *Sculpture by Women in the Eighties*. Pittsburgh: University of Pittsburgh, Up Gallery, 6 November-8 December 1985, 28 pp., 7 illus. (4 color). Curators, Amy Golahny, Ann Sutherland Harris, and Elaine A. King.

This is a display of sculptures and preparatory drawings of the 1980s by seven American women sculptors: Louise Bourgeois, Anne Elliott, Lauren Ewing, Jackie Ferrara, Nancy Graves, Mary Miss, and Jackie Winsor. Includes a biographical summary and shows twenty-seven works.

355 *Sculpture of the Eighties*. New York: Queens Museum, 1987, 39 pp., illus. Curator, Ileen Sheppard.

Essay by Lowery S. Sims. Presents ten female sculptors who symbolize women's impact on American sculpture since 1960. Gives a thorough analysis of each artist and her work. Comments on the issues raised by a women's show, focuses on the influences of fathers, and examines shared interests and the use of personal experience and beliefs. Honors women of postminimalism for reestablishing

narrative, metaphor, and signification to sculpture. Alice Aycock, Jackie Ferrara, Mary Frank, Pat Lasch, Mary Miss, Judy Pfaff, Betye Saar, Ann Sperry, Ursula Von Rydingsvard, and Barbara Zucker.

356 *Self-Portraits by Women Artists.* Los Angeles: Gallery at the Plaza, Security Pacific National Bank, 26 January-17 April 1985, 44 pp., b&w and color illus.

Contributors: Tressa R. Miller, Mary Jane Jacobs, and Anne Sutherland Harris. Short statements on each artist. Includes Mary Ahrendt, Dotty Attie, Blythe Bohnen, Phyllis Bramson, Joan Brown, Judith Golden, Brenda Goodman, D. J. Hall, Marcia Marcus, Cindy Sherman, Anita Stekel, and Ruth Weisberg.

357 *Seven American Women: The Depression Decade.* Poughkeepsie, N.Y.: Vassar College Art Gallery, 19 January-5 March 1976, 40 pp., 18 illus.

Contributors include Karal A. Marling, Helen A. Harrson, E. Shepherd, and B. Merrithew. Describes the careers of Rosalind Bengelsdorf, Lucienne Bloch, Minna Citron, Marion Greenwood, Doris Lee, Elizabeth Olds, and Concetta Scaravaglione. The purpose of the exhibition was "to explore the anomalous and apparently abrupt change in the status of the female artist during the depression epoch through analysis of the careers of seven women who achieved considerable success in the fields of easel painting, mural decoration, sculpture and graphics."

358 *Seven Cycles: Public Ritual–Mary Beth Edelson.* New York: Mary Beth Edelson, 1980, 66 pp., illus.

Lucy Lippard's introduction deals with the political implications of Edelson's ritual performances in which the solidarity of women, fertility, and matriarchal power are asserted. The ritual of rebirth, employing the imagery of fire and stone, is considered in particular detail. Documents seven art performances on the subject of women or involving women, entitled *22 Others* (1971-73), *Woman Rising* (1973-74), *Giving Myself a Five Year Retrospective* (mostly drawings), *Your 5,000 Years Are Up!* (1977), *Memorials to 9,000,000 Women Burned as Witches in the Christian Era* (1977), *Story Gathering Boxes* (1972 ongoing), and *The Nature Of Balancing: Dark Shelters/Light Rocks* (1979). Notes from three workshops held with women at Iowa, Chico, and Amherst are included.

359 *The Students of William Merritt Chase.* Huntington, N.Y.: Heckscher Museum, 1973, 44 pp., illus.

Essay by Ronald G. Pisano. Chase, one of the most influential teachers in the history of American art, had a large number of women students. More than a third of the artists in this exhibition are

women. The notes on individual women artists and information regarding their careers and their work are invaluable. Pisano's essay is even-handed and enlightened in giving us insights into the attitudes and ambitions of Chase's women students. (See *An Exhibition of Women Students of William Merritt Chase* [New York City] Marbella Gallery, 1973.)

360 *Susan Crile: Recent Paintings*. New York: Graham Modern, 1985, 2 color illus.

Cassandra Langer's text addresses the decorative tradition from a feminist perspective and in regard to pattern painting and the repetition of geometric forms in art and fiction.

361 *Susan Hiller*. London: Institute of Contemporary Arts, 1987.

Retrospective overview of work beginning with 1985. Lucy Lippard's "Out of Bounds" looks into the complex body of work Hiller has established over the last 15 years. Her art, Lippard believes, is informed by her empathy with the "Other" and by her insight into the structure of language as a basis of social structures. Lippard argues that Hiller's interest in popular culture is redemptive rather than populist.

362 *Towards Another Picture*. London: Midland Group Gallery, 1977, 1 p. Edited by Morris L. Brighton and A. Nottingham.

Mary Kelly's essay "What is Feminist Art?" questions specifically what is feminist art and asserts that the definition should be expanded so as to make it less exclusionary. Her essay is a criticism of the ideological and theoretical frameworks currently used to explain feminist art.

363 *Tradition and Conflict: Images of a Turbulent Decade 1963-1973*. New York: Studio Museum in Harlem, 27 January-30 June 1985, 99 pp. Foreword by Mary Schmidt Campbell. Introduction by Lerone Bennett. Preface by Benny Andrews.

Essays by Vincent Harding, Mary Schmidt Campbell, and Lucy R. Lippard. 152 works by more than fifty African-American artists. Themes include the American flag, heroes and monuments, the African-American experience, and African motifs. Stresses the ideals of the period, including the Civil Rights Movement, the feminist movement, the antiwar movement, and the artists' responses to these movements.

364 *Transformations: Women in Art 70s-80s*. New York: Feminist Art Institute; Artexpo, N.Y.: New York Coliseum, 5-9 March 1981, 39 b&w illus. Curators, Catherine Allen, Judith Chiti, and Linda Hill.

Presents work by thirty-nine of the most significant American artists active in the women's movement. Overview includes a summation by Judith Chiti. Includes works by Mary Beth Edelson, Anne Healy, Jane Kaufman, Pat Lasch, Nancy Spero, Michelle Stuart, Hannah Wilke, Zarina, Betye Saar, Judith Shea, Faith Ringgold, and Ana Mendieta.

365 *Views by Women Artists*. New York: New York City Chapter of the Women's Caucus for Art, 1982, 70 pp., 143 illus.

A view of sixteen independently curated theme shows, seen throughout New York in February 1982, each containing an introduction by its curator: "Generations: Photography," "Nature as Image and Metaphor: Works by Contemporary Women Artists," "The Future Is Ours: Art for Action and Change," "Sexuality in Art: Two Decades from a Feminist Perspective," "Translucency/ Transparency: Women Working in Watercolor," "Working Women/Working Artists/Working Together," "Women Artists: Self-Images," "Pieced Work," "The Wild Art Show," "Sculptors' Drawings," "Realist Painting: People and Things in Women's Lives," "New Sculpture: Icon and Environment," "Abstract Substance and Meaning: Painting by Women Artists," "Polychrome Sculpture," "Women's Work: A National Collection of Video by Women," and "Women Artists' Books." Despite the serious nature of the art presented, the shows were virtually ignored by the New York art establishment and press, so this remains one of the few sources for researchers interested in exploring issues that became the basis of feminist art criticism during this exciting period.

366 *Views from Jade Terrace: Chinese Women Artists 1300-1912.* Indianapolis: Indianapolis Museum of Art, 3 September-6 November 1988; New York: Rizzoli, pp. 13-29, illus.

Addresses the art of Chinese women artists and the social framework their productions were created in. Marsha Weidner's "Women in the History of Chinese Painting" examines women's place in the rolls of "great masters," the limitations imposed on women by social conventions such as foot-binding, women as "footnotes" to history, stereotypical images of women in biographies, and a host of other fascinating problems. Mentions Lady Zhado, Cai Yan, Wei Shuo, Wang Meiren, Yan, Miss Li, Cao Zhongwan, Miss Wang, and Xiu Yinjun. Biographies and other information-filled texts by Ellen Johnston Laing and Irving Yucheng Lo are included.

367 *Visions and Victories: 10 Canadian Women Artists 1914-1945.* London, Ontario: London Regional Art Gallery, 13 May-27 June 1983, 112 pp., many illus., 15 text figures, 55 works shown. Curator, Natalie Lucky.

Works by ten Canadian women painters and sculptors who made a significant contribution to Canadian art in the years between the two World Wars: Emily Carr, Prudence Heward, Phyllis Jacobine Jones, Frances Loring, Lilias Torrance Newton, Sarah Margaret Robertson, Pegi Nicol MacLeod, Marian Dale Scott, Elizabeth Wyn Wood, and Florence Wyle.

368 *WARM: A Landmark Exhibition.* Minneapolis, Minn.: Women's Art Registry of Minnesota, 1984, 103 pp., 92 illus.
 Contributors: R. Morgan, M. J. Czarniecki, D. Shamash, and S. McDonald. Catalog to an exhibition celebrating twelve years of the Women's Art Registry of Minnesota (WARM), showing work by thirty-seven artists who have been connected with WARM. In their introductions Morgan and Czarniecki note the importance of WARM for the Minnesota art scene and comment on its place in the feminist art movement. In "Connections," Shamash states that connection, community, and communication are the three key concepts in the work shown in the exhibition. She then discusses some of the feminist interpretations of domestic life in the exhibited works. In "Making Art: Political and Personal Change," McDonald describes WARM's work in promoting female artists. A complete list of WARM exhibitions is appended.

369 *We Won't Play Nature to Your Culture: Barbara Kruger.* London: Institute of Contemporary Arts, 4 November 1982-11 December 1983, 64 pp., 54 illus.
 Essays by Craig Owens and Jane Weinstock. Illustrates fifty photomontages, 1981 to 1983. Noticeably influenced by poststructural and postmodern theory, these essays attempt to analyze Kruger's subversive use of the mass media and the sexual and feminist implications of her messages.

370 *The White Marmorean Flock: Nineteenth-Century American Women Neoclassical Sculptors.* Poughkeepsie, New York: Vassar College Art Gallery, 4-30 April 1972, 30 illus.
 William Gerdts's introduction examines a number of nineteenth-century American women neoclassical sculptors who began studying in Italy during the 1850s. He argues that women were drawn to Rome because life there was more congenial for sculptors. Includes Sarah Clampitt, Harriet Hosmer (to whom the major portion of the essay is devoted), Louisa Lander, Emma Stebbins, Margaret Foley, Florence Freeman, and Anne Whitney. Gerdts is sensitive to women artists of color including Edmonia Lewis whose mother was a Chippewa Indian and whose father was black. His concentration, however, is on style rather than the handicaps these women had to overcome in order to do their work. Acceptable black-and-white

illustrations, serviceable biographies, and a useful bibliography make this worthwhile.

371 *The Wild Art Show*. Long Island City, New York: P.S. 1, 17 January 1982.
 Curated by Faith Ringgold, these works expressed women's rage at the circumstances that control their lives and potential. Works were made especially for the exhibition by forty-eight contemporary American women artists. Reviewed by *Woman's Art Journal*.

372 *The Woman Sculptor: Malvina Hoffman and Her Contemporaries*. New York: Berry-Hill Galleries, Inc., 24 October-8 December 1984, 60 pp., 65 illus.
 Celebrates the centennial of the Brearley School. May Brawley Hill's "Small Bronzes by Malvina Hoffman and Her Contemporaries" considers eleven women sculptors: Edith Woodman Burroughs, Bessie Potter Vonnoh, Jane Scudder, Enid Yandell, Evelyn Longman, Gertrude Vanderbilt Whitney, Anna Hayatt Huntington, Abastenia St. Leger Eberle, Alice Morgan Wright, Harriet Whitney Frishmuth, and Malvina Hoffman.

373 *A Woman's Vision: California Painting into the Twentieth Century*. San Francisco: Maxwell Galleries Ltd., 30 November 1983-31 January 1984, 24 pp., 17 b&w and 10 color illus.
 Raymond L. Wilson's historical survey addresses the role that California women artists played in shaping culture in the West. Mentions many neglected women artists such as Elizabeth Borglum, Jessie Arms Botke, Marion Kavanagh Wachtel, Jane Gallatin Powers, Anna Hills, Helen Bruton, Bertha Lum, Eliza Barchus, Alice B. Chittenden, and Helen Forbes. Supplies short biographies.

374 *Women and the Media: New Video*. Oberlin, Ohio: Oberlin College, Allen Memorial Art Museum, 18 April-27 May 1984, 18 pp., 9 illus. Catalog published as *Allen Memorial Art Museum Bulletin* 41, supplement (1983-84).
 William Olander, unlike some gay men, displays the sensitivity one expects from a savvy activist. Olander understands what it means to be working from the fringes of a society that needs margins in order to reassure itself of its own "androsexual" norms, viz. power relations. He has put together a biting survey of video art, 1977-1983, by thirteen American women artists. These diverse expressions are united by their various attempts to exploit, subvert, and deconstruct the popular media in all its forms from women's position as subjects.

375 *Women Artists: 1550-1950*. Los Angeles: Los Angeles County Museum of the Arts, 21 December 1976-13 March 1977. New York:

Alfred A. Knopf, Inc. 1976. Curators, Ann Sutherland Harris and Linda Nochlin.

A path-breaking, blockbuster of a show that cracked open the wall of sexism covering the art-historical establishment and sent it tumbling down, dumping the humpty-dumpty of objectivity on its crown. Its brand of feminism has unremittingly transformed the discipline. In a germinal essay, Harris discusses the status of European women in the Middle Ages, Renaissance, and seventeenth and eighteenth centuries, including craft artists, illuminators, and others. She examines Flanders, Italy, and how critics saw the work of women artists, citing male astonishment at the fact that women artists could create at all, the double critical standard applied, and the tendency to see in women's work a "feminine sensibility." Finally she poses some fundamental questions: "What is the place of women in the history of various movements, to what degree has prejudice resulted in the neglect or inadequate appreciation of their work? Is the relative silence on their work a just reflection of their merits, do any of these women deserve a place in the standard surveys?" By raising questions concerning women's opportunities, education, support, and ghettoization in the "minor" arts, these two scholars were able to problematize the entire study of art history and the representation of women by both male and female artists.

376 *Women Artists in the Howard Pyle Tradition*. Chadds Ford, Pa.: Brandywine River Museum, 6 September-23 November 1975, 28 pp., 5 b&w illus. Introduction by curator Anne E. Mayer.

A selection of women artists working as illustrators under Howard Pyle. Anne Mayer provides fresh information on a number of important women working in the early twentieth century, which is often unavailable in other resources. Includes Eleanor Plaisted Abbott, Anna Whelan Betts, Elizabeth Shippen Green, Ethel Penniwell Brown Leach, Violet Oakley, Ellen Bernard Thompson Pyle, Olive Rush, Jessie Willcox Smith, and Alice Barber Stephens.

377 *Women Artists in Washington Collections*. College Park, Md.: University of Maryland Art Gallery and Women's Caucus for Art, 18 January-25 February 1979, 143 pp., 117 illus.

Contributors: Josephine Withers and Toby Quitslund. A selection of some women artists' works from the collections of Washington museums. Includes paintings, embroidery, sculpture, photographs, quilts, and rugs. Withers explains how the exhibition evolved in conjunction with the Women's Caucus for Art at the University of Maryland and discusses the role of the arts in female culture. Presents seventy-eight works from the eighteenth through twentieth centuries. "Her Feminine Colleagues," a reconstruction of an exhibition of photographs by American women active around 1900,

originally put together by Washington photographer Frances Johnston and shown in Saint Petersburg and Moscow (Fall, 1900) and in Paris (January 1901), contains 39 photographs. Quitslund writes on the development of Johnston's professional life and on other women photographers of the time.

378 *Women Artists of America, 1707-1964.* Newark, N.J: The Newark Museum, 2 April-16 May 1965. Introduction by William H. Gerdts.

Surveys the significance of the activity of women artists in America. This is one of the earliest attempts to focus on neglected women artists. Gerdts presents a balanced and relatively enlightened essay dealing with the main currents of American art to which women have contributed. Includes Henrietta Johnston, Patience Lovell Wright, Ann Hall, Anna Claypoole Peale, Sarah Miriam Peale, Lilly Martin Spencer, Sarah Cole, Mary Nimmo Moran, Harriet Hosmer, Mary Cassatt, and Kay Sage, among many others.

379 *Women at Work: Sculpture from the Corcoran Gallery of Art, 1897-1947.* Washington, D.C.: Corcoran Gallery of Art, 16 May-23 August 1987, illus.

Joan Lemp attempts to assess the creativeness of a group of early twentieth-century women sculptors in the Corcoran collection, the barriers they faced, their stylistic developments, and significant exhibitions they participated in. Includes Edith Woodman Burroughs, Cornelia Van Auken Chapin, Janet de Coux, Margaret French Cression, Abastenia St. Leger Eberle, Sally James Farnham, Harriet Whitney Frishmuth, Laura Gardin Fraser, Anna Vaughn Hyatt Huntington, and Malvina Hoffman.

380 *Women Choose Women.* New York: New York Cultural Center, 1973, 123 pp., illus. Juror, Linda Nochlin.

Includes a speculative essay on what's womanly about women's art by Lucy Lippard. Featuring mostly New York artists, this show was the outgrowth of a vigorous protest against the Museum of Modern Art for its under-representation of women artists in 1972. This exhibit was a milestone in the feminist art movement, posing the question "Is there a woman's art?" See also April Kingsley's discussion, entry 669.

381 *Women in Clay: The Ongoing Tradition.* Ames, Iowa: Octagon Center for the Arts, 22 March-1 April 1984, 48 pp., 32 illus. (6 color).

Contributors: Cletoa Reed and Susan Peterson. Examines pottery by American women potters of the twentieth century, setting it in the context of Native American crafts and contemporary art.

382 *Women of Photography: A Historical Survey*. San Francisco: San
 Francisco Museum of Art, 18 April-15 June 1975, 128 pp., 50 illus.
 Shows the work of women photographers from Julia Margaret
 Cameron (1815-1879) to Marcia Resnick (b. 1950). Organizers J.
 Humphry, A. Noggle, and M. Mann. In "Women of Photography: A
 Historical Survey," Mann argues that women have always been in the
 vanguard of photography, finding the medium satisfying as an art
 form and as a profession. Noggle looks at women's liberation and
 photography with the feeling that "women, like history and theories,
 are unpredictable."

383 *Women of Sweetgrass, Cedar, and Sage: Contemporary Art by Native
 American Women*. New York: Gallery of the American Indian
 Community House, 1985, 100 pp., illus. Curators, Harmony
 Hammond and Jaune Quick-To-See Smith.
 Essays by Lucy Lippard and Erin Younger. No other substantial
 texts existed on contemporary art by Native American women artists
 at the time that this was written. Deals with expressions by thirty full-
 blood and mixed North American Indian women, extending the
 boundaries of form and materials. Includes basketry, ceramics,
 fabric, tapestry, painting, photography, prints, and silver. Theorizes
 common factors uniting the art (i.e., reflection on an inner
 landscape). What interests feminists is the artists' own essays on how
 they came to be artists, and their personal and professional
 reflections on the field of art since the 1930s. See also Jaune Quick-
 To-See Smith's comments (entry 993).

384 *Works on Paper: Women Artists*. Brooklyn, N.Y.: Brooklyn Museum,
 24 September-9 November 1975, 46 pp., 117 illus. Sponsored by the
 Women in the Arts Foundation.
 Contributors: June Blum, Lucy Lippard, Cindy Nemser, and Linda
 Nochlin. Exhibition of drawings, prints, and watercolor paintings by
 American women artists. In her introductory comments, Blum
 includes a short summary of women's art exhibitions from 1971 to
 1975. Lippard comments on the threat of money-making to women's
 art; Nemser discusses the changes in women's art between 1972 and
 1975; Nochlin examines recent changes, pointing out that
 "consciousness has been raised" and museums are giving space to
 women.

385 No entry.

Articles in Periodicals
and Chapters in Books

386 ABER, ITA. "Rifka Angel." *Woman's Art Journal* 7, no. 2 (Fall 1986-
Winter 1987): 32-35.

Born in 1899, Rifka Angelovitch emigrated to the United States in
1914, settling in New York City. She began serious study at 25 with
George Brodsky at the Art Students League in the mid-1920s and
took classes with John Sloan, Ernest Fiene, and Alfred Maurer.
Angel gained national recognition in 1934 and later worked for the
Works Progress Administration. Many of her paintings reflect the
anguish of a Jewish woman concerned with the fate of her family in
Europe during World War II.

387 ADAMS, H. "Anonymous Is a Woman: The Work of Margaret
Harrison." *Art Monthly*, no. 44 (March 1981): 7-9, 2 illus.

Harrison's craft art addresses violence towards women. Discusses
the concept of anonymous art in Marxist-Socialist terms.

388 ADAMS, J. "Judy Chicago." *Horizons* 24, no. 3 (March 1981): 26-33,
5 illus.

Describes Chicago's collaborations *The Dinner Party* (1979) and
The Birth Project (1983). The themes of the new project are birth and
rebirth.

389 ADAMS, MARIE JEANE. "The Harriet Powers Pictorial Quilts."
Black Art 3, no. 4: 12-28.

Discusses the iconography of Powers' quilts, now owned by the
Smithsonian Institution and the Boston Museum, from the point of
view of their African heritage and religious symbology.

390 ADATO, PERRY MILLER. "Imagery in Communication Media."
 Arts in Society 11, no. 1 (Spring-Summer 1974): 41-47, 2 illus.
 Adato explores how media projects the image of women, women's
 status in the media, and possible strategies for changing this negative
 vision.

391 ADES, DAWN. "Notes on Two Women Surrealist Painters: Eileen
 Agar and Ithell Colquhoun." *Oxford Art Journal* 3, no. 1 (April 1980):
 36-42, 5 illus.
 Discusses the two English artists and their position in the
 surrealist movement, stressing the attitudes of the surrealists toward
 women and sexuality.

392 ALLEN, VIRGINIA M. "One Strangling Golden Hair: Rossetti's
 Lady Lilith." *Art Bulletin* 56, no. 2 (June 1984): 285-94, 9 illus.
 Argues that Rossetti's *Lady Lilith* stands for the demonic woman
 who embodied the conflicts experienced by Victorians confronted
 with the women's emancipation movement and controversy over
 family planning in the 1860s.

393 ALLENTUCK, MARCIA. "Henry Fuseli's 'Nightmare': Eroticism or
 Pornography?" In *Woman as Sex Object*, ed. Thomas B. Hess and
 Linda Nochlin (entry 235), 1972, pp. 33-41, 6 illus.
 Discusses Fuseli's psychological motives in relation to "femina
 erotica" and the meaning of copulation in the context of his paintings
 and personal life. Argues that there is a symbolic connection between
 ape/goblin and the male libido. Claims the incubus is pornographic,
 squatting on the woman's mons veneris as though totally in
 possession of her pain and pleasure.

394 ALLISON, L. "Unequal Footing." *Spare Rib*, no. 19 (January 1974):
 11-12, 7 illus.
 The history of footwear expresses status and represents sexual
 symbolism. Argues that shoes psychoanalytically symbolize the
 female genitals and that high heels and extended toes are also
 phallic. Traces fashions in shoes from Roman times through to the
 "wedgie," including imperial China.

395 ALLOWAY, LAWRENCE. "Women's Art in the 70s." *Art in
 America* 64, no. 3 (May-June 1976): 64-72. Reprinted in *Feminist
 Collage*, ed. Judy Loeb (entry 113).
 This is a classic in feminist criticism simply because of the storm
 of controversy it generated and Alloway's access to the centrist press
 at this time. Alloway set the tone of the critical discourse that
 followed, discussing the ways the women's movement had altered the
 look of art over the previous six years. Examines the cumulative

effect of women's demands on the culture industry by looking at exhibitions, criticism, and future possibilities for women's art as a new avant-garde. Cites artists including Judy Chicago, Miriam Schapiro, Audrey Flack, Mary Miss, Jackie Ferrara, Pat Lasch, Joyce Kozloff, Nancy Spero, Mary Beth Edelson, and Rosemary Mayer to make his points.

396 ALLOWAY, LAWRENCE. "Women's Art and the Failure of Art Criticism." *Art Criticism* 1, no. 2 (1979): 55-65.
Alloway shows how unresponsive most art critics were to the subject of feminism. Argues that publications devoted to feminist issues introduced new ideas and reinterpreted old ones, but the art world was reluctant to jump on the bandwagon. He questions the ethics of critical responsibility of those who ignored women's work, hoping it would just go away, as well as critics who supported it, showing that most critics failed to come to grips with a significant cultural and social phenomenon. He concludes that art-critical establishment and its presses showed a basic failure of both consciousness and nerve.

397 ALLOWAY, LAWRENCE. "Post-Masculine Art: Women Artists 1970-1980." *Art Journal* 39, no. 4 (Summer 1980): 295-97, 4 illus.
Alloway proposes a hypothetical exhibition of women's art in the Museum of Modern Art, New York, opening in the autumn of 1981. It would be a "multi-style cross-section of post-masculine art" and would include both representational and abstract art (including pattern painting), conceptual art, process art, outdoor and indoor sculpture (including fibre works), video art, and performance art.

398 ALLOWAY, LAWRENCE. "Reflections on Views." *Woman's Art Journal* 3, no. 1 (Spring-Summer 1982): 27-28.
Describes sixteen independently-curated theme shows held in New York City during February 1982, in conjunction with the annual meetings of the Women's Caucus for Art, the Coalition of Women's Art Organizations, and the College Art Association. He was one of the only critics of either sex to review the shows.

399 ALLYN, JERRI. "Angels Have Been Sent to Me." *The Act* 2, no. 1 (1990): 72-75.
Performance artist Jerri Allyn documents her experience with taking care of her 87-year-old grandmother, Maria Alvarez, after a major stroke, in a series of stories: "Mama 3 Years Later" (1987), "Another Year Later" (1988), and "Cups and Saucers." Photographs by Dona Ann McAdams. This is a deeply moving documentation of activities that involved the artist in coping with aging and disability. It asks the audience to temporarily disable themselves. In an era of

AIDS Allyn's piece aggressively addresses the issue of health care in the United States and particularly in relation to aging women.

400 ALPERS, SVETLANA. "Art History and Its Exclusions: The Example of Dutch Art." Reprinted in *Feminism and Art History*, ed. Norma Broude and Mary D. Garrard (entry 110), 1982, pp. 183-99.

Discussion of sexual politics and how gender applies to art history vis-à-vis value systems. Focuses on definition and the consequences in terms of judgments regarding quality and standards of measure.

401 ARBOUR, R. M. "Art and Feminism." *Cahiers des arts visuels au Québec* 4, no. 13 (Spring 1982): 12-14, 4 illus.

Reviews the exhibition "Art and Feminism" at the Museum of Contemporary Art, Montreal (11 March-2 May 1982). Examines the relationships between art and feminism. Also discusses the approach of female artists, particularly with reference to their calling into question fundamental ideas about art.

402 ARMSTRONG, CAROL. "Edgar Degas and the Representation of the Female Body." In *The Female Body in Western Culture*, ed. Susan Rubin Suleiman (entry 108), 1986, pp. 223-42, 7 illus.

Argues that in Western painting the female body has a genre all its own, that of the female nude and its erotic possession through the brush and the look. Discusses Degas's supposed misogyny, pro and con. Asserts that Degas's nudes may be seen as a deliberate revision of the syntax of the female body and of the structure of viewing in which it was traditionally situated. Neglects the influence of the Japanese print on his space. Concludes that the appropriate myth for Degas is abstinence rather than misogyny. See Broude.

403 ARMSTRONG, CAROL. "The Reflexive and the Possessive View: Thoughts on Kertesz, Brandt, and the Photographic Nude." *Representations*, no. 25 (Winter 1989): 57-70.

Using Picasso as a springboard, Armstrong explores the equation between photography and capture in relation to the female nude, discussing the "lurid fantasies and violent phallicism of the photographic gaze."

404 ARNAUD, N. "The Sex of Which There Is One." *Cahiers des arts visuels au Québec* 4, no. 15 (Autumn 1982): 4-6, 2 illus.

Compares Judy Chicago's work on *The Dinner Party* (1979) with the way Picasso worked with clay, claiming that Picasso depicts woman as passive, while Chicago shows woman as an independent active being.

405 *Artes Visuales* (Museo de Arte Moderno, Bosque de Chapultepec, Reform y Ghandi, Mexico, D.F., Mexico.), January-March 1976.

Articles on women, art, and femininity in relation to contemporary Mexican women artists, written by Charlotte Moser, Lucy Lippard, Judy Chicago, and Arlene Raven.

406 ASKEY, RUTH. "An Interview with Faith Wilding." *Women Artists News* 6, no. 8-9 (February-March 1981): 13-14, 2 illus.

Wilding describes her role in the California women's art movement and how it affected her own work. She was brought up in a religious community in the jungles of Paraguay, so that tropical plants are a constant source of inspiration; she uses leafy organic forms to create cycles of birth, death, and transformation. Her leaf series express all the human emotions and experiences of the body and spirit. See Cassandra Langer on Berenice D'Vorzon (entries 713, 723) and Langer's *Mother and Child in Art* (Crescent Books, 1992).

407 AYLON, HELENE. "Interview with Betty Parsons." *Womanart* 2, no. 1 (Fall 1977): 10-15, 20-21.

Discusses Parsons's career as a gallery dealer, her marriage, her years in Paris, and her own artistic ambitions.

408 BAGCHI, P. "Cledie Taylor." *Black Graphics International*, Fall-Winter 1975, 34-36, 1 illus.

As director of the arts at Extended Gallery on Broadway, sculptor Cledie Taylor promotes a community environment and a sense of connection among her fellow artists. Despite the fact that she acts as a counsellor to a number of black male artists, they do not always acknowledge her status as a woman artist.

409 BAILEY, E. G. "The Cecilia Beaux Papers." *Archives of American Art Journal* 13, no. 4 (1973): 14-19, 4 illus.

Research materials available in the Archives of American Art show that Beaux, who was well-known in her lifetime (1863-1942), was neglected after her death and faded into historical obscurity until renewed feminist scholarship brought her achievements to light. Her correspondence, as well as her published autobiography, reveal insights not only into the artist herself, but into the art circles she frequented as well. See Judith Stien *Cecilia Beaux* (Pennsylvania Academy of the Fine Arts, 1974-75), introduction by Frank H. Goodyear, Jr.

410 BAKER, J. "Women Artists of the Orient: The View from Korea." *Women Artists News* 4, no. 2 (June 1978): 2, 1 illus.

There are 1,500 professional women artists in a population of eight million Korean people. Most of the women artists have studied

abroad. Despite this, male artists still have all the advantages and in some ways women artists are forced to live as outsiders. This seems ironic in a culture that has always considered art an acceptable occupation for women of leisure.

411 BARRY, JUDITH, and FLITTERMAN-LEWIS, SANDY. "Textual Strategies: The Politics of Art-Making." In *Feminist Art Criticism*, ed. Arlene Raven, Cassandra Langer, and Joanna Frueh (entry 112), 1988, pp. 87-97.

Cites a crisis in contemporary criticism and representation that calls for a rigorous examination of sexual politics. Examines women's cultural production in four categories: glorification of an essential female art power (i.e., Gina Pane and Hannah Wilke); women's art as a form of subcultural resistance (i.e., the valorization of crafts); separatism (i.e., Terry Wolverton [implicitly includes lesbians in this grouping]); and artistic practices that situate women at a crucial place within patriarchy, which enables them to play on the contradictions that inform patriarchy itself (i.e., Mary Kelly and Martha Rosler). There are real problems with the way Barry and Fliterman-Lewis problematize feminist art-making particularly as regards "essentialism" and "separatism." See Hammond; Raven.

412 BARTON, C. "Claudia Pond Eyley: A Question of Representation." *Art New Zealand*, no. 36 (1985): 46-49, 6 illus.

Discusses Eyley's development as an artist and examines her sexually, politically, and socially engaged art. Barton cites the paintings *Kitchen Window* and *Shields*, which affirm women's role in society, and the figure drawing *Three Graces at the Astors*, which challenges traditional representations of women, to illustrate her points.

413 BAWOROWKA, B. "Women's Art." *Sztuka Kobiet* 5, no. 4 (1978): 69-70, 86, 89, 4 illus. Summaries in English.

Discusses feminist art from 1969 onwards, with reference to an exhibition in Wroc Hcrossaw, Poland. Work by four women artists: Natalia Il (Poland), Suzy Lacke (Canada), Noemi Maidan (Switzerland), and Carolee Schneemann (United States). Baworowka maintains that feminism does not involve any new proposals, but is attached to actual trends in painting, photography, film, and performance. Concludes that modern art can be a strong weapon in the hands of women if they become as skillful as men. RILA.

414 BECK, EVELYN TORTON, and WITHERS, JOSEPHINE. "Women in Art: Two Approaches to Teaching." *Women's Studies Quarterly* 15, no. 1-2 (Spring-Summer 1987): 45-50, 4 illus.

Transcript of a 1985 interview with the authors about "Women in the Arts" courses they had developed and taught over a ten-year period. Their first courses reflected the biases of their own education when it came to including women of color and class distinctions. They are now creating new ways of thinking about art and its audience.

415 BERLINER, D. "Jan B. Statman (Longview, Texas)." *Art Voices: South* 1, no. 6 (November-December 1978): 17, 2 illus.

Discusses the work of Jan B. Statman, whose 1978 *Mother Goddess* series of large-scale multidimensional polyethylene paintings embody her feminist expression and dig deeply into Western culture's past to the time when women were the acknowledged authorities over life.

416 BERLO, J. C. "Women in Architecture: The Cambridge School." *Feminist Art Journal* 5, no. 1 (Spring 1976): 27-32, 1 illus.

Traces the history of the Cambridge (Mass.) School of Architecture and Landscape Architecture from 1915 to its closing in 1942. Discusses its relationship to other architectural schools and the general status of women in the profession in the twentieth century. Includes Eleanor Raymond, Victorine Homsey, Sarah Harkness, and Jean Fletcher.

417 BERMAN, AVIS. "A Decade of Progress, But Could a Female Chardin Make a Living?" *Artnews* 79, no. 8 (October 1980): 73-79, 20 illus.

Nell Blaine, Miriam Schapiro, Judy Chicago, Deborah Butterfield, Charmion Von Wiegand, Faith Ringgold, Hannah Wilke, Mary Miss, Ida Kohlmeyer, and Alexis Smith comment on changes in the art world and on their relation to it during the 1970s. All agree that discrimination is a reality–largely stemming from the continued dominance of white androcentric values in America.

418 BERNHEIMER, CHARLES. "Degas's Brothels: Voyeurism and Ideology." *Representations*, no. 20 [Special Issue: Misogyny, Misandry, and Misanthropy] (Fall 1987): 158-86.

Discusses the meaning of Degas's images, his supposed misogyny, and the relation between a psychoanalytic interpretation of misogyny and castration fears in relation to his monoprints of prostitutes and for a middle-class white male viewer. Examines the relationship between Degas and Picasso and late capitalism vis-à-vis the female body. See Armstrong; Broude; and *Dealing with Degas*, ed. Richard Kendall and Griselda Pollock (Universe, 1992).

419 BERNSTEIN, ROBERTA. "Marisol's Self-Portraits: The Dream
 and The Dreamer." *Arts Magazine* 59, no. 7 (March 1985): 86-89, 8
 illus.
 Traces the development of the French/Latin-American sculptor
 Marisol Escobar's art during the 1960s and 1970s, when she focused
 mainly on female and women's issues. Claims Escobar's work can be
 seen as a self-portrait of an introspective, sensitive, and independent
 woman.

420 BETTENDORF, M. VIRGINIA B. "Rachel Rosenthal: Performance
 Artist in Search of Transformation." *Woman's Art Journal*, Fall-
 Winter 1988, 33-38, 4 illus.
 Discusses autobiographical content of Rosenthal's art, repression,
 the encounter with Nazism, John Cage and Merce Cunningham,
 theater, her break with them in order to find her own voice, the move
 to Los Angeles, living theater, improvisation, the West Coast
 Women's art movement, and self-healing and transformation through
 performance art. Works like *Charm* and *The Head of Olga K* dealt
 with food, obsession, and compulsive eating, and her confused and
 frustrated relationship with her half-sister. Her subjects have been
 her family, death, and transformation. In the 1980s her concern for
 animals and the planet dominated her work.

421 BETTERTON, ROSEMARY. "How Do Women Look? The Female
 Nude in the Work of Suzanne Valadon." In *Visibly Female*, ed. Hilary
 Robinson (entry 223), 1987, pp. 250-71.
 Discusses the female gaze from a feminist perspective and in
 terms of issues like female sexuality. Looks at the arguments
 presented by the male gaze and contrasts them with a feminist
 approach using Valadon's work. See Lipton.

422 BLUE, CARROLL PARROTT. "Sometimes a Poem Is Twenty
 Years of Memory: 1967-1987." *Sage* 4, no. 1 (Spring 1987): 37-38.
 African-American artist discusses the meaning of her life and
 work from 1967 to 1987. Traces the significance of her creativity in
 the context of racism, photography, independent filmmaking, being
 the other because of professional commitment, and her experiences
 with early filmmakers such as Frances Williams, who was a strong
 force in finishing *Salt of the Earth* in 1982. She sustains herself with
 the often problematic support of other tightrope walkers.

423 BLUM, JUNE. "The Missing Male Critics." *Feminist Art Journal* 2,
 no. 2 (Spring 1973): 9-22, 1 illus.
 Discusses the "Unmanly Art" exhibition, at the Suffolk Museum in
 Stony Brook, New York, which received complimentary reviews from
 Jeanne Paris of the *Long Island Press* (one of Long Island's two

leading newspapers), from Ellen Lubell in *Arts Magazine*, and from Lucy Lippard in *Artnews*. *Newsday* could not be persuaded to view "Unmanly Art" although it usually covers even the minor events at the Suffolk Museum. Lawrence Alloway of *Artforum* viewed but did not review the show.

424 BLUMENKRANZ-ONIMUS, N. "The Women in Italian Futurism." *Opus*, no. 88 (Spring 1983): 10-15, 9 illus.

Argues that despite the notion that the Italian futurists were misogynists, many women contributed to the movement. Cites Valentine de Saint-Point, the feminist group "L'italia Futurista" (founded in 1916), Benedetta Cappa, and Regina Bracchi among others. She describes their activities and asserts they never focused on the feminist character of their work. See Barry Katz.

425 BOIME, ALBERT. "The Case of Rosa Bonheur: Why Should a Woman Want to Be More Like a Man?" *Art History* 4, no. 4 (December 1981): 384-409, 35 illus.

Boime discusses Bonheur's psychosexual life and how it showed a great love for animal life. He argues that Bonheur tried to integrate masculine and feminine traits in her work at a time when the image of androgyne was more frequent in France than in any other country.

426 BONNEY, CLAIRE. "The Nude Photograph: Some Female Perspectives." *Woman's Art Journal* 6, no. 2 (Fall 1985-Winter 1986): 9-14, 6 illus.

In the late 1960s and 1970s women questioned their roles in society and challenged representations of themselves in art and commercial media. Bonney explores how women view themselves, role playing, rituals, how women view each other, women's photographs of male nudes, and men's photographs of nudes. Cites Elsa Dorfman, Judy Dater, Daniela Zehnder, Diana Blok, Cynthia MacAdam, Diamora Niccolini, Arno Minkkinen, and Duane Michaels to illustrate her points. Concludes that all the works discussed have been influenced by female reassessments of representation.

427 BONTEMPS, ARNA ALEXANDER, and BONTEMPS-FONVIELLE, JACQUELINE. "African-American Women Artists: An Historical Perspective." *Sage* 4, no. 1 (Spring 1987): 17-24.

Summary of their catalog text. Black women were essential to the survival of the black community. The authors survey the careers of May Howard Jackson, Meta Fuller, and Laura Wheeler Waring among others and discuss the importance of the Harmon Foundation, Harlem Renaissance, and the black communities since

the nineteenth century. Concludes that African-American women's creativity is too fluid and diverse to summarize.

428 BORDEN, LISSIE. "Women and Anarchy." *Heresies* 1, no. 2 (May 1977): 71-77.
 Discusses the most influential anarchists—Godwin, Proudhon, Bakunin, Kropotkin, Emma Goldman, and Federica Montseny—in terms of the ideas they generated and how feminists activists including Rosa Luxemburg, Clara Zetkin, Angelica Balabanoff, and Alexandra Kollantai responded to them and to issues of equality for women worldwide.

429 BOUCHER, MOISETTE, and GAGNON, PAULE-ESTHER. "The Spiral Body as a New Symbol of the Archetypal Female or Great Mother Figure." *Cahier des arts visuels au Québec* 4, no. 14 (Summer 1982): 27-29.
 Refers to *My Maternity Corset* (1978). The artist Moisette Boucher and philosophy professor Paule-Esther Gagnon comment on the corset as a symbol of a woman's body. They assert the stay-laces form a never-ending spiral showing the victory of the mother figure over life and death. See Kunzle.

430 BOVENSCHEN, SILVIA. "Is There a Feminine Aesthetic?" *Heresies* 1, no. 4 (Winter 1978): 10-12. Excerpts from an article previously published in German in *Aesthetik und Kommunikation*, no. 25 (September 1976). Also as "Is There a Feminine Aesthetic?" trans. Beth Weckemueller, *New German Critique* 10 (Winter 1977). In English in *Feminist Aesthetics*, ed. Gisela Ecker (entry 111).
 Contains old and new appraisals of women's artistic production and excerpts from George Sand's life story, Chantal Akerman's interview in *Women and Film*, Frieda Grafe's piece in *Filmkritik*, Sylvia Plath's *The Bell Jar*, and a poem by Ann Anders. Concludes that as far as aesthetic awareness and modes of sensory perception are concerned, there is undoubtedly a feminine aesthetic, but there is no feminine variant of artistic production or a "painstakingly constructed theory of art."

431 BREITBERG, S. "Women's Art in Israel." *Ariel*, no. 49 (1979): 50-68, 8 illus.
 Discusses both the feminist movement in art and contemporary women artists in Israel. Miriam Sharon is the most consciously feminist artist in Israel and has been influenced by American art critic Lucy Lippard. She claims that women's artistic imagery differs from that of men. Her work portrays the primeval, archetypal, and ritualistic aspects of life. Most Israeli women artists feel no commitment to the feminist movement, rejecting the idea that

creativity should be affected by one's sex. Well-known women artists in Israel are Aviva Uri, Sionah Tagger, Lea Nikel, Tamar Geter, Michal Ne'eman, and Yocheved Weinfeld. RILA.

432 BRODSKY, JUDITH K. "The Status of Women in Art." In *Feminist Collage*, ed. Judy Loeb (entry 113), 1979, pp. 292-95.
 Describes the Women's Caucus for Art and the Coalition of Women's Art Organizations and gives an account of discrimination in the arts. Urges the White House Conference on the Arts to initiate programs to provide more opportunities for women in art.

433 BROUDE, NORMA. "Degas's Misogyny." *Art Bulletin* 59 (March 1977): 97-107. Reprinted in *Feminism and Art History*, ed. Norma Broude and Mary D. Garrard (entry 110), pp. 247-69.
 Contextual and feminist discussion of Degas and Mary Cassatt in relation to Degas as an alleged woman-hater. Cites examples of his friendships with women and his support of gifted women artists such as Cassatt and Suzanne Valedon. See Armstrong.

434 BROUDE, NORMA. "Miriam Schapiro and Femmage: Reflections on the Conflict between Decoration and Abstraction in Twentieth-Century Art." *Arts Magazine* 54, no. 6 (February 1980): 83-87, 17 illus.
 Argues that many of today's most important feminist artists, among them Miriam Schapiro, are heir to decorative impulses in art and are aware of the crucial role that decorative art has played in the formation and emergence of some of the major modernist styles of the early twentieth century. Broude claims that Schapiro's work resumes for a modern tradition the essential dialogue with the correlation of abstraction and decoration fundamental to modern art.

435 BROUDE, NORMA, and GARRARD, MARY D. "Feminist Art History and the Academy." *Women's Studies Quarterly* 15, no. 1-2 (Spring-Summer 1987): 10-16.
 Discusses the strides that have been made in revisionist art history and suggests strategies for the future. Argues for a centrist return to the fold – "universal humanism" – now that women have balanced the scales. The authors' assumptions concerning equal rights and representation ignore the institutional structure of patriarchal education and culture which still universalize white-male experience instead of multiversal differences.

436 BROUDE, NORMA. "Edgar Degas and French Feminism, ca. 1880: 'The Young Spartans,' the Brothel Monotypes, and the Bathers Revisited." *The Art Bulletin* 70, no. 4 (December 1988): 641-59.
 Considers the feminist movement in France, ca. 1878-80, as a context for understanding a group of works by Degas, particularly

Spartan Girls Challenging Boys. Continues Broude's earlier efforts (see Broude, "Degas's Misogyny," entry 433, esp. pp. 99-100) to refute Degas's presumed misogyny, and in light of Diego Martelli's feminism, which had an impact on Degas's imagery. Argues that Degas's art reflected the fears of male society as a whole toward the feminist movement during this period.

437 BROWN, MARILYN R. "Three Generations of Artists: Anne Train Trumbull, Alice Trumbull Mason, and Emily Mason." *Woman's Art Journal* 4, no. 1 (Spring-Summer 1983): 1-8, 6 illus.

Discusses three generations of women artists, none of whom was ever dependent on a male relation for artistic initiative. Anne Leavenworth Train studied in Paris (ca.1884-1885) in a private atelier related to the École des Beaux-Arts and painted landscapes in Connecticut until her marriage in 1891. Her daughter Alice also studied art in Europe, and later in New York in the 1920s. During the 1930s, she was a founding member of the American Abstract Artists Group. Alice's daughter Emily Mason declares her independence from her mother's geometric style while maintaining Alice's commitment to the theory of abstraction.

438 BROWNE, ROSALIND. "Sue Fuller, Threading Transparency." *Arts International* 16, no. 1 (20 January 1972): 37-40.

Discusses Sue Fuller's career and her concepts of light and space.

439 BRUMER, MIRIAM. "Organic Image = Women's Image?" *Feminist Art Journal* 2, no. 2 (Spring 1973): 12-13, 8 illus.

Comments on the qualities in the work of Hans Arp, Isamu Noguchi, Joan Miro, Arshile Gorky, Henry Moore, Louise Bourgeois, Peter Agostini, Nancy Azara, Deborah Remington, Miriam Brumer, Miriam Shapiro, Edward Weston, and Frank Lloyd Wright, among others, which exhibit an organic force that Brumer interprets as a sense of wilful, irrepressible energy inhabiting a form. Argues against thinking that every artist who alludes to organic imagery is conveying a sexual or feminine message. See Lucy Lippard's *Overlay* (entry 151).

440 BRUMER, MIRIAM. "Central Hall: Art outside the Metropolis." *Feminist Art Journal* 2, no. 3 (Fall 1973): 18, 21.

Central Hall is a cooperative gallery on Long Island, composed of eighteen women artists, that seeks to extend culture beyond the metropolis. The gallery is in Port Washington, New York. It is hoped that this venture may break the habit of going to New York in search of culture, and give suburban artists a fresh outlet for their work.

441 BRUMER, MIRIAM, and ORENSTEIN, GLORIA F. "American Artists in Paris." *Women Artists News* 5, no. 5 (November 1979): 1-2, 12-13, 4 illus.

Discusses American women artists active in Paris over the last twenty years.

442 BRUNET, MONIQUE. "Le banquet au feminin: 'The Dinner Party.'" *Canadian Women's Studies* 1, no. 3 (1979): 9-10.

Argues that Judy Chicago's *The Dinner Party* sabotages the tacit purpose of boosting "feminine" art to the status of "high" art by ignoring the contributions of the 400 men and women who worked on the project. Consequently Chicago exalts the "conceptual artist" as sublime and creative while discounting the "artisans" or workers as insignificant instruments to be used. Brunet concludes that this scale of measure indicates that handicraft is evaluated as inferior to thought and betrays the feminist ethic.

443 BUCHANAN, N. "Tales of Power, Pieces of Tail, and Other True-Life Myths." *Dumb Ox*, no. 6-7 (Fall 1977-Spring 1978): 50-51, 1 illus.

Disputes the assertion that women's position has improved recently, pointing out that the art world is still dominated by men and that female art students are sexual game for many of their male teachers. Asserts that women only progress in the art establishment by cultivating male mentors and concludes that women must take a moral stand and demand a revolution in art values.

444 BUCKLEY, C. "Designed By Women." *Art History* 9, no. 3 (September 1986): 400-403. Reviews Isabelle Anscombe's *A Woman's Touch: Women in Design from 1860 to the Present Day* (entry 61).

Criticizes Anscombe's linear and progressive approach because it lacks a detailed history of women designers' work. Calls for a discussion of the social, political, and economic circumstances in which design is produced and consumed in specific historical situations. Concludes that the book reaffirms feminine stereotypes.

445 BUETTNER, STEWART. "Images of Modern Motherhood in the Art of Morisot, Cassatt, Modersohn-Becker, Kollwitz." *Woman's Art Journal* 7, no. 2 (Fall-Winter 1987): 14-21, 9 illus.

Examines the work of four nineteenth-century women artists in the context of modern motherhood and modern developments in child care produced by technology. Claims that Berthe Morisot and Mary Cassatt presented the first "unsentimental" treatment of the theme. Describes Paula Modersohn-Becker as creating two types, with a particular emphasis on "detachment" and the "mixed feelings toward motherhood experienced by many women artists."

446 BURNHAM, JACK. "Mary Beth Edelson's Great Goddess." *Arts Magazine* 50, no. 3 (November 1975): 75-78, 4 illus.

Mary Beth Edelson is concerned with the friction between symbol and mythology in archetype and in reenactment. Burnham represents her work as an example of new feminist art. Edelson's "great goddesses" are an expression of her own feminine consciousness and serve also as poetic statements about feminism. Edelson talks about her background, her artistic development, and her involvement with the feminist movement. When questioned about the dangers of excessive feminism in art, she replied that we "need to study what we have lost by transcending matriarchal values and replace this with a greater awareness of both sexes."

447 BURNHAM, LINDA. "The D.B.D. Experience." *High Performance* 7, no. 2 (1984): 48-53, 90-91.

In two parts: Rachel Rosenthal's *Mind/Body Spa: A Bath for the Soul* and *The Legacy of Instant Theater*. Includes an interview with Rosenthal about her performance workshops and a brief description of instant theater, started by Rosenthal in 1956.

448 BURNHAM, PATRICIA M. "Theresa Bernstein." *Woman's Art Journal* 9, no. 2 (Fall 1988-Winter 1989): 22-27, 2 illus.

Traces Bernstein's career and relationship to Henri and The Eight and discusses her subject matter (i.e., parades and spectacles) and women as subjects in her paintings including *Waiting Room Employment Office* (1917) and *In The Elevated* (1916). Concludes that Bernstein's work is now being rediscovered and her achievements recognized. See Robert Preato (entry 287).

449 BUTTERFIELD, JAN. "Re-Placing Women Artists in History." *Artnews* 76, no. 3 (March 1977): 40-44, 5 illus.

Review of the exhibition "Women Artists 1550-1950" at the Los Angeles County Museum of Art. Argues that women's education has hindered their artistic progress. The exhibition recognizes the need for mentorship felt by many women artists, and explains why so few, with the possible exception of Georgia O'Keeffe, according to Butterfield, are innovators. Claims that the exhibition's weakness is in the modern section because of its arbitrary cutoffs of 1910 for date of birth and 1950 for date of work.

450 CADAVAL, OLIVIA. "Latinos in Washington, D.C." *Cross/Cut* (Washington, D.C.: Washington Project for the Arts), 24 January-5 March 1988, 13-18, illus.

Translated by Rene Horacio Quintanilla and edited by Mel Watkin. Discusses loss of cultural heritage and art exhibit "Ancient

Roots, New Visions" in terms of alternative strategies dealing with racism and a Hispanic tradition.

451 CALAS, ELENA. "Magritte's Inaccessible Woman." *Artforum* 17, no. 7 (March 1979): 24-27.

Examines Magritte's representations of women. Uses psychoanalysis to make a basic connection between women and death in several of Magritte's works by referring to his teenage trauma when his mother committed suicide by drowning herself. Concludes that the female figure in his work is connected with dead, unoccupied buildings, the stone-statuary representation of women's bodies, and the transposition between face and body. Provocatively raises the question of Magritte's glorification of dead woman.

452 CALIFIA, PAT. "Feminism and Sadomasochism." *Heresies* 3, no. 4 (1981 [Issue 12: Sex]): 30-34, 3 illus.

Discusses Califia's sexual fantasies in the context of dominance, submission, punishment, and pain. Describes her hurt and anger as a feminist and lesbian at being ostracized for her "true sexuality." Asserts that discussing sadomasochism in feminist terms is radical sexual freedom. Discusses her own role as a sadist, top/bottom, leather sex, bondage, erotic torture, flagellation, whipping, verbal humiliation, fist fucking, and water sports. Claims sadomasochism scenes are always preceded by a negotiation and that these relationships are "egalitarian" and "safe." Describes symbols associated with sadomasochistic fetishism, and objectification. This article proves that lesbians are just as confused about sex as everyone else. See *Differences* 3 (Summer 1991) and Tania Modleski's "Lethal Bodies" in *Feminism without Men* (Routledge, 1991).

453 CALLEN, ANTHEA. "Sexual Division of Labor in the Arts and Crafts Movement." *Oxford Art Journal* 3, no. 1 (April 1980): 22-27, 4 illus.

Illustrates the rigid stereotyped sex roles in the arts and crafts movement, each craft being considered either typically "masculine" or "feminine." Comments on the Art Workers' Guild.

454 CAMPBELL, NANCY D. "The Oscillating Embrace: Subjection and Interpellation in Barbara Kruger's Art." *Genders*, no. 1 (Spring 1988): 57-74, 14 illus.

Argues that Kruger's work throws the construction of meaning into high relief, stressing that it is counterdiscourse. The female body, as an effect of victimization, delivers messages. Women lack power over their social construction. Two levels of appropriation are cited: her own appropriation of old images from mass-market publications and the art world's appropriation of her assemblages.

Kruger is ambiguously gendered, her subject stereotypes in subjection – through its use of oscillation Kruger's art reveals the pain of ideological subjection.

455 CANNON, C. "The Crazy Comic Conflict." *Spare Rib*, no. 5 (November 1972): 36-37, 5 illus.

Examines the themes and messages in girls' comics such as *Judy*, *Mandy*, *Bunty*, and *Princess Tina*, and argues that they articulate the conflict between the "masculine" independence a girl may have as a child, and the increasing pressures to be feminine as an adolescent. Claims that girls' comics presented problems realistically, but offer unrealistic solutions. Stresses that the adult world presented is full of terror and violence in which nobody can be trusted. The message is the powerlessness of the individual, which links up with the passivity of the feminine character and the irrational fears many women carry over into adulthood.

456 CARROLL, MARGARET D. "The Erotics of Absolutism: Rubens and the Mystification of Sexual Violence." *Representations*, no. 25 (Winter 1989): 3-29.

Discusses the interpretative dilemma that confronts viewers in such paintings as Ruben's *Rape of the Daughters of Leucippus*, Giulio Romano's *Rape of Proserpina*, and Giovanni da Bologna's *Rape of the Sabine*, which distort real life situations into violent fantasies in which assault is seen· as desirable ravishment and natural law in terms of the battle of the sexes over time, and in the context of patriarchal thinking. Argues that the strategy of eliminating violence between men is by redirecting it to women designated as victims for the sake of mitigating conflict and rivalries within a community. Concludes by reminding us how "violently, then as now, such mystifications of sexuality, with their seductive fictions of mastery and submission, can misrepresent the lived experiences of men and women alike."

457 CASTLE, TED. "Carolee Schneemann: The Woman Who Uses Her Body as Her Art." *Artforum* 19, no. 3 (November 1980): 64-70, 10 illus.

Born in 1939, Schneemann is an American artist who uses her body to create art in works such as *Meat Joy*. Her art pays special attention to the patriarchal environment out of which it evolved. See Lucy Lippard's *Overlay* (entry 151).

458 CASTLE, TED. "Alice Neel." *Artforum* 22, no. 2 (October 1983): 36-41, 9 illus.

Alice Neel says she has always been a "women's libber" and discusses her attitudes toward the views of Rebecca West and

Simone de Beauvoir. She admires male artists such as Goya and Munch and does not think that art "specifically has sex." She reminisces about her work for the Works Progress Administration and her treatment at the hands of critics. She sees the twentieth century as a struggle between communism and capitalism, recalling the revolt of the 1960s, and discusses her own support for the Black Panthers and Malcolm X. Art today, she feels, is going nowhere. She also discusses her self-portraits, her attitude toward dying, a visit she made to Russia where she exhibited in 1981, and her admiration for the Mexican painters Diego Rivera and Jose Orozco.

459 CATALANO, G. "About the House: The Domestic Theme in Australian Art." *Art and Australia* 21, no. 1 (Spring 1983): 86-95, 12 illus.

Traces the use of domestic objects and preoccupations by Australian artists from the 1920s and 1930s, when the majority of artists may well have been women. Pays close attention to the work of Margaret Preston and Grace Cossington Smith. Examines the reemergence of the domestic theme in the 1960s and 1970s, citing work by Tony Coleing, Mike Brown, Brett Whiteley, Christine Simons, Garry Shead, and Jenny Watson.

460 CAWS, MARY ANN. "Ladies Shot and Painted: Female Embodiment in Surrealist Art." In *The Female Body in Western Culture*, ed. Susan Rubin Suleiman (entry 108), 1986, pp. 262-87, 7 illus.

Reflects on some problems in representation of female bodies in surrealist photography and painting, touching first their canonization, their consecration, and the laying on of hands, and then the relation of this representation to the supposed consumer, for his or her conspicuous or clearly visible consumption. Ponders women's ways of seeing, writing, and thinking about surrealist art. Concludes we must find integration of ourselves and not just be represented by representing.

461 CHADWICK, WHITNEY. "Eros or Thanatos: The Surrealist Cult of Love Reexamined." *Artforum* 14, no. 3 (November 1975): 46-56, 18 illus.

Discusses the surrealists' idealization of the female image in the context of the literary, psychological, and cultural forces that affected their attitudes. Outlines the influence of de Sade, and the myth of Pygmalion, which functioned as a metaphor for the process of melding oppositions. The surrealists' use of the Oedipus myth in particular reveals the way in which they used and transformed their sources. These themes appear to have masked conflicts which the

surrealists felt between the desire for inspirational love and an unreasoned fear of woman's power and role.

462 CHADWICK, WHITNEY. "The Muse as Artist: Women in the Surrealist Movement." *Art in America* 73, no. 7 (July 1985): 120-29, 14 illus.

Discusses the artists included in the exhibition of the same name at Jeffrey Hoffeld and Company, New York (30 April-8 June 1985). Chadwick rejects André Breton's emphasis on (female) eroticism and collective liberation. Surrealist women artists concentrated on autobiographical narratives of feminine sensibility in relation to artists including Leonora Carrington, Nusch Eluard, Leonor Fini, Frida Kahlo, Jacqueline Lamba, Helen Lundeberg, Kay Sage, and Dorothea Tanning. See Edward Sullivan and Gloria Orenstein.

463 CHADWICK, WHITNEY. "Women Artists and the Politics of Representation." In *Feminist Art Criticism*, ed. Arlene Raven, Cassandra Langer, and Joanna Frueh (entry 112), 1988, pp. 167-85, 6 illus.

Discusses woman's marginal place in the history of Western painting and sculpture and her traditionally passive role as the object of male contemplation in the history of art. Looks at feminism's analyses of traditional art history, its inadequate methodologies, its political ideologies, and how feminism has created a postmodern theory that appears to be shifting attention away from "art and artist" to broader issues concerning ideologies of gender, sexuality and power.

464 CHADWICK, WHITNEY. "Negotiating The Feminist Divide." *Heresies* 6, no. 4 [Issue 24: 12 Years] (1989): 23-25, 3 illus.

Discusses the current discomfort that many feminists feel about our practices and poststructuralist theory. Stepping into the divide between essentialism and poststructuralist theory, Chadwick raises issues that presently confront feminist critics, artists, and theorists. This is a provocative essay that focuses on verbal, visual, intellectual, and emotional relationships and refuses to ignore issues of race, class, sex, and age; a feminist critical history.

465 CHALMER, F. G. "Portrait of the Woman as an Art Viewer." *Art Magazine* 5, no. 15 (Fall 1973): 16-17.

An examination of the various experiments that have been conducted to evaluate women's reactions to art in comparison to men's.

466 CHICAGO, JUDY. "World of The China Painter." *Ceramics Monthly* 26, no. 4 (May 1978): 40-45, 3 illus.

Chicago gives a brief history of china painting in America from its introduction in the second half of the nineteenth century to the present day, illustrating how it is tied up with the history of women in society.

467 CHITI, JUDITH. "The New York Feminist Art Institute: A Struggle for Survival." *Women Artists News* 8, no. 3 (Spring 1983): 20, 1 illus.

Describes the type of art education NYFAI offers and the struggles it has had to remain open. The worsening economic situation and lack of support and leadership forced the Institute to close its doors in 1991.

468 CLIFF, MICHELLE. "Objects into Subjects: Some Thoughts on the Work of Black Women Artists." *Heresies* 4, no. 3 [Issue 15: Racism Is the Issue] (1982): 34-40, 7 illus. Reprinted in *Visibly Female*, ed. Hilary Robinson (entry 223), pp. 40-157.

Deals with black women writers and artists and how racism affects their creativity. Explores the work of African-American and other third-world people in the context of racism. Cites Lorraine Hansberry, Alice Walker, Zora Neale Hurston, Edmonia Lewis, Elizabeth Catlett, Harriet Powers, and Betye Saar. See Wallace; Bontemps.

469 CLOTHIER, P. "Bricks, Brushes, and Barbells." *Art in America* 69, no. 5 (May 1981): 58-61, 5 illus.

Shows the work of three women artists in Los Angeles who, by working with unorthodox materials, appropriate the so-called masculine qualities of strength and muscle power. Maura Sheehan paints parking lots in glowing colors, Susan Kaiser Vogel builds walls of bricks, and Lisa Lyon, a bodybuilder, uses her own body as the art work.

470 CLOVER, CAROL J. "Her Body, Himself: Gender in the Slasher Film." *Representations*, no. 20 [Special Issue: Misogyny, Misandry, and Misanthropy] (Fall 1987): 187-228.

Raises interesting questions concerning violence and healing in seemingly misogynist films such as *Halloween*. Discusses weapons, killings, and the final girl survivors as body and in relation to gender-identity games. See Susan Edwards; Raven.

471 COCHRANE, D. "Alice Neel: Collector of Souls." *American Artist* 37, no. 374 (September 1973): 32-37, 63-64, 10 illus.

Discusses Alice Neel's psychological portraits. Neel has been influenced by northern European expressionist painting and her own interpretations of the human condition. See Castle; Hope.

472 COCKCROFT, EVA. "Women in the Community Mural Movement." *Heresies* 1, no. 1 (January 1977): 14-22, 9 illus.
 Women have played a considerable part in the community mural movement throughout America, but not until 1971-73 did they begin to play a major part in initiating and leading schemes, notably in Chicago, Boston, New York, and Los Angeles. Many mural-painting collectives have strong Marxist and feminist roots, whereas others draw on the values of minority-group ghetto areas, pioneering a movement away from the concept of individualistic art prevalent in today's art world. See Shifra M. Goldman.

473 COHEN, RONNY H. "Eileen Gray: Surprise by Design." *Art in America* 68, no. 7 (September 1980): 88-93.
 Discusses Gray's career as a designer and her impact on the history of decoration and design; avoids the issue of her sexual orientation and its possible impact on her concept of design and taste.

474 COLEMAN, NIKI. "First Museum Devoted to Women's Art Planned." *New Art Examiner* 10, no. 10 (Summer 1983).
 Discusses Mrs. Wallace Holladay's efforts to create a National Museum of Women's Art in Washington, D.C., and the fact that Mr. and Mrs. Holladay's personal collection of art by women artists would form the core of the new museum's collection. See Risatti.

475 COLLINS, G. C. "Women and Art: The Problem of Status." *Studies in Art Education* 21, no. 1 (1979): 57-64.
 Examines the underlying implications of the status of art in society and in the school curriculum. Discusses feminine and masculine identifications of art, speculating that whereas male artists dominate the art world, art itself is seen as female within society and culture. Collins concludes with three possible feminist strategies: the integrationist, by which women would be encouraged to adopt masculine values; the separatist; and the pluralist, by which the art educator would attempt to build up an androgynous value system in the art world.

476 COMINI, ALESSANDRA. "Vampires, Virgins, and Voyeurs in Imperial Vienna." In *Woman as Sex Object*, ed. Thomas B. Hess and Linda Nochlin (entry 235), 1972, pp. 206-21, 18 illus.
 Discusses the female vampire in the context of repressed sexuality, the femme fatale, misogynous messages, and the art of F. W. Murnau, Oskar Kokoscha, Gustav Klimt, Edvard Munch, Egon Schiele, and Richard Gerstl. Argues that as artists turned toward themselves and away from the female they discovered the enemy (the feminine) in themselves. Concludes that in turn-of-the-century

Vienna all this screaming emotion whirling around sex, woman, and himself battled for resolution as artists faced their common heritage.

477 COMINI, ALESSANDRA. "For Whom the Bell Tolls: Private versus Universal Grief in the Work of Edvard Munch and Kathe Kollwitz." *Arts Magazine* (March 1977). Reprinted in expanded form as "Gender or Genius? The Women Artists of German Expressionism" in *Feminism and Art History*, ed. Norma Broude and Mary D. Garrard (entry 110), 1982, pp. 270-91. (See entry 481.)

Compares and contrasts the work of Munch and Kollwitz, showing how Munch's self-concern differed from Kollwitz's universal concern with the human condition.

478 COMINI, ALESSANDRA. "Titles Can Be Troublesome: Misinterpretations in Male Art Criticism." *Art Criticism*, no. 1-2 (Winter 1979-80): 50-54.

Brings art-historical research to bear on sexual misreadings of Klimt by art critics. Singles out two works: the *Judith* of 1901 and *The Kiss* of 1908. Discusses the failure of critics to recognize the explicit sexual meanings of the works as symptomatic of the hypocrisy towards sex at the time. Today, male nudes painted by women are often interpreted as "sensationalist" whereas female nudes by men are merely acceptable studies. Argues that art criticism must be free from this type of sexist bias.

479 COMINI, ALESSANDRA. "Art History, Revisionism, and Some Holy Cows." *Arts Magazine* 54, no. 10 (June 1980): 96-100, 4 illus.

Text of a convocation address presented to the College Art Association of American at the Annual Meeting, held in New Orleans, Louisiana (1 February 1980).

Exposes the sexism that has pervaded art history since its inception, conditioned art criticism, and erased women artists from the history of art. Mothers don't matter in the birth of art or art history so long as a plurality of fathers can be singled out for elevation. During Comini's entire undergraduate and graduate studies she never heard the mention of a woman artist's name. She pleads for the teaching of a whole art history that records the achievements of both male and female artists for the 1980s. This is still a utopia of the future.

480 COMINI, ALESSANDRA. "State of the Field 1980: The Women Artists of German Expressionism." *Arts Magazine* 55, no. 3 (November 1980): 147-53, 33 illus.

Discusses the current critical neglect of artists such as Gabriele Munter.

481 COMINI, ALESSANDRA. "Gender or Genius?: The Women Artists of German Expressionism." In *Feminism and Art History*, ed. Norma Broude and Mary D. Garrard (entry 110), 1982, pp. 270-91. Expanded version of a previously published article (entry 477).

Reassessment of the roles of Kathe Kollwitz, Paula Modersohn-Becker, and Gabriele Munter in the development of German expressionism.

482 No entry.

483 CONNER, J. C. "American Women Sculptors Break the Mold." *Art and Antiques* 3, no. 3 (May-June 1980): 80-87, 4 illus.

Examines the lives and careers of four American women sculptors who struggled against public prejudice to succeed in a male-dominated field at the end of the nineteenth century and the beginning of the twentieth. Three of them – Janet Scudder, Bessie Potter Vonnoh, and Evelyn Beatrice Longman – were students of Lorado Taft. Abastenia St. Leger Eberle was influenced by The Eight, using ordinary people as her subjects. These four women established distinct styles of their own.

484 CORINNE, TEE. "Life into Art." *Women's Review of Books* 6, no. 8 (May 1988): 19-20.

Reviews biography of lesbian painter Gluck (Hannah Gluckstein, 1895-1973) who posed for Romaine Brooks's portrait, *Peter: A Young English Girl.* See Emmanuel Cooper's *The Sexual Perspective: Homosexuality and Art in the Last 100 Years in the West* (entry 95); Diana Souhami, *Gluck: Her Biography* (entry 215); and Breeskin.

485 CORSTIUS, L. B. "The Creation and the Creatrix." *Museum Journal* 24, no. 6 (November 1979): 242-43.

Attacks the inadequacies of the law in the Netherlands regarding women artists and the restrictions imposed on their ability to earn a minimum income, something which is in no circumstances denied to men. She goes on to describe the aims of the pressure group that is attempting to better the lot of the woman artist. RILA.

486 COTTINGHAM, LAURA. "The Feminine De-Mystique." *Flash Art*, no. 147 (Summer 1989): 91-95.

Makes a case for a feminist critique as a political act, citing Chicago's *Dinner Party.* Argues that today's women artists, including Cindy Sherman, Barbara Kruger, Jenny Holzer, Sherrie Levine, Ronnie Horn, Rosemary Trockel, Louise Lawler, and others, are a continuum of second-wave feminism in a postmodernist context. Deconstructive theory and criticism shape her point of view.

487 COTTINGHAM, LAURA. "Thoughts Are Things: What Is a Woman?" *Contemporanea*, September 1990, 44-49, illus.

An interview with Mary Kelly in which Cottingham tries to pin Kelly down about her delusive concepts of feminism. Kelly manages to sidestep Cottingham's best efforts, but in so doing reveals how tied to masculine principles she is.

488 COTTON, C. A., and MILLER, B. B. "An Interview with Linda Nochlin." *Rutgers Art Review* 6 (1985): 78-91.

Discussion includes Nochlin's book on Gustave Courbet, her choice of art history as a profession, the relationship of art and politics, art and the feminist movement, and the interaction between scholars in Europe and the United States.

489 COXHEAD, D. "Growing Up." *Art Monthly*, no. 32 (1979-80): 4-9, 1 illus.

Interviews Lucy Lippard, who discusses how her attitudes to art have changed since she moved to New York and how friends have helped shape her ideas. Lippard mentions her relationship with Robert Ryman and stresses the importance of independence, especially for a woman. She talks about her interest in politics and the relationship between her art criticism and her feminism, criticizing feminist art which has become too integrated. She comments on the difference between the English and American art scene and on vested interest in art.

490 CRARY, J. "Eleanor Antin." *Arts Magazine* 50, no. 7 (March 1976): 8, 1 illus.

Antin's creation of four roles – a king, a ballerina, a black movie star, and a nurse – are crucial to her work. Using a variety of media, especially performance, she reveals the oppressive nature of gender (male-female) relationships in art and society.

491 CURRAN, GRACE WICKHAM. "Ellen Emmet Rand, Portrait Painter." *American Magazine of Art* 19, no. 9 (September 1928): 471-79.

Discusses Rand's career and her portrait commissions in the context of her position as a wife, mother, and artist.

492 CURRY, ELIZABETH R. "Role Model for the Older Woman." *Chrysalis* 1, no. 7 (1979): 55-69, 11 illus.

Kathe Kollwitz serves as a model for the aging woman. Claims that she is the first woman in Western art to establish a standard of beauty and dignity for the older woman and reaffirms, in an age of patriarchal Nazism, the awesomeness and courage of the old and wise.

493 DALLIER, ALINE. "Fear of Feminism in France." *Feminist Art Journal* 4, no. 1 (Spring 1975): 15-18, 30 illus.

Traces the history of the three main forces that oppose French feminism: fear from the bourgeoisie, scorn from leftist groups, and lack of knowledge of what feminism is on the part of artists and of women generally. Dallier also describes art activities, such as the Plastic Artists' Front (FAP) and studios of anonymous artists and artisans who devote themselves to spontaneous self-expression.

494 DALLIER, ALINE. "The Role of Women in the Explosion of Avant-Gardes and the Enlargement of the Field of Arts." *Opus International*, no. 88 (Spring 1983): 24-30, 10 illus.

Discusses the increase in women artists who have entered the field. She singles out sculptors who she asserts have reintroduced subjectivity and expressionism. She argues that in the last decade all forms of art have become means of expression for women artists, who have also contributed to new forms such as textile art, body art, and sociological art. Thus, both sexes are now equally represented among avant-garde artists.

495 DAMON, BETSY. "The 7,000-Year-Old Woman." *Heresies* 1, no. 3 (Fall 1977), 9-13.

Damon discusses her concept of taking back the streets and various responses to such actions, especially from men.

496 DANTO, ARTHUR C. "Frank Stella." *Nation*, 21 November 1987, 602-6.

Discusses Stella's new work in the context of the "feminist" and a feminist sensibility. Examines how feminist consciousness has infiltrated the art world to the point where it has become a salon style and accessible to artists of either gender. His debatable theories are well worth reading.

497 DE BRETTEVILLE, SHEILA LEVRANT. "Some Aspects of Design, from the Perspective of a Woman Designer." *Iconographic*, no. 6 (1973): 4-8.

Argues that design arts reinforce existing sexual stereotypes. Describes some nonestablishment publications that show how people aware of design and its responsibilities are developing design activities based on an ideology that encourages a more democratic and feminized practice.

498 DE BRETTEVILLE, SHEILA LEVRANT. "A Reexamination of Some Aspects of the Design Arts from the Perspective of a Woman Designer." *Arts in Society* 2, no. 1 (Spring-Summer 1974): 114-23, 8 illus.

Based on notes for a lecture given at Hunter College in 1972. Discusses the politics of gender by illustrating how the emphasis on simplicity and clarity of design by the mass media reinforces the idea of male and female roles and determines the character of advertising.

499 DECTER, J. "Nancy Spero." *Arts Magazine* 60, no. 10 (June 1986): 112, 1 illus.

Spero's art depicts suppressed womanhood. Her most recent scroll-narratives deal with the absence of textual elements. Decter claims that the lack of the narrative importance forces the viewer to unravel the sign system and reduces the potential for change. Decter asserts that Spero may be sentimentalizing her subject in the public's eye and reinforcing ideas she wishes to subvert. See Kuspit; Langer.

500 DE LAURETIS, TERESA. "Aesthetic and Feminist Theory: Rethinking Women's Cinema." In *Feminist Art Criticism*, ed. Arlene Raven, Cassandra Langer, and Joanna Frueh (entry 112), 1988, pp. 133-52.

Argues that there is a feminist aesthetic rather than a feminine sensibility in Anglo-American film that pulls in two directions, a tension toward the positivity of politics or affirmative action on behalf of women as social subjects and the negativity inherent in the radical critique of patriarchal bourgeois culture. Citing Silvia Bovenschen, Laura Mulvey, Hegel, and Lacan, she deconstructs the historical discourse of sexual difference. Cites Chantal Akerman, Christa Wolf, Mary Ann Doane, and Adrienne Rich, among others, to support her arguments. She concludes that the contradiction between women in language and culture is manifested in a paradoxical situation in which the construction of the female social subject in film carries its own deconstruction in the very thing represented.

501 DENES, AGNES. "Developing Creativity." *Arts in Society* 2, no. 1 (Spring-Summer 1974): 37-41, 5 illus.

Discusses developing women's consciousness: their work can be innovative and must be developed free from the restrictions of an androcentric society.

502 DENEVE, R. "A Feminist Option." *Print* 30, no. 3 (May-June 1976): 54-59, 88-90, 23 illus.

Sheila Levrant de Bretteville graduated from Yale and began to design corporate brochures and advertising for Olivetti in Milan. She was deeply troubled by this experience and her own sense of social responsibility. The conflict resulted in her joining the newly formed California Institute of the Arts. Here she taught design, designed the

school's graphics, and founded the Women's Design program and the Woman's Building in Los Angeles.

503 DE PASQUALE, C. "Dialogues with Nancy Spero." *Womanart* 1, no. 3 (Winter-Spring 1977): 8-11, 5 illus.
 Presents the transcripts of two conversations with the artist. Spero discusses the ideas behind her mixed-media work *Torture of Women*, explaining why she restricted herself to case histories of the 1970s. De Pasquale contrasts Spero's concern with liberating women's bodies and the violence they have experienced. Spero compares and contrasts the media's presentation of information with her own, discussing her use of typing rather than handwriting. She then comments on her early works on war and the sexual connotations of bombs, the ideas behind her *Artaud* series, and the relation of her art to feminism. Concludes with a discussion of *Hours of the Night*.

504 "Different Aspects of 19th Century Women." *Quarterly Journal of the Library of Congress* 32, no. 4 (October 1975): 268-69, 274-75, 282-83, 288-89, 304-5, 322-23, 336-37, 346-47, 366-69, 53 illus.
 A selection of illustrations drawn from the library's collection of nineteenth- and early twentieth-century periodicals, prints, and posters under the following headings: "Woman as Homemaker," "Woman as Wife," "Woman as Mother," "Woman as Mentor," "Woman as Breadwinner," "Woman on Stage," "Woman in Fashion," "Woman in Sports," and "Woman in Advertising."

505 DIMEN, MURIEL. "Variety is the Spice of Life." *Heresies* 3, no. 4 [Issue 12: Sex] (1981): 66-70, 14 illus.
 Discusses the limitation of erotic pleasure within predictable bounds. Deplores the notion that sex is just for "making babies." Talks about patriarchal ideology, late capitalism, sex roles, and gender. Cites Ester Newton's ground-breaking work on transvestites (see *Hidden from History: Reclaiming the Gay and Lesbian Past*, ed. Martin B. Duberman, Martha Vicinus, and George Chauncey, Jr. [New York: NAL Books, 1989]). Claims there is more to sexuality than just two genders. Illustrations include Lyn Hughe's male *Odalisque*, Carol Harmel's playful monster, media images, and Fran Winant's *The Kiss*. See Califia; Wittig; Wolverton.

506 DIMITRIJEVIC, NENA. "Interview with Yvonne Rainer." *Flash Art*, no. 72-73 (March-April 1977): 15-17.
 Discusses differences between the artist's work in dance and films.

507 DOLL, NANCY. "Seventeen Years and Still Counting: The View from New England." *Women Artists News* 12, no. 1 (February-March 1987): 6, 36-37.

A quantitative analysis of women art historians and artists in the New England area.

508 DONNELL-KOTROZO, CAROL. "Women and Art." *Arts Magazine* 55, no. 7 (March 1981): 11, 1 illus.
Reviews the group exhibition "Women and Art" at the Suzanne Brown Gallery, Scottsdale, Arizona (21 January-19 February 1981). Artists include Betye Saar, Diane Burko, Muriel Magenta, Sylvia Sleigh, Audrey Flack, Judy Raffael, Miriam Schapiro, and Joyce Kozloff.

509 DOUGHERTY, ARIEL. "The State of Women Artists." *WARM Journal* 7, no. 2-3, (1986): 12-15.
An excellent survey giving percentages and facts and figures useful to any art activist looking for support vis-à-vis the backlash. See Ferris Olin's essay in *Making Their Mark* (entry 318) for comparative data.

510 DOUMATO, L. "The Literature of Woman in Art." *Oxford Art Journal* 3, no. 1 (April 1980): 74-77.
Survey of books, periodicals, and other writings relating to women and their role in the arts. Included are *A History of Women Artists* by Hugo Munsterberg, *Women Artists: 1550-1950* by Ann Sutherland Harris and Linda Nochlin (entry 376), *The Obstacle Race* by Germaine Greer, and others.

511 DUBREUIL-BLONDIN, N. "The Land Art of American Women: The Return of Content to Post-Modern Art." *Opus International*, no. 8 (Spring 1983): 16-23, 7 illus.
Focuses on the special problems of feminist artists, which have become issues of great significance in the United States since the 1960s. The author relates art to women's attitudes towards society and analyses the feminist aspect in land art.

512 DUNCAN, CAROL. "Happy Mothers and Other New Ideas in Eighteenth Century French Art." *The Art Bulletin* 55 (December 1973): 570-83.
Deals with economic and social developments within family dynamics as represented in paintings. Discusses images of motherhood and analyzes how women were educated to fit men's representations of motherhood in eighteenth-century France. See *Feminism and Art History*, ed. Norma Broude and Mary D. Garrard (entry 110).

513 DUNCAN, CAROL. "Virility and Domination in Early 20th Century
 Vanguard Painting." *Artforum* 12, no. 4 (December 1973): 30-39, 14
 illus.
 Examines how a number of European avant-garde artists, mainly
 the Fauves, and German expressionists created images that express
 an aggressive male sexuality. They celebrate male-erotic experience
 and reducing woman to a body. Their art is an expression of the
 sexual-artistic will to power of the male artist. Duncan concludes that
 this cultural mode alienated women from the artistic avant-garde;
 women were pushed to the extremity of the nature side of the
 nature/culture dichotomy. She explores the ways in which these
 works articulate and reinforce attitudes that were shared by the
 bourgeois collector who saw his belief in male domination confirmed
 by such images.

514 DUNCAN, CAROL. "When Greatness Is a Box of Wheaties."
 Artforum 14, no. 2 (October 1975): 60-64, 6 illus. Critique of *Art Talk:
 Conversations with Twelve Women Artists* by Cindy Nemser (entry
 35).
 Scrutinizes Nemser's manipulations and in particular her use of
 the key term "greatness," the tone of the different conversations, and
 the way in which her main thesis prevents any serious consideration
 of the female experience in relation to art. Duncan asserts that
 Nemser's failure to criticize, in combination with the interview
 format, leaves the twelve artists in an ambiguous and vulnerable
 position.

515 DUNCAN, CAROL. "The Esthetic of Power in Modern Erotic Art."
 Heresies 1, no. 1 (January 1977): 46-50, 9 illus. Reprinted in *Feminist
 Art Criticism*, ed. Arlene Raven, Cassandra Langer, and Joanna
 Frueh (entry 112).
 Argues that the erotic is a culturally defined concept and
 ideological in nature. Male confronts the female nude as an
 adversary and in relation to power and supremacy, inviting fantasies
 of male conquest. The equation is of female sexual experience as
 surrender and victimization. Cites Delacroix's *Woman in White
 Stockings* (1832), *Death of Sardanapalus* (1827), and Ingres's *Roger
 and Angelica* (1867) as examples of the heroines as slaves, murder
 victims, and women in terror. She contrasts the femme fatale, as a
 paradox, who also surrenders, as in Munch's *Madonna* (1893-94).
 Concludes that these works acquire an invisible authority and act to
 confirm power and maintain the male-dominated shape of culture.

516 DURLAND, STEVEN. "The White House as an Alternative Space:
 Sue Dakin Manifests 'The Art of Politics' with a Run for the
 Presidency." *High Performance* 7, no. 2 (1984): 54-55, 91-92, 2 illus.

A hypothetical account of American artist Sue Dakin's presidential campaign in 1983-84. Dakin's candidacy raises the issue of whether the American public would vote for a woman or an artist as president. Durland describes the campaign and the balance it struck between serious political speeches and artistic events, and between feminist and artistic issues.

517 DU VIGNAL, P. "Meredith Monk." *Art Press*, no. 20 (September-October 1975): 33-34, 2 illus.

In French. In this interview, Meredith Monk discusses the work of her group "The House" and aspects of her productions *Vessel*, *Education of a Child Girl*, and *Petits Coeurs*, with special reference to the contribution of individual actors and to the use of music, voice, and lights. She comments on the influence of eastern theater on her work and on its orientation towards an essentially feminine/feminist expression.

518 EASTMOND, E. "Images of Men." *Art New Zealand*, no. 20 (Winter 1981): 26-27, 74, 4 illus.

Reviews exhibition "Images of Men," thirty-three works by fifteen Auckland women artists, held at the Outreach Gallery, Auckland (March 1981). Treats images of men in a variety of ways – feminist and nonfeminist – resulting in images that extend from the narrative through the symbolic, the portrait, the stereotype, and the nude.

519 EBERT, TERESA L. "The Romance of Patriarchy: Ideology, Subjectivity, and Postmodern Feminist Cultural Theory." *Culture Critique*, no. 10 (Fall 1988): 19-57.

Discusses contemporary popular romance narratives as models and primary sites for the ideological construction of individuals as gendered subjects in a patriarchal society. Patriarchy is the organization and division of all practices and signification in terms of gender and the privileging of one gender over the other, giving males control over female sexuality, fertility, and labor. While seemingly universal, the particular structure of patriarchy at any given moment is always historically determined since it is formed in conjunction with specific social information and its dominating mode is production. Argues for a transformational approach to theory and analysis using a neo-Marxist approach.

520 EDELSON, MARY BETH. "Mary Beth Edelson on Saving the World." *Art Criticism* 2, no. 3 (1986): 49-54.

Presents Edelson's ideas concerning the roles of artists, museums, dealers, and collectors. She argues that the originators of art movements associated with women, such as pattern painting and body art, have been ignored in favor of later male imitators.

521 EDELSON, MARY BETH. "Open Letter to Thomas McEvilley."
 New Art Examiner, April 1989, 34-38.
 Edelson, a feminist artist, objects to McEvilley's misrepresenta-
 tion of her objectives: he ignores her recent work simply because it
 doesn't fall into the framework he has constructed for her and other
 feminist artists who don't conform to the deconstructive/postmodern
 mode of creativity as defined by white male fabrications of discourse.

522 ELLIOT, MARGUERITE TUPPER. "Lesbian Art and
 Community." *Heresies* 1, no. 3 (Fall 1977): 106-7, 1 illus.
 Discussion arising from "Reflections of Lesbian Culture," an
 exhibition of lesbian art shown at the Woman's Building, Los
 Angeles, of which Elliot was an organizer. She would like to see
 lesbian artists, including herself, make the most outrageous art they
 can think of. Work for the show was chosen if it reflected either a
 lesbian or a feminist consciousness.

523 ELWES, CATHERINE. "Floating Femininity: A Look at
 Performance Art by Women." In *Women's Images of Men*, ed. Sarah
 Kent and Jacqueline Morreau (entry 241), 1985, pp. 164-93, 6 illus.
 Begins by criticizing Piero Manzoni's use of a female model in his
 Living Sculpture, then traces the history of performance, and gives a
 selective reading of performance and video based on Elwes's own
 experience as both a performer and a video-maker. Uses
 psychoanalytic theory, quotes Mary-Anne Doane on voyeuristic
 desire, and cites Valentine de Saint-Point's "Manifesto of Lust" and
 the works of Isadora Duncan, Ann Halprin, Silvia Ziranek, Martha
 Rosler, Gina Pane, Sonia Knox, Shirley Cameron, and Carolee
 Schneemann to support her views about evolving new narratives. See
 Goldberg; Katz; Raven; Roth; Sims.

524 ESCOFFERY, G. "Sisterhood and Individualism." *Jamaica Journal*
 18, no. 2 (1985): 57-61, 3 illus.
 Discusses the work of four woman artists: Samere Tansley, Rachel
 Fearing, Judith Salmon, and Laura Facey, all but the last of whom
 were featured in a recent exhibition. Their work is placed in the
 context of feminism as it pertains to Jamaica. RILA.

525 FAHLMAN, BETSY. "Eyre de Lanux." *Woman's Art Journal* 3, no. 2
 (Fall 1982-Winter 1983): 44-48, 4 illus.
 Traces de Lanux's career and her connections with Adrienne
 Monnier's *Shakespere and Company*, Natalie Clifford Barney,
 Romaine Brooks, Eva le Gallienne, Carlotta Monterey, Martha
 Gelhorn, and Lytton Strachey. Discusses de Lanux's involvement in
 the decorative arts, her furniture designs, and her current

experimentation with small abstract sketches and photographic techniques. Her sexuality remains enigmatic.

526 FARWELL, BEATRICE. "Courbet's 'Baigneuses' and the Rhetorical Feminine Image." In *Woman as Sex Object*, ed. Thomas B. Hess and Linda Nochlin (entry 235), 1972, pp. 64-79, 18 illus.

Tracing the theme of bathing nudes, Farwell attempts to show how Courbet democratized high art by imbuing it with low erotic undercurrents. Although Farwell touches on lesbianism and racism as well as sexism in this essay, she fails to really engage in a thorough-going feminist critique. The gaze between women is still not addressed and the focus is on the male audience and artists.

527 FAVORITE, MALAIKA. "Portrait of Self Contemplating Self: The Narrative of a Black Female Artist." *Sage* 4, no. 1 (Spring 1987): 39-40.

Favorite's autobiographical narrative of artist's portrait of self contemplating self.

528 FAXON, ALICIA. "Images of Women in the Sculpture of Harriet Hosmer." *Woman's Art Journal* 2, no. 1 (Spring-Summer 1981): 25-29, 3 illus.

Traces Hosmer's career, relating some of the sculptor's images of women to events from her life. Briefly discusses the group of American women sculptors that emigrated to Rome in the nineteenth century. See Gerdts.

529 FEINBERG, JEAN; GOLDBERG, LENORE; GROSS, JULIE; LIBERMAN, BELLA; and SACRE, ELIZABETH. *Heresies* 1, no. 4 (1978): 28-37.

Five authors examine works in different cultures in the context of production and aesthetics. An attempt is made to avoid assessments of quality and assumptions regarding Western beliefs about power and abuse.

530 FERNANDES, J. "Chicago and Feminism: An Uneasy Alliance." *New Art Examiner* 11, no. 1 (October 1983): 5, 15, 1 illus.

A series of personal narratives by Chicago women in and out of the art world: Kate Horsfield (artist and director of the Video Databank Study Center), Phyllis Kind (gallery owner), Phyllis Bramson (on cooperatives), Sonja Rae (director of the Arts Division of the Illinois Arts Council), Alene Valkanas (public-relations director of the Museum of Contemporary Art), and Nancy Forest Brown (who claims sexism in New York is much worse than Chicago).

531 FIDELL-BEAUFORT, MADELEINE. "Elizabeth Jane Gardner
 Bouguereau: A Parisian Artist from New Hampshire." *Archives of
 American Art Journal* 24, no. 2 (1984): 2-9.
 Discusses Elizabeth Jane Gardner Bouguereau's training, career,
 and relationship with her husband in light of her emergence as an
 artist in her own right.

532 FINE, AMY. "Cesarine Davin-Mirvault: Portrait of Bruni and Other
 Works by a Student of David." *Woman's Art Journal* 4, no. 1 (Spring-
 Summer 1983): 15-20, 4 illus.
 After the French Revolution, reforms in the Académie Royale de
 Peinture et de Sculpture resulted in an increase both in the number
 of women exhibiting at the Salon, and in the number of portraits
 being shown. Most of the artists who produced this unprecedented
 quantity of portraits worked in the manner of David, and many of
 these painters were women. Cesarine Davin (1773-1844) was a minor
 portrait-painting student of David; her most accomplished picture,
 Portrait of Bruni (1804), Frick Collection, New York, was once
 attributed to him.

533 FINKEL, C. "Feminist Focus Blurred by Recollections." *New Art
 Examiner* 7, no. 7 (April 1980): 8, 3 illus.
 Claims that the purpose of books like *Recollections* by Margaretta
 Mitchell (New York: Viking Press, 1979), is to show neglected work
 and to present models for a new generation of women
 photographers. She examines sexism in the arts and how well women
 photographers including Barbara Morgan, Berenice Abbott, and
 Lotte Jacobi were able to make a career for themselves in
 photography. Finkel also examines the larger question of whether
 there is a female imagery and argues that the kind of photographers
 Mitchell illustrates in her book could stunt the creativity of young
 women.

534 FISH, MARY. "WCA Awards Presented by President Carter in
 Historic White House Ceremony." *Women's Caucus for Art
 Newsletter* 2, no. 2-3 (Spring 1979): 1-2, 2 illus.
 Discusses the awards for outstanding achievement in the visual
 arts given out at the Women's Caucus for Art Annual Conference in
 Washington, D.C., January 1979. Recipients were Louise Nevelson,
 Alice Neel, Georgia O'Keeffe, and Mary Ann Tighe. Nineteen
 ninety-two marks an anniversary celebration of twenty years of
 activity by the Women's Caucus.

535 FISHMAN, LOUISE. "How I Do It: Cautionary Advice from a
 Lesbian Painter." *Heresies* 1, no. 3 (Fall 1977): 74-75.

Fishman, who considers making paintings as one of the most spiritual and illuminating ways to focus a life, here offers comments, advice, and information about her work process. She goes through several ritual processes before trying to "take the painting by surprise." She advises constant attention to good painting and suspects wholesale rejection of past artists. By caring for herself, the artist also expresses her commitment to her work.

536 No entry.

537 FLEISHER, P. "Love or Art?" *Art Magazine* 5, no. 15 (Fall 1973): 18-20, 10 illus.

Examines the question of women artists of the past and shows that despite the general impression, there have been a substantial number of women artists of quality. She gives details of some of these, such as Angelica Kauffmann and Paula Modersohn-Becker, and then proceeds to an account of Canadian women painters and sculptors of the last 100 years.

538 FLEISHER, P. "Conversations with Badanna Zack: A Female View of Sexuality." *Art Magazine* 7, no. 24 (December 1975): 24-28, 12 illus.

An interview with the Canadian artist. Her works are an attempt to combat the hypocrisy surrounding sexuality in society, and share some affinities with primitive sculpture, though her images are androgynous. She criticizes the past portrayal of women by male artists.

539 FLESCHER, S. "Women Artists at the Paris Salon of 1870: An Avant-Garde View." *Arts Magazine* 52, no. 3 (November 1977): 99-101.

Discusses Zacharie Astruc's "The Feminine Decameron," which reviews the salon of 1870. Astruc's article considers the problems for women artists and suggests that the main problem is that of education. His solutions were radical: women should "quit the studios of men and show us feminine work." Astruc demanded the same critical standards of women as he did of men.

540 FORTE, JEANIE. "Women's Performance Art: Feminism and Postmodernism." *Theater Journal* 40, no. 2 (May 1988): 217-35.

Using postmodern feminist theory, Forte explores the politics of women's performance art, discussing its deconstructive intent through the lens of the French theorists and their critics. Artists include Faith Wilding ("The Waitresses"), Suzanne Lacy, Leslie Labowitz, Ulrike Rosenbach, Carolee Schneemann, Catherine Elwes, Nancy Buchanan, Linda Montano, Barbara Smith, Mary Beth Edelson, and Rachel Rosenthal. Forte argues that in deconstructing

the system of representation, this performance practice is paradigmatic as a powerful strategy of intervention into dominant culture and resistance to it.

541 FOSTER, HAL. "Re:Post." In *Art after Modernism: Rethinking Representation*, edited by Brian Wallis. New York: New Museum of Contemporary Art; Boston: David R. Godine, Publisher, Inc., 1984, pp. 189-201.

Describes postmodernism as a conflicted concept, as conceived in parochial (stylistic) or recuperative (historicist) terms – or grandiosely as the index of a new episteme, a new discursive formation distinct from the modern. Provides a helpful discussion of the limits of critique, which have prompted many feminists to examine the uses and abuses of postmodernism.

542 FRANCIS, S. "Women's Design Collective." *Heresies* 3, no. 3 (1981): 17, 1 illus.

In Britain, groups of women took an active role in the planning of housing and communities, meeting to discuss the design and production of buildings as well as their personal experiences of working in a predominantly male discipline. A national network of radical architects and building users was formed, the Women's Design Collective, twenty working or in-training architects who have taken on projects including renovating five terraced houses in South London as a women's refuge, developing alternative proposals for a health care center, and setting up a skills/training center for homebound women to learn carpentry and joinery skills.

543 FRANK, ELISABETH. "Miriam Schapiro: Formal Sentiments." *Art in America* 70, no. 5 (May 1982): 106-11, 7 illus.

Critiques Schapiro's retrospective exhibition. Questions the status of her art, which is inspired by feminist ideology, by tracing her evolution from abstract expressionism in the 1950s through hard-edged symbolism and geometric abstract works such as *Big Ox* (1968) to her conversion to feminism in 1970. The technique of "femmage" that she espoused created icons of feminine history and experience. Frank argues that this synthesis of collage, decorative fabric, and geometry, "a merger of the grid and the handkerchief," is superficial and fails as art because its "guaranteed" significance is achieved at the expense of internal criticism. Tracing attacks on Schapiro and other feminists may prove instructive in exploring the politics of "backlash."

544 FRASER, ANDREA. "Post-Partum Document." *Afterimage*, March 1986, 6, 1 illus.

Reviews Mary Kelly's documentation of *Post-Partum Document*, a six-year work, in six parts, resulting from a 135-piece interrogation of

maternal femininity in 1973. Discusses the interactions of Kelly, Laura Mulvey, and Juliet Mitchell at the study group Women's Liberation Workshop in London. Asserts that Kelly poses the question of how women can represent themselves as subjects rather than objects of desire and has provided a theoretical study of feminine sexuality as a discursive text. Discusses Lacan's theory and sexual difference in language and culture.

545 FREIVOGEL, E. F. "Lilly Martin Spencer." *Archives of American Art Journal* 12, no. 4 (1972): 9-14, 3 illus.

Traces the career of Lilly Martin Spencer through almost 100 letters written to her parents and 150 more from agents, clients, and childhood friends. Describes her life from her arrival in Cincinnati in 1841, referring to her early artistic achievements, her marriage, and her move to New York, and shows how many of the problems of a woman in the nineteenth century trying to succeed both as a wife and mother and as an artist are revealed in her correspondence.

546 FRIEDLANDER, J. "The Aesthetics of Oppression: Traditional Arts of Women in Mexico." *Heresies* 1, no. 4 (Winter 1978): 3-6, 1 illus.

Women's traditional arts are seldom considered art either by the women who produce them or by the society that uses them. Presents a cross-cultural analysis of the relationship of women to the arts in Mexico and the United States, referring specifically to the "aesthetics of oppression" operated by patriarchal societies against their female members.

547 FRUEH, JOANNA. "The Psychological Realism of Ellen Lanyon." *Feminist Art Journal* 6 (Spring 1977): 17-21, 5 illus.

Ellen Lanyon has evolved a personalized imagery by combining surreal elements with material generally indicative of woman's consciousness. Her sophisticated primitivism developed while she was a student at the Art Institute of Chicago, but in the late 1960s she turned to magic and fantasy and her involvement in the women's movement during the 1970s led her to see her imagery as culturally provoked. The box is the most frequent of Lanyon's images and her *Super Production Die Box* (1970), *The Bewitched Teacup* (1970), and other works exhibit her interest in metamorphosis. *The Egret* is an example of her enthusiasm for tropical birds, in which the real bird is juxtaposed with statue counterparts, which emphasize the primacy of the living bird. Lanyon's psychological realism embraces the universal.

548 FRUEH, JOANNA. "The Liberation of Homosexual Art." *Chicago Reader*, 31 March 1978, 33.

Frueh discusses photographer Keith Smith's work in light of its homosexual content and society's repressions of "deviant" sexualities. The article is one of the earliest demonstration of Frueh's recurrent interest in issues of sexuality and the erotic.

549 FRUEH, JOANNA. "Eros and Thanatos: The Art of Robert Lostutter." *New Art Examiner,* May 1979.
 This article on a Chicago painter affiliated with the Imagists but not always included in the Imagist canon is Frueh's first entry into the use of more than one narrative voice and mode.

550 FRUEH, JOANNA. "Rethinking Women's Galleries: Reflections on Arc and Artemisia." *New Art Examiner* 7, no. 3 (December 1979): 5, 2 illus.
 Frueh was coordinator of the Artemisia Gallery, Chicago, from 1974 until January 1977. Discusses Artemisia's status as a feminist gallery, contrasting it with Arc Gallery which sees itself as an alternative gallery run by women.

551 FRUEH, JOANNA. "Crucibles of Beauty: Occult Symbolism and Seven Chicago Women." *New Art Examiner* 8, no. 2 (November 1980): 4, 3 illus.
 Discusses the use of occult symbolism by seven women artists and feminists: Phyllis Bramson, Janet Cooling, J. Douglas, Nancy Kerner, Diana Foster, Auste, and Hollis Sigler. The special element in all their work is described as the special relations of womanhood with occult symbolism.

552 FRUEH, JOANNA. "Re-Vamping the Vamp." *Arts Magazine* 57, no. 2 (October 1982): 98-103.
 Frueh sees many contemporary women artists – from Louise Bourgeois to Janet Cooling to Joan Snyder – as revamping the vamp of femme fatale-ism and evil invented by Symbolist artists and carried into more recent work by men.

553 FRUEH, JOANNA. "Towards a Theory of Feminist Art Criticism." Parts 1, 2. *New Art Examiner,* January, June 1985. Reprinted in *Feminist Art Criticism,* ed. Arlene Raven, Cassandra Langer, and Joanna Frueh (entry 112), pp. 153-65.
 Part one is an overview of feminist art criticism and part two critiques the first part in a much more passionate and poetic way meant to be the practice of a feminist criticism that comes from lived experience as well as scholarship. This is what makes this one of the most significant theoretical essays to date. Provides a link between the emerging theory of the 1970s and the ongoing dialogue of the

1980s, postmodernism, and structuralism, and suggests linguistic structures for meaningful change.

554 FRUEH, JOANNA. "The Dangerous Sex: Art Language and Male Power." *Women Artists News* 10, no. 5-6 (September 1985): 6-7, 11, 1 illus.

Frueh discusses what she terms the language of war and the language of miracles, art language that "denies women's authentic power and even the questionable power of woman-as-dangerous-sex." Argues that the nature of the language used in art criticism denies women authentic power by expressing a challenge for the artist to achieve success in male terms. The myths that art language expresses are those of men, not women. The author believes it is necessary to rewrite art history and art criticism with a new language of art. This is an edited version, not to the author's liking, of a paper originally delivered on "The Artist and the Critic" panel at the College Art Association conference in 1985, and it begins Frueh's live presentation of scholarly material in a performance style.

555 FRUEH, JOANNA. "A Chorus of Women's Voices." *New Art Examiner*, May 1988, 25-26.

An overview of the Woman's Building Conference on Criticism. A wry critical analysis of the issues raised by this important conference.

556 FRUEH, JOANNA. "Leaping to Conclusions: Small Truths from the Regions." In *Positions*, edited by Cassandra Langer. Reflections on Multi-Racial Issues in the Visual Arts, vol. 1, no. 1. New York: New York Feminist Art Institute, 1989, pp. 45-66, 5 illus.

Considers the issue of being a regional artist from the perspective of ten women artists from throughout the United States, whose comments Frueh integrates into poems and a critical essay, creating a three-part discourse that equalizes the voices presented.

557 FRUEH, JOANNA. "Has the Body Lost Its Mind?" *High Performance* 12, no. 2 (Summer 1989): 44-47.

Text of a paper given at the January 1988 conference "The Way We Look; The Way We See: Art Criticism for Women in the 90s," Woman's Building in Los Angeles. A performance-lecture text that argues against the 1980s marginalization – in art criticism and theory – of discussions of the body and of woman as active political agent. Body-consciousness comes from thinking about the body as a base of knowledge and using it as such. Using Morris Berman's *The Reenchantment of the World*, Frueh argues that artists and critics who approach art from body-consciousness are often mislabeled "essentialists" by their opposition. Sexuality is socially constructed but it is also bio-logically determined. Ultimately, to bypass the bio-

logical is to condemn the female body to absenteeism and not allow it to speak through the language of its owner. Concludes that body politics is not essentialism but activism.

558 FRUEH, JOANNA. "Speakeasy." *New Art Examiner*, June 1991, 13-14, 56.

Frueh uses scholarship, fiction, and autobiography to critique what she calls the "rhetoric as canon." She writes that despite theoretical understandings that language is not "natural, transparent, absolute as a conveyor of the universal or true," art storytelling continues to be written in a standard essay form, which diminishes differences in content.

559 FRYE, GLADYS-MARIE. "Harriet Powers: Portrait of a Black Quilter." *Sage* 4, no. 1 (Spring 1987): 11-15, 1 illus.

Discusses Powers' subject matter, African-American symbolism in the context of Dahomean tapestries, the provenance of the quilts, personal history, and the historical content of her art. Powers depicted stories that she had heard and dictated to Jennie Smith those stories that had impressed her, so that we now have a detailed record of the real significance of her experiences and the African heritage she embodied in her quilts.

560 GAGGI, S. "Leonor Fini: A Mythology of the Feminine." *Art International* 23, no. 5-6 (September 1979): 34-39, 49, 4 illus.

For over forty years, Fini has been developing a personal vocabulary of images and symbols through which women, as the keepers of life and death, guard the secret rituals of a society dominated by women. Although her images recreate the matriarchal primitive societies concerned with fertility, birth, and death, there is also a strong feminist aspect to Fini's paintings and career. In spite of her association with the Paris surrealists during the late 1930s, she was never a member of the group. See Chadwick; Orenstein.

561 GAGNEBIM, M. "From One Tension to Another." *Opus International*, no. 88 (Spring 1983): 34-37, 6 illus.

Discusses the work of three woman artists, Gina Pane, Colette Brunschwig, and Irena Dedicova, in the context of the female nude throughout the ages, in particular by Henry Moore and Max Ernst. Gagnebim concludes that the three women use the female body in an utterly different way, which explores its essential femininity.

562 GARB, TAMAR. "Revising the Revisionists: The Formation of the Union des Femmes Peintres et Sculpteurs." *Art Journal* 48, no. 1 (Spring 1989): 63-70.

Discusses the formation of the Union des femmes peintres et sculpteurs in the context of the economic and social changes in the Paris art world of the last decades of the nineteenth century. Gives a brief history of the difficulties faced by women artists and analyzes their position and the institutional barriers to women's advancement in the arts.

563 GARRARD, MARY. "Women and the E.E.O.C." *Feminist Art Journal* 4, no. 3 (Fall 1975): 16-21.

Describes four women who had filed individual complaints and suits against universities with the Equal Employment Opportunity Commission. Garrard describes the results of their actions. Argues that eventually the collective impact of all the cases under investigation will produce important changes. Carol Green, an E.E.O.C. lawyer, provides information about filing sex-discrimination complaints.

564 GARRARD, MARY D. "Feminism: Has It Changed Art History?" *Heresies* 1, no. 4 (Winter 1978): 59-60.

Gauges how feminism and women's studies have affected art history. Most importantly, the changes in thinking that have resulted from these activities are discussed and the possible directions in which art history can go now are anticipated.

565 GARRARD, MARY. "Status of Women in Ph.D. Granting Departments' Statistical Summaries." *CAA Newsletter* 6, no. 1 (April 1981): 7-9.

A depressing and eye-opening compilation of facts and figures. See *Making Their Mark* (entry 318) for a comparison.

566 GATELEY, ROSEMARY CONNOLLY. "Crazy Quilts in the Collection of the Maryland Historical Society." *Antiques* 134, no. 3 (September 1988): 558-73.

General analysis of crazy quilts of the 1840s by Kate Henry Lloyd, Ella Scott Teal, Olivia Hardesty Kirk Conkling, Mary Jane Walker Spencer, and Mrs. Van Cott.

567 GEVER, MARTHA. "Pictures of Sickness: Stuart Marshall's *Bright Eyes*." *October*, Winter 1987, 108-26, 9 illus.

Gever discusses Stuart Marshall's videotape *Bright Eyes* as a media disruption of the typical heterosexist discourses developed by PBS in their "Frontline" series pertaining to AIDS. Marshall's tape was conceived to contest homophobia by using sensational headlines from newspapers, rapid cuts from realistic melodramas, and historical data. The video encourages an analysis of the pathology of

fear and shows how media manipulation encourages discrimination against gay men and lesbians.

568 GIBBS, M. "De Appel and Performance Art in Holland since 1975." *Artes Visuales*, no. 26 (November 1980): 10-16, 7 illus.

Also in Spanish. Discusses Wies Smals's opening of the independent gallery space De Appel in an old Amsterdam warehouse in 1975 to provide a place to show live videotapes, temporary installations, and performances of the mid-1970s. Since its inception De Appel has run special programs dealing with feminist art.

569 GIDLOW, ELSA. "Lesbianism as a Liberating Force." *Heresies* 1, no. 3 (Fall 1977): 94-95, 1 illus.

Gidlow's own experience (as a poet) is described as confirmation that lesbianism is liberating for the woman artist. The lesbian personality manifests itself in a willingness to take responsibility for oneself instead of accepting "authorities," and the lesbian is generally to some degree creative because she has freed herself from the external and internal domination of the male, and so rejected the social assumptions that domestic functions are peculiarly hers. See *Sinister Wisdom* 6 (Summer 1978) and *Differences* [Queer Theory], Summer 1991.

570 GILMAN, SANDER L. "AIDS and Syphilis: The Iconography of Disease." *October*, Winter 1987, pp. 87-107, 9 illus.

Provides evidence that there are verbal and visual contradictions in our understanding of AIDS and examines the construction of the two diseases, comparing and contrasting the development of meaning within a contemporary and historical context in which the female becomes the source of the infection. Sander gives us keys for reading the privileging of male suffering and showing how the discourse of vice and disease is connected to woman and homosexual males as seductive and physically corrupt.

571 GITTLER, WENDY. "Amalia Messa-Bains: Grotto of the Virgins." *Women Artists News* 13, no. 1 (Spring 1988): 15, 2 illus.

Reviews Mexican-American artist's three chosen female saints at INTAR Gallery, New York City (December 1987-January 1988). Selecting Frida Kahlo, Dolores Del Rio, and her own grandmother, Messa-Bains explores their Mexican heritage through images associated with religious culture, folk traditions, and personal narratives mixed with cultural myths. In these sacred altars she voices the double lives all of her heroines led in trying to meet both Mexican and Anglo-Saxon systems of values.

572 GLUECK, GRACE. "Making Cultural Institutions More Responsive to Social Needs." *Arts in Society* 11, no. 1 (Spring-Summer 1974): 48-58, 4 illus.

Theoretically, cultural institutions, by exhibiting the work of all creative people, can affect the way in which we see ourselves and assist in the destruction of damaging cultural stereotypes. Describes reality versus fantasy when it comes to exhibitions by black or women artists, and how alternative institutions have been set up by these groups. Glueck, while asserting that women must overcome the sexist conditioning that has discouraged them from taking responsibility and attain administrative positions in these institutions, seems to ignore the economic realities of sexist and racist discrimination.

573 GLUECK, GRACE. "Women Artists and Germaine Greer: An Interview." *Atlantis* 5, no. 1 (1979): 184-89.

Germaine Greer's views on women artists from the sixteenth century to 1979, in an interview originally published in the *New York Times Book Review*, 28 October 1979.

574 GLUECK, GRACE. "Women Artists '80: 'A Matter of Redefining the Whole Relationship between Art and Society.'" *Artnews* 79, no. 8 (October 1980): 58-63, 13 illus.

Rough chronological summary of the highlights, events, and conflicts during the 1970s, as well as the risktaking by which women artists achieved a new sense of themselves and their potential and leaped the first hurdles in banishing sexism from the art world's acceptance of them as artists. Sums up the results of a decade of agitation by women artists for recognition in a male-dominated art world. At the beginning of the 1980s, women artists have a sense of their own potential.

575 GOLDBERG, ROSELEE (with Laurie Anderson, Julia Heyward, and Adrian Piper). "Public Performance, Private Memory." *Studio International* (London) 192, no. 982 (July-August 1976): 19-33, 8 illus.

Asserts that the contributions of Laurie Anderson, Julia Heyward, and Adrian Piper represent a new performance style. Cites *Candle/Light* from *For Instants* – Part 3, 1976; *Duets on Ice* (Summer 1974); *God Heads Whitney Museum* (1976); *I Am The Locus*; *It Doesn't Matter Who You Are, no. 2*; and *Some Reflective Surface*. Each artist talks about her work.

576 GOLDEN, EUNICE. "The Male Nude in Women's Art: Dialectics of a Feminist Iconography." *Heresies* 3, no. 4 [Issue 12: Sex] (1981): 40-42.

Examines women's "unabashed" portrayal of the sexualized male body and phallic imagery. Contrasts female nude with male nude and

challenges the male denial of female sexuality. Discusses her own work and central core imagery, heterosexuality, phallic power, and other female artists including Marjorie Strider, May Stevens, Audrey Flack, Martha Edelheit, Sylvia Sleigh, Marion Pinto, and Nancy Grossman. Urges women to defy censorship and take control of their own "image-making processes."

577 GOLDMAN, E. "*The Dinner Party*: A Matter of Taste." *Women Artists News* 6, no. 8-9 (February-March 1981): 22-23.

Describes Chicago's installation *The Dinner Party* and considers its aesthetic and feminist implications. Goldman believes that *The Dinner Party* was a challenge to white-male mainstream art, and that one of its achievements was that it made many people think. On one level the piece was clumsy; yet it asked the viewer to look at the world in a different way, and, more importantly, it took seriously both the truths and excesses of female consciousness.

578 GOLDMAN, SHIFRA M. "Six Women Artists of Mexico." *Woman's Art Journal* 2, no. 3 (Fall-Winter 1982-83), 1-9, 6 illus.

Examines the role of women in modern Mexican art, focusing on six contemporary women artists working in Mexico: Elizabeth Catlett, Fanny Rabel, Mariana Yampolsky, Susana Campos, Pilar Castaneda, and Lourdes Grobet.

579 GOLDMAN, SHIFRA M. "Portraying Ourselves: Contemporary Chicana Artists." In *Feminist Art Criticism*, ed. Arlene Raven, Cassandra Langer, and Joanna Frueh (entry 112), 1988, pp. 187-205, 3 illus.

A no-punches-pulled discussion of the second-class citizenship of writing in the modern Latin-American art field and the condition of Chicana artmakers in relation to the art world, politics, society, and economics. Traces the colonization of Puerto Ricans and Chicanos as well as other Hispanic peoples from an advocacy position, gives a history of the Chicano sociopolitical movement, and discusses the impact of feminism. Goldman tellingly illustrates her points with a series of "testimonies" by Teresa Archuleta-Sagel, Santa Barraza, Yolanda Lopez, Judy Miranda, Armilla Trujillo, and the Mujeres Muralistas, among others. See Eva Cockcroft.

580 GOSDEN, M. "Judy Chicago: The Second Decade 1973-1983." *Women Artists News* 9, no. 5-6 (Summer 1984): 12-14, 3 illus.

Surveys the exhibition "The Birth Project" at ACA Galleries, New York (5-26 May 1984). Chicago discusses with the feminist filmmaker Barbara Hammer her relationship with the women with whom she has worked and explains why there is a predominance of Caucasian women in *The Birth Project*. Chicago comments on her use

of goddess imagery, which relates to symbolism. Hammer discusses the artist's approach to the audience, the reasons she has not been able to expand her work in ceramics, and the way in which, for her, form grows out of content. Chicago answers questions on her attitude to female crafts, especially the fusion of paint and needlework, and ends by defending herself against charges that she refers mainly to white American culture in her work.

581 GOUMA-PETERSON, THALIA. "Elizabeth Catlett: "The Power of Human Feeling and of Art." *Woman's Art Journal* 4, no. 1 (Spring-Summer 1983): 48-56, 13 illus.

Discusses Catlett's identification with four exploited groups – blacks, Mexicans, women, and poor people. Traces Catlett's background and career, and the sexist discrimination, even in black intellectual circles, against women artists. Talks about Catlett's harassment by the American government due to her politics. Includes *Target Practice*, *Torture of Mothers*, *Harriet*, and earlier works.

582 GOUMA-PETERSON, THALIA. "The Theater of Life and Illusion in Miriam Schapiro's Recent Work." *Arts Magazine* 60, no. 7 (March 1986): 38-43, 12 illus.

Describes Miriam Schapiro's recent mixed-media works in which the image of the creative woman has taken human form and her space of action can be clearly identified as the theater, complete with proscenium stage, curtains, and footlights. The creative woman claims the legitimacy of her image as an active human being who functions on the stage as herself and not in images created by man. Gouma-Peterson places these acrylic and fabric works in the context of Schapiro's earlier paintings, stating that her art is "a continuous critique of masculine representation."

583 GOUMA-PETERSON, THALIA, ed. "Transformations: Teaching about Women and the Visual Arts." *Women's Studies Quarterly* [Special Feature] 15, no. 1-2 (Spring-Summer 1987), inside front cover, 67.

Introduction to a useful collection of essays that fails to include the development of an American feminist theory and criticism in the visual arts. Includes articles by Mary Garrard, Norma Broude, Moira Roth, and Christine Havice and a partial feminist bibliography by Ferris Olin and Barbara Miller.

584 GOUMA-PETERSON, THALIA, and MATHEWS, PATRICIA. "The Feminist Critique of Art History." *Art Bulletin* 69, no. 3 (Fall 1987): 326-57.

This is a retrogressive, postfeminist-feminist overview of feminist art history and art criticism that runs the danger of reducing

American feminist art criticism and art history of the 1970s and early 1980s to a standard patriarchal model of chronology and development that fails to account for the spirit of pluralism and originality characteristic of feminist art and criticism, particularly as regards "essentialism" and the social construction of gender.

585 GOUMA-PETERSON, THALIA, and MATHEWS, PATRICIA. Review of *Framing Feminism: Art and the Women's Movement, 1970-1985*, edited by Roszika Parker and Griselda Pollock (entry 115). *Women's Review of Books* 5, no. 6 (March 1988): 21-23.
 Stresses the virtues of English feminist theory and faults the illustrations in this text for failing to represent many of the points to their best advantage.

586 GRABENHORST-RANDALL, TERREE. "The Woman's Building." *Heresies* 1, no. 4 (Winter 1978): 44-46, 4 illus.
 Outlines the history, building, decorations, and activities of the Woman's Building in Chicago, at the World's Columbian Exposition, Illinois (1892), relating it to the activities of feminists at that time. Mentions Sophia G. Hayden, its architect, and the hall of fame with images by Mary Cassatt, Mary Macmonnies, Lucia Fairchild-Fuller, Amanda Brewster Sewall, Rosina Emmett Sherwood, and Lydia Emmett. Other murals and paintings were contributed by women artists from the United States, Germany, Austria, England, France, and Spain. See Corn; Erlene Stetson's "A Note on the Woman's Building and Black Exclusion" (entry 1008).

587 GRAHAM, JULIE. "American Women Artists' Groups, 1867-1930." *Woman's Art Journal* 1, no. 1 (Spring-Summer 1980): 7-12.
 Discusses the Ladies' Art Association (New York), the National Association of Women Artists, Inc. (New York), and the Art Worker's Club for Women (New York) as pioneering forces for women artists and women's liberation in the nineteenth and twentieth centuries.

588 GREEN, ALICE. "The Girl Art Student in Paris." *Magazine of Art*, no. 6 (1883): 286-87.
 Pragmatic advice for the woman art student trying to learn her craft in the late nineteenth century. Makes a sharp contrast between what was expected from female students when compared to the same sort of article for male students, and in relation to changes in social behaviors over time.

589 GREGG, SARA. "Gabriele Munter in Sweden: Interlude and Separation." *Arts Magazine* 55, no. 9 (May 1981): 116-19, 10 illus.

Makes an analogy between the year 1916, which Munter spent in Stockholm, and the Paris Year of 1906-1907, which marked a transitional phase in the artist's life. Analyzes Munter's Stockholm works with emphasis on their biographical references to Munter's relationship with Kandinsky. Originally presented at the symposium on women artists in early twentieth-century Germany at the Busch-Reisinger Museum, Harvard University, Cambridge, Mass. (25 October 1980). See Comini.

590 GROTLITSCH, G. "We Are Feminists." *Flash Art*, no. 68-69 (October-November 1976): 17-20, 12 illus.
Also in Italian. An interview with Gislind Nabakowski, chief editor of *Heute Kunst*, in which she gives her definition of feminist art as "a long-term and lengthy discussion of old role images and a breakthrough of a feminist culture into daily life." Grotlitsch discusses the representation of female sexuality in feminist art, with reference to Lygia Clark, Carolee Schneemann, Joan Jonas, Verita Monselles, and Iole de Freitas, and explains her definition of art as androgynous, pointing out that it is important for feminists to realize that men, too, are suppressed by patriarchy.

591 GROVER, JAN ZITA. "AIDS: Keywords." *October*, no. 43 (Winter 1987): 17-30.
Deconstructs key words associated with AIDS in society and culture. Grover examines certain shared assumptions already embedded in the AIDS discourse. Her analysis regarding sexual desire, double lives, and the binary oppositions of homosexual and heterosexual clearly reveals the negative bias operating in most heterosexist discourses about AIDS. This holds true for other gay issues as well. See Gever.

592 GROVER, JAN ZITA. "Dykes in Context: Some Problems in Minority Representation." In *The Contest of Meaning*, edited by Richard Bolton. Cambridge, Mass., and London: MIT Press, 1989, pp. 162-203, 16 illus.
A significant lesbian feminist analysis of illustrated book covers of lesbian pulp paperbacks in the 1940s through 1960s, lesbian photographers, and problems of representation. Grover's emphasis is on lesbian visual self-representation. Presents some very provocative ideas for reading the lesbian code, without developing a coherent theory for deconstructing what that code "otherness" embodies and means in relation to either dominant heterosexist narratives and discourses or the new politically correct written representations of lesbians. Photographers include Tee Corinne, Lynette Molnar, Joan E. Biren (JEB) and Danita Simpson. See Hammond; Langer.

593 GULLIVER, P. "Painting It Out." *Spare Rib*, no. 16 (October 1973):
 39-41, 6 illus.
 Speculates that women dominate the field of art therapy because
 the pay is too low to appeal to men, and part-time work is
 appreciated by women with families. Art therapy encourages
 communication at nonverbal levels, fostering individual expressions
 of the essential self free from the pressures of standards and
 conventions and recognizing the more alarming aspects of
 personality. Remedial art is considered a valid approach for many
 groups, including children in care, the physically handicapped,
 schools for subnormal children, adolescent treatment centers, and
 drug units.

594 HAMMER, BARBARA. "Women's Images in Film." In *Women's
 Culture*, ed. Gayle Kimball (entry 239), 1981, pp. 117-29, 3 illus.
 Discusses independent women filmmakers within the "art for art's
 sake" aesthetic. Examines the images in her own films and those of
 Maya Deren and Marie Menken; explores the methods and forms
 used by Joyce Wieland, Barbara Linkevitch, Chick Strand, Gunvor
 Nelson, and Dorothy Wiley.

595 HAMMOND, HARMONY. "Feminist Abstract Art: A Political
 Viewpoint." *Heresies* 1, no. 1 (January 1977): 66-70, 3 illus. Reprinted
 in *Wrappings*, by Harmony Hammond (entry 128).
 The view that abstract art is private expression and cannot,
 therefore, be political is indefensible. Women's past creativity has
 often been in abstract forms but was rejected by critics as "craft" as
 opposed to "art." Feminist painters are developing their art through
 use of this "craft" material to express their life and sense of
 community with other women.

596 HAMMOND, HARMONY. "Class Notes." *Heresies* 1, no. 3 (Fall
 1977): 34-36. Reprinted in *Wrappings*, by Harmony Hammond (entry
 128).
 As a lesbian feminist artist, Hammond examines the assumptions
 of class and heterosexuality in art and the role of lesbian art as a
 potential catalyst for social change. The article focuses on the myth
 of art as classless and shows how this myth prevents a true perception
 of the artist's reality. She discusses how lesbian artists need to defy
 this myth by developing class consciousness and incorporating
 elements of lesbian art and culture.

597 HAMMOND, HARMONY. "Sense of Touch." *New Art Examiner* 6,
 no. 10 (Summer 1979): 4, 10, 5 illus. Reprinted in *Wrappings*, by
 Harmony Hammond (entry 128).

Suggests that lesbian imagery in art and sexuality in art by women are not the same thing. Whereas perhaps all woman-focused sexuality (and ways in which it is expressed in art) contains some lesbian feeling, regardless of whether the artist is straight or lesbian, not all art by lesbians is sexual in nature. She looks at the way women artists see their bodies and the way they define sexuality without any reference to men.

598 HAMMOND, HARMONY. "Horseblinders." *Heresies* 4, no. 1 (1980): 45-47, 6 illus. Reprinted in *Wrappings*, by Harmony Hammond (entry 128).

Both the art establishment and the feminist community approach feminism as an aesthetic or style, whereas feminism is the political analysis of the experience of being a woman in a patriarchal culture. Art and feminism then are not separate, nor are they the same thing. The male-dominated art establishment needs to define feminist art as another style, and critics also need to be able to qualify it instead of seeing its diversity of philosophy and aesthetic as one of its bases. The author describes some pitfalls of female collectives, showing that artists and nonartists have the right to operate on a multitude of individual and collective levels instead of resorting to the historical limitation of choosing one or the other. A future direction for women in art and politics is outlined. See Alloway.

599 HANDLER, R. "Upwards by Gentle Energy." *Das Kunstmagazin*, no. 9 (September 1984): 768-73, 5 illus.

Discussed the career changes that are possible for women in the arts in Germany, Switzerland, and Austria. Profiles five women who are part of this change: Wibke von Bonin (art editor for West German television), Erika Billeter (director of the Musée Cantonal des Beaux-Arts, Lausanne), Katharina Schmidt (director of the Staatliche Kunsthalle, Baden-Baden), Ursula Krinzinger (head of an Innsbruck art gallery), and Karla Fohrbeck (a leading figure in arts administration and author). RILA.

600 HARPER, PAULA. "Suffrage Posters." *Spare Rib*, no. 41 (November 1975): 9-13.

Predates Lisa Tickner's book on the English suffrage movement (entry 219). A methodological classic in the area of graphic arts that brings the debate surrounding art and politics/the political as personal into sharper focus.

601 HARPER, PAULA. "Votes for Women? A Graphic Episode in the Battle of the Sexes." In *Art and Architecture in the Service of Politics*, edited by Henry A. Millon and Linda Nochlin. Cambridge, Mass.: MIT Press, 1978, pp. 150-161, 15 illus.

Describes and analyzes a group of previously unpublished picture posters made by members of the women's suffrage movement in the United States and Great Britain between 1900 and 1920. Focuses on the ways in which both the content and the style of the poster images are linked with suffragist ideology and political strategy.

602 HARPER, PAULA. "The First Feminist Art Program: A View from the 1980s." *Signs* 10, no. 4 (Summer 1985): 762-81.

Discusses the history and values embodied in the radically new Feminist Art Program organized by Judy Chicago and Miriam Schapiro, which lasted only three years. Examines consciousness-raising activities and their impact on the students and teachers, Womanhouse, networking, the exhibitions (for example, *Menstruation Bathroom* and *Nurturant Kitchen*), and the general female environment that was created there. Talks about her own experience as an art historian developing a women's history of art and being in the vanguard of scholarly revisionism. Cites former students Mira Shor, Suzanne Lacy, Nancy Youdelman, Robin Morgan, and Faith Wilding as being in the "boot camp" of feminism. Brings up issues of separatism, lesbianism, the family, mixed loyalties, domestic environments, and autonomy. Concludes with a discussion of the differing directions taken by Chicago and Schapiro during the 1980s and the practical path feminists are resigned to taking, which requires tenacity and endurance over the long haul.

603 HARREN, PETER E. "Three Women Painters." *Arts Magazine* 57, no. 5 (January 1983): 6, 1 illus.

Reviews paintings by three East Village artists: Marianne Edwards, Judith Glantzman, and Patricia Fleming.

604 HARRIS, ANN SUTHERLAND. "The Second Sex in Academe." *A.A.U.P. Bulletin* 56, no. 3 (September 1970): 283-95.

Gives facts and figures compiled by the Women's Caucus for Art for the College Art Association on discrimination in the visual-arts profession.

605 HARRIS, ANN SUTHERLAND. "Women in College Departments and Museums." *Art Journal* 32, no. 4 (1973): 17-19.

The Women's Caucus of the College Art Association has collected and disseminated information about the distribution of women in college and university art departments and in art museums. They are trying to define the problems of women artists, art historians, and museum professionals, to publicize the legal avenues of redress open to women who believe they have been discriminated against, and to sponsor political action to eliminate such discrimination. Figures now available demonstrate a diminishing proportion of women in posts

further up the scale, despite a lack of discrimination at college admission level. Different and higher standards are applied to women seeking jobs in the arts.

606 HARRIS, ANN SUTHERLAND. "Letter to the Editor." *Woman's Art Journal* 4, no. 2 (Fall-Winter 1983-1984): 53-54. Reprinted in *Visibly Female*, ed. Hilary Robinson (entry 223), pp. 222-26.

A critique of Griselda Pollock's essay "Women, Art, and Ideology: Questions for Feminist Art Historians" (entry 893). See Pollock's reply (entry 892) for further insights into the debate surrounding *Old Mistresses: Women, Art, and Ideology* by Rozsika Parker and Pollock (entry 183).

607 HARRIS, ANN SUTHERLAND. "Fresh Paint." *Women's Review of Books* 4, no. 12 (September 1989): 8-10.

Reviews Mary Garrard's *Artemisia Gentileschi: The Image of the Female Hero in Italian Baroque Art* (entry 118). Brief overview of Gentileschi's career; cites the 84-page appendix, twenty-eight known letters, and Garrard's interpretations of the tradition of the "Femmes Fortes" and paintings as key elements that distinguish it as a welcome and imaginative study in the field of art history.

608 HARRIS, I. C. "Sex and Representation." *Vanguard* 13, no. 9 (November 1984): 22-25, 4 illus.

Discusses the role of sexual identity and "being." The development of meaning and of the individual within culture is a function of sexual difference. Culture and representations, he suggests further, are attempts to construct order out of sex. He concludes by considering a video work by Paul Wong, *Confused: Sexual Views*, with reference to these ideas.

609 HARRISON, MARGARET. "Notes on Feminist Art in Britain 1970-1977." *Studio International* (London) 193, no. 987 [Feminist Issue] (1977): 212-20.

Using her personal experience, Harrison gives us a survey of feminist art in the U.K. The survey charts the beginnings of a feminist consciousness and of a forceful and progressive struggle to write women back into history and art. Cites Mary Kelly, Alison Fell, Monica Sjoo, Sally Frazer, and Liz Moore to illustrate her points and mentions *Spare Rib*, *Women's Report*, *Women's Voice*, and *Red Rag* as alternative publications. She discusses exhibitions, posters, and activities of such groups as the Women's Free Art Alliance, Women's Art History Collective, Hackney Flashers, Feminist Postal Art Group, and Birmingham Women's Art Collective and performance artists Rose Finn-Kelcy and Tina Keane. For contrast see Robins.

610 HARTMAN, R. "Feminists Are Talking about Feminist." *Art Journal*
 4, no. 1 (Spring 1975): 49-50, 3 illus.
 Reviews the recent work of three artists. Hannah Wilke, known
 for her softly tinted vaginal sculptures, did a three-hour performance,
 Starification, at the "5 Women Artists in Paris" exhibition at the
 Piltzer Gallery. Judith Bernstein exhibited her large-scale, dark,
 hairy, phallic screw drawings at the Piltzer Gallery. Recognition has
 replaced harassment of her work. Sylvia Sleigh paints realistic
 portraits and nudes of her friends. She wonders if the reaction
 against her male nude at the Bronx museum would have been so
 adamant if it had been female.

611 HAVEMEYER, A. "Cassatt: The Shy American." *Horizon* 24, no. 3
 (March 1981): 56-63, 9 illus.
 Describes the career and works of the American painter Mary
 Cassatt, and the difficulties of surviving as a female artist in the late
 nineteenth century. Focuses on Cassatt's role in introducing
 impressionist and postimpressionist art to the United States. He also
 describes the influence of Degas on Cassatt and her reticence to
 discuss her own work.

612 HAVICE, CHRISTINE. "In a Class by Herself: 19th Century Images
 of the Woman Artist as Student." *Woman's Art Journal* 2, no. 1
 (Spring-Summer 1981): 35-40, 4 illus.
 Examines the image of the woman artist in the nineteenth century
 as seen in the work of Cochereau, Grandpierre-Deverzy, and
 Stephens; reflects gradual stages from segregation to egalitarian
 training of women artists, recording the limitations and possibilities
 of their education.

613 HAVICE, CHRISTINE. "The Artist in Her Own Words." *Woman's
 Art Journal* 2, no. 2 (Fall-Winter 1981-1982): 1-7.
 Discusses the published writings of Berthe Morisot, Mary Cassatt,
 Cecilia Beaux, Elisabeth Vigée-Lebrun, Rosa Bonheur, Barbara
 Leigh Smith (Bodichon), Marie Bashkirtseff, and Kathe Kollwitz.

614 HAVICE, CHRISTINE. "Introduction to Anne Truitt's *'Daybook'*."
 Woman's Art Journal 3, no. 2 (Fall 1982-Winter 1983): 36-43.
 Extracts from the *Daybook* of the artist Anne Truitt (New York:
 Pantheon Books, 1983). The book is in the tradition of published
 autobiographies by women artists. The *Daybook* combines the
 introspection of the artist about her work with the present situation
 of the artist in combining a vocation with motherhood and domestic
 responsibilities.

615 HAVICE, CHRISTINE. "Teaching about Women in the Visual Arts: The Art History Survey Transfigured." *Women's Studies Quarterly* 15, no. 1-2 (Spring-Summer 1987): 17-20.

An excellent hands-on observation of how to teach women in art. Discusses structure, approach, and feminist attitudes in teaching the first half of the art-historical survey course.

616 HAVICE, CHRISTINE. Reviews of *Feminist Art Criticism: An Anthology* and *Crossing Over: Feminism and Art of Social Concern*. *National Women's Studies Journal* 1, no. 3 (Spring 1989): 538-41.

Reviews two anthologies of writing by women on art by women and the theoretical, practical, and aesthetic implications of the art. The collections are especially valuable because much of the discourse is not easily available. The jargon-free language and directness of most of the essays represent a strategy for outreach not characteristic of most critical writing. Cites work by Lowery Sims, Shifra Goldman, Cassandra Langer, Joanna Frueh, Moira Roth, Teresa de Lauretis, and Arlene Raven. Also reviews Raven's pioneering contributions to early feminist theory and criticism, showing her engaged activism with contemporary art and feminism. Cites "Rape," "We Did Not Move from Theory/We Moved to the Sorest Wounds," and other essays. See entries 112 and 193.

617 HAYDEN, DOLORES. "Skyscraper Seduction, Skyscraper Rape." *Heresies* 1, no. 2 (May 1977): 108-15.

An examination of phallic imagery, penetration, and architecture as a form of sexual politics. Hayden argues that phallic culture dominates architectural creativity.

618 HEISNER, BEVERLY. "Harriet Morrison Irwin's Hexagonal House: An Invention to Improve Domestic Dwellings." *North Carolina Historical Review* 58 (April 1981): 105-24, 21 illus.

In 1869, Harriet Morrison Irwin became the first American woman to patent an architectural design. It was for an hexagonal house. Irwin's ideas are discussed and her patent design examined in detail. See Hayden.

619 HELSON, R. "Inner Reality of Women." *Arts in Society* 11, no. 1 (Spring-Summer 1974): 24-36, 13 illus.

Due to women's inability to control their own bodies, childbearing and rearing precluded women's serious commitment to art. However, the concept of creativity defined by a phallocentric society has prevented us from seeing woman as creator of ideas as well as of children. Reinforcement of this old image is found in the primary school, and comparative studies of men and women in art schools, as

mathematicians, and as authors explore the results of this conditioning.

620 HENNING, E. B. "The Woman in the Waves." *Artnews* 83, no. 3 (March 1984): 104-6, 3 illus.

Discusses Gauguin's painting *Ondine* or *Woman in the Waves* (1889). This painting depicts woman as the root of sin and death. The simple composition of the painting demonstrates the synthetic approach and also shows Gauguin's symbolic use of color.

621 HESS, ELIZABETH. "Success! A Boone for Feminists?" *Village Voice* [Art Special], 6 October 1987 and Fall Art Supplement.

Discusses Sherrie Levine and Barbara Kruger's ascendancy into the Valhalla of Mary Boonedom. Asserts that women became a force in the art world during the 1970s, which facilitated the ready acceptance of Levine and Kruger into a host culture into which others were not absorbed (i.e., Suzanne Lacy, Nancy Spero, Harmony Hammond, and May Stevens). Argues that in the 1980s the alternative gallery system virtually collapsed and that artists like Elizabeth Murray and Ida Applebroog, although in mainstream galleries, still maintain their integrity while the system works for them.

622 HESS, J. E. "Domestic Interiors in Northern New Mexico." *Heresies* 3, no. 3 (1981): 30-33, 12 illus.

A description of the interiors of homes in the northern New Mexico village of Los Adobes, where the transition from subsistence agriculture to wage earning in distant cities has left economic fragmentation and uncertainty. The Los Adobes interiors, arranged by the village's women in response to their daily lives, are complex sign systems that transmit a great deal of information about shared norms. These norms and the interiors that reflect them are constantly in the process of change – a process described here with reference to the social interactions that determine it.

623 HICKLIN, F. "Keep Your Hands on the Plough – Hold on!" *Arts in Society* 11, no. 1 (Spring-Summer 1974): 102-5, 2 illus.

Argues that women in the arts are caught in a circle of discrimination that is kept in place by patriarchal attitudes toward the arts: 1) art has been associated with elite groups rather than the community at large and has been assigned a peripheral rather than a core role in our lives; 2) although traditionally male-oriented and reflecting male values, art has been deemed effeminate. The only way to change this is for women to provide alternatives. Suggests strategies for immediate action and encourages women to be

mutually supportive, tolerant, and open-minded yet persistent in their attacks on discrimination.

624 HIGONNET, ANNE. "Secluded Vision: Images of Feminine Experience in Nineteenth-Century Europe." *Radical History Review*, no. 38 (1987): 16-36, 5 illus.

Examines women's traditions of self-expression through traditional photo albums and amateur painting. Argues that these images represent women's definitions of themselves and must be judged by other than high-art norms. Cites the Belgian Duchesse de Vendome, Marie de Krudener, and George Sand. Discusses class bias and representations of aspects of domestic life. Asserts that feminine imagery should be seen as marginal visual culture. The return of these works to public view is a marketplace phenomenon in which the high art market often ignores the meanings and integrity of the work in search of sales.

625 HIGONNET, ANNE. "A Woman Turned to Stone." *Women's Review of Books* 5, no. 12 (September 1988): 6-7.

Reviews Reine-Marie Paris's *Camille: The Life of Camille Claudel, Rodin's Muse and Mistress*, and *Camille Claudel*, the exhibition catalog, also by Paris, of the Claudel show held at the National Museum of Women in the Arts, Washington, D.C. (25 April-31 May), which showed fifty-three works. Contains precise information on Claudel's life, but the books are ultimately disappointing because they gloss over the really tough questions regarding the artist's position as a woman and its consequences. (Bruno Nuyhen's 1990 film *Camille Claudel* was edited and now represents the standard.) Claudel is generally presented as mentally defective but evidence suggests that she suffered from low self-esteem due to the discrimination she experienced at the hands of the men she trusted.

626 HIGONNET, ANNE. "Writing the Gender of the Image: Art Criticism in Late Nineteenth-Century France." *Genders*, no. 6 (Fall 1989): 60-73.

Analyzes the extreme positions in late nineteenth-century art criticism, focusing on genderization. Higonnet asks what supposedly constitutes masculinity and femininity in painting? How does art criticism situate painters in genderized terms? How is femininity articulated by art criticism's language? What larger cultural purpose does femininity serve in art-critical discourse? She concludes that the power of gender as a rhetorical strategy is in its paradoxical ability to make and yet mask the connections it establishes between sexual difference and institutional or economic power. This power must be

analyzed and resituated historically to understand why art criticism in later nineteenth-century France wished to assign gender to images.

627 HILLS, PATRICIA. "Art History Text Books: Hidden Persuaders." *Artforum* 14 (June 1976): 58-61.
 Hills examines Frederic Hartt, Helen Gardner, and Horst Waldemar Janson's histories of art from a Marxist and feminist viewpoint, and in relation to their impact on the approximately "455,000,000 students enrolled in colleges and universities during the early 1970s." She examines the ideology contained in these texts and how their ethnocentricity leads readers to believe in a hegemony of American art that slights Latin Americans, African-Americans, Asians, and women. Hills neglects gay and lesbians in dealing with the politics of sexuality and gender vis-à-vis discrimination and indoctrination.

628 HILTON, ALISON. "Bases of the New Creation: Women Artists and Constructivism." *Arts Magazine* 60, no. 2 (October 1980): 142-45, 20 illus.
 The direction of Russian constructivism was influenced by several women artists–notably Natalia Goncharova, Alexandra Exter, Olga Rozanova, Lubov Popova, and Varvara Stepanova–all of whom pursued early interests in folk and applied arts. Their ability to relate abstract concepts to function may owe much to the attention given to applied arts in Russia–and to the relative prominence of women in promoting education in the applied arts–from the mid-nineteenth century on. The constructivist's goals were related to this tradition. They sought not merely "new principles of form" pertinent to easel painting, but the restructuring of the environment of daily life.

629 HIRSCH, GILAH YELLIN. "Ruth Weisberg: Transcendence of Time through Persistence of Imagery." *Woman's Art Journal* 6, no. 2 (Fall 1985-Winter 1986): 41-45.
 Discusses Weisberg's Judaism and how it has impacted on her work and transformed her life. One aspect of women's spirituality in feminism.

630 HOBBS, ROBERT. "Sally Mitchel: The Other Avery." *Woman's Art Journal* 8, no. 2 (Fall 1987-Winter 1988): 3-14, 11 illus.
 Discusses Mitchel's career in relation to her development and the influence of her husband.

631 HOFFMAN, JAN. "Rear Window: The Mystery of the Carl Andre Murder Case." *Village Voice* 38, no. 13 (29 March 1988): 25-32.
 A comprehensive overview of the sensational death of Ana Mendieta, who was well on her way to proving that a woman artist

with third-world roots (Cuba) and a so-called "minority" artist could establish herself as an innovator. Reviews her death on 8 September 1985, which Leon Golub said "symbolized the murdered feminist Third World martyr." Artist Howardena Pindell explained (*Art Examiner*) the outcome of the trial (Andre was acquitted) saying the decision tells women and minorities that in this society your life isn't worth anything.

632 HOFRICHTER, FRIMA FOX. "Proposition – Between Virtue and Vice." *Feminist Art Journal* 4, no. 3 (Fall 1975): 22-26.

A classic in feminist criticism. Looks at Judith Lyster's *Proposition* from a woman's view point, showing the female interpretation of a masher putting the make on a virtuous woman. Refreshing and full of insights on differences in gender and sexual relations between the sexes in art.

633 HOLCOMB, ADELE M. "Anna Jameson on Women Artists." *Woman's Art Journal* 8, no. 2 (Fall 1987-Winter 1988): 15-24, 6 illus.

Discussed Anna Jameson's criticism, defending her position as an early feminist within her era. Her response to Artemisia Gentileschi's *Judith Decapitating Holfernes* (1620) is not unlike the mixed reviews later accorded Peter Greenaway's film *The Cook, The Thief, His Wife and Her Lover* (1990) vis-à-vis violence and feminist politics. Traces Jameson's life and aesthetic development as a working critic, quotes extensively from her thoughts on female artists, and concludes with a contextual analysis of Jameson's criticism.

634 HOLDER, MARYSE. Review of "Another Cuntree: At Last, a Mainstream Female Art Movement." *Off Our Back*, September 1973. Reprinted in *Feminist Art Criticism*, ed. Arlene Raven, Cassandra Langer, and Joanna Frueh (entry 112), pp. 1-20, 7 b&w illus.

A path-breaking essay on female sexuality as expressed in the fine arts. Holder traces her own consciousness of women in the arts from hearing Judy Chicago talk at Cornell and seeing work by Georgia O'Keeffe, Louise Bourgeois, and Miriam Schapiro. Discussed the frequency of images such as "cunts and measured cocks." Cunts appeared as fruit and elements of the landscape. Breasts also appeared and reference was made to the significance of the "prick." In some ways, this article prefigures Lacan's theory of phallic symbolism in language and culture vis-à-vis women's concerns during this period with the phallus as a signifier of male power in the culture and in general. Discusses images of blood and birth in women's art including abortion and death. Concludes by asserting that for the first time these artists are not copying from men but creating directly from the female experience and their own reality. She pulls no punches in dealing with women's right to sexuality in all its visual

forms. Includes Louise Bourgoise, Anita Steckel, Joan Semmel, and Martha Edelheit.

635 HOLLIBAUGH, AMBER, and MORAGA, CHERRIE. "What We're Rollin around in Bed With: Sexual Silences in Feminism. [A Conversation toward Ending Them.]" *Heresies* 3, no. 4 [Issue 12: Sex] (1981): 58-62.

A series of talks developed over many months that developed into a critique of sexual issues. Argues that feminism has dealt with sexuality inadequately. Discusses sadomasochist, lesbian, and third-world perceptions of the problem from an activist position. See Califia; Hammond; Langer; Raven.

636 HOLLISTER, V., and WEATHERFORD, E. "By the Lakeside There Is an Echo: Towards a History of Women's Traditional Arts." *Heresies* 1, no. 4 (Winter 1978): 119-23, 11 illus.

An anthropologist and an artist assemble and analyze the sparse information available to them on the arts of women in traditional societies. Each brings the approaches of her individual specialization to the questions she poses. These categories are: the art of women's rituals; art as symbols of authority; personal decoration; the utilitarian arts; female musicians, bards, and singers; women artists' communities; women's art and cultural change.

637 HOLYOAKE, M. "Women Artists in Imperial China." *Art and Australia* 19, no. 4 (Winter 1982): 446-50, 7 illus.

An account of the work and identities of women artists of imperial China, a class of artist ignored by Western art historians, although well documented in China. The author describes the work of several artists from the fourth century A.D. to Ma Ch'uan (1768-1848), noting that they concentrated on garden themes and on refining techniques rather than on innovation. Though they are often condemned for this by art historians, the author considers that they could do no better given the restrictions imposed on them.

638 HONNEF-HARLING, G. "Women and Art: Associations on a Capricious Theme." *Kunstforum International*, no. 3 (July-September 1985): 272-75.

The relationship between women and art is a balancing act between conforming to and resisting art activities created by men. Cites examples in art history of the contradictions this relationship has engendered and describes the effects of the women's movement on art and the role of the female artist. She concludes that the strength of women artists derives from their wilfulness. RILA.

639 HOPPIN, MARTHA J. "The Danforth Women Artists in Boston, 1870-1900: The Pupils of William Morris Hunt." *American Art Journal* 13, no. 1 (Winter 1981): 17-46, 31 illus.

Discusses the generation of Boston women who began their careers as students of Hunt (ca. 1870) and his teaching methods drawn from his own experience in France. Deals with works by Helen M. Knowlton, Sarah W. Whitman, Elizabeth H. Bartol, Sarah J. F. Johnston, Elizabeth Boott, Rose Lamb, Ellen D. Hale, and Helen B. Merriman.

640 HUGHES, MIRIAM. "Toward a Feminist Art Education." *Women Artists News* 6, no. 2-3 (Summer 1980): 15-16.

Describes Miriam Schapiro's activities in creating a feminist art education during the 1970s. In 1970, Schapiro and Judy Chicago founded the Feminist Art Program at the California Institute of Arts. This led to the Womanhouse project involving the validation of women's domestic experiences. Schapiro returned to New York in 1975 and was influential in the establishment of the New York Feminist Art Institute in 1979 (which had to curtail its activities in 1990 owing to lack of economic support and administrative problems). Schapiro feels she is still concerned with the fusion of artistic and political concerns and the creation of a new aesthetic sensibility.

641 HUGUNIN, J. "Rachel Youdelman: A Pleasant Sense of Ennui." *Afterimage* 7, no. 7 (February 1980): 6-7, 2 illus.

Discusses the work of photographer Rachel Youdelman, whose carefully posed compositions have a humorous feminist slant. On the one hand, her work often deals with womanly topics, which provokes one to disregard them as trivial. By contrast, the content of the works themselves often questions this bracketing of the feminine with the trivial. At a third level, the carefully contrived photographs present themselves as cultural artifacts, in direct contrast to the usual academic view of what a photograph should be.

642 HUNTER, ALEXIS. "Feminist Perceptions." *Artscribe*, no. 25 (October 1980): 25-29, 6 illus.

The author describes feminist exhibitions and individual works with which she has identified as a woman and as an artist over the past ten years. Among these are the Woman Magic (formerly Woman Power) Group; Kate Walker's 1977 exhibition *A Portrait of the Artist as a Young Housewife* (Institute of Contemporary Arts, London); and the photographic-text work of Jo Spence.

643 HUST, KAREN. "The Landscape Chosen by Desire: Laura Gilpin
 Renegotiates Mother Nature." *Genders*, no. 6 (Fall 1989): 20-48, 16
 illus.
 Discusses Gilpin in the context of a male photographic tradition
 and explains her recasting the nature/culture divide by refeminizing
 the landscape and giving the Great Mother back her ancient power.
 This provocative and well-focused analysis should serve as a feminist
 model for anyone interested in dealing with nature/culture issues in
 the context of gender ideology. See *Impressionism*, by Norma Broude
 (entry 81).

644 INGELMAN, I. "Women Artists in Sweden: A Two-Front Struggle."
 Woman's Art Journal 5, no. 1 (Spring-Summer 1984): 1-7, 6 illus.
 Traces the struggle of women artists in Sweden to achieve equal
 status with men. In 1864, the Swedish Royal Academy of Fine Arts,
 Stockholm, opened its doors to women, but many women artists still
 faced problems both within and outside the home. Some women who
 achieved recognition include: Amalia Lundegren, Amanda Sidwall,
 Hanna Pauli, Sigrid Hjerten, Eva Bagge, Esther Kjerner, Vera
 Nilsson, Siri Derkert, and Tyra Lundgren. The author notes that
 Lundgren, in spite of great success, was still not free of what is
 considered woman's continual scourge – lack of self-confidence.

645 "Inter-view: When the Photographer is a Woman." *Infinity* 21, no. 1
 (January 1973): 5-13, 19 illus.
 A forum of fifteen women photographers discuss how they
 became photographers, the position of women in the photography
 world, their attitudes towards money, their aims, and the problems
 they face.

646 ISKIN, RUTH. "Cassatt and Her Oeuvre from a Feminist
 Perspective." *Womanspace Journal* 1, no. 2 (April-May): 13-14.
 Review of E. John Bullard's *Mary Cassatt's Oils and Pastels* (New
 York: Watson-Guptil Publications, 1972). Discusses differences in
 reading the text and facts concerning the relationship between Degas
 and Cassatt.

647 ISKIN, RUTH E. "Female Experience in Art: The Impact of
 Women's Art in a Work Environment." *Heresies* 1, no. 1 (January
 1977): 71-78, 9 illus.
 An exhibition of the work of fifteen women artists in the cafeteria
 conference dining rooms of an aerospace corporation during the
 summer of 1975 brought strong reactions from the female employees
 to the imagery in feminist works. Most sought to reject too-painful
 identification with their own lives by describing the work as
 "pornographic," whereas the middle-class women who had overcome

female role-conditioning in their jobs and were sympathetic to the feminist movement reacted favorably to the exhibition.

648 JAUDON, VALERIE, and KOZLOFF, JOYCE. "Art Hysterical Notions of Progress and Culture." *Heresies* 1, no. 4 (1978): 38-42.

A hard-hitting essay that exposes the assumptions of art-historical inquiry, pointing out the significance of language in constructing methodologies in the discipline and the implicit biases of those systems of value. Using quotations from art historians, Jaudon and Kozloff examined them for evidence of discrimination and sliding scales of value in ranking and evaluating art by the gender of the artist.

649 JOHNSON, BUFFIE, and BOYD, TRACY. "The Eternal Weaver." *Heresies*, no. 5 [Great Goddess Issue] (Spring 1978): 64-69, 9 illus.

In ancient civilizations, weaving was carried out by women, and symbolized mysteries relating to the worship of the great female goddesses who were the repositories of power, wisdom, and fertility. Certain designs and patterns were reserved exclusively for devotional purposes, and every motif was symbolic of the magic of birth and fertility. In such cultures the connection between spinning, weaving, and the process of birth admits no boundaries of culture or time. Concentrates on the history of weaving by Navajo women, its spiritual functions, and the motifs they used.

650 JOHNSON, PATRICIA. "Photography and Fiber Interact." *Journal of Photography in New England* 5, no. 1 (Fall 1983): 9-12, 12 illus.

Traces the revival in contemporary women photographers' art of nonsilver and other nineteenth-century techniques that have recently been shifted to printed images on fabric grounds. She cite Bea Nettles, Catherine Jansen, Betty Hahn, and Janice Golojuch's art to underscore her feminist analysis of the impact of the women's movement on photographic images and their meanings during the 1970s.

651 JONES, K. "Spin-off or Rip-off?" *Spare Rib*, no. 20 (February 1974): 5-16, 5 illus.

Argues that there is no such thing as an innocent design. The image of a clean, shining, streamlined kitchen, just like the inside of a spaceship, has been steadily evolving over the last ten years. The housewife was supposed to feel she was participating in society's greatest technological advancements. The image is deceptive: drawbacks include expense, toys to play with rather than time-saving gadgets, and the use of products such as chrome trim, which militate against hygiene, and standardization of surface heights, which fails to take into account the differing heights of women. But now the

emphasis is on the energy crisis, ecology, and the rustic idyll: no longer are stoves sold as scientific instruments for technicians but as natural tools for earth mothers.

652 KAHR, M. "Women as Artists and Women's Art." *Woman's Art Journal* 3, no. 2 (Fall 1982-Winter 1983): 28-31.
 Kahr pleads for the integration of female and male artists into the art-historical canon, and for the well-being of art. In achieving equality for women, men must also participate, and the more women work with men, Kahr argues, the more opportunities there will be for mutual understanding and friendship.

653 KAMPEN, NATALIE, and GROSSMAN, ELIZABETH G. *Feminism and Methodology: Dynamics of Change in the History of Art and Architecture*, Working Paper #122. Wellesley College Center on Women: Wellesley, Mass., 1983.
 Authors discuss traditional methods of art historians of the twentieth century and examine assumptions underlying those methods and the impact/or lack of impact they had on the study. Consists of an introductory section in which general problems are covered, a brief history of changes that have been occurring in the feminist literature of art in the last fifteen years, and an extended case study of the problems raised and solved by a feminist approach to the history of modern American architecture. Includes a bibliography that is still useful despite the fact that it stops at 1982.

654 KAMPEN, NATALIE B. "The Muted Other." *Art Journal* 47, no. 1 (Spring 1988): 15-19.
 Argues that classicizing art has rarely been explored in terms of gender ideology and the construction of the "other." Discusses norms of moral behavior from the golden age of the late first century B.C. in Rome and in relation to eighteenth-century European examples. She takes their themes including the Sabine women and demonstrates how the subtext of coercion forces women to behave according to man-made laws.

655 KATZ, BARRY M. "The Women of Futurism." *Woman's Art Journal* 7, no. 2 (Fall 1986-Winter 1987): 3-13, 8 illus.
 Discusses the responses to futurism of eight Italian women artists: Valentine de Saint-Point, Rosa, Adriana Bisi Fabbri, Alma Fidora, Benedetta, Leandra Angelucci (Cominazzini), Regina, and Marisa Mori. Concludes that what distinguishes the women is "their proclivity to partake in the minor arts." The implications of this are not explored. Discusses their attitudes toward feminism and within the context of the time. Includes "Manifesto of the Futurist Woman"

and "Futurist Manifesto of Lust" by Valentine de Saint-Pont. See Elwes.

656 KAUFMAN, V. K. "Miriam Schapiro." *Visual Dialog* 1, no. 2 (December 1975-February 1976): 19-21, 2 illus.

Recounts Kaufman's experience at the Feminist Art Program at the California Institute of the Arts, directed by Schapiro. The year-long program is based on the critical belief that a woman's art is vigorous if it is autobiographical; individual guidance and group sessions are provided. The Feminist Art Program maintains a slide registry of works of female artists from the Renaissance to the contemporary period. Schapiro's art divides into discrete styles that correspond to significant autobiographical facts: the movement from such themes as "The Computer" to "The Shrine" to "The Dollhouse" is traced. Schapiro talks about her recent work, which is a combination of painting and collage, and about the strength she gained as a feminist art educator.

657 KELLER, M. "Women of the Bauhaus." *Heresies* 1, no. 4 (Winter 1978): 54-56, 5 illus.

About 10 per cent of the faculty members at the Bauhaus were women. They formed about one-third of the student body. Their writings cast light on the politics of the art/craft split of their time. After spending six months in a preliminary course, students moved on to one of several specialist workshops. Most of the women ended up in the textiles workshop. The sociological implications of that fact are examined here.

658 KELLY, MARY, and YATES, M. "Feminist Art: Assessing the Seventies and Raising Issues for the Eighties." *Studio International* (London) 195, no. 991 (1981): 40-41.

Traces the beginnings of the women's movement in the 1970s, cites Whitney Museum's raising its quota of women by 20 per cent, and discusses Rozsika Parker's "Getting A Piece of the Rotten Pie," Lippard's *From the Center*, the all-woman show, Kunstlerinnen International, women's galleries, mainstream journals, and alternative magazines. Concludes that it was feminist art that pioneered the now constant reexamination of our identities and our politics.

659 KENNEDY, M. "Seven Hypotheses on Female and Male Principles in Architecture." *Heresies* 3, no. 3 (1981): 12-13, 7 illus.

Architecture in the West is considered a predominantly male domain, but it was once primarily a woman's field. Women were the builders in nearly all the early civilizations and remain so in many developing nations. The seven hypotheses stated here distinguish

male and female principles in architecture in a way comparable to the distinctions made in biology and psychology. Kennedy suggests how women might realize a fusion of the contradictory demands of the two sets of principles to furnish an alternative to current architecture governed by male standards and values.

660 KENT, SARAH. "Feminism and Decadence." *Artscribe* 47 (July-August 1984): 54-61, 9 illus.
 Analysis of feminist perspectives in the work of contemporary women artists.

661 KENT, SARAH. "Looking Back." In *Women's Images of Men*, ed. Sarah Kent and Jacqueline Morreau (entry 241), 1985, pp. 55-74, 11 illus.
 Examines looking. "A woman who looks openly at men is seen as brazen." Women looking at men challenges the status quo and usurps the observer's role, and women artists depicting men as models and objects expose and make men vulnerable, which outrages them. Kent points out that male homosexual erotica did not meet with the derision and scathing attacks with which women's images of male nudes were treated. Cites Édouard Manet, Pablo Picasso, David Hockney, Suzanne Valadon, Alice Neel, and others to illustrate her points. See Kent's "The Erotic Male Nude" (in the same anthology), Califia's "Feminism and Sadomasochism," and Holder's "Another Cuntree" (entry 634).

662 KENT, SARAH. "Scratching and Biting Savagery." In *Women's Images of Men*, ed. Sarah Kent and Jacqueline Morreau (entry 241), 1985, pp. 3-12, 8 illus.
 Reviews the exhibition "Women's Images of Men" (see entry 677) discusses the three issues it fused—the rebirth of figurative art, the use of art as a vehicle for political comment, and the emergence of women artists as an important force in the art world. Cites Mary Kelly's *Post-Partum Document*, Alexis Hunter's *Considering Theory*, Monica Sjoo's *God Giving Birth*, and Eileen Cooper's *Second Skin*. Concludes that women artists are "free to assert their independent voices" and to explore a full range of personal expressions and political commitments.

663 KIMBALL, BARBARA. "Women and Fashion." In *Women's Culture*, ed. Gayle Kimball (entry 239), 1981, pp. 130-46, 4 illus.
 Explores the freedom fashion designers have tried to give women. Discusses pioneers Amelia Jenks Bloomer, Chanel, Diana Vreeland, Mme. Gres, Nina Ricci, Madeleine Vionnet, Elsa Schiaparelli, Mme. Joseph Paquin, Jeanne Lanvin and Sonia Rykiel, Edith Head, Zandra Rhodes, Mary Quant, Jean Muir, Bonnie Cashin, Pauline Trigere,

Anne Klein, Mary McFadden, Hattie Carnegie, and Norma Kamali. These women helped advance creativity and expression in women's apparel.

664 KIMBALL, GAYLE. "Defining Women's Culture: An Interview with Robin Morgan." In *Women's Culture*, ed. Gayle Kimball (entry 239), 1981, pp. 30-41, 8 illus.

Questions radical feminist writer and former artist Robin Morgan about women's culture. Morgan does not see the aesthetic vision as inseparable in integrity from all political action. She sees the unlocking of creative energy as valuable to all genders. Morgan comments on "metaphysical feminism" and passionate thinking, saying "a feminist art begins to refuse polarities." Defines an approach to culture that begins with a whole history. New York, Boston, San Francisco, and Los Angeles are centers; names institutions that she sees as pivotal. Touches on the thorny issue of men's participation in women's culture and a religious revolution that involves love, overcoming dualities, and a host of other things.

665 KIMBALL, GAYLE. "A Female Form of Language: An Interview with Judy Chicago." In *Women's Culture*, ed. Gayle Kimball (entry 239), 1981, pp. 60-71, 4 illus.

Discusses "center-core imagery," gender transcendence, flight and compression, God the Father, Erich Neumann's "Great Mother," *The Dinner Party*, and myth and history in feminism and in the framework of future possibilities.

666 KIMBALL, GAYLE. "Goddess Imagery in Ritual: Interview with Mary Beth Edelson." In *Women's Culture*, ed. Gayle Kimball (entry 239), 1981, pp. 91-115.

Covers liturgy, birth imagery, becoming and evolving, cosmic forces, Amazon-like women, multiplicity, cycles, layering, personal rituals, loving the earth, working with nature, spirituality, and the women's movement.

667 KING, YNESTRA. "Feminism and the Revolt of Nature." *Heresies* 4, no. 1 [Issue 13: Earthkeeping/Earthshaking: Feminism and Ecology]: 12-16, 1 illus.

Discusses radical feminism, ecology, and social feminism in the context of the dialectic of dualism, arguing for integration of traditional women's ways in order to transcend men's denial of their female selves as projected in nature. Concludes that ecological feminism is about reconciliation of the world that is nondualistic.

668 KINGSBURY, MARTHA. "The Femme Fatale and Her Sisters." In
 Woman as Sex Object, ed. Thomas B. Hess and Linda Nochlin (entry
 235), 1972, pp. 183-203, 26 illus.
 Traces the development of two distinctive types of femme fatale,
 discussing her as allegorical figure and in the context of style and
 ideology, stressing the threatening power of female eroticism. See
 Vogel; Comini.

669 KINGSLEY, APRIL. "Women Choose Women." *Artforum*, April
 1973, 69-73.
 Discusses the pioneering aspects of the show "Women Choose
 Women." Describes it as a "do-it-yourself show," organized by the
 minority group. Includes 111 women, among them Alice Barber,
 Andree Golbin, Pat Adams, May Steven, Buffie Heller, Helene
 Aylon, Anne Healy, Nina Yankowitz, Betsy Damon, Michelle Stuart,
 Cecile Abish, Elise Asher, Lois Dodd, Sari Dienes, Muriel Castanis,
 Perle Fine, Joan Snyder, and Faith Ringgold. Also discusses Lucy
 Lippard's essay (see exhibition catalog, entry 380).

670 KINGSLEY, APRIL. "Pat Lasch: Death and Transfiguration." *Arts
 Magazine* 56, no. 3 (November 1981): 130-31, 3 illus.
 An account of the artistic development of Pat Lasch, whose
 mixed-media structures, sculptures, wall pieces, and thread works
 embody ways of making art without reference to traditional male
 media and techniques. Her work commemorates the natural,
 irrevocable events of life – her ancestors, relationships, birth, death,
 ceremonies, and rites of passage – in abstract and symbolic form. At
 first austere, her more recent work shows elaborate flourish and self-
 confident use of a developed personal vocabulary.

671 KIRSHNER, JUDITH RUSSI. "A Narrative of Women's
 Experience." *Art Criticism* 6, no. 1 (1989): 20-31.
 The female body as locale and the female self as sexually and
 culturally split into self and other made up this narrative. Artists
 Christina Ramberg, Ida Applebroog, Hollis Sigler, Nancy Bowen,
 Heanne Dunning, and Judy Ledgerwood are discussed. Kirshner
 attempts to construct a theory of feminist representation based on
 her observations of cultural stereotypes. Concludes that "women
 artists have opened doors to the scene and unseen, the scene and the
 obscene or what literary critics called gendered readings, not unlike
 gendered viewing."

672 KOLBOWSKI, SILVIA. "Mary Kelly and Laura Mulvey in
 Conversation." *Afterimage*, March 1986, pp. 6-8.
 The text of this conversation was recorded in 1983 and brought to
 the editor's attention by Kolbowski. A discussion of *Post-Partum*

Document and of Kelly's inspiration by Mulvey and Peter Wollen's *Penthesilea*, a film based on Kleist's version of the Amazon myth. These two talk about postmodernism, deconstruction of the mother's voice, psychoanalysis as a tool, Kelly's Institute of Contemporary Art show in 1976, Joseph Kosuth's dictum that art is an analytical proposition, and Kelly's assertion that the work demonstrates that sexual personality is never really fixed–for mother or child–but rather a problem continually posed and re-posed.

673 KRAFT, SELMA. "Cognitive Function and Women's Art." *Woman's Art Journal* 4, no. 2 (Fall 1983-Winter 1984): 5-9, 4 illus.
Argues that women have a different way of processing information, and that in art this reveals itself in the emphasis of intervals and arrangements of repeated motifs. Relevant findings show that males process information by concentrating on one particular stimulus at a time, tend to separate stimuli from their fields, and are superior in three-dimensional spatial skills. Females respond better to a number of stimuli simultaneously, respond to stimuli more contextually, and appear to use broader but shallower fields of vision. Asserts that women are particularly suited to the creation of pattern art, in which contextual relationships of multiple images are presented in relatively shallow space. Kraft surveys art from antiquity through contemporary painting, doing some sexist speculating about a feminine way of interpreting and producing art. She suggests that recognition of this difference will raise new questions about the role of visual language in human experience and in the arts.

674 KRAMER, HILTON. "The Current Backlash in the Arts." *New York Times*, 23 May 1976, Sec. 2, p. 1.
Kramer's conservative discourse attacks, under the guise of objective art standards, qualities he claims women's art just doesn't have.

675 KRAMER, HILTON. "Does Feminism Conflict with Artistic Standards?" *New York Times*, 27 January 1980, D1, D27, 2 illus.
Discusses the recent awareness of women artists and asks "How are we to reconcile the claims of social justice with the need to distinguish artistic quality?" Based on his dubious claims that art galleries have "flung open their doors" to women artists. His question "Has the women's movement contributed to an erosion of critical standards in art?" reveals Kramer's thinly veiled attempt to maintain patriarchal power in the realm of culture.

676 KRASILOVSKY, ALEXIS RAFAEL. "Feminism In the Arts–An Interim Bibliography." *Artforum*, June 1972, pp. 72-75.

An early bibliographic reference work, now totally outdated.

677 KRIKORIAN, T. "Women's Exhibitions." *Aspects*, no. 13 (Winter
 1980-81): 8-12, 12 illus.
 Discusses four exhibitions: "Women's Images of Men," "About
 Time," "Eight Artists: Women 1980," and "Issue: Social Strategies by
 Women Artists." Consists of written responses to questions by the
 author. The main issues are whether there is an essentially feminine
 art and whether there is a risk in emphasizing the politics of
 feminism at the expense of formal and aesthetic values.

678 KRONSKY, BETTY. "The Psychology of Art." *American Artist* 48,
 no. 508 (November 1984): 28-29, 97, 100-101, 1 illus.
 Female psychology is defined here as the discovery that both men
 and women have a great deal to gain in transcending gender
 definitions that restrict the expression of the authentic self. Kronsky
 comments on the way in which early conditioning may inhibit the
 development of gifts and potential, and on psychological studies that
 show how deeply women have been influenced to disavow their
 talents and ambitions. Preoccupation with success keeps many
 women from undertaking art even as a hobby but it is the author's
 belief that women can develop autonomy through the art-making
 process. She concludes by suggesting an exercise women and men
 may undertake in order to transcend gender.

679 KUCHTA, RONALD A. "May Stevens." *Arts Magazine* 52, no. 2
 (October 1977): 7, 1 illus.
 Stevens's work has always been politically committed and uses a
 seductive symbolism to convey the moral content of her message. All
 of her political allusions are personalized and interiorized as they
 relate to family or friends, and a recurrent figure in her paintings is
 "Big Daddy," transposing her Congregationalist father into an absurd
 symbol of male chauvinism and arrogance. Subtle handling of color
 characterizes Stevens's unique blend of surrealist, pop, and realist
 elements. See Stevens; Bell.

680 KUNZLE, DAVID. "The Corset as Erotic Alchemy: From Rococo
 Galanterie to Montaut's Physiologies." In *Woman as Sex Object*, ed.
 Thomas B. Hess and Linda Nochlin (entry 235), 1972, pp. 91-165, 39
 illus.
 Traces the rise of the staymaker, the education of women's bodies,
 eroticism, lust, lines of beauty, tight lacing, fashion, romanticism,
 realism, and the social psychology of the corset in France and
 England through the art of Leon Bonnet, William Hogarth, Honoré
 Daumier, Édouard Manet, Henri de Montaut, and others.

681 KUSPIT, DONALD B. "Strider's Projecting Presences." *Art in America* 64, no. 3 (May-June 1976): 88-89, 3 illus.

Discusses Marjorie Strider's recent work as "quasi-realistic sculpture, witty spectacle and primal slime" that transcends formal concerns in favor of "grotesque fulsomeness." Traces these forms to her 1963 *Pin-Up Girl*, commenting on the three-dimensional projection of buttocks and breasts in these pieces as an embodiment of self. Cites gender as iconic eroticism and an expression of woman's amplitude, which is paradoxical in Strider's work.

682 KUSPIT, DONALD B. "Nancy Spero at AIR and Miriam Schapiro at Andre Emmerich Downtown." *Art Journal* 36, no. 2 (Winter 1976-1977): 144-46, 2 illus.

Analysis of the work of two feminist artists. Schapiro works to create art out of dress materials, her major piece being *Anatomy of a Kimono*, which provocatively remodels, through modernist art, fashions associated with traditional female clothing in Japan. Spero's *Torture of Women* is a direct graphic presentation of information that shocks viewers and is counterbalanced by the correlation to textual sources.

683 KUSPIT, DONALD B. "Betraying the Feminist Intention: The Case against Feminist Decorative Art." *Arts Magazine* 54, no. 3 (November 1979): 124-26.

Contends that feminist idealism has authoritarian overtones that blunt the edge of the revolutionary element within it. As such it is tyrannical and to a measure self-destructive. He suggests that feminist decorative art (especially pattern painting) as an expression of the authoritarian elements of the movement is doomed to becoming as "corporate" and establishment as the products of the masculine ideology it seeks to overthrow. Feminism's choice lies between the pattern (which echoes the self-certainty of the existing order) and a critical relationship with the status quo (which involves the risks of unpredictable, experimental creativity and possibly social and artistic rejection).

684 KUSPIT, DONALD B. "Spero's Apocalypse." *Artforum* 18, no. 8 (April 1980): 34-35, 1 illus.

Nancy Spero's art transforms the methods of medieval art by intermingling of text and image on the open field of a scroll. Kuspit asserts that the medieval nun Ende (coillustrator of the Beatus Apocalypse) is Spero's heroine, and her art should be seen in terms of the "apocalyptic spirit" of Ende.

685 KUSPIT, DONALD B. "Gallery Leftism." *Vanguard* 12, no. 9 (November 1983): 22-25, 4 illus.

Kuspit reviews *Revolutionary Power of Women's Laughter*, Protetch McNeil Gallery, New York, 1983, which presented the works of six artists; Mike Glier, Ilona Granet, Jenny Holzer, Mary Kelly, Barbara Kruger, and Nancy Spero. The exhibition tried to show the self-contradictory role of women in society. Kuspit blasted the exhibit, calling it "gallery leftism," which he defined as art with a sociopolitical content that limits its effect to the art world and exploits fashionably radical causes without advancing those causes in society in general. Only the work of Holzer and Spero overcame this problem, expanding one's understanding of the feminist critique.

686 KUSPIT, DONALD B. "From Existence to Essence: Nancy Spero." *Art in America* 72, no. 1 (January 1984): 88-96, 15 illus.

Breaks Spero's art into four phases: expressionist paintings, more black than bright; expressionist protest gouaches; the *Codex Artaud* psychodramatic collages/text images; and the sociodramatic feminist collages. Argues that Spero's woman is condemned to individuality because she is the eternal outsider, and much of her art is about her refusal of "feminine" decorum and propriety. In her recent work, woman symbolizes mythical freedom rather than protest and resistance. Concludes her women represent willpower and have more self-awareness than men.

687 LABOWITZ, LESLIE. "Developing a Feminist Media Strategy." *Heresies* 4, no. 1 (1980): 28-31.

Argues that "male-controlled media" perpetuates a patriarchal and capitalistic system that is the prime target in the battle to achieve feminist aims for permanent social and cultural change. Stresses that old repressive symbols must be transformed into new images imbued with a feminist consciousness.

688 LACROIX, MARGOT. "Mujer y Arte en la America Latina: Notas desde el Northe–Women & Art in Latin America: Notes from the North." *Aquelarre* (April-June 1990): 9-15, 4 illus.

In Spanish and English. Asks "What of Latin American women artists–their realities and contradictions; what difficulties and particularities does the term Latin American woman artist express or conceal?" Argues against the erasure of differences and focuses on collective colonialism and foreign domination as crucial to critical and responsible examinations of art in Latin America. The author reflects on the inescapable "alterity" of Latin American artists. Cites Anita Malfatti, Teresita Fortin, Tarsila do Amaral, and Diamela Eltit. Notes the problematic presence of Latin American women artists through exhibitions such as "Hispanic Art in the United States," Houston 1987 (only 2 women), and "Art of the Fantastic: Latin American 1920-1987," Indianapolis Museum of Art, 1987.

689 LACY, SUZANNE, and LABOWITZ, LESLIE. "Evolution of a Feminist Art: Public Forms and Social Issues." *Heresies*, no. 5 [Great Goddess Issue] (Spring 1978): 77-86.

Comments on the backlash against feminism and the increasing violence toward women. Describes the process by which the authors personally arrived at a public statement of their feminism through art, which included "Three Weeks in May," "Record Companies Drag Their Feet," and "In Mourning and in Rage" (entry 690). Labowitz discussed her first performance coming out of female consciousness *Menstruation-Wait* and how it connected her to political art. Lacy describes *Ablutions* as one of the first art vehicles for the portrayal of women's experiences of violence and speaks of her gathering of shockingly painful testimonials the year before of women who had been raped. Highlights the place of the Women's Building as a focal point for education of women in performance.

690 LACY, SUZANNE. "In Mourning and in Rage." *Frontiers: A Journal of Woman's Studies* 3, no. 1 (Spring 1978).

Discusses feminist rape-strategy performance piece and commercial media in California.

691 LACY, SUZANNE, and PALUMBO, LINDA. "The Life and Times of Donaldina Cameron." *Chrysalis Magazine*, no. 7 (Winter 1978): 76, 78, 85, 23 illus.

Describes Lacy's performance piece. Inquires about racism through a portrait of two women, Donaldina Cameron and a fictional character named Leung Ken-Sun. Includes a dialogue between Lacy and her collaborator Kathleen Chang as they explore the hidden history of Chinese women used as prostitutes in their performance on Angel Island.

692 LACY, SUZANNE. "Skeptical of the Spectacle." *The Act* 2, no. 4 (1990): 36-42.

Is spectacle "a grand display of empty sentiment?" Answers using her own performance project *The Crazy Quilt* and artists Judy Chicago, Christo, Judy Baca, Lynn Hershman, Merle Ukeles, et al., and discusses scores of large-scale performances between 1985 and 1990, including John Reed's *Paterson Strike Pageant*, to make her telling points about media and mass psychology. Includes Barbara Krueger, Jenny Holzer, Robert Longo, and Newton and Helen Harrison. Her main concern is creating an alternative voice–the strategy of spectacle–appropriate to our times.

693 LADUKE, BETTY. "Latin America." In *Women Artists of the World*, edited by Cindy Lyle, Sylvia Moore, and Cynthia Navaretta. New York: Midmarch Art Press, 1984, pp. 135-139.

Discusses how throughout the Americas rural and urban women are reshaping traditional crafts and fine-arts media.

694 LADUKE, BETTY. "Women, Art, and Culture in the New Grenada." *Latin American Perspectives* 11, no. 3 (1984): 37-52, 4 illus.

Following the revolution of 1979, art and culture became the focal points of policies to raise levels of literacy, promote social equality, and stimulate nationalism. The new role played by women in this process was essential. LaDuke evaluates the efforts of several women artisans and artists in Grencraft, the Grenadian Arts and Crafts Centre, to meet the goal of the revolution.

695 LADUKE, BETTY. "Edna Manley: The Mother of Modern Jamaican Art." *Woman's Art Journal* 7, no. 2 (Fall 1986-Winter 1987): 36-40.

Describes Manley's political role in Jamaican life and culture, citing her work of the twenties and thirties as symbolic portrayals of the Jamaican people's struggle to free themselves from English colonial rule. Discusses the impact of Norman Manley's death in 1969 on her work, comparing Manley's art with that of Kollwitz's post-World War I protective-mother series.

696 LADUKE, BETTY. "Lois Mailou Jones: The Grande Dame of African-American Art." *Woman's Art Journal* 8, no. 2 (Fall 1987-Winter 1988): 28-32, 4 illus.

Discusses the then 82-year-old black artist's life and career. Comments on her discovery of African masks in a Parisian art gallery, racism in America, her connection to the "New Negro Movement," and her use of her African heritage as the theme for her work. Cites *Ubi Girl from the Tai Region* (1972) as embodying the old and new Africa in Jones' work.

697 LADUKE, BETTY. "Susanne Wenger and Nigeria's Sacred Osun Grove." *Woman's Art Journal* 10, no. 1 (Spring-Summer 1989): 17-21.

Discusses Wenger's forty-year love affair and spiritual relationship with the Yoruba and their religious beliefs. Her freestanding sculptures and shrines, are integrated into the sacred Osun Grove.

698 LALLIER, ALEXANDRA DE. "Dorothy Gillespie: The Shape of Festivity." *Woman's Art Journal* 3, no. 2 (Fall 1982-Winter 1983): 49-54, 3 illus.

Traces the career of Dorothy Gillespie (b. 1920), painter, sculptor, environmental artist, filmmaker, educator, and lecturer. Discusses

her involvement with the women's art movement and several of her works, concluding that her art expresses the pure joy of creativity.

699 LALLIER, ALEXANDRA DE. "Fay Lansner: Woman as Metaphor." *Woman's Art Journal* 7, no. 2 (Fall 1986-Winter 1987): 41-46.

Fay Lansner's art is a continuum of inquiring allegories that reflect the inner states and psychic struggles of twentieth-century women. Traces Lansner's development as an artist, including her studies in aesthetics with Suzanne Langer at Columbia University in New York and Hans Hofmann in Provincetown and her friendships with Elaine de Kooning, Grace Hartigan, and Joan Mitchell. Examines Lansner's attitudes toward feminism during the 1960s and 1970s, exploring the transformative nature of her floating figures and dreamlike paintings. During the 1980s, the artist "has stepped back to let the individuality of a particular woman come through and represent a common identity."

700 LALUMIA, MATTHEW. "Lady Elizabeth Thompson Butler in the 1870s." *Woman's Art Journal* 4, no. 1 (Spring-Summer 1983): 9-14.

Discusses Elizabeth Thompson's *The Roll Call* and other works from a feminist perspective, in the context of changing British attitudes toward the military, and in terms of social-realist art.

701 LANGDON, A. R. "Feminist Art: What Is It? Where Is It?" *Women Artists News* 8, no. 5-6 (Summer 1983): 22.

Four years after the opening of Judy Chicago's *The Dinner Party*, there is still no extensive feminist art circuit in the United States. Author blames the system of patronage and market for this. Asserts that women must not lose heart and must use feminist art as a means to revive and preserve the creative inner spirit of women.

702 LANGER, SANDRA. "Sexual Politics." *Women's Studies and The Arts*. New York: Women's Caucus for Art, 1978, pp. 15-18.

A first-hand account of what pioneering in women's studies in the state of Florida required from women scholars in the 1970s. Includes a discussion of academic politics and sexual harassment "southern style."

703 LANGER, SANDRA. "The Sister Chapel: Towards a Feminist Iconography, with Commentary by Ilise Greenstein." *Southern Quarterly* 17, no. 2 [Special Issue: Art and Feminism in the South] (Winter 1979): 28-39, 40-41, 2 illus.

Sister Chapel by Ilise Greenstein and thirteen other women is an attempt to show women's experience, biologically, psychologically, sociologically, and physiologically, through images created by a

diverse group of artists. It consists of Greenstein's 18-foot circular ceiling piece and eleven additional 9' x 5' paintings showing various images of women as depicted by May Stevens, Diana Kurz, June Blum, Sylvia Sleigh, and other women artists. See Orenstein.

704 LANGER, SANDRA. "Emerging Feminism and Art History." *Art Criticism* 1-2 (Winter 1979-80): 66-83.

One of the first overviews to present the conservative and radical perspectives that emerged during the 1970s. An important historical essay that should be read in conjunction with Thalia Gouma-Peterson and Patricia Mathews's "The Feminist Critique of Art History" (entry 584) to gain some perspectives on feminism, art history, and feminist art criticism. Examines the premises and methods underlying four feminist-inspired histories of women's art in an effort to better understand the relationship between feminism, women's studies in the arts, and the general discourse of art history as a whole.

705 LANGER, SANDRA. "The Avant-Garde: Twelve in Atlanta." *Contemporary Art/Southeast* 2, no. 4-5 (1980): 28-29.

Discusses the work of several important regional feminist artists, among them performance artist Alison Pou and conceptual artist Julia Fenton.

706 LANGER, SANDRA. "Fashion, Character and Sexual Politics in Some Romaine Brooks' Lesbian Portraits." *Art Criticism* 1, no. 3 (Spring 1980): 25-40.

A generative essay on lesbian perceptions in art and life during the early twentieth century. Argues for a more informed reading of Brooks's self-portrait – as ironic rather than suicidal – and for a reinterpretation of the portraits of Una Troubridge, Natalie Barney, and other lesbians from the perspective of dress as an identity code and a representation of lesbian empowerment and life-styles instead of reading the work through heterosexist politics as usual.

707 LANGER, SANDRA. "Women Artists in All Ages and Countries: Re-viewed." *Woman's Art Journal* 1-2 (1980-81): 55-58.

A critical and historical analysis of Mrs. Elizabeth Ellet's famous art-historical study of 1859, from a feminist point of view.

708 LANGER, SANDRA. "Against the Grain: A Working Gynergenic Art Criticism." *International Journal of Women's Studies* 5, no. 3 (1982): 246-64. Reprinted in *Feminist Art Criticism*, ed. Arlene Raven, Cassandra Langer, and Joanna Frueh (entry 112), pp. 111-31, 2 b&w illus.

The basis of this article was an essay on art history that appeared in *Art Criticism* 1, no. 2 (1979). One of the first overviews to suggest strategies and a series of methodological questions for future feminist art historians and critics to ask themselves. Feminist practice is demonstrated through an examination of theory, sexuality, and maternity in the works of a select group of women critics and artists.

709 LANGER, SANDRA. "Paul Cadmus." *Art Papers*, March-April 1982, 17-18, 2 illus.

A feminist and psychoanalytic critique of the gay male gaze and sexual politics as embodied in Paul Cadmus's work, and his desire for the male.

710 LANGER, SANDRA. "Harmony Hammond: Strong Affections." *Arts Magazine* 57, no. 6 (February 1983): 122-23, 4 illus.

An overview and counterargument to phallic interpretations of lesbian feminist artist Harmony Hammond's work.

711 LANGER, SANDRA. "Against the Grain: A Working Feminist Art Criticism." In *Feminist Visions: Toward a Transformation of the Liberal Arts Curriculum*, edited by Diane Fowlkes and Charlotte S. McClure. Birmingham: University of Alabama Press, 1984, pp. 84-96.

Proposes a few tentative steps toward formulating a redefinition, working theory, and methodology of feminist art criticism (i.e., "What implicit assumptions underlie my definition of a specific art-historical problem?").

712 LANGER, SANDRA. "Salving Our Wounds: Maternal Patronizing and the Women's Movement." *Redact* 1, no. 1 (1984): 111-14.

Reviews and discusses *American Women Artists* by Charlotte Streifer Rubinstein. The book, despite its many useful aspects as a reference, fails because it falls back on patriarchal art-historical methodology and structure (i.e., accepting validity of style rather than discussing ideology of taste and how it affected women artists). It is full of jargon and uses heterosexually sanctioned language (i.e., "alternative lifestyles" instead of gay, lesbian, or homosexual), and its treatment of women of color also leaves much to be desired. Langer argues that feminists who reviewed this book appeared willing to create an overly therapeutic community in which an air of permissiveness allowed questionable and just-plain-timid work to pass as substantial criticism.

713 LANGER, SANDRA. "Berenice D'Vorzon." *Arts Magazine* 58, no. 6 (February 1984): 4.

Sexual politics and the art of landscape as organic metaphor in the gestural realism of abstract energist painter Berenice D'Vorzon.

714 LANGER, SANDRA. "Diana Kurz." *Arts Magazine* 58, no. 6
 (February 1984): 14.
 The artist's work is a model of feminist criticism in action in
 relation to her choice of subject matter (pottery) and its relation to
 cultural history.

715 LANGER, SANDRA. "The Mythology of Success: A Gynaesthetic
 Reading." *WARM Journal* [Success Issue], Autumn 1984, 4-5.
 Speculates on what a feminist philosophy of succeeding might
 embody. Suggests replacing the label "success" with the actuality of
 "growth." Urges women to get disentangled from patriarchal value
 systems, define themselves, and focus their energies on what they
 want rather than sell themselves out for false security. Argues against
 "bon marché criticism," for networking, for self-definition, for
 alternatives, and against the "cockocracy."

716 LANGER, SANDRA. "Cecily Cecil." *Arts Magazine* 59, no. 9 (May
 1985): 16.
 Deals with sexual imagery and creative freedom in the works of
 French artist Cecily Cecil, who paints covertly and overtly sensual
 female subjects engaged in a variety of erotic lesbian activities.

717 LANGER, SANDRA. "Is There a New Feminist Criticism?" *Women
 Artists News* 10, no. 6 (September 1985): 4-5, 1 illus.
 Looks at the development of a modern feminist theory of art
 criticism, stressing the difficulties of definition. Argues that feminist
 art critics will have to explore uncharted territory in order to develop
 a system of values outside those defined by the male art
 establishment. The hope is to develop a critical discourse that
 respects differences rather than represses them.

718 LANGER, SANDRA. "Harmonious Imagination: Paintings by
 Robert de Niro." *Arts Magazine* 60, no. 9 (May 1986): 28-33.
 Male art interpreted from the perspective of feminist art criticism,
 with particular notice given the young turks of postmodern criticism
 and de Niro's connection to the feminine through his identification
 with the actress Greta Garbo.

719 LANGER, CASSANDRA L. "Beyond the Myth: The
 Unacknowledged Georgia O'Keeffe." *Kansas Quarterly* 19, no. 4
 [Special Issue: Georgia O'Keeffe & Other Women Artists] (1987):
 11-23.
 Argues that O'Keeffe's early academic training has been grossly
 neglected in service of the modernist mythology that Alfred Stieglitz
 fostered and she herself later helped to perpetuate. Shows how

academic art and William Merritt Chase influenced her aesthetics and shaped her practice as a modern artist.

720 LANGER, CASSANDRA. Review of *Crossing Over: Feminism and Art of Social Concern*, by Arlene Raven (entry 193). *Women Artists News* 13, no. 2 (Summer 1988): 37.

Reviews an important collection of critical essays. Discusses essays on rape and healing, citing Raven's significance and contributions to feminist art criticism.

721 LANGER, CASSANDRA. "Teaching about Women and the Visual Arts." *Women Artists News* 13, no. 2 (Summer 1988): 37-38.

Reviews a collection of essays edited by Thalia Gouma-Peterson, including work by Faith Ringgold, Christine Havice, Mary Garrard, Norma Broude, Ferris Olin, and other feminists, scholars, and educators.

722 LANGER, CASSANDRA. "Autobiography: In Her Own Image." *Women Artists News* 13, no. 3 (Fall 1988): 26-27.

Review of Howardena Pindell's exhibit at INTAR gallery, May 1988. Multicultural poetry and politics that attempt to rescue otherness from the postmodern. Includes a catalog and works by Ana Mendieta, Theresa Hak Kyung Cha, Sophie Rivera, Asiba Tapahache, Pena Bonita, Yong Soon Min, Lorna Simpson, Emma Amos, Camille Billops, Margo Machida, Clarissa Sligh, Janet Henry, Vivian Browne, Adrian Piper, Claudia Alvarez, Marina Gutierrez, and others.

723 LANGER, CASSANDRA. "Berenice D'Vorzon." *Women Artists News* 13, no. 3 (Fall 1988): 25-26.

Review of new paintings at Vered Gallery, East Hampton, N.Y., May 1988. Examines the critical relationship between D'Vorzon's Dionysian impulses and Igor Stravinsky's *Rites of Spring* as landmarks. These heathen musings on the creation myth, using swamps as subjects, necessarily make us conscious of life in death, female sensuality, and spirituality. See Wilding.

724 LANGER, CASSANDRA. "Yesterday: Reflections on Asian Childhood." *Women Artists News* 13, no. 3 (Fall 1988): 26.

Review of exhibition at Asian Art Institute, N.Y., 1988. Discusses ambivalence and identity in relation to the New York art scene and negotiating the contradictions between two cultures. Catalog includes a sensitive essay by poet Kimiko Han and work by Yoshiki Araki, Byron Kim, Amy Cheng, Carol Sun, Gordon Wong, Carrie Yanaoka, Hugo Kobayashi, Lanie Lee, Kyung-Lin Lee, Charles Yuen, John Nakazawa, Anna Kuo, and Mary Lum.

725 LANGER, CASSANDRA. "Nancy Spero: Work since 1950." *Women Artists News* 14, no. 3 (Fall 1989): 13.

Nancy Spero's art, like Saint Joan's crusade, is original and presumptuous. She is an outspoken feminist in an era where the F word (feminism) has been rehabilitated by fashionable postmodernism and declared passé. She has an unbounded and unconcealed contempt for official patriarchal systems of value and authority and it shows in every probing image she constructs. What is most striking about her morality is the directness of the message – for her, avoidable wrongs are simply something to be done away with by general consent.

726 LANGER, CASSANDRA. "O'Keeffe, Stieglitz, and the Critics, 1916-1929." *Women Artists News* 14, no. 3 (Fall 1989).

If phallic criticism can be said to have created the myth of Georgia O'Keeffe, here at last is a book that unravels the tangled web. See Lynes.

727 LANGER, CASSANDRA. "Sarah Schulman – 'Salome.'" *High Performance*, Fall 1990, 57.

Reviews Sarah Schulman's feminist burlesque of Wilde's gay misogynist fantasy, asking why Salome wants the head, and how creating a dialogue between the two women changes how we receive the play. Discusses female representation in Wilde and the gender reversal in the dance. Concludes that the irony falls short of the mark due to the actors.

728 LANGER, CASSANDRA. "Turning Points and Sticking Places in Feminist Art Criticism." *College Art Journal* 50, no. 2 (Summer 1991): 21-28, 4 illus.

An overview of the state of feminist art criticism from 1969 to the present as seen through the author's experience as a working feminist art critic. Discusses the work of Suzanne Lacy, Adrian Piper, Nancy Spero, Hanna Wilke, Ana Birnbaum, Ana Mendieta, Betye Saar, and other women artists in relation to critics including Donald Kuspit, Arthur Danto, Craig Owns, Hal Foster, Arlene Raven, Joanna Frueh, and Camille Billops, the changing frontiers in feminist art criticism, essentialism and social constructions of culture, postmodernism, Jeff Koons, David Salle, Barbara Kruger, Cindy Sherman, feminism, racism, sexism, the state of feminism today, and strategies for the 1990s, particularly as regards coalitions between women of color and the push for social change.

729 LANGER, CASSANDRA. "Ann Papoulis, Medea: A Solo Physical Theater Play." *High Performance* 14, no. 4 (Winter 1991): 50.

Papoulis creates a visualization of women's oppression through her retelling of the Medea myth. This is an antimilitarist, lavish, and passionate portrayal that teaches women what they have forgotten about empowerment.

730 LANGER, CASSANDRA. "Christina Schlesinger: Painting from the Birch Forest." *Women Artists News* 15, no. 4 (Winter 1991): 11, 1 illus.

Schlesinger's new work embodies matter and spirit. Discusses the sexually charged undercurrent that blazes through her depictions of trees and the landscape.

731 LANGER, CASSANDRA. "Jane Kaufman: Quilted Pieces and Screens." *Women Artists News* 15, no. 4 (Winter 1991): 9, 14.

Discusses the problems feminist artists have getting reviewed, elitism in New York City, and Kaufman's minimalist roots. Comments on the artist's use of craftart, her sense of humor, and the political significance of her art, which documents and celebrates women's lives and beliefs.

732 LANGER, CASSANDRA. "Mexico: Gender, Culture, and Society." *Women Artists News* 15, no. 4 (Winter 1991): 20-21.

Discusses the symposium at the National Academy of Design for Women in Mexico. Panelists included Sarah Lowe, Hayden Herrera, Jean Franko, Janet Kaplan, Mary Anne Martin, and Elena Climent. In the question-and-answer session, questions of sexual freedom, particularly concerning Frida Kahlo's love for women, appeared to disturb some of the participants.

733 LANGER, CASSANDRA. "The Queer Show." *Women Artists News* 15, no. 4 (Winter 1991): 6-7, 1 illus.

Discusses Wessel O'Connor Gallery's "Queer Show," which took place in September 1990. Langer was glad to see that the problem of lesbians being deprived of a political existence through "inclusion" as female versions of male homosexuality was finally being raised. Laments the lack of balance vis-à-vis male and female in the exhibit. Chooses to discuss works by Martha Fleming and Lyne Laponte, Linda Matalon, Marcia Salo, Carrie Yamaoka, Millie Wilson, Eve Ashcraft, and Melissa Harris and includes Robert Marshal and Hunter Reymond. Giving gay and lesbian artists a fair showing is commendable, but it would be nice to expand the audience's narrow definition of "queer" art to embrace a large number of varieties within physical and sensuous facts.

734 LANGER, CASSANDRA. "Women in Mexico/La Mujer en Mexico." *Women Artists News* 15, no. 4 (Winter 1991): 2-4, 2 illus.

Discusses National Academy of Design exhibition, which features more than one hundred works by twenty-two women artists. Includes Maria Izquierdo, Frida Kahlo, Olga Costa, Remedios Varo, Leonora Carrington, Lola Alvarez Bravo, Graciela Iturbide, and Tina Modotti. Discusses Edward Sullivan's essay and the savage realities depicted by these women. Concludes that the show ventured too little and its pseudo-Mexicanism was hard to accept, but it was to be applauded for creating an opportunity for a wider audience to become familiar with some women artists working in Mexico. (See also exhibition catalog, entry 326).

735 LANGER, CASSANDRA. "Reflections on Gender: Mary Kelly's *Interim." Woman's Art Journal*, Spring-Summer 1992.
Critique of Mary Kelly's *Interim* at the New Museum of Contemporary Art, 16 February-8 April 1990. Examines the position of woman in middle age that Kelly has created, criticizing it for its reliance on French male-derived theory, its exclusive application of English feminist ideology, and it's reliance on strategy at the expense of women's feelings and experience, and because it seldom comes to grips with the question of what form women's power and authority will or might take.

736 LANGER, CASSANDRA. "Transgressing Le Droit du Seigneur." Forthcoming in *Feminist Criticism Now: Identity, Art, Action*. Harper/Collins, 1993.
Examines the postmodern theory of the gaze as male, analyzing it from the point of view of a number of self-identified lesbian feminists. Discusses how a lesbian gaze might differ from the standard heterosexual and gay-male models and their assumptions, using works by Gustave Courbet, J.A.D. Ingres, Hiram Powers, Paul Gauguin, and others to illustrate central points; contrasts them with works and statements by Harmony Hammond, Marcia Salo, and other lesbian feminists who were shaped by the sixties and seventies. Using Romaine Brooks's art and life, Langer critiques heterosexist readings of lesbian art and offers an alternative methodology to patriarchal models of art history and criticism. The most threatening thing about the essay is its theoretical foregrounding of gynocentric difference (prismatic criticism) as an alternative to patriarchal universalism.

737 LARIEUX, J. M. "Women Painters: Five Centuries of Fighting to Have Another Vision of Art Recognized." *Arts*, no. 26 (10 July 1981): 8-9, 2 illus.
Traces history of female artists from the Middle Ages through succeeding centuries. Examines how the role of the female artist gradually expanded. Confronts the obstacles faced by women wanting

to be professional artists. Concludes by raising the question of the existence of a feminine art and emphasizing changes in attitudes due to the women's liberation movement.

738 LARSON, KAY. "For the First Time Women Are Leading Not Following." *Artnews* 79, no. 8 (October 1980): 64-72.

Examines the "shock tactics" used by feminist artists to pave the way for a new era in which women artists themselves began to define what art should be. Argues that far from displacing men, female leadership in the arts has opened up new avenues of exploration for all artists. Illustrates this by showing seminal works by both male and female artists.

739 LASCAULT, G. "Meret Oppenheim." *XXe Siècle* 37, no. 45 (December 1975): 148-49, 4 illus.

In French, with a summary in English. Describes Oppenheim as a "painter-sorceress," emphasizing her affinity with the night, which is expressed through her use of black. Illustrates her attitude towards woman's struggle for independent recognition through selected extracts from letters to Alain Jouffroy. See J. Withers and Robert J. Belton, "Androgyny: Interview with Meret Oppenheim" in *Surrealism and Women*, ed. Mary Ann Caws.

740 LASSEN, H. "Ornamentation as a Feminine Means of Expression?" *Louisiana Revy* 25, no. 3 (July 1985): 48-53, 70, 13 illus.

Summary in English. An essay published on the occasion of the exhibition "Homo Dekorans: Det Dekorerende Menneske" at the Louisiana Museum, Humlebaek, Denmark (6 July-1 September 1985). This issue of *Louisiana Revy* served as the catalog for the exhibit. Questions the traditional ways women use ornamentation and concludes that there are just as many examples of male use in both the past and the present. Claims, however, that there may be certain areas in which women express themselves differently from men, for example in the use of organic or female sexual symbols and in the use of repetition. Also attempts to explain the renewed interest in ornamentalism. RILA.

741 LEACH, J. "Harriet Hosmer: Feminist in Bronze and Marble." *Feminist Art Journal* 5, no. 2 (Summer 1976): 9-13, 44-45, 5 illus.

Account of nineteenth-century sculptor Harriet Hosmer's life and career, from her childhood in Watertown, Massachusetts, to her death in 1908. Hosmer's career as a sculptor began with *Hesper* (1850), and continued with the works made in Rome under the tutelage of John Gibson including *Daphne, Medusa, Beatrice, Cenci*, and *Zenobia, Queen of Palmyra*, all of which gained Hosmer a high reputation. Illustrates how these successes allowed the sculptress to

achieve financial and personal independence and to set a precedent for other American women artists such as Margaret Foley, Louisa Lander, and Anne Whitney.

742 LEADER, BERNICE KRAMNER. "Antifeminism in the Paintings of the Boston School." *Arts Magazine* 56, no. 5 (January 1982): 112-19, 9 illus.

From about 1890 to 1918, the Boston school specialized in painting idealized female figures. Using the paintings of Edmund Charles Tarbell, Frank Weston Benson, Joseph Rodefer Decamp, William McGregor Paxton, Philip Leslie Hale, and their students, Leader analyses their meaning against the backdrop of the women's suffrage movement. She demonstrates that these male artists were unable or unwilling to face the complex realities of the expanded sphere of influence wielded by Boston women and chose to portray them as beautiful dreamers rather than energetic reformers, thus transforming the real Boston lady into an ideal of womanhood closer to male representations of the feminine demanded by both conservative male patrons and artists. Concludes that the "Remonstrance Movement" was clearly antifeminist and the paintings of the Boston School reinforced the Brahmin status quo regarding women's place in the scheme of things.

743 LERMAN, ORA. "Autobiographical Journey: Can Art Transform Personal and Cultural Loss?" *Arts Magazine* 59, no. 9 (May 1985): 103-7.

Lerman discusses individual artists' work including Ruth Weisberg's rediscovery of her Jewish heritage and her own ethnicity, demonstrating how art can resolve conflicts of identity and reclaim heritages lost through cultural assimilation and patriarchal mandates that neglect women's role in culture and life cycles, including Jewish and Greek traditions.

744 "Lesbian Art and Artists." *Heresies* 1, no. 3 (Fall 1977): 38-49, 7 illus.

Several artists describe what it means to them to be lesbian artists, including Jane Stedman, Maryann King, Ellen Ledley, Sandra Desando, Janice Helleloid, Monica Sjoo, Debbie Jones, Amy Sillman, and Phylane Norman.

745 LEVIN, E. "Judy Chicago: *The Dinner Party*." *Ceramics Monthly* 27, no. 6 (June 1979): 46-49, 9 illus.

Describes the development of the idea and the many techniques and forms–embroidery, ceramics, and china painting–used by the women artists who worked on the project.

746 LEVINE, L. "Dallas Has the Airport But Houston's Got the Art: Lone Star Four." *Arts Magazine* 48, no. 6 (March 1974): 30-39, 7 illus.

Draws attention to the spread of significant activity in contemporary American art far beyond the confines of New York City. Provides personal portraits of four women, three of whom are gallery owners and one of whom is a patron: Mrs. John de Minil (with particular reference to the Rothko Chapel in Houston), Janie C. Lee and Barbara Cusack (both owners of new Houston art galleries), and Fredericka Hunter (director of the Texas Gallery, Houston).

747 LIKOS, PAT. "Sexism at the First Woman's Art College." *Feminist Art Journal* 4, no. 3 (Fall 1975): 34-35.

Describes Likos's education at Moore College of Art, at which less than ten percent of the faculty were women. Students' work was criticized as being "feminine." Likos discusses the double-bind situation of male faculty offering constructive criticism with sexual advances as the norm, and notes that the work of founding director Emily Sartain was ignored. Repressive techniques such as harassment and accusations of mental illness were used against the students and faculty who dared to combat the situation.

748 LINDQUIST-COCK, ELIZABETH, and JUSSIM, ESTELLE. "Machismo in American Architecture." *Feminist Art Journal* 3, no. 1 (Spring 1974): 9-10, 4 illus.

The authors define "machismo" as the "hyped-up, swaggering super-male stereotype usually associated with Latin Americans and the certified U.S. movie-hero cowboy." They then examine the reasons for the vogue for skyscrapers. They point out that women are almost totally excluded from the profession of architect, and suggest that the desire for bigger skyscrapers is a symbol of man's desire for domination. This type of architecture is seen to have originated in the ideas of poet Walt Whitman (who was gay) and the work of architect Louis Sullivan. Argues that Sullivan's theories would ultimately lead to "the worship of the phallus." The authors argue for the creation of a more humane and environmentally conscious architecture.

749 LINKER, KATE. "Representation and Sexuality." In *Art After Modernism: Rethinking Representation*, edited by Brian Wallis. New York: New Museum of Contemporary Art; Boston: David R. Godine, Publisher, Inc., 1984, pp. 391-415, 8 illus.

Argues from a postmodern perspective that the death of the author has encouraged a model based on a reader who is positioned to receive and construct the text, a historically formed reader, shaped in and through language. Focuses on sexuality in relation to meaning, language, and discourse. Asserts that woman (from a theoretical

point of view) is unauthorized, illegitimate, and represented. Uses Jacques Lacan and his rewriting of Freud as a basis. Cites Mary Kelly's *Post-Partum Document* as central to disruption of the maternal discourse. Includes work by Victor Burgin, Silvia Kolbowski, and Barbara Kruger. Addresses the masquerade as a representation of male desire in Kolbowski's work and woman as constructed by the social "other" in Kruger's disjunctive practices, within the register of sexuality.

750 LINKER, KATE. "Eluding Definition." *Artforum* 23, no. 4 (December 1984): 61-67, 9 illus.

Considers the shift in feminist aesthetic from a sense of the personal to one formed by the male-established system and structure, with particular reference to the writings of French theorist Jacques Lacan. She also explores the work of the artist Louise Lawler who challenges the notion of the artistic text by noting its dependence on the outside world through titles, labels, and other parts of language. These ideas are seen as both agreeing and disagreeing with certain aspects of contemporary feminism. Other artists discussed include Annette Lemieux and Mary Kelly.

751 LIPPARD, LUCY. "Why Separate Women's Art?" *Art and Artist* 8, no. 7 (October 1973): 8-9, 6 illus.

Lippard believes that the current focus on specifically women's art in exhibitions or classes will not be necessary in a few years' time, and she finds "women's" shows, like "black artist's" shows, not any more discriminatory than any other group exhibitions: the art should speak for itself regardless of labels. What is disturbing is the discriminatory absence of women's work from major galleries and museums. She believes that the different social and biological experiences of women will produce an art that can be differentiated from that of men and that will reveal what women's sensibilities might be, though it will be too diverse for any blanket description.

752 LIPPARD, LUCY. "Ree Morton at the Still Point of the Turning World." *Artforum* 12, no. 5 (December 1973). Reprinted in *From the Center*, by Lucy Lippard (entry 150).

A retrospective overview tracing southern artist Ree Morton's ideas, realities, and maturation as a woman and artist through the artist's own diaries, letters, and observations and Lippard's own impressions of Morton and the development of her work.

753 LIPPARD, LUCY. "Six." *Studio International* (London) 187, no. 963 (February 1974): 96.

An examination of art by women that expresses their social and biological experience. Argues that women are trying to transcend the

stigma of inferiority that still governs attitudes towards them. Claims women hesitate to use their sexual identities in their art for fear of being branded as inferior. Lippard believes sexual identity is as much a part of them as their minds and must be expressed. Women should create their own system within which their so-called "illogicalities" will become logical.

754 LIPPARD, LUCY. "More Alternate Spaces: The L.A. Woman's Building." *Art in America* 62, no. 3 (May-June 1974): 85-86, 2 illus.

Discusses work being done by and for women artists in California. "Womanspace" holds an "open wall" for women artists in Los Angeles where work in a variety of styles is exhibited and where a collection of slides of women's work was enthusiastically received. Includes a general survey of the galleries and magazines that represent women's art to the American public, and examples of sex discrimination. Defends the separatist nature of the women's art movement on the grounds that as women open up and become more imaginative and assertive, in a single-sex environment they will become strong enough to cope with the realities of a sexist society.

755 LIPPARD, LUCY. "Judy Chicago Talking to Lucy Lippard." *Artforum* 13, no. 1 (September 1974): 60-65, 10 illus.

Texts from a taped conversation recorded between Judy Chicago and Lucy Lippard in Georgetown in September 1973. Chicago discusses the development of her work since 1963, her attitude toward women's art, changes in the materials and technique of her work, the reason behind writing on the canvas, female imagery, and the distinction between women's art and men's art.

756 LIPPARD, LUCY. "Yvonne Rainer on Feminism and Her Film." *Feminist Art Journal* 4, no. 2 (Summer 1975): 5-11, 3 illus.

An account of Rainer's work in dance and film. Stresses Rainer's film about "A Woman Who" merges images and words. Lippard focuses on Rainer's experience as a woman and hesitant feminist. Rainer comments on her own use of repetition and narcissism. She believes turning autobiography into fiction avoids narcissism. Her combination of style and psychological insight pushes at the formal barriers of the detachment she believes masquerades as "modernism."

757 LIPPARD, LUCY. "Clouds over Whitney Again ... Rocky Times Ahead." *Women Artists Newsletter* 1, no. 9 (February 1976): 1, 5.

Describes picketing the Whitney Museum of American Art, New York, because of its bicentennial exhibition of the John D. Rockefeller III collection, purporting to represent "Three Centuries

of American Art" when it contained only one work by a woman and none by black artists. See *Forever Free* (entry 282).

758 LIPPARD, LUCY. "The Pains and Pleasures of Rebirth: Women's Body Art." *Art in America* 64, no. 3 (May-June 1976): 73-81, 14 illus.
 Patriarchal culture has often rejected feminist art, labeling it retrograde or "radical." Women had a hard time realizing the potential of body art because their perceptions of themselves and their bodies were shaped by man-made representations. Their attempts at body art were considered narcissistic. Criticizes men's exploitation of women in the field of body art and asserts that female unease about roles generally takes the form of gentle self-exploration or transformation, whereas anxiety in men takes a violent, self-destructive form. Lippard comments on the conspicuous absence of pregnancy or childbirth as a theme. See Madeleine Cottenet-Hage, "The Body Subversive: Corporeal Imagery in Carrington, Prassinos and Mansour" in *Surrealism and Women*, ed. Mary Ann Caws, Rudolf Kuenzli, and Gwen Raaberg (Cambridge, Mass., and London: MIT Press), 1991.

759 LIPPARD, LUCY. "Projecting a Feminist Criticism." *Art Journal* 35, no. 4 (Summer 1976): 337-39.
 One of the most coherent early assessments of feminist art and its criticism. Quotes architect Susana Torre, who explains, "Maybe existing forms of art for the ideas men have had are inadequate for the ideas women have." Although Lippard offers no solutions, she raises some very interesting questions, which are presently being answered by a younger generation of feminist art critics.

760 LIPPARD, LUCY. "The Pink Glass Swan: Upward and Downward Mobility in the Art World." *Heresies* 1, no. 1 (January 1977): 82-87. Reprinted in *Feminist Collage*, ed. Judy Loeb (entry 113).
 Marxist analysis. Argues that the art world has evolved its own class system, with possession as the end goal, "appreciation" as an instrument of upward social mobility, and "making" at the bottom of the scale. Artists identify themselves as "workers" while believing that art is "above it all," see themselves as superior to buyers/owners and middle-class art students, disguise themselves as working-class men, and produce pop art, process art, and conceptual art, all against "art for the rich" but bearing no relation to the working-class value system. See Cockcroft.

761 LIPPARD, LUCY. "Making Something from Nothing: Towards a Definition of Women's Hobby Art." *Heresies* 1, no. 4 (Winter 1978): 62-65, 4 illus.

Refers to three books: *How to Make Something from Nothing* by Mae and Frank B. Grifith, *Creating with Cattails, Cones and Pods* by Dot Aldrich, and *Feather Flowers and Arrangements* by Hazel Pearson Williams. Looks at traditional definitions of "art" and "women's art" in relation to creative craft and the decorative aspects of women's work. Suggests that the work of feminist artists will lead to an exchange in these definitions and changes in consciousness will reorient criteria of taste, which will not be standardized by patriarchal institutions, but will vary from home to home.

762　LIPPARD, LUCY. "Some Propaganda for Propaganda." *Heresies* 4, no. 1 (1980): 35-39, 6 illus. Reprinted in *Visibly Female*, ed. Hilary Robinson (entry 223), pp. 184-94.

Some of today's most successful propaganda combines words and images (i.e., comic strips, slide shows, photo-novels, film, television, and posters). Visual artists have begun to reconsider styles of communication that formerly seemed to belong to other realms. To face these issues artists have had to overcome the modernist taboo against "literary" art, which surrounds almost all art with political/social intentions. Lippard shows how feminists approach these problems and how they can initiate media strategies that use routes opened by media propaganda for social change. See Linker; Lacy.

763　LIPPARD, LUCY. "Judy Chicago's 'Dinner Party'." *Art in America*, no. 4 (April 1980): 114-26, 13 illus.

Judy Chicago's large installation *The Dinner Party* is a cooperatively executed movable feast of sculpture, ceramics, china painting, and needlework whose subject is the history of women through Western civilization from prehistoric times. It successfully integrates a strong aesthetic with powerful political content. Describes the thirty-nine place settings and runners. Explores multiple levels of meaning of this piece and implications for the establishment of new art and historical contexts, based on women rather than men.

764　LIPPARD, LUCY. "Sweeping Exchanges: The Contribution of Feminism to the Art of the 1970s." *Art Journal* 40, no. 1-2 (Fall-Winter 1980): 362-65.

Assesses the extent of the feminist contribution to the avant-garde and/or modernist arts of the 1970s; shows the ways these artists attacked hierarchical and sexist structures of art institutions and practices and pointed the way toward new concepts. Argues that whether the new approaches or models be socialist or nonsocialist, they can never work if they stop short of social change. See Cassandra Langer, "Turning Points and Sticking Places" (entry 728).

765 LIPPARD, LUCY. "Sex and Death and Shock and Schlock."
 Artforum 19, no. 2 (October 1980): 50-55, 13 illus.
 Gives a brief account of the art and organization of the 1980
 "Times Square show" as well as commenting on its iconography of sex
 and violence from a feminist point of view.

766 LIPPARD, LUCY. "Binding/Bonding." *Art in America* 70, no. 4
 (April 1982): 112-18, 7 illus. Version of an article first published in
 the catalog of Harmony Hammond's exhibition at the WARM
 Gallery, Minneapolis, Minn., 1981 (see entry 294).
 Discusses Hammond's work since 1973, from the ragbag figures of
 1970s to the amplitude of her recent swaddled sculptures. Hammond
 works in the area between political content and abstract form.
 Lippard discusses Hammond's transformation of rags into fetishistic
 "bags," accompanied by objects based on women's traditional crafts,
 knitting and weaving. In the early 1970s Hammond produced
 confrontations between art and life in the form of monochromatic
 paintings with a heavy "weave" of paint. These forms are related to
 her lesbianism and her study of the martial arts Aikido and Tai Chi.
 See Langer; Raven.

767 LIPPARD, LUCY. "Both Sides Now [A Reprise]." *Heresies* 6, no. 4
 [Issue 24: 12 Years] (1989): 29-34, 10 illus.
 Claims that difference is the essence of feminism. Discusses
 various positions regarding racism, anti-Semitism, essentialism,
 deconstructivism, and class. Argues that there are some experiences
 "I share only with other women." Sometimes only idealism can
 reclaim the positive and disclaim the negative. Lippard calls for
 experimenting with alternatives and examining our multiple identities
 and how our priorities are constructed. She advocates action. See
 Frueh; Langer; Raven.

768 LIPTON, EUNICE. "Manet: A Radicalized Female Imagery."
 Artforum, March 1975, 48-53.
 This is the first article on Edouard Manet to take seriously the fact
 that his representations of women subvert social as well as pictorial
 conventions. Lipton argues that many of Manet's most compelling
 paintings both offer and withhold time-honored scenarios with their
 promises of satisfaction. On the one hand, he presents naked women
 with clothed men, an odalisque with maid, couples in romantic
 proximity, mothers and children. On the other, his couples ignore
 each other, mothers behave selfishly, naked women refuse the
 possessive male gaze.

769 LIPTON, EUNICE. "The Laundress in Late 19th Century French Culture: Imagery, Ideology, and Edgar Degas." *Art History*, September 1980, 295-313.

Since the eighteenth century, laundresses have been represented in Western art as first and foremost sexually alluring. The discrepancy between these representations and the actual conditions of laundresses' lives is striking. This article examines Edgar Degas's versions of the laundress subject and finds in them an upper-class man's sexual interest in and disdain for working-class women as well as his unmistakable admiration.

770 LIPTON, EUNICE. "One Woman Show." *Women's Review of Books* 6, no. 79 (April 1989): 10-11.

A review of Linda Nochlin's *Women, Art, and Power and Other Essays* (entry 180). Discusses the collection, pointing out the pivotal role Nochlin has had in revisionist and feminist art history, citing her "mischievous juxtapositions, rereading of patriarchal art histories in terms of power relations, the right to dissent, feminist taste, and a host of other barricades in art history that she has courageously and brilliant battled her way across over the last two decades." See Langer.

771 LIPTON, EUNICE. "Representing Sexuality in Women Artists' Biographies: The Cases of Suzanne Valadon and Victorine Meurent." *The Journal of Sex Research* [Special Issue: Feminist Perspectives on Sexuality, edited by Carol Pollis and Carole Vance], February 1990: 81-93.

Lipton examines a critical circuit by which women artists have been excluded from art-historical discourse. By focusing on two women, Suzanne Valadon and Victorine Meurent, we see how critics and art historians have represented those artists first and foremost as women. They are seen as models, mothers, daughters, inviting bodies; they are never represented as subjects, as desiring people, in short, as artists.

772 LIPTON, EUNICE. "Women, Pleasure, and Painting (e.g. Boucher)." *Genders*, Spring 1990, 69-86.

This article makes two proposals: that the lushly sexual paintings of Francois Boucher may be pleasurable and useful to contemporary feminists and that we can extrapolate from these works the power of some rich and educated eighteenth-century women (and what they subsequently lost in the French Revolution).

773 LISS, CARLA. "Show Me Your Dances . . . Joan Jonas and Simone Forti Talk with Carla Liss." *Art and Artists* 8, no. 7 (October 1973): 14-21, 6 illus.

Jonas, Forti, and Liss discuss Jonas's video piece, "Organic Honey's Visual Telepathy," explaining the influence of her feminism and of Japanese No theater on her creativity. Forti describes themes in her own dancing and painting, and both of them develop feminist themes in the light of their own experiences and philosophies.

774 LOACH, ROBERTA. "June Wayne." *Visual Dialog* 2, no. 3 (April-May 1977): 4-8, 4 illus.

A founder of the Tamarind Institute of Printmaking in Los Angeles, June Wayne discusses how she was forced to obscure her own artistic name in the process. Although most people know her as a lithographer, she works in several media. In discussing the feminine sensibility of artists, Wayne insists that she works more from an "outsider's" sensibility, her work not being strictly feminine. In her printmaking she has invented several processes, but she is more interested in the results than the techniques. See Raven.

775 LORBER, ROBERTA. "Women Artists on Women in Art." *Portfolio* 2, no. 1 (February-March 1980): 68-73, 12 illus.

Assesses the status of women in American art. A selection of American women artists at various stages in their careers were asked to express their feelings about the progress – or lack of it – towards artistic equality: Lee Krasner, Nancy Spero, Sari Dienes, Joyce Kozloff, Howardena Pindell, Joan Jonas, Louise Bourgeois, Carolee Schneeman, Betye Saar, Alice Aycock, Colette, and Louise Nevelson.

776 LORD, CATHERINE. "Women and Photography: Some Thoughts on Assembling an Exhibition." *Afterimage* 7, no. 6 (January 1980): 6-13, 16 illus.

Discusses "The Image Considered," which was held at the Visual Studies Workshop, Rochester, New York (19 December 1979-1 February 1980). Among the woman photographers exhibited were Eileen Berger, Alma Davenport, Colleen Kenyon, Ann Rosen, and Jessie Shefrin. Lord discusses the problems of organizing an exhibition dealing with such critical issues as "women's art" or "women's vision" and describes the different ways the exhibitors approached these questions. Concludes that although the questions about women's role in society cannot be answered by such an exhibition, it is crucial that they be asked.

777 LORD, CATHERINE. "What Becomes a Legend Most: The Short, Sad Career of Diane Arbus." *Exposure* 23, no. 3 (Fall 1985). Reprinted in *The Contest of Meaning*, ed. Richard Bolton. (Cambridge, Mass., and London: MIT Press), 1989, pp. 110-123.

Lord asks the questions: "What was made of Diane Arbus? What is her legacy? What does she mean?" Biographical overview of

Arbus's life and career from the perspective of examining the act of writing history.

778 LOUGHERY, JOHN. "Blending the Classical and the Modern: The Art of Elsie Driggs." *Woman's Art Journal* 7, no. 2 (Fall 1986-Winter 1987): 22-26.

A historical and semibiographical overview that discusses Driggs's work in the context of precisionism and her artistic education, particularly the influences of Maurice Sterne, Leo Stein, and Piero della Francesca as they relate to her steel plants and bridges of the late 1920s. Uses *Pittsburgh*, *Blast Furnaces*, and *The Queensborough Bridge* to illustrate the artist's response to the machine age. Discusses her neglect after the Depression and her recent mixed media constructions such as *Roman Graffiti* (1980) and *The Dakota Frame* (1983).

779 LUDLEY, DAVID A. "Anna Jameson and D. G. Rossetti: His Use of Her Herstories." *Woman's Art Journal* 12, no. 2 (Fall 1991-Winter 1992): 29-33, illus.

Ludley documents the discrimination Jameson suffered at the hands of Victorian men, including John Ruskin and Dante Gabriel Rossetti. He cites the striking coincidence of Rossetti's using Jameson's analysis of Giotto as an example of her influence on him and also his annotated copy of Jameson's *Sacred and Legendary Art* (1848). Ludley then goes on to make a very strong case for Jameson's work being operative in shaping Rossetti's tastes in art, and in turn those of the Pre-Raphaelites. He speculates that had Ruskin realized Rossetti's debt to Jameson, whom he despised and toward whom he apparently felt jealousy, he might not have been so cordial to the movement.

780 LUNDE, KARL. "Lorrie Goulet: Themes of Woman." *Arts Magazine* 50, no. 1 (September 1975): 82-83, 2 illus.

Her former dealer argues that Goulet's female nude sculptures present "woman as an object to be contemplated." Her women do not do anything specific – like primordial woman they are concerned with "being rather than doing." Describes several of Goulet's sculptures, including *Estuary* (1972) and *Xenia* (1974). Claims that Goulet is a traditional artist working in stone and is not competing with male criteria for artistic excellence. She has rejected male stereotypes of society, and because of this her "nudes are not sexual objects whose power resides in affecting male creativity." Concludes her sculptures reflect the serenity that she feels is the primary goal of an artist and of life.

781 LYLE, CINDY. "A Window on the World." In *Women Artists of the World*, edited by Cindy Lyle, Sylvia Moore, and Cynthia Navaretta. New York: Midmarch Art Press, 1984, 147 pp., 138 illus.

Discusses three international women in the arts festivals. Included in this collection are many pieces that have appeared in *Women Artists News*.

782 MCGREEVY, LINDA F. "Policing the State: The Art of Sue Coe." *Arts Magazine* 1, no. 6 (February 1987): 18-21.

Discusses sexual politics as critique through the work of Sue Coe, showing that her unbridled feminist iconography is implicitly and explicitly critical of all forms of inhumanity.

783 MACHIDA, MARGO. "Margo Machida: An Artist's Perspective." *Upfront: A Journal of Activist Art* 14-15 [Double Issue] (Winter 1987-Spring 1988): 56-57.

A third-generation Japanese-American discusses her perceptions of America, the New York art world, and her Asian identity in the context of racism and sexism.

784 MACHIDA, MARGO. "(re)Orienting." *Harbour* 1, no. 3 (August/September/ October 1991): 37-43. Reprinted with additions in *New Feminist Criticisms: Art, Identity, Action*, ed. Arlene Raven, Cassandra Langer, and Joanna Frueh (New York: Harper/Collins), 1993.

A summary based on Machida's public symposia series on Asian-American Women Artists held in New York City. Machida describes the fictitious images of Asian women that have been created in American popular culture, for example, Dragon Ladies. Using the work and perceptions offered mainly by artists of Korean, Japanese, and Chinese descent, Machida attempted to open up a dialogue on power, position, ethnicity, and gender. Her essay examines the results of these interactions, including a series of panels formed to foster discussion among artists, critics, art historians, and curators.

785 MCMAHON, HILARY. "Towards a Feminist Art." *Focus: Midwest* 9, no. 59 (1973): 17.

McMahon rejects the use of Freudian analysis in examining feminist art and urges a more subtle form of symbolism. Argues that feminist art must be "first person" art, that is, assertive and diverse.

786 MAGENTA, MURIEL. "An Uneasy Trio of Conferences." *Women Artists News* 6, no. 4 (September-October 1980): 6-7, 3 illus.

Describes three simultaneous conferences held in Copenhagen (14-30 July 1980): the United Nations Decade for Women – World Conference On Equality, Development, and Peace; the Mid-Decade

Forum of Non-Governmental Organizations; and the International Festival of Women Artists. The three conferences were important because they focused world attention on women's issues, and those attending were able to assess their own ideas by comparing them with differing ideologies.

787 MAHONEY, MARGARET. "Higher Education and Women." *Arts in Society* 11, no. 1 (Spring-Summer 1974): 95-99, 1 illus.

Contrasts the ideal of equal opportunity for women in higher education with the reality that sexist conditioning produces. Argues that although a grievance and arbitration procedure, involving collective bargaining through a union, should exist in all such institutions, a positive self-image is essential for women if their negotiations are to be effective. Stresses that black women often experience double prejudice from heads of African-American studies departments. Ways of increasing opportunities for the pool of women available for teaching and administrative posts are explored.

788 MAINARDI, PATRICIA. "Quilts: The Great American Art." *Feminist Art Journal* 2, no. 1 (Winter 1973): 1, 18, 23. Reprinted in *Feminism and Art History*, ed. Norma Broude and Mary D. Garrard (entry 110), pp. 330-46, 13 illus.

Examines techniques of quilt making, designs and their sources, special-occasion quilts, and the social setting of quilt making. Discusses quilts as the works of individual women artists, with collective production playing a minor role. Makes connections between women's creativity and contemporary abstraction, giving credit where credit is due.

789 MALEN, LENORE. "The Real Politics of Lorna Simpson." *Women Artists News* 13, no. 3 (Fall 1988): 4, 8.

Discusses marginality and vulnerability in the context of African-American artist Lorna Simpson's photographs. Examines the ironic content of Simpson's messages using her clichés: for example, "Black as coal" or "Stereotypes."

790 MALOON, TERENCE. "Mary Kelly." *Artscribe*, no. 13 (August 1978): 16-19, 1 illus.

Terence questions Mary Kelly about her *Post-Partum Document*, her relationship with the women's movement and feminist art, and how her work differs from that of the radical feminists. Kelly argues that it was only in the work of women artists that the personal could be political, because the women's movement has always argued that the personal is political.

791 MARLING, KARAL ANN. "Portrait of the Artist as a Young
 Woman: Miss Dora Wheeler." *Bulletin of the Cleveland Museum of
 Art* 65, no. 2 (February 1978): 47-57, 14 illus.

 An account of *Portrait of Miss Dora Wheeler*, 1883, by William
 Merritt Chase (Museum of Art, Cleveland) and the artistic career of
 the sitter compared with that of her mother, Candace Thurber
 Wheeler, both active in the Associated Artists firm. Examines the
 place of women artists in the late nineteenth century working for
 Associated Artists, an interior decorating firm (New York, N.Y.)

792 MARMER, NANCY. "Womanspace: A Creative Battle for Equality
 in the Art World." *Artnews* 72, no. 6 (Summer 1973): 38-39, 2 illus.

 Traces the history of Womanspace, a nonprofit feminist gallery
 and artists' center created as an alternative to fight sexism in a
 constructive manner. When the feminist art program was formed in
 the autumn of 1971 at the California Institute of Arts and the
 "Womanhouse" exhibition launched, plans for this gallery began
 under Wanda Westcoast, Max Cole, Fran Raboff, Eugenie Osman,
 and Judy Chicago. The development of the gallery and their
 exhibitions, especially "abstract form and female sexuality," are
 discussed in relation to their aims.

793 MARTER, JOAN M. "Introducing and Teaching a Course on
 Women in Art at a Small Liberal Arts College." In *Women's Studies
 and the Arts*. New York: Women's Caucus for Art, 1978, pp. 25-32.

 Discusses her experiences teaching and how feminism changed
 her attitudes concerning the history of art and methods she used for
 connecting with students.

794 MARTER, JOAN M. "Three Women Artists Married to Early
 Modernists: Sonia Delaunay-Terk, Sophie Tauber-Arp, and
 Marguerite Thompson Zorach." *Arts Magazine* 54, no. 1 (September
 1979): 88-95, 13 illus.

 Examines the impact of marriage on the careers of three women,
 all born in the 1880s, who reached their artistic maturity in the
 second decade of the twentieth century. Each had accepted and
 worked with the most avant-garde trends in European modernism,
 and played an important role in its development and application.
 Marriage – to Robert Delaunay, Hans Arp, and William
 Zorach – resulted in successful collaboration and interaction between
 husband and wife in each case, but recognition of the work of these
 women has come only recently: a mixture of social pressures and
 domestic responsibilities meant that their output was subordinated to
 that of their husbands, who also wrote about their personal
 aesthetics, whereas their wives rarely did so in published form.

795 MARTER, JOAN. "Confrontations: The Paintings of Selina Trieff."
Arts Magazine 60, no. 10 (June 1986): 51-53.

Discusses Trieff's work as figurative, enduring, and autobiographical. Cites Trieff's relationship to art history, Watteau's Commedia del'Arte, and Munch and abstract expressionism. Examines the place of drama, stage settings, costumes, and animal symbolism in her paintings and suggests that they are mystical quests, revealing much about the psyche, particularly personal images of death. Concludes with a discussion of Trieff's feminism.

796 MARTIN, J. "Who Judges Whom: A Study of Male/Female Percentages in the Art World." *Atlantis* 5, no. 1 (1979): 127-29.

Report on the percentages of females on Canada council juries, selection committees, and advisory panels–and among grant applicants and recipients during the years 1972-77.

797 MARTIN, T. "Beyond Lace: A Detail Of 'The Dinner Party.'" *Art Papers* 6, no. 5 (September-October 1982): 14, 2 illus.

Describes the overall effect of Judy Chicago's *The Dinner Party* and illustrates in detail the place settings of Saint Bridget and Emily Dickinson, commenting that a certain uniformity was necessary to emphasize the fact that, despite the enormous differences between the women represented, their gender, rather than their achievements, determined their fates.

798 MATHEWS, PATRICIA. "A Dialogue of Silence: May Stevens' Ordinary/Extraordinary, 1977-86." *Art Criticism* 3, no. 2 (1987): 34-42.

Discusses Stevens's art as a renewal and transformation of narrative structure, moral strategies, and women's issues within a framework of integrated visual, psychological, and ethical problems. Concludes that the power of the work results "from a synthesis of form and content." By using a new narrative structure the artist puts into language the unspeakable and presents this fragmentation in a coherent way. In this article Mathews, like many postmodern feminists, accepts male authority as a theoretical framework for representing feminism, for instance, Paul Ricoeur, Roy Schafer, Michel Foucault, and Gregory Ulmer. See Linker.

799 MATHEWS, PATRICIA. "Feminist Art Criticism: Multiple Voices and Changing Paradigms." *Art Criticism* 5, no. 2 (1989): 1-34.

An overview of feminist art criticism in America and England, which should be read with caution. She uses several texts to illustrate the differences among feminist critics during the past fifteen years. Mathews draws some highly controversial conclusions regarding essentialism and the body as primary issues in contemporary

feminism, as well as employing dubious divisions such as first wave, second wave, etc., which help to marginalize the contributions of American feminist critics and their unique contributions to this field during the postmodern backlash and into the present. Concludes that the extent to which feminism has altered art and criticism is difficult to determine largely because of the influence of postmodern and deconstructive thought. She believes feminist criticism goes "beyond" the attention to "women's issues" to embrace a "totally new" consideration of the production and evaluation of art and the role of the artist.

800 MAYER, R., and KITCHEL, N. W. "Contexts." *Tracks* 3, no. 1-2 (Spring 1977): 82-90.

Argues that art works in contemporary society as criticism and resists dominating social conditions. It also acts as a repository of all the values, forms, images, and concepts that are not currently useful to a society but that it is unable or unwilling to eliminate. Claims the art of a society is what a society is not, which is why art has been identified as female for so long. The women's movement can use art to destroy what already is and to reveal what might be possible in a new kind of society.

801 MEANS, AMANDA. "Maureen Connor." *Bomb*, no. 29 (1989): 20-21.

Means interviews Maureen Connor, concentrating on her new body images, taboos, clothing, and the connection between our earliest taboos toward the body. Discusses expressions of modesty and/or sexual difference women have been educated to believe in. Claims that Connor has "saturated" herself with "the physical presence of . . . forms we find disgusting and horrifying," and because of these considerations, her art explores repressions. See Edwards.

802 MEYER, MELISSA, and SCHAPIRO, MIRIAM. "Waste Not Want Not: An Enquiry into What Women Saved and Assembled: Femmage." *Heresies* 1, no. 4 (Winter 1978): 66-69, 9 illus.

Germinal article in which Meyer and Schapiro coin the term "femmage" to cover the activities of collage, assemblage, decoupage, and photomontage, traditionally practiced by women using their own techniques and materials saved through thrift. Argues that despite the beauty of the extraordinary works of art created by women using these methods, their value has been trivialized by sexist art historians and they have been excluded from art history. In order to redress the balance somewhat and to provide an alternative set of aesthetics by which to judge such works, the authors develop a set of criteria to determine whether or not a work can be called "femmage." They then applied these criteria to a selection of women's art and looked for

similar elements that appeared in this art most frequently. Reprinted in a catalog available from Bernice Stienbaum Gallery, New York City.

803 MIFFLIN, M. "From a Whisper to a Shout: Suzanne Lacy Talks about Art as a Network for Women's Voices." *High Performance* 7, no. 2 (1984): 38-41, 83, 6 illus.
Describes American performance artist Suzanne Lacy's work as feminist and activist and describes her performance art as feminist criticism. Includes an interview in which Lacy talks about her parallel interests in art and feminism and her work at the Woman's Building in Los Angeles, which is a center for women's issues in art. Lacy also discusses the proper role for men in feminist art, and her philosophical development. Her latest work, a filmed performance – "Whisper, the Waves, the Wind" – is illustrated with photographs and quotations that illustrate the questions this work on ageism raises.

804 MILLAR, JOYCE. "The Girls." *Gallerie* 1, no. 4 (Spring 1988): 4-7, 5 illus.
Discusses Canadian sculptors Francis Loring and Florence Wyle. Traces this "inseparable, somewhat eccentric" couple's career and the astonishing body of work they produced. Seems to dance around implications that they were a lesbian couple and how that may have facilitated their art-making.

805 MITCHEL, D. "Women Libeled: Women's Cartoons of Women." *Journal of Popular Culture* 14, no. 4 (Spring 1981): 597-610, 4 illus.
Examines the humor sections of twenty underground comics by women artists published in California between 1970 and 1976. Notes their autobiographical basis and self-debunking tone, and that much of the humor results from the contrast between socially conditioned expectations and disillusioning reality. Traditional images of women in newspaper strips are parodied, even the women's movement, though it is generally treated as a positive force.

806 MITCHELL, M. H. "Sexist Art Criticism: Georgia O'Keeffe – A Case Study." *Signs* 3, no. 3 (1978): 681-87.
Shows the sexism of most art criticism, using Georgia O'Keeffe as a case study. Claims that critics of O'Keeffe have not been as overtly sexist as critics of Mary Cassatt, but O'Keeffe has been described as a "prisoner of sex" and a "spokesman" of emotionalism. Refutes assertions that O'Keeffe owed her success to her husband and questions how the label "woman artist" affects the work of an artist who happens to be a woman. See Langer; Lynes.

807 MONGAN, AGNES. "A Fete of Flowers: Women Artists'
 Contribution to Botanical Illustration." *Apollo* 119, no. 266 (April
 1984): 264-67, 11 illus.
 Discusses the collection of books and manuscripts acquired by
 Mildred Bliss between 1948 and 1969 for the Garden Library,
 Dumbarton Oaks, Washington, D.C. Concentrates on women from
 the seventeenth through twentieth centuries.

808 MONGZBU, KYRA. "Maud Morgan." In *Women's Caucus for Art
 8th Annual Honor Awards for Outstanding Achievement in the Visual
 Arts*. Philadelphia: WCA, 1987, pp. 5-6.
 Discusses Morgan's mystical relationship with the spiritual and the
 Canadian landscape, citing her lifelong love affair with nature,
 illustrated by such works as *Roots of the Root* and *Youth and Age*.

809 MONK, P. "Axes Of Difference." *Vanguard* 13, no. 4 (May 1984): 10-
 14, 6 illus.
 An examination of the conditions shaping the construction of
 meaning in images of contemporary art in Toronto. Individual artists
 are discussed; male and female artists are seen to share a framework,
 although the content of their work differs. The social conditions
 determining these differences are noted, and the implications for the
 position of women as artists is discussed.

810 MOORE, SYLVIA. "An Interview with That Man Janson!" *Women
 Artists News* 4, no. 1 (May 1978): 1, 8, 2 illus.
 Controversial interview with the art historian Horst Waldemar
 Janson, whose book, *The History of Art*, 2d ed. (Englewood Cliffs, N.
 J.: Prentice-Hall, 1977), contains no women artists. Janson insists
 that in academic life he has seen no discrimination against women,
 but he does not believe in a "feminine" sensibility or style in art and
 believes that no women artists were "great" enough to include in his
 book. The response from Moore is that women must create their
 own art history.

811 "More on Women's Art Exchange: Diane Burko, Mary Beth
 Edelson, Harmony Hammond, Miriam Schapiro, Benson
 Woodroofe, Sarbenne Stone, and Donna Nelson." *Art in America*,
 November-December 1976.
 Women's responses to Lawrence Alloway's "Women's Art in the
 1970s" (entry 395). Includes his reply. See Alloway.

812 MORGAN, ROBIN. "Ana Mendieta." *Arts Magazine* 62, no. 7
 (March 1988): 111.
 Discusses Mendieta's art in the context of her ideas and
 posthumous retrospective. Suggests the central focus of her art was

"testimony" to an "extraordinary and passionate intelligence, an intelligence of the body," which unites impulses as direct experience. Cites her background and the *Silueta* series as examples that confront nature and culture. Refers to the body, sexuality, and sensuality as primordial marks of self-identification and mysticism and as expressions of being her own woman in the worlds of art and life.

813 MORRIS, DIANA. "6 N.Y. Shows." *Women Artists News* 8, no. 2 (Winter 1982-1983): 8-10, 4 illus.

Reviews works by Lee Krasner; paintings by four women in a show entitled the "Symbolic View"; "Invitational Exhibition of 17 Established American Colorists, on Color"; "Paintings by Katherine Porter"; and "Photographs by Cindy Sherman." "Five and Japan" explores the effect of a visit to Japan on Howardena Pindell, Joyce Abrams, Jasper Johns, Arnold Wechsler, and William Paden. See Pindell.

814 MORRISON, A. "Strata: Nancy Graves, Eva Hesse, Michelle Stuart, Jackie Winsor." *Parachute*, Winter 1977-78, 12-14, 4 illus.

Reviews the exhibition "Strata" at the Vancouver Art Gallery, Vancouver, British Columbia, showing the work of four women artists. In works by Hesse and Graves, there is a real comprehension of how the audience sees, and both manipulated these different aspects of understanding. Winsor's work is direct and physical, expressing spatial ambiguity. Stuart's work is a metaphysical and poetic contemplation on the environment.

815 MOSS, IRENE; KATZEN, LILA; and TUCKER, MARCIA. "Separatism, the New Rip-off." *Feminist Art Journal* 2, no. 2 (Spring 1973): 7-8, 14, 2 illus.

A group of five short articles. "Wombism: The New Hang-Up," by Moss, asserts that women don't only use their female urges and organs as a means of expression. "Equal But Not Separate" argues that women want their work to be as competitive as men's in the battle for equality with male artists through fair competition, adding that good work is being done by women. "How to Be Seen and Counted," by Katzen, discusses discrimination and "social expectancy" and its impact on the education system; she advises women to keep challenging the male-dominated system. Tucker, a curator, in "Women in (and out of) Museums" discusses how feminism has changed the way she responds to the social and political conditions surrounding curating. "Georgia O'Keeffe and These People," by Moss, comments on why successful women artists in general, and Georgia O'Keeffe in particular, are reluctant to identify themselves with less successful artists.

816 MULVEY, LAURA. "You Don't Know What Is Happening, Do You, Mr. Jones?" *Spare Rib*, no. 8 (1973): 13-16, 30. Reprinted in *Framing Feminism*, ed. Rozsika Parker and Griselda Pollock (entry 115), pp. 127-31.

A biting critique of Allen Jones's sculptures of women as expression of male fears of the female.

817 MULVEY, LAURA. "The Hole Truth." *Spare Rib*, no. 17 (November 1973): 37-38, 4 illus.

Penelope Slinger's recent exhibition "Opening" at the Angela Flowers Gallery, London, provided graphic images of fantasy that only a woman could have produced. In the surrealist tradition, Slinger explores the workings of the mind, using sexuality to express hidden desires and fears, which warp and govern it. Using two themes – food, and birth and death – Slinger creates works that challenge patriarchal culture. "Opening" was conceived around the theme of food and orality. It expresses a tension between the power and strength of the woman's mouth (vagina) and the more familiar image of the female as an object of consumption. Next Slinger deals with birth and death, or womb and tomb. The artist links images of the corpse and the meal through the use of the sacrificial altar, site of both ritual death and ritual food. See *Surrealism and Women*, ed. Mary Ann Caws, Rudolf Kuenzli, and Gwen Raaberg (Cambridge, Mass., and London: MIT Press), 1991.

818 MULVEY, LAURA. "Post-Partum Document by Mary Kelly." *Spare Rib*, no. 53 (1976): 40. Reprinted in *Framing Feminism*, ed. Rozsika Parker and Griselda Pollock (entry 115), 203 pp.; in *Visibly Female*, ed. Hilary Robinson (entry 223), pp. 100-101; and in *Post-Partum Document*, by Mary Kelly (entry 140), p. 201.

Cogent discussion of producing children vs. creativity as a central problem of value, patriarchal and cultural. Foregrounds the mother/artist conflict as a feminist issue in the context of Mary Kelly's work.

819 MULVEY, LAURA. "Visual Pleasure and Narrative Cinema." In *Art after Modernism: Rethinking Representation*, edited by Brian Wallis. New York: New Museum of Contemporary Art; Boston: David R. Godine, 1984, pp. 361-73, 8 illus.

In this problematic germinal essay, Mulvey psychoanalytically examines phallocentrism, especially in film. She argues that women are bearers of meaning/not makers of meaning, examines the language of desire – and scopophilia (divided into active/male and passive/female looking) – and claims that the gaze is male. She neglects gay and lesbian gazes, although she mentions "buddy movies." She argues that the female (lack) evokes anxiety vis-à-vis the

castration complex in the male view. Discusses sadism and fetish in relation to von Sternberg, Hitchcock, and the male gaze as patriarchal ideology and women's distance from it in terms of interactive gazing. Now a highly debatable theory that has produced a body of criticism in feminist metacriticism.

820 NABAKOWSKI, G. "Interview with Ulrike Rosenbach." *Heute Kunst*, no. 16 (October-December 1976): 3-5, 9 illus.
Also in German. Ulrike Rosenbach talks about the differences between the theory and practice of feminism in Europe and the United States, with particular reference to feminist art. She discusses the distinguishing features of feminist art, as opposed to art by women, and explains the use of "body-language" to represent psychical states in her own work. She also describes her video piece *Dance for One Woman*. Rosenback believes feminist art can be linked with socialist art since both stress content over aesthetics. RILA.

821 NAVARETTA, CYNTHIA. "Beyond Survival: Old Frontiers/New Visions." *Women Artists News* 14, no. 1-2 (Spring-Summer 1989): 37-39; 58.
Reviews an all-day symposium on multicultural and gender issues at Cooper Union in New York City organized by Cassandra Langer, with assistance from Catherine Morris, for the New York Feminist Art Institute, and featuring Arlene Raven, Lowery Sims, Robert Storr, Nancy Chunn, Nancy Fried, Joanna Frueh, Emma Amos, Miriam Hernandez, Mary Lum, Gloria Ortiz, Jeff Perrone, Nancy Azara, Dore Ashton, Camille Billops, Eleanor Heartney, Margo Machida, and Carol Sun. Audience participants included Susan Schwalb, Joan Semmel, Mary Beth Edelson, and several unidentified younger women. See *Positions*, ed. Cassandra Langer, Reflections on Multi-Racial Issues in the Visual Arts, vol. 1, no. 1 (1989), available from New York Feminist Art Institute, 91 Franklin St., New York, N.Y.

822 NAVARETTA, CYNTHIA. "Helene Aylon." *Women Artists News* 14, no. 1-2 (Spring/Summer 1989): 40-42.
Reviews Aylon's antinuke installation project *SAC* and *Rescued Earth/Endangered Earth Sac*, in which the artists visited thirteen nuclear sites collecting and rescuing desecrated earth. The eco-activist project culminated at a rally at the U.N. In the same issue see Jeanne Claude Christo, "Can We Shrug This Off?" (p. 41) concerning Aylon's trial of 29 August 1988, which touches on the destruction of this project through the negligence of Richardson's Fine Art Handlers Co., San Francisco. Aylon's trial accents the double

injustice that environmental and political activists generally experience at the hands of a patriarchal legal system.

823 NAVARETTA, CYNTHIA. "The Idea of the Moral Imperative in Contemporary Art." *Women Artists News* 14, no. 1-2 (Spring-Summer 1989): 33-35.

Reviews College Art Association panel chaired by Mel Pekarsky and featuring panelists Amy Baker Sandback, John Baldessari, Luis Camnitzer, Suzi Gablik, Jeff Koons, and Robert Storr. Pekarsky states, "Nobody cares what you paint until you become a commodity." Sandback seems to validate the idea of power by saying, "Being able to speak well of your work is good for business." Baldessari seems to echo this in an anecdote about running into Jeff Koons and his comment, "When I think of morality I think of money." Gablik agrees that, "The Art Industry is inseparable from the giant web of our cultural addictions to work, money, possessions, prestige, materialism and technology." Koons, perhaps the most cynical of all the panelists despite his feigned modesty, explained that white middle-class kids use art for social mobility as some ethnic groups use basketball for social mobility. Robert Storr summed it up: "the artist is morally responsible, not to be a sucker for his/her own ideas and sincerity, and not to ask anyone else to be one either."

824 NEMSER, CINDY. "Stereotypes and Women Artists." *Feminist Art Journal*, April 1972, 1, 22-23.

One of the first articles to attack the status quo and decode gender discrimination in the art world. A must read for insights into the emergence of feminist consciousness.

825 NEMSER, CINDY. "An Interview with Members of A.I.R." *Arts Magazine* 47, no. 3 (December 1972-January 1973): 58-59.

Artist members of the first women's cooperative gallery discuss their program, structure, organizational methods, and relations with the art market and in the context of the aspirations of women's liberation. The problems of collective effort as opposed to egotistical careerism, and of professionalism, are debated. The concept of an inherent feminine artistic consciousness is rejected and a distinction between a female and a feminist sensibility is proposed.

826 NEMSER, CINDY. "Conversation with Barbara Hepworth." *Feminist Art Journal* 2, no. 2 (Spring 1973): 3-6, 22, 7 illus.

Sculptor Barbara Hepworth talks about the position of the woman artist, her working techniques, the problems facing a woman artist with a family, some important stages in her career, her recent lithographs, the work of such artists as Henry Moore and Barnett Newman, and specific works such as the *Family of Man.*

827 NEMSER, CINDY. "An Open Letter to *Artforum.*" *Feminist Art Journal* 2, no. 2 (Spring 1973): 9.

Response to Lawrence Alloway's suggestion in *Artforum* that the Whitney Biennial be turned over to "special interest groups" rather than be curator-selected. Nemser accuses him of advocating separatism among such groups as blacks, Puerto Ricans, Indians, Chinese, and women and of employing the paternalistic practice of divide and conquer. She claims that if the Whitney Biennial became a big net for the unwanted of the art world it would release everyone who has been acting according to prejudice – dealers, curators, collectors, and art critics – from the need to exercise unprejudiced critical judgment and ensure that the show would be sneered at. Nemser believes that all artists need to be judged on the same basis as white male professional artists and accepted on those terms only. She asserts that women are now in a position to be granted the recognition they deserve.

828 NEMSER, CINDY. "Art Criticism and Women Artists." *Journal of Aesthetic Education* 7, no. 3 (July 1973): 73-83.

Outlines critical and literary stereotyping of woman as a noncreative being who is simultaneously capable of "captivation" and by virtue of her physical nature is best suited to mechanical art techniques. She then proceeds to discuss the "phallic criticism" contained in male writings on women artists, showing that they have been typecast in accordance with the accumulated clichés associated with female biology. In conclusion she suggests that one should keep in mind Lawrence Alloway's assertion that "the notion of feminine and masculine sensibilities revealed by art is a prejudicial cliche." See *Visual Dialog* 1, no. 2 (1976).

829 NEMSER, CINDY. "A Conversation with Marisol." *Feminist Art Journal* 2, no. 3 (Fall 1973): 1, 3-6, 21, 6 illus.

Despite her public reputation for cool beauty, chic, and remote silences, Marisol was a warm, responsive person to interview. She thinks other female artists have suffered far more from discrimination than she has. She does, however, suffer from the desire of the media to create myths around her. She feels that in the last decade there was a tendency to ignore the political content of works of art while exhibiting them freely. In the late 1960s she left the United States for the Far East and South America, discovering things of great beauty that were unheard of in Western art. She could only recently bring herself to settle back in North America and work there again, producing highly finished pieces such as the exotic fishes whose anguished faces reproduce her own features. See Roberta Bernstein.

830 NEMSER, CINDY. "An Afternoon with Joan Mitchell." *Feminist Art Journal* 3, no. 1 (Spring 1974): 5-6, 24, 3 illus.

A discussion with Mitchell at her home in France. The painter talked about her life and work. She studied painting in Chicago and Paris before returning to New York. Nemser discusses with her many aspects of the art world and its attitudes towards women artists, with particular reference to an interview Nemser had with Louise Nevelson. Finally the author describes the paintings Mitchell showed her, and comments that they project a restless energy, aggression, and yet reticence, which seem to reflect the painter herself.

831 NEMSER, CINDY. "In Her Own Image: Exhibition Catalog." *Feminist Art Journal* 3, no. 1 (Spring 1974): 11-18, 45 illus.

These pages of the *Journal* constitute the catalog of the exhibition "In Her Own Image," held at the Samuel S. Fleisher Art Memorial, Philadelphia, and arranged by Cindy Nemser. In the introduction, Nemser discusses the ways in which men artists have depicted women through the ages and proceeds to examine the question of whether art has a gender. She argues that without prior knowledge of the gender of the artists, one would not know if the works exhibited were by men or women, but feels that since it is known that only women artists are exhibiting, then it is valid to examine the works in terms of what each depiction reveals about the female identity.

832 NEMSER, CINDY. Letters. *Feminist Art Journal* 3, no. 1 (Spring 1974): 21, 25.

The first letter suggests that Hilton Kramer's labeling of Alice Neel's portraits as "neurotic" and "grotesque" reveals his own neurotic refusal to face the painful implications in the work. It is his fixation with the content of the portraits that leads to his charge that Neel lacks proficiency in "handling of design and in all-over control of the motif." Nemser ridicules Kramer's admiration of the "objectivity" of Phillip Pearlstein's people, noting that such commentary stands critical objectivity on its head because Pearlstein subjectively dehumanizes every person he paints, whereas Neel captures the essence of the sitter. The second letter points out to art critic A. D. Coleman that Anne Tucker's book *The Woman's Eye*, although it may be flawed, affirms unequivocally that women have made indispensable contributions to art of photography. See Kramer.

833 NEMSER, CINDY. "Letters to a Young Woman Artist." *Feminist Art Journal* 3, no. 3 (Fall 1974): 16, 18.

Cites that the German poet Rainer Maria Rilke's series of letters to Franz Xaver Kappus, subsequently known as his "Letters to a Young Poet," inspired Miriam Schapiro to request similar comments from various well-known women in the arts, to be included in a

catalog called "Anonymous Was a Woman" of the Women's Art Festival at the California Institute of Arts, 27-31 May 1971. Contributors included Judy Chicago, Deena Metzger, Deborah Remington, Pat Steir, Rochelle Owens, Fay Lansner, and Cindy Nemser. See Schapiro.

834 NEMSER, CINDY. "Lynda Benglis: A Case of Sexual Nostalgia." *Feminist Art Journal* 3, no. 4 (Winter 1974-75): 7, 23.

Questions whether Lynda Benglis's nude with dildo advertisement in *Artforum* is a feminist statement. Nemser erroneously concludes that Benglis is only making a frantic bid for male attention and is manipulating men through the exploitation of female sexuality. The defiant posture is only posturing; this self-exploitation has nothing to do with what the liberated woman wants. It is part of an old world, mere nostalgia that will become passé. In retrospect feminist critics realized the power of the critique that Benglis's deconstruction indicated also had a dissident lesbian element that is being exploited by some contemporary feminists.

835 NEMSER, CINDY. "Blowing the Whistle on the Art World." *Feminist Art Journal* 4, no. 2 (Summer 1975): 25-31, 1 illus.

Examines fashions and myths in the New York art world, in the context of Tom Wolfe's *The Painted Word*. Nemser recalls her conditioning not to see images in modern paintings, rather the flatness that was supposed by teachers and critics to constitute modernity. Argues that description of art in formal or structural terms is a method of dealing with any potentially disturbing phenomenon. Artists and the public in the 1950s and 1960s convinced themselves that art functioned in its own little microcosm: this at a time of cold war, race riots, and peace demonstrations. Asserts that process art, dematerialized art, information art, body art, conceptual art, and most photo-realism have continued to tap American consumer culture but take no stand on its merits or deficiencies.

836 NEMSER, CINDY. "Art Criticism and Women Artists." *Visual Dialog* 1, no. 2 (December 1975-February 1976): 4-6, 1 illus.

Nemser analyses the stereotypes about what constitutes women's art so that they may be laughed out of existence. Most stereotypes stem from one source, the biological functions of the female sex organs, as stereotypes of the male artist stem from the male organs. Male-dominated society values the male qualities, so, in comparison, women's art is always the loser. Compare the adjectives *imitative, passive, narrow-minded,* and *intuitive* with *strong, assertive, grand,* and *vigorous.* Female artists who successfully emulate male art are accused of denying their female nature.

837 NEMSER, CINDY. "Conversation with Janet Fish." *Feminist Art Journal* 5, no. 3 (Fall 1976): 4-10, 5 illus.

Fish describes her associations with the male-dominated figurative alliance in New York in the 1960s, the foundation in partnership with Paul Fschinkel and Frank Viner of the Ours cooperative gallery, and the development of her own painting. Her prime interest in her paintings of vinegar bottles, packaged fruit, glasses, and other subjects is with the forms created and recast by reflective surfaces and with the communication of the spirit of the object depicted. Nemser comments on the link with seventeenth-century Dutch still lifes and the sense of universality arising from Fish's use of small, everyday objects.

838 NEMSER, CINDY. "Conversation with Betye Saar." *Feminist Art Journal* 4, no. 4 (Winter 1976): 19-24, 6 illus.

California artist Betye Saar draws deeply on her experience as an African-American woman to create an impressive and hauntingly beautiful body of work. She converts symbols of oppression into symbols of revolution – Aunt Jemima equipped with rifle and revolver – and delves into African culture to find the bones, feathers, leather strips, and beads she uses in her shrines and hanging pieces. She has been able to build a contemporary and multiversal vision out of the changing social attitudes of the past decade. Saar discusses the ideas behind her *Aunt Jemima*, occult works, and black nostalgia pieces and describes the difficulties of the black woman artist.

839 NEMSER, CINDY. "Conversation with Diane Burko." *Feminist Art Journal* 6, no. 1 (Spring 1977): 5-12, 4 illus.

Diane Burko, a young artist whose depictions of mountains are beginning to win her national recognition, speaks of her development as an artist and a feminist. She explains how her painting style has evolved from abstraction to figuration, how her medium has changed from oil to acrylic paint, and how she developed her technique from the slide projector. She expounds her reasons for having chosen mountains and questions whether she really is a photo-realist. She goes on to discuss the problems she faces as a married female graduate student and describes the influence of her parents, as well as that of her husband, on her career. She concludes by declaring that she intends to combine being a professional woman with being a mother.

840 NEWMAN, M. "The Ribbon around the Bomb." *Art in America* 71, no. 4 (April 1983): 160-69, 16 illus.

Refers to a traveling exhibition organized by the Whitechapel Art Gallery, London, of Frida Kahlo's paintings and Tina Modotti's photographs. Addresses the lives and careers of the artists and

considers their circumstances, political beliefs, and the social context of their lives in postrevolutionary Mexico. Several of their works are described in detail, as is their concern with the representation of women in art. See Langer.

841 "A New York City Collective." *Heresies* 1, no. 3 (Fall 1977): 102-5, 5 illus.

Five members of a New York lesbian artists' collective (Ellen Turner, Flavia Rando, Fran Winant, Jessica Falstein, and Maxine Fine) discuss how it feels to be a lesbian artist in the lesbian community, how relevant it is, and what impact they have on other lesbians' lives.

842 NOCHLIN, LINDA. "Why Have There Been No Great Women Artists?" *Artnews* 69, no. 9 (January 1971): 22-39, 67-71. Reprinted in *Art and Sexual Politics*, ed. Thomas B. Hess and Elizabeth C. Baker (entry 62), pp. 1-39.

In her brilliant, provocative, and forceful essay, Nochlin predicted contemporary feminists would take one of two lines of argument in responding to her question. The first would be the defensive assertion that, indeed, there had been great women artists but they had somehow been excluded from art history by sexist male art historians, and the second would be finding a different standard of measure to evaluate the work of women artists of the past. The accuracy of her prediction is amply borne out by the literature produced during the 1970s.

843 NOCHLIN, LINDA. "Miriam Schapiro: Recent Work." *Art Magazine* 48, no. 2 (November 1973): 38-41, 6 illus.

Discusses feminism in relation to art and, more specifically, feminism in relation to abstract art, as for example in recent works by Miriam Schapiro. Taken as a group, Nochlin suggests they constitute a radical statement of the artist's identity as a member of the contemporary vanguard of abstract artists and as a feminist struggling to create a valid imagery of women's consciousness. The author comments that there is nothing stereotypically "feminine" in Schapiro's collages although they can be characterized as feminist; she analyses *Lady Gengi's Maze* to demonstrate this statement. Also discussed is her Womanhouse, produced while codirector of the feminist art program at the California Institute of the Arts.

844 NOCHLIN, LINDA. "Some Women Realists." Part 1. *Arts Magazine* 48, no. 5 (February 1974): 46-51, 8 illus.

Describes the development of modern women realist painters, arguing that women artists have turned to realism "through force of circumstance if not through inclination." However, she warns against

necessarily reading feminine attitudes into their art because of the difficulty of separating unconscious motives from conscious intentions in choosing a realist motif. Women painters dealing with social realism, evocative realism, and literal or "thing-in-itself realism" are discussed with particular reference to such artists as Georgia O'Keeffe, Sylvia Mangold, Yvonne Jacquette, and Janet Fish. See entry 846 for Part 2.

845 NOCHLIN, LINDA. "How Feminism in the Arts Can Implement Cultural Change." *Arts in Society* 11, no. 1 (Spring-Summer 1974): 80-89, 6 illus.

Feminism has influenced the author's approach to art history, transforming for her the very "institution" and nature of art. The suppression of talent in female children, the concept of male "genius," and the historical focus on individuals (usually male) fostered her questioning of past values as applied to women artists. Rejecting accepted critical attitudes toward nineteenth-century painter Rosa Bonheur, Nochlin reappraised her most popular work, *The Horse Fair*, employing feminist criteria; this led to an interest in nineteenth-century British women painters. The author also describes her changed approaches to the "democratization" of art, with reference to the "Theorem" paintings that replaced some needlework arts in the nineteenth century, and the color schema formulated by Seurat, Signac, and friends. In effecting change as individuals and as members of social groups, women must first combat prejudice and discrimination, consistently question "natural" assumptions about life in general and art in particular, and act to promote cultural change.

846 NOCHLIN, LINDA. "Some Women Realists." Part 2. *Arts Magazine* 48, no. 8 (May 1974): 29-33, 5 illus.

Accepted standards of aesthetic quality and historical convention in portraiture are being challenged by such women painters of the figure as Alice Neel and Sylvia Sleigh. In Neel's paintings, primitive clichés about the role of woman as mother or fertility goddess are subverted in her pictures of pregnant women, "dwelling on its very unnaturalness for this sophisticated, individuated, urban woman." In Sylvia Sleigh's paintings the sex roles of the male artist and the nude female model are reversed in such works as *Phillip Golub Reclining*, where the active female artist is observed painting the passive nude male model. The value of these artists lies in the raising of consciousness about sexual questions which have previously been considered merely "aesthetic questions of quality." See entry 844 for Part 1.

847 NOCHLIN, LINDA. "Women and the Decorative Arts." *Heresies* 1, no. 4 (Winter 1978): 43.

An excerpt from "Women Artists: 1550-1950," which shows the pitfalls inherent in trying to evaluate the contribution of women artists to the decorative arts according to traditional art-historical and aesthetic criteria. See entry 376 for fuller version.

848 NOCHLIN, LINDA. "Florine Stettheimer: Rococo Subversive." *Art in America* 68, no. 7 (September 1980): 83-85.
Discusses Stettheimer's career, family relations, and art, stressing the historical and social context reflected in the work and Stettheimer's identification with feminine energy. See Van Vechten; Zucker.

849 NOCHLIN, LINDA. "Courbet's *L'origine du monde*: The Origin without an Original." *October* 37 (1986): 76-86, 7 illus.
Discusses Courbet's *Origin* in the context of repetitive quest and in terms of masculine desire, which ultimately leads to another "scenario of origination, that of the origin of art itself"; the desire for the absent object–the female sex organ–results in the very first art work. Argues that Courbet's *Origin* poses a question of want and finally reenacts the infinite repetitiveness of desire, the impossible quest for the lost original.

850 NUNN, PAMELA GERRISH. "The Case History of a Woman Artist: Henrietta Ward." *Art History* 1, no. 3 (September 1978): 293-308, 2 illus.
Examines the career of Henrietta Ward, who was born into an artistic family (James Ward, George Morland, etc.) and later married an artist (E. M. Ward). Examines her career as an example of Victorian women artists, discussing opportunity, expectation, effort, lack of art education, and the Royal Academy.

851 NUNN, PAMELA GERRISH. "Ruskin's Patronage of Women Artists." *Woman's Art Journal* 2, no. 2 (Fall 1981-Winter 1982): 8-13, 4 illus.
Discusses Ruskin's patronage of women artists in terms of the development of thinking about women artists characteristic of his time and the ambivalent way in which prominent men used their position with regard to women artists. Ruskin patronized most consistently Elizabeth Siddall, Louisa Stuart, and Lady Waterford, but he never bought their work, only commissioning them to make copies of old masters. Although Ruskin's ideas about women artists changed over the years, Nunn concludes that his prejudiced expectations of women made him of very limited use to the women he patronized.

852 NYEBOE, I. "Performance Art: A Contrast In Styles." *Women Artists News* 6, no. 4 (September-October 1980): 10-11, 2 illus.

Discusses the performance art included in the International Festival of Women Artists, held in Copenhagen (14-30 July 1980). Most of the pieces focused on interpretations of the female condition and the desire to present a different reality. Whereas American performers were concerned with enactments of rituals, the Europeans preferred to work within existing theatrical forms.

853 O'GRADY, H. "Women, Society, and the Creative Process." *Feminist Art Journal* 4, no. 4 (Winter 1976): 32-33.

Discusses the Wisconsin Women in the Arts Conference, held at the University of Wisconsin-Oshkosh in Autumn 1975. Marge Piercy's talk, "Overcoming the Barriers to Creativity," described discrimination in a patriarchal society. She insisted women must have the freedom to deal exclusively with their own concerns if they so choose. June Wayne's talk, "Creativity: Artists, Carpenters, and the Flat Earth Society," focused on how society and technology impinge on the artist.

854 OLIN, FERRIS, and MILLER, BARBARA B. "Women and the Visual Arts: A Bibliographical Essay." *Women's Studies Quarterly* 25, no. 1-2 (Spring-Summer 1987): 62-66.

Focuses on research strategies for locating and accessing materials on women artists and themes of women in art. A brief survey of books, exhibition catalogs, reference collections, journals, art education, artists, architecture, crafts and needle arts, film, painting, performance art, photography, sculpture, criticism, and miscellaneous citations. Gives a sampling from each category and suggestions for getting at the information you want to research.

855 O'NEILL, EILEEN. "The Re-Imaging of Eros: Women Construct Their Own Sexuality." *Ikon*, 2d ser., no. 7 (Spring-Summer 1987): 118-126, 5 illus.

Discusses women's eroticism and the visual arts from the point of view of redefinition of pornography and "noxious pornography," using art by Meredith Lund, Margo Machida, Lee Stoliar, Barrie Karp, and Anita Steckel. The article never really comes to grips with sadomasochism and patriarchy in the context of feminist criticism. See Deirdre English, "The Politics of Porn: Can Feminists Walk the Line," *The Best of Mother Jones*, (Berkeley, Calif.: Mother Jones), 1985, 49-58.

856 OPPLER, ELLEN. "Paula Modersohn-Becker: Some Facts and Legends." *Art Journal* 35, no. 4 (Summer 1976): 364-69, 6 illus.

Critical overview of works by Modersohn-Becker that have rarely been seen outside her native Germany. Oppler describes the tragic facts of the artist's life and the discrimination that led to the critical neglect of her pioneering work. Using the artist's letters and diaries, Oppler examines Modersohn-Becker's early Worpswede landscapes, her self-portraits of 1906, and the ritualistic "figure composition" of 1907. Looks at contemporary criticism of the painter's achievements, notably that of the German poet Rilke, and assesses her importance for feminism.

857 ORENSTEIN, GLORIA F. "The Women of Surrealism." *Feminist Art Journal* 2, no. 2 (Spring 1973): 1, 15-21, 9 illus. Reprinted in *Feminist Collage* (entry 113), ed. Judy Loeb.

One of the first articles to restore the women of surrealism to art history. Outlines the aims of surrealism and examines the movement's attitude toward women and the part played by women in it. Argues that woman's role in surrealism is equivocal, ambiguous, and fraught with contradictions because it was shaped by men, who, although they held the female in high esteem, bestowed on her an identity that suited their own needs for artistic inspiration. Orenstein gives a detailed description of the work of Leonor Fini, who, although a great friend of the group, never attended their meetings because she wanted to be autonomous as an artist, and outlines the life and work of Leonora Carrington, whose paintings had their roots in the occult. Orenstein also interprets work by Meret Oppenheim, Remedios Varo, Maria Cerminova (called Toyen), Bona de Mandiargues, Dorothea Tanning, Jane Graverol, and Joyce Mansour. See Whitney Chadwick and *Surrealism and Women*, ed. Mary Ann Caws.

858 ORENSTEIN, GLORIA F. "Frida Kahlo: Painting for Miracles." *Feminist Art Journal* 2, no. 3 (Fall 1973): 7-9.

Describes Kahlo's work from a feminist perspective and in the context of surrealism, autobiography, and Mexican culture. This article was translated into German and anthologized in *Frauen in der Kunst*, ed. Gislind Nabakowski (entry 116).

859 ORENSTEIN, GLORIA F. "Natalia Goncharova: Profile of the Artist's Futurist Style." *Feminist Art Journal* (Summer 1974): 1-6, 19.

Describes the Russian revolutionary in the context of Italian futurism and its impact on Russian painting in the early years of the twentieth century. Shows Goncharova's paintings to have been a pioneering influence in the emergence of Russian "Rayonism."

860 ORENSTEIN, GLORIA F. "Art History and the Case for the
 Women of Surrealism." *Journal of General Education* 27, no. 1
 (1975): 31-54, 2 illus.
 Focuses attention on the accomplishments of surrealist women.
 Overcoming the woman-child stereotype, the women of surrealism
 proved "that maturity did not imply the abandoning of a woman's
 creative powers nor the betrayal of her sexual identity." Woman as
 subject rather than object dominates their paintings; woman is
 goddess, alchemist, scientist, creator, spiritual guide, visionary, and
 the Great Mother. Interprets works by Leonor Fini, Leonora
 Carrington, Meret Oppenheim, Remedios Varo, Dorothea Tanning,
 and others, revealing their symbolic search for female identity and
 their defiance of stereotypes usually associated with art done by
 women.

861 ORENSTEIN, GLORIA. "Art History." *Signs*, no. 1-2 (Winter 1975):
 505-25.
 An early and hard-hitting critique of art history and its
 texts—Janson, Gardner, etc. Gives insights into discrimination and
 indoctrination in the patriarchal education system at the college level.
 See Hills; Sylvia Moore.

862 ORENSTEIN, GLORIA. "The Reemergence of the Archetype of the
 Great Goddess in Art by Contemporary Women." *Heresies*, no. 5
 [Great Goddess Issue] (Spring 1978): 74-84, 16 illus. Reprinted in
 Visibly Female, ed. Hilary Robinson (entry 223), and in *Feminist Art
 Criticism*, ed. Arlene Raven, Cassandra Langer, and Joanna Frueh
 (entry 112), pp. 71-86.
 Orenstein's pioneering and somewhat debatable interpretation of
 the meaning of the goddess in contemporary women's art. A new
 feminist myth is being created, especially by women artists who are
 using old symbols, images, artifacts, rituals, and psychic forces that
 were an inherent part of the ancient celebration of the mysteries of
 birth and fertility. By summoning up the power associated with the
 goddess archetype, women artists are exorcising the patriarchal
 creation myth through a repossession of the female visionary
 faculties. Works by Mary Beth Edelson, Carolee Schneeman, Mimi
 Lobell, Buffie Johnson, Judy Chicago, Donna Byars, Donna Henes,
 Miriam Sharon, Ana Mendieta, Betsy Damon, Betye Saar, Monica
 Sjoo, and Hannah Kay have this concept in common.

863 ORENSTEIN, GLORIA F. "Evocative Images." *Arts Magazine* 54,
 no. 9 (May 1980): 17, 2 illus.
 Posits a new aesthetic sensibility in which the invisible feminist
 link between woman and the charges of energy flowing through the
 universe is slowly being made manifest. She renounces prior

patriarchal dichotomies that separate mind from matter and reaffirms the basic affinity between the synergic powers of woman and the potent energies and forces of nature. "Evocative Images" (Fordham University, Lincoln Center, New York, 1 May-30 June 1980) brought together the work of ten women artists whose ability to commune with the life force in its many natural incarnations reflects a new artistic counterpart to this spirituality. The artists were Francia, Miriam Brumer, Susan Schwalb, Hanna Kay, Buffie Johnson, Louise Bourgeois, Carolyn Kaplowitz, Marilyn Fox, Diane Kaiser, and Marjorie Abramson.

864 ORENSTEIN, GLORIA F. "Creation and Healing; An Enpowering Relationship for Women Artists." *Women's Studies International Forum* 8, no. 5 (1985): 439-58, 10 illus.

Discusses the alienation of women from the art of healing as a form of women's empowerment, specifically the relationship of the midwife to the woman in labor. Holistic healing and the mind-body system are foregrounded as feminist strategies that yield new approaches. In the past, artists used their art as part of a shamanistic communal ritual. Orenstein argues that contemporary feminist art enables one to participate in a similar experience. Vision quests and journey narratives are expressions of the spiritual in contemporary culture and in opposition to patriarchal systems. Artists include Claire Falkenstein, Ruth Weisberg, Helene Aylon, Jerri Allyn, Anne Gauldin, Cheri Gaulke, Sue Maberry, Rachel Rosenthal, Christine Oatman, Mary Beth Edelson, and Ana Mendieta, among others. Concludes in the gynocentric vision of woman's empowerment; the healer replaces the invalid as the hero of the new myth of the artist. Creation permits life-affirmation. See Langer; Lippard; Raven.

865 ORTNER, SHERRY. "Is Female to Male as Nature Is to Culture?" *Feminist Studies* 1-2 (Fall 1974): 10-22. Reprinted in *Woman, Culture, and Society*, ed. Michelle Rosaldo and Louise Lamphere (Stanford, Calif.: Stanford University Press), 1974.

An innovative essay examining the connection between feeling and thought, emotion and objectivity. A must read for anyone interested in landscape and ecology from a feminist perspective. Problematic food for thought in the nature/culture debate. See Cassandra Langer's essay "The Many Masques of Eve" in the exhibition catalog *Original Sin* (entry 337).

866 OSBORNE, CAROLINE. "Alexis Hunter." *Artscribe*, no. 45 (February-April 1984): 48-50, 2 illus. Reprinted in *Visibly Female*, ed. Hilary Robinson (entry 223), pp. 62-71.

Alexis Hunter explains the depiction in her recent paintings of various concepts as mythological animals, images gleaned from

books on the occult and rare animals. Hunter also discusses the appropriation of art by the middle classes in England, the conflict between ambition and desire, her attitude towards feminism, and her desire to break down the phallic perspective in painting, particularly those dealing with fear, rape, and economics.

867 OSTERMAN, G. D. "A Conversation with Elaine Starkman." *Women Artists News* 7, no. 5 (March-April 1982): 11-12, 2 illus.
 New York gallery owner Elaine Starkman discusses the need for a women's gallery, financial support for artists, and the question of a woman's artistic sensibility. She tries to take a broad line in choosing women's work for her gallery and supports those artists whose work she affirms. An interesting set of propositions when it comes to "matronage" and the failure of feminist patronage.

868 OWENS, CRAIG. "The Discourse of Others: Feminists and Postmodernism." In *The Anti-Aesthetic: Essays in Postmodern Culture*, edited by Hal Foster. Port Townsend, Wash.: Bay Press, 1983, pp. 57-82, 5 illus.
 Argues that postmodernism is treated as a crisis of cultural authority, specifically vested in Western European culture and its institutions. Cites Jean-François Lyotard, Arnold Toynbee, Jacques Derrida, Michel Foucault, Frederick Jameson, Paul Ricoeur, Immanuel Kant, Karl Marx, Martin Heidegger, Julia Kristeva, Roland Barthe, and Guy Montrelay, among others, and uses artists Laurie Anderson, Martha Rosler, Mary Kelly, Dara Birnbaum, Sherrie Levine, Louise Lawler, Cindy Sherman, Jenny Holzer, and Barbara Kruger to illustrate his points. The trouble with this article is that bright young men continue to speak as though American feminist art critics can't be trusted to voice their own insights when it comes to masculine authority and the discourse of others—especially women.

869 PAINE, J. "The Women's Pavilion of 1876." *Feminist Art Journal* 4, no. 4 (Winter 1976): 5-12, 6 illus.
 The Philadelphia Centennial Pavilion presented a distinct and startling summary of women's accomplishments, preoccupations, and goals. The history of the inception of the idea to have such a pavilion and the means of raising revenue for it are related. The plan and decoration of the building are described. Some of the achievements of women demonstrated were in the fields of journalism, medicine, science, art, literature, invention, teaching, business, and social work from thirteen countries. Feminists protested that women's true unequal position in society was not shown.

870 PARKER, ROZSIKA. "Making W.A.R. (Women Artists in Revolution)." *Spare Rib*, no. 14 (August 1973): 38-40, 3 illus.

Discusses the documenting by Rosalee Goldberg (now teaching at New York University) of the history of women artists and her collecting material on contemporary women artists in order to start seminars on women in the arts at various colleges. Notes that women artists in America are concerned with forcing art schools to employ women in the same ratio as the student female/male ratio, 55 per cent. Tactics such as the march on the Whitney Museum have resulted in many more women being included in subsequent annual shows. Parker believes that despite the fact that so much art criticism fails to confront patronizing gender-oriented descriptions, all the American magazines now dutifully cover women's shows. She also understands that arguments about "women's art" avoid challenging the sexism that works against female culture and suppresses historical evidence of female achievement.

871 PARKER, ROZSIKA. "Valerie Wilmer." *Spare Rib*, no. 17 (November 1973): 39-40, 3 illus.

Discusses Wilmer's exhibition "Jazz Seen: The Face of Black Music," which had a two-year tour of the British Isles. Influenced by the photography of Eugene Smith and inspired by her love of jazz itself, Wilmer photographed musicians and their wives and families and wrote about jazz. She owes part of her concern with women's liberation to the black-liberation movement.

872 PARKER, ROZSIKA. "Art of Course Has No Sex. But Artists Do." *Spare Rib*, no. 25 (July 1974): 34-35, 4 illus.

Looks at the problems involved in putting on Lucy Lippard's all-women conceptual art exhibition titled "C. 7,500" at the Garage, London, in 1974 and a variety of responses to it. Among the questions raised by the show were role playing, identity, the nature of art, the artists' own attitudes, and how the audience received the work. Critics are accused of casting off their responsibilities as mediators between artist and audience by commenting "it stinks of the ghetto" and rejecting the whole show rather than dealing directly with the realities of sexual politics – or confronting the realities of exclusion and privilege.

873 PARKER, ROZSIKA. "Feminist Art Practices in *Women's Images of Men, About Time,* and *Issue.*" *Art Monthly*, no. 43 (1981): 16-19, 3 illus.

Discusses three major feminist exhibitions held at the Institute of Contemporary Arts, London, which presented a variety of feminist art strategies that deliberately inhibited the conventions of the institutions that presented them. Examines the techniques that surfaced in feminist art illustrated by these shows and identifies a few of the difficulties and possibilities that materialized.

874 *Patchwork Quilt.* Edited by Schnuppe von Gwinner and Beatrijs Sterk. Translated by Christine Bell. Hannover: Textilwerkstatt-Verlag, 1986.
 In German and English. Comments on and describes the state of patchwork art in Europe. RILA.

875 PENA, LYDIA M. "In the American Scene: The Life and Times of Agnes Tait." *Women's Art Journal* 5, no. 1 (Spring-Summer 1984): 35-39.
 Documents Tait's contributions to American art, particularly during the decades of the 1930s and 1940s. Gives fresh insights into the lives of women artists during this neglected period of American modernism and how their development differed from that of their male colleagues.

876 PERREAULT, JOHN. "I'm Asking–Does It Exist? What Is It? Whom Is It for?" *Artforum* 19, no. 3 (November 1980): 74-75, 2 illus.
 Discusses the question of "gay culture" in art, citing the example of Marsden Hartley as a "homosexual artist." *Gay* seems to be understood in this context as predominantly male homosexual. This is an ongoing problem in gay and lesbian studies in art (and elsewhere), where lesbians are rarely mentioned by both gay female and male identified scholars. Regarding possible reasons for this deplorable state, see Marilyn Frye, "History and Responsibility," in *Hypatia Reborn*, ed. Azizah Y. Al-Hibri and Margaret A. Simons (Indiana University Press, 1990), pp. 300-304.

877 PERRONE, JEFF. "*Women of Photography*: History and Taste." *Artforum* 14, no. 7 (March 1976): 31-35, 10 illus.
 Discussion based on the exhibition "Women of Photography," San Francisco Museum of Art. Perrone considers the socially oriented content of the exhibits and the effect of the exhibition and examines the photographs as art and in terms of the information they give about women.

878 PETTYS, CHRIS. "Pioneer of 'The New Matronage.'" *Women Artists News* 4, no. 1 (May 1978): 1, 5, 10, 3 illus.
 Pettys describes her transformation from a housewife and mother into a major researcher compiling a dictionary of women artists. This

project helped her grow in self-confidence and move into positions of power; for example, she is now on the board of trustees of the Denver Art Museum, Colorado. She has committed herself to helping others discover women's art heritage.

879 PHELAN, PEGGY. "Feminist Theory, Poststructuralism, and Performance." *TDR* 32, no. 1 (Spring 1988): 107-27, 8 illus.

Questions Derrida's claim that woman is a catalog of negation and absence and asks what "feminist theory and poststructuralism have to say to one another?" Argues that the fetishized female image functions as a fantasy of erotic desire. Uses Yvonne Rainer's "The Man Who Envied Women" (1985) and Angelika Festa's performance *Untitled Dance with Fish and Others* to illustrate her claims concerning gender and power relations. See *Female Perversions*, by Louise J. Kaplan (entry 138).

880 PIERRE-NOEL, LOIS. "Changing the Values and Practices of Cultural Institutions." *Arts in Society* 11, no. 1 (Spring-Summer 1974): 70-75, 3 illus.

A discussion led by Lois Pierre-Noel that explores potential strategies to implement equality of opportunity for women artists and administrators. Rigid institutional polarizations must be broken by political action, but so far only minor concessions have been won. Compares women's struggle for sufficient representation and authority sharing with the Civil Rights movement. Tactics such as consciousness-raising, followed by pressure on and infiltration of the policy-making sectors, are advised as practical courses of action.

881 PINCUS-WITTEN, ROBERT. "Winsor Knots: The Sculpture of Jackie Winsor." *Arts Magazine* 51, no. 10 (June 1977): 127-33, 16 illus.

Pincus-Witten uses interviews with the artist to look at her work and to see how her background has influenced it. Winsor has emerged as a serious feminist presence in today's art world, but she denies being exclusively feminist. She favors "a recognition of the status of the artist as the embodiment of something special and of merit compared to the unconscious contempt she believes artists are held in by bourgeois society." Interviews of this sort raise questions concerning how feminists collude in their own oppression by refusing to own their politics because of possible consequences in the marketplace and elsewhere.

882 PINDELL, HOWARDENA. "An American Black Woman Artist in a Japanese Garden." *Heresies* 4, no. 3 [Issue 15: Racism Is the Issue] (1982): 54.

Discusses her experiences with discrimination and sexism in Japan.

883 PINDELL, HOWARDENA. *Artist du Jour*. New York: Pests, 1987.

A provocative compilation of statistics taken from *Art in America*, detailing discrimination in the fine-art publication and gallery system in New York City. This is only a small sampling of the damning information on racism in the arts that Pindell has made available to anyone who contacts her and is willing to pay for photocopying costs. (State University of New York, Stony Brook).

884 PINDELL, HOWARDENA. *Statistics, Testimony, and Supporting Documentation*. Agendas for Survival Conference. New York: Hunter College, 27-28 June 1987.

A detailed study of racial discrimination among New York galleries, museums, and art magazines. Gives facts and figures. See also previous entry.

885 PINDELL, HOWARDENA. "Covenant of Silence: De Facto Censorship in the Visual Arts." *Third Text*, no. 11 (Summer 1990): 71-90.

Pindell argues that Western values maintain that they are universal, relying on what she calls the Kantian and Hegelian traditions, which generally support a glaring "omission" of artists of color. Cites 1979, "Nigger Drawings" at Artists' Space, New York; discusses First Amendment rights as a slippery tool of "repression." Pindell uses the Bill Moyers' PBS program "The Public Mind" as an example of the kind of thinking we should be doing regarding racism. She critiques interpretations of the constitution's "The eternal rule of fairness" and how it applies to those who are victimized by it. In this surprisingly frank and often fiercely passionate exposé Pindell takes white America (and by extension all of us) and the art world to task for its business-as-usual, do-nothing attitude. A two-part version of this essay appeared in the *New Art Examiner*, 1991.

886 PIPER, ADRIAN. "Adrian Piper's Open Letter to Donald Kuspit." *Real Life Magazine*, no. 17-18 (Winter 1987-88): 2-11.

Piper's vehement, blow-by-blow objections (as well as her satiric visualizations) to statements made by Donald Kuspit in response to his essay "Adrian Piper: Self-Healing through Meta-Art," which was supposed to be published in a catalog (Adrian Piper: Reflections 1967-1987) in conjunction with her retrospective exhibition at the Alternative Museum, 1987. Piper learned that despite her objections, Kuspit had published his essay on her (which she had rejected) in the journal he edits, *Art Criticism* (III, 3, September 1987, 9-16). The text is presented as an exchange of dialogue/letters in which Piper asserts herself and her right to control information and interpretation concerning her work. She objects to the psychological overlay that Kuspit has used to analyze her and her art, suggesting that, after all,

the artist knows herself best. What is of issue here is authenticity rather than the imposition of a supposedly unbiased text (which re-represents the artist) on the subject. Piper argues that one white upper-class male's biased opinion of who he thinks she is should not stand unchallenged simply because he has unrestricted access to publication. This is an old argument and makes fascinating reading as a feminist critique of power relations in the New York art world, conscientious criticism, sexual politics, racism, and psychoanalysis.

887 PITTS, P. "A Practical Wardrobe: Notes on Christine Hellyar's Aprons Art." *New Zealand*, no. 41 (Summer 1986): 65-67, 7 illus.
Describes Christine Hellyar's textiles, which are configured as aprons and comprised of latex objects, flounder, squid, flaps of tripe, and offal, which she stitches on materials such as unbleached calico and muslin. Frequently her work is influenced by the American women's art movement and involves the significance of domestic life.

888 POGGI, C. "The New Spiritualism." *Women Artists News* 6, no. 2-3 (Summer 1980): 6, 1 illus.
Discusses the panel "Feminism, Spirituality, and the Arts," held at the New York Feminist Art Institute, New York (16 May 1980). The moderator and panelists, Linda Hill, Nancy Azara, Bambi Brown, Catti, Donna Henes, Ana Mendieta, and Merlin Stone, explored the idea of spirituality in feminist art and how feminist artists are struggling to create an art that expresses more accurately their own experiences and subjectivity. See Orenstein.

889 POLLOCK, GRISELDA. "Underground Women." *Spare Rib*, no. 21 (March 1974): 36-39, 7 illus.
Nine women painters have thirteen paintings that may be found at the National Gallery, London, but not one of them is exhibited on the main floors. The artists include Rosa Bonheur and Berthe Morisot. Their lives reveal much about art in general, the conditions required to become an artist, and what a woman artist has to do to gain recognition.

890 POLLOCK, GRISELDA. "Issue (to emerge; to be born; outcome; event; the point in question): An Exhibition of Social Strategies by Women Artists." *Spare Rib*, no. 103 (February 1981): 49-51, 3 illus.
The "Issue" exhibit at the Institute of Contemporary Arts, London, presented art objects in the context of feminist political practice, challenging the idea of art as the personal expression of a glamorized individual. Pollock deplores the disregard of this kind of art by feminists who are not themselves artists.

891 POLLOCK, GRISELDA. "Vision, Voice, and Power: Feminist Art
 History and Marxism." *Block*, no. 6 (1982): 2-21, 5 illus.
 Argues that although Marxism offers a useful framework for the
 study of the social production of art, it does not attend to the sexual
 divisions of society. Nevertheless, two aspects of Marxist theory shed
 light on the relationship between feminism and art history: ideology
 and Marxism have shown bourgeois art history to be unhistorical.
 Asserting that a feminist art history must employ these insights,
 Pollock addresses the differences between a bourgeois feminist art
 history and a Marxist-feminist interpretation, using the work of
 Elisabeth Vigée-Lebrun (1775-1842) and the writings of several
 feminist art historians, including Linda Nochlin, Ann Sutherland
 Harris, and Germaine Greer. The problem here is the degree of
 reliance on patriarchal theory, references, and relatively conservative
 approaches to these issues. See Frueh; Langer; Lorde.

892 POLLOCK, GRISELDA. "Reply to Ann Sutherland Harris."
 Woman's Art Journal 4, no. 1 (Summer 1983): 39-47. Reprinted in
 Visibly Female, ed. Hilary Robinson (entry 223), pp. 226-27.
 Response to Ann Sutherland Harris's critique (entry 606) of
 "Women, Art, and Ideology: Questions for Feminist Art Historians."
 Pollock attempts to correct what she sees as misinterpretations
 regarding her position on self-criticism and the feminist movement.

893 POLLOCK, GRISELDA. "Women, Art, and Ideology: Questions for
 Feminist Art Historians." *Woman's Art Journal* 4, no. 1 (Spring-
 Summer 1983): 39-47.
 A variation on the theme discussed in entry 891 (Marxist and
 feminist art history). Author's highly debatable suggestion that even
 though Marxism never addresses the issue of society's sexual
 divisions, it offers a paradigm for feminist art history because of its
 historical account of the social production of art, which has come
 under fire from other feminists. Traces the divergent relationship
 between woman and artist, and concludes that most women artists
 were never acknowledged as artists, which reinforced a sexual
 hierarchy that was based on the construction of the family. See Ann
 Sutherland Harris's reply (entry 606).

894 POLLOCK, GRISELDA. "Women, Art, and Ideology: Questions for
 Feminist Art Historians." *Women's Studies Quarterly* 15, no. 1-2
 (Spring-Summer 1987): 2-9. Shorter version of "Vision, Voice, and
 Power: Feminist Art History and Marxism" (entry 891). Reprinted
 from *Woman's Art Journal* 4 (Spring-Summer 1983): 39-47.
 Raises hotly debated methodological questions for feminist art
 historians and art critics.

895 POLLOCK, GRISELDA. "Missing Women." In *The Critical Image: Essays on Contemporary Photography*, edited by Carol Squires. Seattle: Bay Press, 1990, pp. 202-19.

Reexamines an article Pollock wrote in 1977, entitled "What's Wrong with 'Images of Women'?" Here Pollock discusses her position and how it has changed in relation to images of women, which she now believes don't exist except as signs of the dominant (i.e., male) culture.

896 POLLOCK, GRISELDA. "Mary D. Garrard. *Artemisia Gentileschi: The Image of the Female Hero in Italian Baroque Art.*" *Art Bulletin* 72, no. 3 (September 1990): 499-504.

Pollock's review tackles the thorny problem of conservative feminist art history vs. feminist art criticism informed by postmodern methodology. This issue is at the heart of radically different notions of what feminist art history and criticism should aspire to currently. In her critique of Garrard's book Pollock argues that it is impossible to carry out an alternative art-historical critique within the confines of the traditional monographic form, which demands a celebration of genius. Pollock believes such actions simply support established practices and the art-historical canon. She sees Garrard's writing as an expression of a "possessed" agent rather than as a producer of its own authentic difference. She also rightfully asks why Garrard has not questioned issues of class, patronage, and social relations, probing the meaning of sexual difference in a patriarchal framework. Telling points are made concerning religious difference (i.e., Jewish vs. Christian), which are not taken up in Garrard's study. Concludes with Helene Cixous's notion of woman's authentic voice remaking history and transforming humanity. For contrast see Shelia Ffolliott, *Woman's Art Journal* 12, no. 1 (Spring/Summer 1991): 41-42.

897 POLSON, MARGARET R. "The Feminine Sensibility and Inner Space: Some Thoughts concerning Jungian Psychology in Art." *Southern Quarterly* 17, no. 2 (1979): 42-51.

Polson suggests that any society that consistently devalues the feminine should be made aware of the various dimensions of the female as they have been expressed symbolically through women's art. She argues that the female will be better understood and the society can better understand itself if this is accomplished.

898 POWELL, RICK. "Margo Humphrey." *Hatch-Billops Collection, Inc.*, 5 (Visual Arts) 1987: 56-65.

Interview traces Humphrey's career and discusses African-American art, Tamarind Workshop, internationality, travels, feminism, Robert Colescott's influence on her satirical prints, Raymond Saunders, Betye Saar, and future plans.

899 PRINCENTHAL, NANCY. "Synthesizing Art, Nature, and Technology." *Heresies* 6, no. 2 [Issue 22]: 68-71, 7 illus.

Comments on the lack of attention women artists working with the environment get as compared to males, for example, Betty Beaumont vs. Michael Hiezer or Walter de Maria. Princenthal believes the reason for this is Beaumont's radical utopianism and her belief in the cultural and social applications of new technology. Also considers the shows "Les Immateriaux" at the Pompidou (1985) and "Cybernetic Serendipity" (1985) at the Institute of Contemporary Arts, London. Concludes that Beaumont is able to "preserve a humanistic ideology on just the grounds where postmodernism finds it most seriously threatened."

900 PROSKE, B. GERTRUDE. "American Women Sculptors." Part 1. *National Sculpture Review* 24, no. 2-3 (Summer-Fall 1975): 8-15, 28, 16 illus.

Catalogs the careers of a large number of American women sculptors, from the early eighteenth century to the 1930s. In the mid-nineteenth century most of them emigrated to Rome to study and to work. Argues that after the Civil War the climate in the United States was more favorable to the development of women's talents, with more access to art schools, apprenticeships, and commissions.

901 PROSKE, B. GERTRUDE. "American Women Sculptors." Part 2. *National Sculpture Review* 24, no. 4 (Winter 1975-1976): 8-17, 28, 25 illus.

Proske claims that by the 1920s sculpture by women tended towards stylization and simplification; artists such as Katharine Lane Weems placed more emphasis on basic form than on naturalistic detail. Many of the artists described here frequently use wildlife as subject matter, particularly Gertrude K. Lathrop, who designed detailed medals for the conservation of wildlife; Charlotte Dunwiddie, who made animal portraits for owners; Grete Schuller, who made many small animal sculptures; and Hazel Brill Jackson. Other themes such as Joan of Arc's riderless horse and *The Crusader* were more ambitious. Various artists concentrated their energies on domestic tasks, figures of children, and religious themes.

902 RABINOVITZ, L. "Issues of Feminist Aesthetics: Judy Chicago and Joyce Wieland." *Woman's Art Journal* 1, no. 2 (Fall 1980-Winter 1981): 38-41, 3 illus.

Compares the careers, intentions, working methods, and achievement of Joyce Wieland and Judy Chicago, with reference to their respective installations, *True Patriot Love/Veritable Amour Patriotique* (1971) and *The Dinner Party* (1979). Both shows use women's crafts to unify thematic presentations. In writing books to

accompany their exhibits, both artists showed how their political beliefs and associations with other artists helped them to arrive at their conception. Wieland's superficial charm and naïveté masks a rigorous intellectualism that empowers active audience participation. By comparison, *The Dinner Party* passively involves the audience, banks on patriarchal religious symbolism, and uses simplistic means to realize its ends. Concludes that Chicago furnishes some disturbing and disappointing resolutions to challenges that Wieland illustrated eight years before. *True Patriot Love* is about its own contradictions. *The Dinner Party* lacks awareness of the contradictions it proposes.

903 RADYCKI, J. DIANE. "The Life of Lady Art Students: Changing Art Education at the Turn of the Century." *Art Journal* 17, no. 1 (Spring 1982): 9-13, 8 illus.

Discusses the life of female art students in Europe in the late nineteenth to early twentieth centuries, especially in Paris and Germany. Cites the activities of the Union des Femmes Peintres et Sculpteurs, founded in Paris in 1881, and the Verein der Kunstlerinnen, founded in Berlin in 1868. Also examines the art education of Kathe Kollwitz and Paula Modersohn-Becker as examples of art training available to women in that period. See May Alcott.

904 RAHMANI, AVIVA. "The Mental Technology of Requiem." *The Act* 2, no. 1 (1990): 64-67.

A 366-minute meditation by the artist, an incest victim, who reconciled with her father before he died and commemorated him in this piece. She discusses the work as a burial ritual: for surviving an abusive past, for her father's slow death from cancer, for the end of an "unmarriage" of twenty-three years, for herself, for outsiders – the insane, abused children, violent men, and battered women.

905 RAND, ERICA. "Women and Other Women: One Feminist Focus for Art History." *Art Journal* 50, no. 2 (Summer 1991): 29-34, 2 illus.

Rand charges that relations between women are neglected, calling for more attention to be focused on lesbians and the meaning of lesbianism. She correctly asserts that the feminist art movement suffers from homophobia, and then examines the invisibility of lesbian cultural agents within the discipline as a whole, especially in revisionism. Concludes feminists need to embrace a lesbian focus because the study of women together reveals multiple oppressions within the society at large. Citing Mary Stoppert's *El Angel Desarrollando* and a letter from her mother, Rand examines women's multiple masks and the psychology that produces them.

906 RANDELL, CLARE. "Sonia Delaunay and the Expanding Definition of Art." *Woman's Art Journal* 4, no. 1 (Spring-Summer 1983): 35-38, 2 illus.

Looks at Sonia Delaunay's (1885-1979) innovative ideas about the nature and scope of art. Discusses her artistic career both in relation to her husband Robert and in terms of her own development, asserting that her career validates the many roles women play in daily life and arguing that Delaunay's success shows that these demands do not have to stifle the creative instinct. See Marter.

907 RANDO, FLAVIA. "The Essential Representation of Woman." *Art Journal* 50, no. 2 (Summer 1991): 48-52.

Rando, like many feminists, asserts that "no social reality exists for a given society outside of its particular sex-gender system." She posits a "schism in feminist theory between" discussions of "woman" and of "differences of culture, ethnicity/race, sexuality, and class." (Here one might logically throw in age.) She divides feminism along the lines of empirical, radical, or cultural, and the French poststructuralists and then presents these views through theory, criticism, art, and film. She concludes by refusing the questions as presently posed and urges us to reconsider the way that "art history and practice function with in gender ideology" and are, in fact, one "technology of gender."

908 RATCLIFF, CARTER. "Harmony Hammond." *Arts Magazine* 50, no. 7 (March 1976): 7, 1 illus.

The feminist intentions of Harmony Hammond might be missed if the spectator was unaware of the ironies of, for example, her *Floor Pieces* in the form of rag rugs. She "wants to touch on values more profound – from a feminist point of view – than those of traditional modernism or ethology." Her suprapersonal metaphysical equilibrium "occurs as primordial patternings (the processes, evocations, and results of weaving) that transcend borrowed traditions and even individual personality to reveal ultimate meanings." See Langer; Lippard; Raven.

909 RAUCH, ANGELIKA. "The Trauerspeil of the Prostituted Body, or Woman as Allegory of Modernity." *Cultural Critique*, no. 10 (Fall 1988): 77-88.

Examines the avant-garde at the turn of the century in light of Walter Benjamin's theory of culture and the meaning of femininity. Argues that the realm of art becomes a place for unconsciously projecting one's desires. The usurpation of women for the mechanism of representation in the history of aesthetics is exposed as a referential structure that is a cultural sign. Woman in aesthetics can be said to be the sublimated representation of male desire. The whore sells her appearance of femininity as a commodity. Cites

Warhol's Marilyn Monroe. Claims that "by selling her own commodity, she can manipulate this appearance to her advantage." See Susan Edwards; Langer; Lippard; Raven.

910 RAVEN, ARLENE. "Women's Art: The Development of a Theoretical Perspective." *Womanspace Journal* 1, no. 1 (February-March 1973): 14-15, 17, 20.

One of the first essays in feminist art theory to tackle the problems of developing alternative practices to patriarchal systems of interpretation and academic theorizing. From the outset it is understood that women must develop a voice of their own without the constraints of patriarchal language, structure, institutions, and traditions.

911 RAVEN, ARLENE, and ISKIN, RUTH. "Through the Peephole: Toward a Lesbian Sensibility in Art." *Chrysalis*, no. 4 (1977): 19-31, 11 illus.

A generative dialogue between two prominent feminist art historians in the process of developing a specifically lesbian sensibility that began to emerge during the late 1960s within the context of the feminist movement in art. "The lesbian perspective – like other minority perspectives – quintessentially symbolizes the feeling of encapsulation, aloneness, isolation experienced by any individual who is willing to confront the human condition." (Raven 20). The discussion is based on the artwork created in the Feminist Studio Workshop at the Woman's Building, Los Angeles. Artists include Nancy Fried, Jerri Allyn, Dara Robinson, Candance Compton, Nancy Angelo, Diane de Vine, Marguerite Elliot, Marcie Baer, and Lili Lakich. See Wolverton; and *Frontiers* 4, no. 3 [Lesbian History Issue] (Fall 1979).

912 RAVEN, ARLENE. "The Circle: Ritual and the Occult in Women's Performance Art." *New Art Examiner* 8, no. 2 (November 1980): 8-9, 3 illus. Reprinted in *Crossing Over*, by Arlene Raven (entry 193), pp. 23-32.

Raven examines the occult ritual at the center of feminist performance art, referring to the ritual use of the female body as a divine entity in the closed, private circle of feminism, to bear witness to the abuses of women's lives, to raise their consciousness, and to heal. Discusses a number of performances that took place at Womanhouse, a collaborative art environment created by twenty-three women of the feminist art program at the California Institute of the Arts, Los Angeles, under the direction of Judy Chicago and Miriam Schapiro.

913 RAVEN, ARLENE. "Passion/Passage." *High Performance* 21 (1983):
 14-17. Reprinted in *Crossing Over*, by Arlene Raven (entry 193), pp.
 47-56.
 Reviews a performance in eight tableaus by Cheri Gaulke, *This Is
 My Body*, at the Church in Ocean Park, California, seeking
 redemption, exorcising evil, and choosing survival. The event revised
 5,000 years of theological overlay and biblical history from a feminist
 perspective. It is a tri-medium text of performance, sound, and slide
 projection inspired by Mary Daly's *Gyn/Ecology*, feminist theology.

914 RAVEN, ARLENE. "The Art of the Altar." *Lady-Unique-
 Incantation-of-the-Night*, Autumn 1983, 29-41. Reprinted in *Crossing
 Over*, by Arlene Raven (entry 193), pp. 71-82.
 Raven builds a theory of altars as art, mentions Gloria Orenstein's
 "New York Women's Salon," her work on the sensibility and spirit of
 the female surrealists, Linda Vallejo and her Chicana background,
 Betye Saar's ritual boxes and multicultural assemblages, and Cheryl
 Swammack's eclecticism. Using first-person statements by these
 artists, Raven weaves a tapestry of connecting spiritual consciousness
 that recounts the creating of a new vision.

915 RAVEN, ARLENE. "A Hunger Artist." *High Performance*, no. 29
 (1985): 44-47. Reprinted in *Crossing Over*, by Arlene Raven (entry
 193), pp. 57-62.
 A critique of bulimia as an American sickness and how the
 media's highlighting of the "you can't be too rich or too thin"
 mentality distorts women's images of what a healthy body is. Artist
 Vanalyne Green's work uses autobiography to illuminate the fact of
 alcoholism as a family disease and how it impacted on her need to
 starve herself. Raven cites the cases of Johnny Cash, Elizabeth
 Taylor, Liza Minelli, and Mary Tyler Moore, all "Starving for
 Attention." She cites Karen Carpenter's anorexia and how it shocked
 us in *People* magazine as one example. In this article, Raven argues
 for an art of social change that is activist and lauds Green's material
 as transformational.

916 RAVEN, ARLENE. "Star Studded: Porn Stars Perform." *High
 Performance*, no. 28 (1984): 24-27, 90, 91. Reprinted in *Crossing Over*,
 by Arlene Raven (entry 193), pp. 171-81.
 The piece grew out of a dialogue on feminism and pornography
 with Linda Brunham and six readers at *High Performance*. Traces
 how feminist performance has given us an overview of
 pornography – its origins, victims, and implications – through the
 works of Annie Sprinkle, Veronica Vera, and Ellen Steinberg and
 discussion of the Dworkin-MacKinnon ordinance (certainly one of
 the most debated of issues in feminist debates on pornography pro

and con). A serious examination of the risks involved in reconsidering pleasure and sexual freedom in the context of pornography and a patriarchal society. Raven focuses on the differences in definitions of pornography that can cause confusion and commonality among women vis-à-vis this issue. Cites Annie Sprinkle's "Deep inside Porn Stars" to make very telling points in this often confusing and infuriating debate among liberals and radical and conservative feminists.

917 RAVEN, ARLENE. "Cognitos: June Wayne's New Paintings." *Arts Magazine*, October 1984, 119-21. Reprinted in *Crossing Over*, by Arlene Raven (entry 193), pp. 63-69.

Reviews twelve works in Wayne's first New York exhibition in thirty years. The works speak to a consciousness "one knows at once even though one has never seen it before." The surface of each work is a different topography made of handmade paper applied to canvas or built up of gesso, acrylics, sand, or stone. Raven speaks to Wayne's experience as a wise crone who knows that "the deepest knowledge of the universe reaches underneath the humanistic convention which animates our social conduct to an understanding of manner and pattern beyond human endeavor and human nature."

918 RAVEN, ARLENE. "We Did Not Move from Theory/We Moved to the Sorest Wounds." In *Rape* (part of an exhibition catalog). Columbus: Ohio State University Gallery of Fine Art, 1985, pp. 5-12. Reprinted in *Crossing Over*, by Arlene Raven (entry 193), pp. 157-66.

In an essay dedicated to Ana Mendieta, Raven deals with the theme of rape. In this exhibit, twenty artists created works dealing with sexual violence. The shared experience, one Raven herself was a victim of, a crime of violation, gives one insight into rape as a political act. Rape touches and diminishes all our lives. This show has been a compelling action of creative survival and acts as a catalyst for healing for all those who participated in it or viewed it. See Raven's "Close to Home," which describes her experience in writing the essay for "Rape," which is also in *Crossing Over*.

919 RAVEN, ARLENE. "Not a Pretty Picture: Can Violent Art Heal?" *Village Voice*, 17 June 1986. Reprinted in *Crossing Over*, by Arlene Raven (entry 193), pp. 183-88.

In this forceful essay, Raven argues that confronting art of violence and the violated is always easier at a distance, citing the photographer Weegee's murders and victims, and Andy Warhol's electric chairs and race riots. She claims that seeing performances, for example Jerri Allyn's ("My chest crumbling in, my eyes slitting, I can barely see. This hurts. I wanna know why . . ."), and viewing objects that deal with battering, incest, and crimes against women

such as those made by Aviva Rahmani, Clarissa Sligh, Nancy Grossman, Nancy Fried, and Nancy Spero can make the public aware of these issues on a level that verbal communication doesn't. The "wounded healer, hurt, exiled, and without even a thin skin," Raven explains, turns rage to poetry. She argues against censoring violence precisely because opening these wounds "may trigger a healing revolution."

920 RAVEN, ARLENE. "Rare Book Collection." *Women's Review of Books* 4, no. 7 (April 1987): 11-13.
 The feminist art movement has had an impact on the art press. But gender-based discrimination against a background of national economic decline has hit the arts hard. Despite some gains, the backlash has hurt women's art and feminism. Examines women artists' books. Cites Nancy Azara, Barbara Nessim, Kathy Constantinides, the exhibition "Cross Pollination," and collective thinking as illustrated in the performance work of Suzanne Lacy, Linda Montano, Jerri Allyn, Martha Rossler, and Eleanor Antin. Concludes that at their best artists' books can catalyze an instant revisionary insight of their subject.

921 RAVEN, ARLENE. "The Last Essay on Feminist Criticism." In *Feminist Art Criticism*, ed. Arlene Raven, Cassandra Langer, and Joanna Frueh (entry 112), 1988, pp. 228-38. Parts of this article appeared in *Art Papers*, September-October 1987, and *Village Voice*, September 1987.
 Discusses postmodernism in the 1980s, suggesting that a large body of work examines the social body on the one hand and the physical body on the other. Examines the stigmatized aspects of pattern, decoration, vaginal imagery, body art, ritual, and other forms pioneered by women in response to their particular experience. Scrutinizes the discourse of essentialism in relation to feminism through a series of statements by prominent feminist artists and critics, and the attacks on it in the postmodern 1980s.

922 RAVEN, ARLENE. "Body Beauty." *Village Voice*, 26 January 1988, p. 84.
 Reviews Nancy Fried's most recent show at Graham Modern, N.Y. Discusses Fried's sculpture in the context of classical art, grief, and cancer and, from a feminist vantage point, stressing that loss of a breast is not loss of self or the spirit of life.

923 RAVEN, ARLENE. "Beyond Survival: Old Frontiers/New Visions–Artists Speak Out." In *Positions*, edited by Cassandra Langer. Reflections on Multi-Racial Issues in the Visual Arts, vol. 1,

no. 1. New York: New York Feminist Art Institute, 1989, pp. 1-14, 27 b&w illus.

Raven poses a set of five provocative questions, asking individual artists to deal with survival, support for living an artist's life, insider/outsider status within the art world, racism and sexism, and the healing properties of art making. Artist responses include those of Clarissa T. Sligh, Chie Nishio, Renee Rockoff, Helen Oji, Emma Amos, Carol Sun, Asiba Taupahache, Regina Tierney, G. C. Ortiz, Nancy Chunn, Yong Soon Min, Jaune Quick-to-See Smith, Liliana Porter, Elba Herrero Fiallo, Barbara Nessim, Margo Machida, Josely Carvalho, Meredith Lund, Judite Dos Santos, and Editha Messina.

924 RICH, ADRIENNE. "Disloyal to Civilization: Feminism, Racism, and Gynephobia." *Chrysalis*, no. 7 (1979): 9-27.

Rich confronts the crossroads "mined with pain and anger" from a lesbian/feminist vantage point. Everywhere racism is acknowledged in feminist writings and the antiracist, class-transcending impulse is basic to the movement. Discusses "Amazon power," "feminist accountability," and survival.

925 RICH, ADRIENNE. "Compulsory Heterosexuality and Lesbian Existence." *Signs* 5, no. 4 (Summer 1980): 631-60. Reprinted as "Compulsory Heterosexuality" in *Powers of Desire*, ed. Ann Snitow, Christine Stansell, and Sharon Thompson (New York: Monthly Review Press), 1983.

Discusses the heterosexual contract and its complex psychological and legal effects on women and, in particular, the homosexual community, especially lesbians. A must for anyone interested in exploring issues of gender, diversity, and the gaze in art.

926 RICH, RUBY. "In the Name of Feminist Film Criticism." *Heresies* 3, no. 1 [Issue 9] (Spring 1980): 74-81.

An earlier version was published as "The Crisis of Naming in Feminist Film Criticism," *Jump/Cut*, no. 19 (December 1978): 9-12. In this essay Rich inclines toward a view of feminist film criticism as an area of study rather than an arena for political activism.

927 RICHARD, NELLY. "Margins and Institutions: Art in Chile since 1973." *Art and Text*, no. 21 [Special Issue] (May-July 1986).

In English and Spanish. Ten critical essays in conjunction with the exhibition "Art in Chile since 1973." Of particular interest to feminist researchers are "Ellipsis and Metaphor," which includes information on Catalina Parra's *Diario de Vida* and the resistance of Chilean artists to censorship; "The Photographic Condition," which discusses the code in the work of art; and "The Rhetoric of the Body," which

deals with the body as the physical agent of the structures of everyday experience, particularly as regards signs of sexuality and gender in the work of Diamela Eltit.

928 RICKEY, CARRIE. "Why Women Don't Express Themselves: Put the Blame on the Boys, Mame." *Hue Points* 12, no. 1-2 (Spring-Summer, 1983): 5-6, illus. Reprinted from the *Village Voice*, 2 November 1982.

Rickey criticizes "postfeminist women" for their denial of feminism and cites "Neo-Expressionism" as a celebration of "penis-as-paintbrush" mentality, showing how the new spirit in painting for the 1980s hurts women and particularly feminist artists. She argues that postmodern art is a direct consequence of feminism and points out that the autobiographical, diaristic, confessional, and expressionistic modes of women artists have been appropriated by male artists including Frank Stella, Lucus Samaras, Kenny Price, David Salle, and Julian Schnabel. The "systematic exclusion of women expressionist artists deliberately distorts the contemporary art situation." She points out that women who are in positions as curators, editors of major journals, and gallery owners are as much to blame for the situation as men.

929 RIISAN-JEANTET, C. "Why Do the Angels Lack Sex?" *Opus International*, no. 88 (Spring 1983): 38-40, 3 illus.

In French. Claims that sexual expression in a work of art is not an element of it but a subconscious expression of the artist. Considers the hidden sexual elements in the arts, discusses their function and means, and presents ways of recognizing these sexual allusions.

930 RINGGOLD, FAITH. "Being My Own Woman." *Women's Studies Quarterly* 15, no. 1-2 (Spring-Summer 1987): 31-34.

These excerpts from an unpublished autobiography deal with the years 1966-67. Seen against the background of Martin Luther King, Malcolm X, and James Baldwin, Ringgold describes the dichotomy between white and black people, women, and her visual perceptions. Discusses her paintings from the 1960s, when she emerged as a major American artist who was black. Talks about Spectrum Gallery, the white and black power structures, being a woman, and emerging feminism, and illustrates these points with her *United States Postage Stamp Commemorating the Advent of Black Power* (1967) and *The Flag is Bleeding* (1967). See Cliff; Roth; Wallace.

931 RINGGOLD, FAITH. "What Do Black Women Really Want?" *Women Artists News* 13, no. 2 (Summer 1988): 5-6.

"I don't pay taxes like a black woman. I pay taxes like a white man!" Ringgold doesn't feel she's made it yet and she is angry about

the fact that she can't get her work out to the public the way a white male can, that she isn't equal, that she can't get the same opportunities as a man. She also notes ageism and discusses her bicoastalism, teaching in San Diego and working in New York.

932 RISATTI, HOWARD. "Lippard's 'Get The Message' Garbled." *New Art Examiner* 12, no. 6 (March 1985): 44-45, 1 illus.

Review of Lucy R. Lippard's *Get the Message?* (entry 152), a collection of forty-six essays by one of the art world's leading feminists and left-wing activists. Risatti considers the book to be poorly edited and points out several factual errors, before going on to criticize some of Lippard's oversimplified premises, particularly the equation of modernism with a male-dominated formalism and Lippard's division of the art world into producers and profiteers. He concludes that all ideological extremism, whether from the right or the left, endangers the truth. Few would argue the point but how unreasonable or valid his reading is remains open to debate.

933 RISATTI, HOWARD. "The National Museum of Women in the Arts." *New Art Examiner*, Summer 1987, 27-29.

Poses the question "Is the founding of this museum another coup for the conservatives?" Gives background on Wilhelmina (Billie) Holladay and how she raised millions for the new museum, which is housed in a former Masonic temple. Discusses the lively debates concerning ghettoization of women's art and feminist politics surrounding the museum (i.e., segregation of women's art, status, retrogressive politics). Some artists also expressed skepticism about the concept. Others, however, saw it as a necessary step to help women and worried about its lack of a firm commitment to feminism. The issues are complicated and remain volatile. Views by Linda Nochlin, Lucy Lippard, Mel Watkins, and Nancy Spero are presented. Risatti rightfully concludes that the Women's Museum should open its doors to all women by letting guest curators with a broad range of positions share their views. To date this still has not happened, and the museum continues to be a conservative enclave shaped by collector mentality. See John Loughery, "Mrs. Holladay and the Guerrilla Girls," *Arts* 62, no. 2 (October 1987): 61-65.

934 ROBERTS, ALLYN. "Men and Women as Partners in Change." *Arts in Society* 2, no. 1 (Spring-Summer 1974): 62-70, 4 illus.

A discussion led by Roberts, which begins by analyzing men's fear of and emotional reactions to the women's movement and focuses on the biological, genetic, and psychic roots of the problem and the historical processes that have produced the women's liberation movement. She argues that the adoption of technocratic gods by Western society is gradually being rejected for more meaningful

value systems, of which more self-determination is an important element for black people, women, and all underprivileged groups. Asserts that this has precipitated a deep male fear of inadequacy and annihilation by the female principle. Both the fears of men and the repression of women through them are facets of our society, and it is against this that the sexes must unite to promote change.

935 ROBINS, CORINNE. "Patsy Norvell." *Arts Magazine* 50, no. 9 (May 1976): 14, 2 illus.

Discusses *The Great Parabola* and *Expansion Circle* in the context of Norvell's development. Her sculptures use many different materials including wood, wire, bones, and sticks, which is one result of her feminist interests.

936 ROBINS, CORINNE. "Judith Bernstein." *Arts Magazine* 53, no. 4 (December 1978): 18, 1 illus.

Reviews an exhibition of paintings and drawings by Judith Bernstein who has been creating images of giant architectural screws for nine years. Bernstein's emphasis on the phallus seems more connected with repression than release.

937 ROBINS, CORINNE. "The Women's Art Magazines." *Art Criticism* 1, no. 2 (1979): 84-95.

Discusses the recognition of the existence of women artists made by two short-lived but significant American journals on women's art: *Womanart* (1976-78) ran to only seven issues and was not around long enough to effect significant changes in awareness; *Feminist Art Journal* (1972-77) published nineteen issues and is an invaluable resource for future feminist historians. She concludes that as far as providing source material about the directions and achievements of contemporary women artists in the 1970s is concerned, both journals remain only as adjunct publications to other art magazines of the period.

938 ROBINS, CORINNE. "Words and Images through Time: The Art of Nancy Spero." *Arts Magazine* 54, no. 4 (December 1979): 103-5, 5 illus.

Nancy Spero's art centers on women's role in primitive and modern society. Spero, an activist in the feminist community, creates pictures that are didactic comments on the underlying complex problems that still face women in so-called "civilized" society. Using past torture in Babylonian myth and present torture in Uruguay and Chile, the artist weaves a complex pattern of violence and violation that calls into question the whole structure of patriarchal society and its laws. Robins also refers to the artist's identification with the

poems of Antonin Artaud and her series of pictures about him, the *Codex Artaud*, begun in 1969. See Richard.

939 ROBINS, CORINNE. "Nancy Fried." *Arts Magazine* 62, no. 7 (1988): 97.

Reviews Fried's show at Graham Modern, New York City, discussing the twenty-six small terra-cotta sculptures in the context of pain, radical mastectomy, recognition of loss, historical presence (Roman and Etruscan), and what is human and connected in us all. See Langer; Raven.

940 ROGERS, G. "She Has Been There Once or Twice: A Talk with Lee Krasner." *Women Artists Newsletter* 3, no. 6 (December 1977): 3-4, 8, 1 illus.

Krasner discusses her success, the women's movement, and her most recent work. She believes that her marriage to Jackson Pollock presented her with difficulties in her own career. Although there has been progress and many women artists are now better known that they would have been when she started painting, she feels women are still considered second-class citizens. See Rose.

941 ROM, CHRISTINE C. "One View: The Feminist Art Journal." *Woman's Art Journal* 2, no. 2 (Fall 1981-Winter 1982): 19-24.

Discusses the formation of *Feminist Art Journal* in 1972, its goals, functions, limitations, and successes, and reasons for its failure and collapse in 1977. See Robins.

942 ROONEY, F. "Persimmon." *Resources for Feminist Research* 13, no. 4 (1984): 30-32.

In this interview, Canadian feminist sculptor Persimmon Bladebridge discusses the political and sexual nature of her art, the pieces on which she and Sheila Gilhooly collaborated, public criticism and condemnation of her work, and lesbianism in art.

943 ROOS, JANE MAYO. "Another Look at Henry James and the 'White, Marmorean Flock.'" *Woman's Art Journal* 4, no. 1 (Spring-Summer 1983): 29-33, 3 illus.

Refers to James's disparaging phrase (from *William Wetmore Story*, 1903) about Harriet Hosmer and other American women sculptors living and working in Rome; briefly discusses Hosmer as a sculptor and a woman. See Gerdts.

944 ROOS, SANDRA. "Women's Imagery/Woman's Art." In *Women's Culture*, ed. Gayle Kimball (entry 239), 1981, pp. 42-59, 4 illus.

Traces certain consistent types of images in women's art from prehistoric to contemporary times, focusing on shared attitudes.

Cites Helen Frankenthaler, Lee Bontecou, Eva Hesse, Barbara Hepworth, Alice Aycock, Gina Pane, Judy Chicago, and Louise Bourgeois.

945 ROSE, BARBARA. "Vaginal Iconology." *New York Magazine* 7 (11 February 1974): 59.
 Discusses the emergence of central imagery in women's art and its possible meanings. Includes work by Judy Chicago and others. See Lippard; Schapiro.

946 ROSLER, MARTHA. "The Private and the Public: Feminist Art in California." *Artforum* 16, no. 1 (September 1977): 66-74, 10 illus.
 The history of and the present activities at the Woman's Building in Los Angeles are narrated, and its theoretical bases are treated as the major instance of feminist art theory in southern California. Its particular formulation of feminism can be characterized as cultural feminism, by analogy with cultural nationalism. The problem of division between rhetoric and practice is raised. The work of several artists is discussed in detail for the disclosure of a growing interest in pragmatic strategies. Notable among them are Suzanne Lacy, Laurel Klick, and Lynn Hershman, all of whose art performances relating to prostitutes are analyzed.

947 ROSLER, MARTHA. "Some Contemporary Documentary." *Afterimage* 11, no. 1-2 (Summer 1983): 13-15, 12 illus.
 Recent social-documentary photography by women photographers is involved in reshaping photographic practice, and it is a response to actual social relations, particularly those involving women.

948 ROSSER, PHYLLIS, and LIEDERMAN, TOBY Z. "Feminism and Art: Four Lectures by Arlene Raven." *Women Artists News* 10, no. 5-6 (September 1985): 10-11.
 Reviews four lectures Arlene Raven gave at the New York Feminist Art Institute on "Feminism and Art"; "The Culture As Male – As Seen in the Feminist Analysis of Art in the 60s and 70s"; "Male Culture as Both Sadistic and Pornographic, a Discussion of Expressionism"; and "Women's Spirituality." The underlying theme of these lectures was the concern for survival that must extend to the art world, particularly in the inclusion of women's art in important museum shows. Raven also pressed for more support for women's art outside the male establishment.

949 ROTH, MOIRA. "Visions and Re-Visions: A Conversation with Suzanne Lacy." *Artforum* 19, no. 3 (November 1980): 42-45, 4 illus. Reprinted in *Feminist Art Criticism*, ed. Arlene Raven, Cassandra Langer, and Joanna Frueh (entry 112).

Suzanne Lacy talks about performance art in a feminist context, discussing its political motivation and effectiveness, and the importance of the feminist "rewrite of history" that is prerequisite to the forging of a female identity independent of patriarchal concepts. The importance of autobiography, contemporary issues, and attitudes affecting the lives of all women in feminist art are also discussed, and she describes events that incorporated women on global, national, and city levels.

950 ROTH, MOIRA. "Visions and Re-visions: Rosa Luxemburg and the Artist's Mother." *Artforum* 19, no. 3 (November 1980): 36-39, 5 illus.

Reviews ten years of feminist art, taking stock of the present state and future direction of both feminist art and feminist art criticism in order to determine what constitutes effective feminist art criticism now. This reassessment is necessary because of the radical changes that have occurred in the criteria for feminist art and its criticism over a few years before 1980. Reprinted in *Feminist Art Criticism*, ed. Arlene Raven, Cassandra Langer, and Joanna Frueh (entry 112). For an update see *Art Journal* 50, no. 2 (Summer 1991).

951 ROTH, MOIRA. "Teaching Modern Art History from a Feminist Perspective: Challenging Conventions, My Own and Others." *Women's Studies Quarterly* 15, no. 1-2 (Spring-Summer 1987): 21-24.

A thoughtful exploration that offers strategies for future development and challenges convention, urging a remaking of art history itself. Roth argues that the integrity of the discipline requires that insights and information provided by feminist scholars be used not to include the occasional woman artist into the saga of male geniuses but to redefine the perspective and values of modern art as a whole. See Frueh; Langer; Pollock; Raven.

952 ROTH, MOIRA. "Suzanne Lacy: Social Reformer and Witch." *TDR*, Spring 1988, 42-60.

A comprehensive article discussing Suzanne Lacy's performance and participation pieces: *Freeze Frame: Room for Living Rome*, which included more than 100 women, and *Whisper, the Waves and the Wind*, in which more than 150 white-clad women from a variety of racial and cultural backgrounds and ranging from 60 to 98 years of age sat on a La Jolla beach and told their secrets. The work calls up several questions: what is the impact of these enormous tableaux and pageants, and how can we judge them? Discusses Lacy's criteria for measuring the effectiveness of her work. In the second part, Roth discusses Lacy in the context of the "witch" and spirituality in Western culture. Lacy's work recognizes archetypal connections although not necessarily in a scholarly way. At the heart of Lacy's work is the need to both experience and become one with "the other."

Concludes by asking if Lacy's work leads to a redefinition of the shaman's role and female power.

953 ROTH, MOIRA. "The Tangled Skein: On Re-Reading Heresies." *Heresies* 6, no. 4 [Issue 24: 12 Years] (1989): 84-88, 10 illus.

A short, sensitive, and critical overview of the *Heresies* collective enterprise. Roth emphasizes the collective nature of the publication, its dedication to diverse ideas, its wild diversity of voices, its adamant determination to support difference, and its staying power as a real alternative to mainstream practice. Central to Roth's analysis is a recognition that *Heresies* celebrates a wide range of information and viewpoints and gives ample voice to the very real differences that are the underlying strength of the feminist movement.

954 ROY, HELENE. "A Question of Art, Feminine, Feminist, or Other Question." *Cahiers des arts visuels au Québec* 4, no. 13 (Spring 1982): 7-10, 22, 3 illus.

Asserts that women's art offers a new vision or version and that this subversive character is perhaps responsible for a reluctance to accept it. Roy suggests that what makes art "feminist" is that it is by women and concerns the situation of women in society. It corresponds to a social and political reality and should be accepted as such, not subjected to an "institutional judgement" on its artistic quality. She describes her own art as essentially autobiographical and concludes that although it is very probably "feminist," this is not the result of a conscious choice.

955 RUBINSTEIN, CHARLOTTE STREIFER. "The First American Women Artists." *Woman's Art Journal* 3, no. 1 (Spring-Summer 1982): 6-9, 3 illus.

Discusses weaving and painting on leather by early American Indian women. Excerpted from her book *American Women Artists* (entry 41).

956 RUSSELL, DIANE H. "Art History." *Signs* 5, no. 3 (1980): 468-81.

Reviews recent informational and conceptual literature on women and the visual arts, stating that among the most important works is the exhibition catalog *Women Artists: 1550-1950* (entry 376). Research on women artists has increased rapidly and has added vitality to art history scholarship and legitimacy to the study of women artists, whereas the study of women's imagery, a subject that is difficult to grasp and to discuss, is heavily influenced by sexual politics.

957 RUSSELL, DIANE H. "On the 'State of Research' in "Letters to the Editor." *Art Bulletin* 1, no. 70 (March 1988): 138.

One of the few critical commentaries regarding the Gouma-Peterson and Mathews essay, "The Feminist Critique of Art History" (entry 584), to find the light of publication in the pages of the largely male-controlled, official College Art Association publication whose then editor censored the publication of many other letters from feminists on the most transparently sexist grounds. Russell rightly explains that the essay "is unnecessarily polemical and ungracious to a number of dedicated feminist scholars and . . . gives no idea of the richness and importance of publications in women's studies . . . now available."

958 SANDIFORD, J. "A Litany of Aspirations: Judy Chicago and the Dinner Party." *Vanguard* 8, no. 7 (September 1979): 18-20, 5 illus.

The circumstance leading to this conversation was Chicago's invitational lecture of 7 June 1979 at Langara College, Vancouver, British Columbia. Chicago comments on the concept and execution of *The Dinner Party*, a multidimensional challenge to the values of a patriarchal society, which took her five years to complete. Includes Sandiford's comments on the piece and the artist.

959 SANDLER, IRVING H. "Fay Lansner." *Fay Lansner*, no. 1 (1977).

Discusses Lansner's background, studies with Suzanne Langer at the Hofmann school in Paris in 1949, existentialism, Matisse, Picasso, the Hansa Gallery, and the figurative tradition. Describes changes in recent work and the "winged monsters" in Assyrian myth and how these relate to flight and hope and the theory of "Personism." Concludes with the personal and psychological symbolism now evident in Lansner's work.

960 SANG, BARBARA. "Women and the Creative Process." *Arts in Psychotherapy* 8, no. 1 (1981): 43-48.

Sang analyzes the difficulties experienced by women in translating their creative impulses into works of art. These are primarily social in origin: women have been conditioned to value security, conformity, and social approval rather than independence, innovation, and the isolation that often accompanies the creative process, so they lack self-confidence and tend to devalue their own experience. It is also noted that women artists have been discouraged from specialization and commitment and perhaps fear being totally absorbed by art.

961 SANTORO, SUZANNE. "Suzanne Santoro: The Archetype." *Segno*, no. 6 (January 1978): 39, 1 illus.

In Italian. Santoro discusses her interest in the nature of feminine imagery and the possible relationships in art between female anatomy and natural elements, noting the way in which ambiguity of

sexual imagery allows indirect expression of what an artist may not be able to state directly. RILA.

962 SAUZEAU-BOETTI, A. M. "Negative Capability as Practice in Women's Art." *Studio International* 191, no. 979 (January-February 1976): 24-27, 4 illus.

A survey of art and feminism in Italy, where women artists are still engaged in a private identification. Approaches differ but include those connected, though not necessarily explicitly, with the body, the "oppression and negation which are also self-expression and self-negation," and an "indirect and difficult path" that relates the female and male polarities existing within the female artist. An integration of feminist principles cannot on its own constitute art, which is "a mysterious filtering process requiring the labyrinths of a single mind." The author also provides a calendar of events connected with the new awareness of women artists in Italy, 1975-76; surveys of the work of Carla Accardi, Jole de Freitas, Ketty La Rocca, and Marisa Merz; and reproductions of works at "Magma," a women's collective exhibition in Italy, Nov. 1975-April 1976. RILA. See Katz; Santoro.

963 SAVITT, M. "Hannah Wilke: The Pleasure Principle." *Arts Magazine* 50, no. 1 (September 1975): 56-57, 5 illus.

Examines such works as *Ponder R-Rosa* (1974) and *S.O.S.* (1975). Savitt focuses on the erotic imagery present in Wilke's works and believes the artist "explores a range of evocative images, and presences which affirm with a new sense of openness the pure humanistic pleasure principles." See Frueh.

964 SAWYER, JANET, and MAINARDI, PAT. "A Feminist Sensibility? Two Views." *Feminist Art Journal* 1, no. 1 (April 1972): 4, 25.

Artist Janet Sawyer and art historian Pat Mainardi engage in an exchange. Sawyer talks about how the reproductive process shapes her consciousness of herself and how "collective" the unconscious is. Making images is one way of gaining knowledge of what it really means to be a woman. Mainardi thinks the question of gender in art is asked as a red herring to conceal the real question, which is "is any art being made – by anyone, male or female?" She answers that there is very little being made. She says men have the right to make what they please, whereas women do not. She thinks the question itself is about opportunism and reactionary vis-à-vis biological determinism. Mainardi makes a distinction between feminist art and a feminine sensibility.

965 SCHAPIRO, MIRIAM. "Recalling Womanhouse." *Women's Studies Quarterly* 15, no. 1-2 (Spring-Summer 1987): 25-30.

Describes the collaboration Womanhouse, which started in the fall of 1971. Discusses her own feelings, the students' feelings, works, aesthetics, authority, memories, and teaching on the edge of a revolution. Cites artists Beth Backenheimer, Sherry Brody, Judy Chicago, Susan Frazier, Camille Grey, Vicki Hodgetts, Kathy Huberland, Judy Huddleston, Karen LeCoq, Janice Lestar, Paula Longendyke, Ann Mills, Robin Mitchell, Sandy Orgel, Jan Onenberg, Christine Rush, Robin Schiff, Mira Schor, Robin Welsch, Faith Wilding, Shawnee Wollenman, and Nancy Youdelman to illustrate her points. See Lacy; Raven.

966 SCHAPIRO, MIRIAM, and WILDING, FAITH. "Cunts, Quilts, Consciousness." *Heresies* 6, no. 4 [Issue 24: 12 Years] (1989): 6-17.

Discusses cunt, body, and spiritual art in the context of French feminist writers and their impact on women's art. Cites cunt art, autobiography/narrative representation, domestic and traditional arts, and community and collaboration as fundamental strategies. Concludes that exploring female sexuality and desire and seeking new voices for the unheard, the suppressed, and the silenced and ways to change the art system will structure the art of the 1990s. Illustrations include works by Alice Neel, Emma Amos, Hannah Wilke, Michelle Stuart, Faith Wilding, Judy Chicago, Lucinda Parker, Dotty Attie, Bailey Doogan, Jane Kaufman, Mimi Smith, Sabra Moore, and Barbara Kruger, among others. See Roth.

967 SCHOENFELD, A. "On Choosing between Art and Politics." *Women Artists News* 6, no. 2-3 (Summer 1980): 5.

Report on the panel discussion "Art and Politics: So We Have to Choose Between the Two," held at the New York Feminist Art Institute, 5 June 1980. The panelists, Joan Braderman, Betsey Hess, Candace Hill-Montgomery, Lucy Lippard, and Beverly Naidus, discussed issues surrounding art and politics from the point of view that the two are inseparable from the idea that they exist autonomously.

968 SCHOR, MIRA. "Representations of the Penis." *Meaning*, no. 4 (November 1988): 3-15.

Discusses work dealing with the male nude and the penis. Argues that man privileges himself through the visibility of the penis and women's "lack" of it, and she distinguishes between the phallus and the penis. Cites examples from art history to illustrate her points. Argues that the cloak of man-made law shrouds male desire, particularly in the works of Herman Nitsch, Vito Acconci, and Eric Fischl. Describes the "Tootsie syndrome," in which the best woman is a man (this appears to be truth in lesbian and gay studies too). Also brings in the gay dimension and talks about the male nude as an

object of male desire as in Mapplethorpe's homoerotic images and gay subculture in relation to Nancy Grossman's work of the sixties and seventies. Asserts that female knowledge of the penis, in all its humor and anger, is illustrated in the works of Alice Neel, Nancy Spero, and Margaret Doogan. Claims women's depictions of the penis by Louise Bourgeois, Mia Westerlund Rosen, and others represent the all-powerful phallic mother. Concludes that only by unveiling the phallus can society re-animate and de-castrate itself.

969 SCHOR, MIRA. "From Liberation to Lack." *Heresies* 6, no. 4 [Issue 24: 12 Years] (1989): 14-21.
 A thoughtful and provocative analysis of the three phases of the political and historical development of feminism from the demand for equality, through the rejection of patriarchy by radical feminism, toward a third position that sees the male/female dichotomy as "metaphysical." Cites various readings that relate to these points – postmodernism, deconstruction, psychoanalysis – and that influenced the author's ideas over the past two decades. Compares and contrasts work by Cindy Sherman, Mary Kelly, Frida Kahlo, Elizabeth Murray, and Louise Bourgeois.

970 SCHOR, MIRA. "Patrilineage." *Art Journal* 50, no. 2 (Summer 1991): 58-63. Reprinted in *New Feminist Criticisms: Art, Identity, Action*, ed. Arlene Raven, Cassandra Langer, and Joanna Frueh (New York: Harper/Collins), 1993.
 In this "scattershot" overview of the problems faced in dealing with predetermined systems in art and art history, Schor argues for a complete revamping of our practices. Citing the legitimation through the father in relation to the women artists who have "made it" in the contemporary art marketplace, she notes the persistence of legitimation via referencing as a control factor in the production of art and texts about art that are published and distributed, for example exhibition reviews, feature articles, and catalog essays, all of which feed into the art-star production system. She accurately cites the heavy reliance on the male system to validate a feminist practice as one of the most repressive self-victimizations currently existing in the field of women's studies in art under patriarchy. She concludes by arguing for placing oneself in a matrilineage and a sisterhood as well as a patrilineage and brotherhood, stressing that by knowing one's own history and foremothers we might not only cause a disruption to patriarchal systems, but we might provide a path to a new art history and a different, more inclusive system of legitimation.

971 SCHUBERT, G. "Women and Symbolism: Imagery and Theory." *Oxford Art Journal* 3, no. 1 (April 1980): 29-34, 4 illus.

Examines images of women in late nineteenth- to early twentieth-century art, citing the work of Puvis de Chavannes, Paul Gauguin, Puvis Carriere, Gustave Moreau, and others and linking the visual themes to those of contemporary literature and music. The reactions and writings of Huysmans and des Esseintes are presented for their reflection of symbolist thought in relation to women, and this is linked to the increasing demand being made at the time by women to be recognized as artists in their own right.

972 SCHWARTZ, JUDITH. "Old Maids, Spinsters, and Maiden Ladies." *Lesbian Voices* 2, no. 1 (Winter 1975-76): 41-57; no. 2 (March 1976): 35-48.

Reexamines the unquestioned patriarchal assumption that unmarried women are sexless and lonely (i.e., Rosa Bonheur or Mary Cassatt). See Hammond.

973 SCHWARTZ, THERESE. "They Built Woman a Bad Art History." *Feminist Art Journal* 2, no. 3 (Fall 1973): 10-11, 22.

Surveys art-historical and critical literature, explaining that although a number of males are quoted on the subject of women artists in *The Social History of Art* by Arnold Hauser, only one artist listed out of 450 is a woman. During the 1920s, critics described women's art as "petty, lifeless and strictly limited." By contrast, Pliny and Giorgio Vasari discussed female artists and praised their work. After 1850, and perhaps as a response to feminism, works such as Walter Sparrow's *Women Painters of the World* (1905) (entry 42) resurrected female artists only to dismiss them as delicate and tender, therefore not to be taken seriously when compared to male artists.

974 SCHWARTZ, THERESE. "Who Were These Women?" *Women Artists News* 7, no. 4 (January-February 1982): 5-8, 8 illus.

Addresses the exhibition "Art of the Avant-Garde in Russia: Selections from the George Costakis Collection at the Guggenheim Museum, New York." Among the constructivist artists included are Ljubov Popova, Alexandra Exter, Varvara Stepanova, Antonia Sofranova, Ksenia Ender, and Olga Rozanova.

975 SECREST, MERYLE. "A 'Thief of Souls': Portraits by Romaine Brooks." *Smithsonian* 1, no. 12 (March 1971): 38-45, 7 illus.

Considers lesbian painter Romaine Brooks's life and art in the context of the late nineteenth and early twentieth centuries. The text is dominated by Secrest's prevailing heterosexist views. Shows portraits of Renata Borgatti, Ida Rubenstein, Una Lady Troubridge, and others, which appeared in an exhibition at the National Museum of American Art (Washington, D.C.).

976 SEIFERT, C. J. "Images of Domestic Madness in the Art and Poetry of American Women." *Woman's Art Journal* 1, no. 2 (Fall 1980-Winter 1981): 1-6, 3 illus.

Contrasts images of the American housewife in art between the eighteenth and nineteenth centuries with images in the writings of women from the 1960s onward. She discusses in detail the themes of the housewife, cleaning, and cooking in the work of poets and visual artists, including Ellen Lanyon, Sylvia Mangold, Judy Chicago, and Marjorie Strider, tracing how the nineteenth-century conception of the housewife as the epicenter of the home is transformed by the 1960s into the frustrated housewife-sex object and victim of domestic madness and, finally, during the 1970s, into a feminine power that can transform the reality of the world through fantasy. See Pollock; Raven.

977 SEIGEL, JUDY. "Women's Panels at the C.A.A." *Feminist Art Journal* 2, no. 2 (Spring 1973): 10-11, 14, 2 illus.

Discusses women's panels at the annual meeting of the College Art Association, January 1973. The first panel was concerned with "How the art world evaluates women artists." Questions about sexual and racial prejudice in art history, museums, art colleges, and galleries, and by buyers of art, together with the recurring question of whether male and female art differ, were discussed. The second panel was composed of working artists and dealt with the practical problems of discrimination. The CAA adopted four of the women's caucus's ten resolutions, endorsing hiring and advancement by demonstrated merit only and equal pay for equal work, and opposing discrimination against women in admissions, grants, and all other areas. News coverage of the women's panels was slight; in the eyes of the public women artists still hardly exist. When that public changes its viewpoint, gallery directors, critics, and museums will necessarily also see the light. Women's art activist groups are listed in the report.

978 SEIGEL, JUDY. "How Old Are You Little Woman?" *Feminist Art Journal* 3, no. 1 (Spring 1974): 26.

Asserts that aging is a greater stigma to women than to men in our society. Gives a series of statistics that show women frequently leave out their birth dates, whereas men do not. In the 1973 Whitney biennial catalog, all 170 men gave their birth date; only 4 of 52 women did. While the stigma holds, embarrassment will probably remain. But the age of the artist is relevant where categorizations or critical evaluations of work are to be made and Seigel advises "toughing it out" and giving birth dates.

979 SEIGEL, JUDY. "Women in the Arts: Gallery Action." *Feminist Art Journal* 3, no. 1 (Spring 1974): 7-25, 1 illus.

Reports on a demonstration held by women in the arts showing what a small proportion of work by women artists is displayed in various New York art galleries. The galleries picketed were Knoedler Contemporaries, Pace, Marlborough, Borgenicht, O.K. Harris, Weber, Frumkin, Castelli, Janis, Sonnabend, Poindexter, and Denise Rene. Accounts of the reactions of passers-by and of some of the gallery officials are given. See Pindell; Olin.

980 SEIGEL, JUDY. "Joyce Kozloff." *Visual Dialog* 1, no. 2 (December 1975-February 1976): 7-10, 2 illus.

Kozloff claims sexism leads to the devaluation of certain kinds of art. In studying art of the past she noticed that much art that denies the decorative is highly decorative; this prompted Kozloff to acknowledge the decorative aspect of painting frankly and ostentatiously. She is fascinated by Berber and Navajo rugs, both done by women. She believes the "low" arts, such as pottery and weaving, are denigrated because they are things women have done traditionally. The feminist revolution may change many people's ideas on such topics. If it did, more critics would be reviewing crafts.

981 SEIGEL, JUDY. "The Personal and Public in Women's Art." *Women Artists News* 3, no. 7 (January 1978): 1-2, 1 illus.

Describes a panel, "Contemporary Women: Consciousness and Content," held at the Brooklyn Museum, New York, on 23 October 1977. The speakers, Joan Semmel, Harmony Hammond, Carter Ratcliff, May Stevens, Joyce Kozloff, and Lawrence Alloway, discussed women artists' ability to promote themselves and their relationship with male critics. Seigel asserts that the exchanges between the men and women were not of a particularly high intellectual nature.

982 No entry.

983 "Sexuality in History." *Radical History Review*, no. 20 (Spring-Summer 1979).

Sets the historical debate concerning gender and sexuality in the context of feminism. Essential for any overview of lesbian history. Articles by Blanche Wiesen Cook, Nancy Sahli, and Bert Hansen. See Fishman; Hammond; Langer; Shabazz.

984 SHABAZZ, NEEMAH. "Homophobia: Myths and Realities." *Heresies* 2, no. 3 [Issue 8] (1979): 34-36.

Attacks homophobia and deals with the truth and consequences of identifying with lesbianism. Comments that homophobia is one of the major causes of division within the feminist movement and lesbianism is often used as a "discipline" on heterosexual women to

keep them "in line" and "under control." The home is the primary foundation of such socialization, and this is reinforced in primary, secondary, and high schools. Churches and colleges also participate. Myths about lesbians and why a woman "is that way" include the following: she has a "natural defect," is emotionally unstable, is sexually frustrated, is self-indulgent, is morally degenerate, is antirevolutionary, hates men, suffers from penis envy, is a security risk, wears men's clothes, is sexually aggressive, is physically unattractive, is afraid of men, etc. Concludes these are symptoms of homophobia that help reinforce self-victimization and cause heterosexual women to identify with men. Third-world women and particularly feminists need to look at these negatives and question them.

985 SHEWMAKE, MITZI. "The Five Winston-Salem Printmakers." *Woman's Art Journal* 5, no. 1 (Spring-Summer 1984): 40-46, 4 illus.
 Susan Moore and Ann Carter Pollard are southern artists who have shared a studio for fourteen years. Shewmake gives an extensive description of their work. They were later joined by Martha Dunigan, Virginia Ingram, and Anne Kesler Shields and formed the Five Winston-Salem Printmakers. See Langer.

986 SIMS, LOWERY S. "Black Americans in the Visual Arts: A Survey of Bibliographic Material and Research Resources." *Artforum*, April 1973, 66-70.
 A selective bibliography that includes information on black women artists. Refers to Women Students and Artists for Black Liberation, founded by Faith Ringgold to protest the exclusion of blacks, women, and black women from the "alternative" Biennale show that was to be set up at the School of Visual Arts in New York City.

987 SIMS, LOWERY. "Art: 19th Century Black Women Artists." *Easy Magazine*, January 1978, 32.
 Discusses the myth that women's creativity is in "giving birth and homemaking." Traces the history of the art system, cites Mary Cassatt as a representative example of an American woman artist, and discusses the careers of African-American women artists including Edmonia Lewis, Annie Walker, Meta Warrick Fuller, May Howard Jackson, Laura Wheeler Waring, Elizabeth Prophet, Bertina Lee, Ella D. Spencer, and Lottie Wilson Moss. Highlighting the "overwhelming need for more research," Sims contributes to our understanding of the historical reality of American art and the contributions of African-American women to it.

988 SIMS, LOWERY S. "Third World Women Speak." *Women Artists News*, December 1978, 1-10.

Record of a panel discussion (13 October-20 Soho 1978) held in conjunction with an international exhibition by eight third-world women: Camille Billops, Lula Mae Blocton, Evelyn Lopez de Guzman, Yoko Nii, Howardena Pindell, Faith Ringgold, Selena Whitefeather, and Zarina. Tomei Arai talked about her work at City Arts, Pindell described the "Queen for a Day" syndrome, and Ringgold talked about survival. See Raven in *Positions* (New York: New York Feminist Art Institute, 1989).

989 SJOO, MONICA. "Women's Art in London." *Feminist Art Journal* 2, no. 3 (Fall 1973): 18, 21, 1 illus.

Five women artists exhibited at Swiss Cottage Library, London, in April 1973: Liz Moore, Ann Berg, Roslyn Smythe, Beverly Skinner, and Monica Sjoo. Many people of all classes, sexes, and races saw the exhibition, despite attempts to close it because of alleged pornography in some of the paintings. The exhibition questioned the nature of art and its domination by the male business world. Claims that in our patriarchal society women are told that having children is their sole creative capacity, and competing with male artists means fighting such discrimination. Some female figures in the paintings shown were described as "ugly" and "aggressive" because they didn't wear masks attractive to men, as are seen every day in advertisements and some male art. Women artists must use their art as a revolutionary act.

990 SKILES, JACQUELINE, and MCDEVITT, JANET. *The Women's Movement*. Pittsburgh: Know, 1972.

Account of the emergence of a women's art movement in the United States, particularly New York City. Includes reprints of Muriel Castanis's "Behind Every Artist is a Penis," *Village Voice*, March 1970, and "Forum: Women in Art," *Arts Magazine*, February 1971. Account of the New York demonstrations against museum sexism.

991 SKILES, JACQUELINE. "Looking Back: The Past Ten Years." *Women Artists News* 6, no. 2-3 (Summer 1980): 1, 11-13, 3 illus.

Women artists' organizations founded during the past ten years have their roots in the feminist movement and are more demanding than groups founded in the 1960s and earlier. Skiles analyzes the goals of several of these organizations, including Women Artists in Revolution (WAR) and the Art Workers Coalition (AWC). She believes in the importance of left-wing groups who shun the organized art world and those who seek to transform the art world by insisting on and promoting a new spirituality in women's art,

concluding that in both cases women must become an integral part of the changing process rather than stand on the sidelines.

992 SLOANE, PATRICIA. "Statement on the Status of Women in the Arts." *Art Journal* 31, no. 4 (Summer 1972): 425-27.
 Despite its polemical tone, reflects the passionate commitment to change that characterized the women's movement in art during this period. Comments on the fact that neither the women's movement in general nor the women's art movement have yet produced a definitive theorist. Stresses equal opportunity for all women as an ultimate goal and the creation of a new type of world. Demands more activism and fingering who the enemy is. Discusses the reluctance of the College Art Association to move on women's issues and the complicit behavior of male colleagues; invites women artists to speak for themselves, and addresses the role of critics and gallery owners in discrimination. Calls gender as a concept into question and questions the representation of women. Makes the analogy between women and blacks as groups who are second-class citizens in America. Clamors for radical social change.

993 SMITH, JAUNE QUICK-TO-SEE. "Women of Sweetgrass, Cedar, and Sage." *Women's Studies Quarterly* 15, no. 1-2 (Spring-Summer, 1987): 35-41.
 Comments on an exhibition guest-curated by Lucy Lippard and Harmony Hammond (see exhibition catalog, entry 384). Examines Native American perception of art as "closely intertwined in Indian life, women's commonalities, and the need to beautify life." Cites Florence Benedict, Mary Adams, Mae Whiteman, Rhonda Holy Bear, Jimmie Fife, Gail Tremblay, Gail Bird, and Yazzie Johnson as artists who celebrate beauty and tap the roots of an old and spiritual art form. She discusses the importance of the landscape and self-identification in the work of Sylvia Lark, Kay Miller, Kate Walking Stick, Emmi Whitehorse, Dorothea Romero, and herself. Abstraction, the feeling of the earth, and naive renderings in the work of Otellie Loloma, Charleen Touchette, Romona Sakiestewa, and others refer back to a dream world. Indian women have transcended tradition, bridging two cultures and two histories of art to set a new standard that belongs in the mainstream of world art.

994 SMITH, ROBERTA. "Difference in America." *Art in America* 73, no. 4 (April 1985): 190-99, 16 illus.
 Reviews "Difference: On Representation and Sexuality" at the New Museum, New York (8 December 1984-10 February 1985). Organized around the themes of the representation of sexual difference and the difference between text and image in British and American art of the 1970s and 1980s, the show was heavily influenced

by Mary Kelly and Victor Burgin. It included works by Marie Yates, Yve Lomax, Silvia Kolbowski, Hans Haacke, and Jeff Wall. Smith accurately concludes that the show suffered from a confusion between sexuality and gender, asserting that most of the work questioned the "status" of maleness and femaleness but failed to question the construction of sexuality itself. See de Lauretis; Langer.

995 SMITH, ROBERTA. "Waging Guerrilla Warfare against the Art World." *New York Times*, 17 June 1990, sec. 2, pp. 1, 31, 2 illus.

Considers the Guerrilla Girls, a band of women wearing hairy masks and lace stockings and using unusual tactics to fight sexism and racism. These women have taken feminist theory, given it a populist twist and some Madison Avenue pizazz with their political posters criticizing the art world, and set it loose in the streets. Starting with the first poster in 1985, the group has produced more than thirty in the five years they have been active. Their anonymity is unsettling to some prominent art-world figures and makes their criticism a little easier to take. Smith comments that she parts company with them when it comes to "their attitude toward the notion of quality." Smith concludes that there is still plenty for the Guerilla Girls to do because the art world is still centered on male creative genius and is an elite world and sexist scene. See Josephine Withers, "Guerilla Girls," *Feminist Studies* 14, no. 2 (Summer 1987).

996 SMITH, T. "An Alternative View." *Art Monthly*, no. 57 (June 1982): 6-8, 2 illus.

Text of a lecture given at the 4th Sydney Biennale, "Art, Social Content, and Validation." Claims that the Biennale was political not in terms of the work shown but in what it refused to exhibit and the resistance provoked by this exclusion. Smith lists a range of political work that reflects the diverse practices of artists according to the particular audience and political situation, including critical interrogation, exposure, and arguing in the media, as seen in the work of Conrad Atkinson, Carole Conde, and Karl Beveridge; he explores aspects of female sexuality, from Miriam Schapiro's recovery to explicitly feminist work on social/psychic construction, and looks also towards community work and nonart audiences.

997 SNOW, DEBORAH. "Eye to Eye: Portraits of Lesbians." *Sinister Wisdom*, no. 11 (Fall 1979): 68-70, 3 illus.

Reviews this book and focuses on thirty-nine portraits by lesbian photographer JEB (Joan E. Biren). The publication includes a herstory of lesbian photography by Judith Schwarz and a foreword by Joan Nestle. JEB gives us a tender and bold picture of a diverse lesbian community. Discusses the human quality of JEB's work and her pioneering efforts to give dignity and meaning to lesbian life.

998 SNYDER-OTT, J. "Women's Place in the Home (That She Built)."
 Feminist Art Journal 3, no. 3 (Fall 1974): 7-8, 18, 3 illus.

 An art-historical overview that describes the representation of
 women artists at the World's Columbian Exhibition in Chicago, 1892.
 The monumental statuary on top of the Woman's Building was
 designed by Alice Rideout; the rotunda walls were covered by two
 murals, by Mary Cassatt and Mary Fairchild Macmonnies. See Corn.

999 SNYDER, JOAN. "The Great Debate: Miriam Schapiro and
 Lawrence Alloway on Women's Art at AIR." *Women Artists
 Newsletter* 2, no. 8 (February 1977): 1, 6, 1 illus.

 Report on the discussion at AIR Gallery, New York, between
 Lawrence Alloway and Miriam Schapiro on the nature of women's
 art. Snyder, a serious artist, felt that Alloway continued to ignore the
 existence of female sensibility, but Schapiro stressed too heavily this
 aspect of women's art. Snyder wondered what was the reason for
 Alloway's interest and support of women's art, in the light of his
 views, and she thought that more research was needed to prove the
 existence of a female sensibility.

1000 SONTAG, SUSAN. "The Third World of Women." *Partisan Review*
 4, no. 2 (1973): 180-206.

 Sontag is interviewed by Robert Boyers. She discusses
 colonization, women's second-class adulthood, and the risks–rape or
 physical violence–run by women alone in patriarchal society. Argues
 that women's struggle is not just about equality but about power. She
 accurately links sexism and economics to the class struggle and
 patriarchal culture. Suggests strategies for radical change, many of
 which have been used by the women's art movement.

1001 SONTAG, SUSAN. "Women, the Arts, and the Politics of Culture:
 An Interview with Susan Sontag." Robert Boyers and Maxine
 Bernstein. *Salmagundi*, Fall 1975-Winter 1976, 28-48.

 Discusses the aesthetics of fascism, the work of art as an advocate
 of nothing, her approach to criticism, and her response to Adrienne
 Rich's criticism (*New York Review*, 20 March 1975). Sontag says she
 wants "armies of women and men to be pointing out the
 omnipresence of sexist stereotypes in language, behavior and imagery
 in our society." She defends feminist criticism and abhors "party line."
 Also discusses her "Notes on Camp," "The Pornographic
 Imagination," "The Story of O," and the true meaning of criticism.
 Sontag concludes by asserting that any serious argument about
 culture must honor its complexity.

1002 SPERRY, ANN. "Women and Large Scale Sculpture: Feminist, Macho, or Androgynist?" *Women Artists Newsletter* 2, no. 10 (April 1977): 1, 5.

A discussion on women and large-scale sculpture, held by the Women's Caucus, College Art Association at Los Angeles in 1977. The panel included Lila Katzen, Lin Emery, Claire Falkenstein, Josefa Filkosky, Ann Healy, Beverly Pepper, and Athena Tacha Spear. Artists showed work and the discussion focused on the philosophical implications of women and large-scale sculpture. The question of financing such work was discussed, and personal experiences were shared.

1003 SPRINGER, ANNE JULIE. "Some Images of Women in French Posters of the 1890s." *Art Journal* 33, no. 2 (Winter 1973-74): 116-24, 11 illus.

Woman became the chief focus of French posters in the 1880s and 1890s. Two themes dominated: "L'ingénue," the girl on the threshold of womanhood, and "La Bourgeoise," the middle-class, married woman. The latter was depicted as elegant, bored, and flirtatious, reflecting the temper of a society of arranged marriages. Women were also shown participating in the arts, indicating the new type of woman trying to strike out on her own. See Harper.

1004 SPRINGER, ANNE JULIE. "Art and the Feminine Muse: Women in Interiors by John White Alexander." *Women's Art Journal* 6, no. 2 (Fall 1985-Winter 1986): 1-8, 8 illus.

Traces the rarified ideal of women that exemplified the aesthetic movement in nineteenth-century American art. This contemplative art required a male projection of the feminine so it took it for granted that the female subject would be spoken for and represent an "interior being." These images reinforced the idea that the female mind tended more toward feeling and intuition, and hence toward spirituality and mysticism, than the more intellectual and scientific male mind. Havelock Ellis and the medical profession of the day tended to reinforce these ideas and perpetuated their own stereotypic notions of the feminine. Discusses the male artist's identity with the lady as a projection of his own sensibilities, suggesting that the artist and the lady were psychologically linked as a metaphor for the male artist himself who was odd man out in a getting and spending society.

1005 SQUIERS, CAROL. "Slouch Stretch Smile Leap." *Artforum* 19, no. 3 (November 1980): 46-54, 14 illus.

An analysis of the "fashionable" poses, body postures, body types, and gestures adopted by models posing in clothing for commercial display since the second decade of the twentieth century. Traced through the works of eminent fashion photographers and the leading

American fashion magazines. Argues that these postures provide an index of the contemporary attitudes towards women and their prescribed images and roles.

1006 STANKIEWICZ, MARY ANN. "The Creative Sister: An Historical Look at Women, the Arts, and Higher Education." *Studies in Art Education* 24, no. 1 (1982): 48-56.

Focusing on the education of women in art at the College of Fine Arts at Syracuse University, Syracuse, N.Y., in the nineteenth century, the author takes a broader look at attitudes at the time towards the education of women. She provides examples of the arguments used to justify and refute the value of education for women at this time.

1007 STANKIEWICZ, MARY ANN. "Art at Hull House, 1889-1901: Jane Addams and Ellen Gates Starr." *Woman's Art Journal* 10, no. 1 (Spring-Summer 1989): 35-39.

Stankiewicz considers the relationship between aesthetic life at the settlement house and varying interpretations of the relationship of art to labor. This is particularly important to women's studies in the arts because women, as Ann Sutherland Harris and Linda Nochlin pointed out in their introduction to their herstoric catalog *Women Artists: 1550-1950* (entry 376), often were allowed to work and find a place to express their artistic talents only in the minor or craft-art area. Stankiewicz points out, on the one hand, that Starr and Addams had read Ruskin and the art curricula taught at Hull House helped to reinforce the woman-as-caretaker syndrome, and, on the other, that the art and experiences the poor received through the settlement home gave them spiritual and practical benefits that helped many of them break away from the crisis of their class, which was always in a "state of siege," and realistically aspire to a better life.

1008 STETSON, ERLENE. "A Note on the Woman's Building and Black Exclusion." *Heresies* 2, no. 4 [Issue 8: Third World Women] (1978): 45-47.

Provides a historical context for Terree Grabenhorst-Randall's article (entry 586) on the same subject. Insists on dealing with Anglo-American racism; describes the Female Benevolent Firm of Boston, the Colored Women's League, the Boston's Women's Era Club, and the development of the National Federation of Afro-American Women. Stresses the need for a balanced look at sexism and power relations among women, particularly as regards class and color, when it comes to the history of the Woman's Building and its exclusion of nonwhite women.

1009 STEVENS, MAY. "New Images of Women: A Responsibility to Artists?" *Art in Society* 11, no. 1 (Spring-Summer 1974): 18-21, 2 illus.

A discussion led by May Stevens, exploring the woman artist's primary responsibility of integrity to her experience. Participants think focusing on this will bring a new body of information to the arts and thus dissolve the "male domain" idea that still exists regarding certain subjects, media, and techniques. Women artists will attain confidence in their work as a valid expression of relevant experience, and this art should have a didactic and communicative function.

1010 STEVENS, MAY. "Taking Art to the Revolution." *Heresies* 4, no. 1 (1980): 40-44, 14 illus.

A Marxist-feminist call to integrate new ideas, ideals, art, and structures to create a new and dynamic society. Stevens feels that art, based on solid political foundations, will support a society of equal and responsible people. She believes the new society must be rooted so firmly in personal human experience that it will cut across the boundaries of sex, race, and class.

1011 STOFFLET-SANTIAGO, MARY. "Feminist Art Program in San Francisco." *Feminist Art Journal* 4, no. 4 (Winter 1976): 38-39.

This article focuses on lectures, an exhibition, and consciousness-raising groups in which the concept of women passing on knowledge is crucial to all artistic production. Topics included Mary Cassatt's works, an explanation for quilt making, and story telling. Barbara Hammer described her attempts to combine real and fantasy time in her films. Suzanne Lacy talked about the political importance of sharing rituals; she feels that her own work and that of other performance artists allows women to clarify their desires.

1012 STRAUSBERG, A. "Renaissance Women in the Age of Technology: Women Artists of Revolutionary Russia." *Spare Rib*, no. 19 (January 1974): 38-40, 9 illus.

Acknowledges the major contributions made by Russian constructivist women artists during 1917-25, while deploring their neglect by Western art critics. Natalia Goncharova (1881-1962) exploited traditional icon painting and Russian folk art; Olga Rozanova's (1886-1918) focused on the reconciliation of art and industry. Alexandra Exter (1882-1949) concentrated on form and "dynamic" construction in both art and the theater. Varvara Stepanova (1894-1958), who lived in Russia during the Stalinist era, and taught set designing, typographical design, exhibition and poster design, and cinema and costume design; Liubov Popova (1889-1924) designed sets, fabrics, and fashions and collaborated with the Lef group, making book designs and posters.

1013 STURGEON, G. "European Dialogue: Cries and Whispers." *Art and
 Australia* 17, no. 2 (December 1979): 145-57, 18 illus.
 Assesses the 1979 Biennale entitled "European Dialogue," held in
 Sydney, Australia. Questions the ways in which European artists have
 established distinct modes of art making and where Australian art
 stands in relation to overseas forms, whether European, British, or
 American. RILA.

1014 SULLIVAN, EDWARD J. "Herod and Salome with the Head of
 John the Baptist by Josefa de Ayala." *Source* 2, no. 1 (Fall 1982): 26-
 29, 3 illus.
 Traces the artist's life and works and compares her use of subject
 matter to that of contemporary painters Josefa Sanchez and Jesuelda
 Sanchez and the sculptor Luisa Roldan. Argues that Ayala's
 depiction of Herod and Salome (private collection) is quite
 unconventional in that the two appear to be engaged in a disputation
 over the head of the saint. Cites the burgeoning popularity of the
 image of St. John's severed head in seventeenth-century Spain and
 provides a list of supporting examples. See Comini; Langer; Tufts.

1015 TABAK, M. N. "Do! Do! Do! and Do!" *Craft Horizons* 33, no. 4
 (August 1973): 18, 32-35.
 Tabak examines the difficulties facing female artists and criticizes
 them for failing to take responsible political action on their own
 behalf as a unified group. She gives examples of women who
 effectively put pressure on the system before the rise of the women's
 movement and congratulates women in the visual arts who do act
 politically.

1016 TABAK, M. N. "Notes on Pesky Problems." *Craft Horizons* 33, no. 5
 (October 1973): 41, 66-67.
 The painting of Charlotte du Val D'Ognes, formerly attributed to
 J. L. David, has been reattributed to Constance-Marie Charpentier.
 Tabak uses this incident to discuss how women artists have suffered
 at the hands of male-oriented art historians. She writes of her own
 reaction to famous women as historical figures, attacks the
 "professionalism" that fosters an elitist art, and concludes with her
 opinion of the Watergate scandal.

1017 TAMBLYN, CHRISTINE. "No More Nice Girls: Recent
 Transgressive Feminist Art." *Art Journal* 50, no. 2 (Summer) 1991:
 53-57. 5 illus. Reprinted in *New Feminist Criticisms: Art, Identity,
 Action*, ed. Arlene Raven, Cassandra Langer, and Joanna Frueh
 (New York: Harper/Collins), 1993.
 Discusses work by feminist artists including Barbara Hammer,
 Abigail Child, Karen Finley, Holly Hughes, Linda Montano,

Veronica Vera, and Annie Sprinkle. Examines how explicit sexual representation, the journey from victimization to liberation, confessionals, and a rebellious stance contributed to feminist resistance. Tamblyn asserts that Levine, Braderman, and others have deviated from "the confessional mode artists adopted during an earlier phase of feminism," "resorting to slippery rhetorical devices and unpredictable behavior" to "sabotage patriarchal moral codes." Concludes that these artist privilege difference rather than constructing idealized role models.

1018 TANNENBAUM, J. "Joan Semmel." *Arts Magazine* 50, no. 2 (October 1975): 7, 1 illus.

Joan Semmel's new paintings are autobiographical, embodying "the artist's perception of herself" or, more specifically, "what she sees of herself at intimate moments when she is alone or with someone to whom she is physically and emotionally close." The artist assimilates self-portraits and nudes, concentrating on bodies not faces, making the viewpoint of the artist and spectator the same. The author cites such paintings as *Patty and I*, *A Cat Called Che* and *Intimacy-Autonomy*.

1019 "The Tapes." Edited by Louise Fishman. *Heresies* 1, no. 3 (Fall 1977): 15-21, 5 illus.

"The Tapes" are the edited comments of ten lesbian visual artists who met in a New York City group in 1977. As well as personal and emotional topics, the artists discuss their attitudes to the art world, their work, their energy, the positive effects of their lesbianism on their work, and the conflict between motherhood and an artistic career.

1020 TARELLA, JOSEPH. "An Analysis of Architecture Texts from a Feminist Perspective."

A graphic presentation to a seminar on The Built Environment: Sex Roles and Social Policy, Columbia University Division of Urban Planning, Spring 1977.

1021 TENHAAF, NELL. "The Trough of the Wave: Sexism and Feminism." *Vanguard* 13, no. 7 (September 1984): 15-18, 3 illus.

Compares and contrasts the position of women artists in the 1980s with that in the 1970s, lamenting the backsliding by women artists vis-à-vis the progress made in the early phase of the women's art movement. Presents evidence that women's art is being excluded again, thus reversing the progress made by women in the 1970s. Tenhaaf explains that the accepted artistic vocabulary is that of the patriarchy, and that the vocabulary established by feminist art is judged by patriarchally educated critics to be invalid or passé. She

calls for an active strategy to prevent further backsliding. See Susan Faludi, *Backlash* (New York: Crown Publishers, 1991).

1022 TESFAGIORGIA, FREIDA HIGH. "Afrofemcentrism and Its Fruition in the Art of Elizabeth Catlett and Faith Ringgold." *Sage* 4, no. 1 (Spring 1987): 25-29.

 Black women artists today assert their race, sex, and artistic ability in their work. Mentions Elizabeth Catlett and Faith Ringgold. Tesfagiorgia examines the ideological and aesthetic fruition of Afro-female-centered consciousness in the visual arts. States that no major texts exist on the art of African-American women. Extols "Forever Free: Art by African-American Women, 1862-1980" (entry 282) as the most important work to date. Identifies five characteristics of Afrofemcentrism and refers to leading critics Larry Neal, Barry Gaither, David Driskell, Samella Lewis, and Keith Morrison. Mentions the "double jeopardy of Black women's experience" in feminism, centering on the African diaspora, icons of fertility, liberation, etc. Stresses that black women make themselves primary, active, and real through self-depiction.

1023 THOMPSON, J. M. "World of the Double Win: Male and Female Principles in Design." *Feminist Art Journal* 5, no. 3 (Fall 1976): 16-20, 9 illus.

 Argues that there are problems when most architecture is designed by men for women, because men are not sensitive to women's needs and preferences. She stresses the need for pluralism on the part of both male and female designers and examines the validity of her contention that women's perception is more sensory, men's more purely visual, through an analysis of early work in interior architecture by Le Corbusier, Eileen Gray, and Walter Gropius with Ise Gropius. Thompson calls for a revalidation by both sexes of what she labels "the feminine principles" in design and in society.

1024 TICKNER, LISA. "The Body Politic: Female Sexuality and Women Artists since 1970." *Art History* 1, no. 2 (June 1978): 236-51, 16 illus.

 Asserts that work by a number of women artists originates from the human body. This means that female artists will revolutionize erotic representation. Paradoxically the most significant characteristic of women's erotic art is that of de-eroticizing, the de-colonizing of the female body and the challenging of its taboos. Tickner claims that such work can be divided into the following categories: "the male as motif," "vaginal iconology," "transformations and processes," and "parody: self as object." Concludes that women need to liberate themselves from the myths of how art has

represented them and integrate new representations into the art-making process itself.

1025 TICKNER, LISA. "Pankhurst, Modersohn-Becker, and *The Obstacle Race*." *Block*, no. 2 (Spring 1980): 24-39, 8 illus.
 Reviews *The Obstacle Race* by Germaine Greer, *Paula Modersohn-Becker* by Gillian Perry, and *Sylvia Pankhurst: Artist and Crusader* by Richard Pankhurst.

1026 TICKNER, LISA. "One for Sorrow, Two for Mirth: The Performance Work of Rose Finn-Kelcey." *Oxford Art Journal* 3, no. 1 (April 1980): 58-72, 4 illus.
 A subjective comparison between Finn-Kelcey's and Tickner's own work. She briefly notes similar work in the United States and Europe. Tickner defines performance art and discusses the contribution made by women such as Carolee Schneeman and Finn-Kelcey. She mentions the performances *Her Mistress's Voice* (1977) and *The Boilermaker's Assistant* (1978) and gives extracts from Finn-Kelcey's written statements and an interview between herself and the artist.

1027 TICKNER, LISA. "May Stevens." *Block*, no. 5 (1981): 28-33, 2 illus.
 Reviews May Stevens's book *Ordinary/Extraordinary* (1980), a collage of words and images of Rosa Luxemburg and of Stevens's mother, Alice. The artist's objective is to contrast through juxtaposition the lives of these two women, one who lived in the public eye and one who was unknown outside her family and circle of friends and acquaintances. See Matthews; Stevens.

1028 TICKNER, LISA. "Feminism, Art History, and Sexual Difference." *Genders*, no. 3 (Fall 1988).
 Tickner introduces class as an issue to be added to this discourse, but does so from a heterosexual point of view that does not adequately deal with sexual differences or diversity. Her example of the harem neglects the gay-male gaze and also does not consider the lesbian attitude at all. She also assumes a white-male and sometimes female middle-class Eurocentric audience that identifies with patriarchal power rather than representing the audience as the mosaic it actually is.

1029 TRINI, T. "Marisa Merz." *Date*, no. 16-17 (June-August 1975): 49-53, 10 illus.
 In Italian. Marisa Merz's latest exhibition at the Galleria Attico in Rome (March 1975) presented a collection of remarkably serene works that led Trini to examine the way in which Merz constructs a relationship between her own work and a capitalist and male-

oriented art system. Marisa Merz's art, defined as "intra-objectual" because it consists of collections of sewn, embroidered, or carved elements, reveals a disregard for the art history that has repressed it and displays a sense of survival in its demolition of the exploitable value of its elements. RILA.

1030 TRUJILLO, MARCELLA. "The Dilemma of the Modern Chicana Artist and Critic." *Heresies* 2, no. 4 [Third World Women] (1979): 5-10.

Concentrates on poetry, but a similar analysis may be applied to Chicana art and artists. Surveys the 1960s, discusses Latin American philosophers and writers in the late nineteenth and twentieth centuries, particularly Octavio Paz, and addresses the quest for identity through the indigenous mother, for example, Eve/Mary, La Malinche, and La Llorona. Examines the Mexican desire to transcend this mythical maternal image and find refuge in a Christian feminine deity, La Virgen de Guadalupe, which was in reality a Christian/Aztec mingling of religion and culture. Argues that the Chicano/a artist creates art for people's sake not for commercialism. By examining such art Chicana feminists can discover themselves. See Cockcroft; Shifra M. Goldman; Sullivan.

1031 TUER, D. "Feminine Pleasure in the Politics of Seduction: James Coleman." *Canadian*, no. 4 (Winter 1985): 22-23, 2 illus.

Critiques James Coleman's videotape *So Different ... and Yet*, exhibited in Toronto at the Art Metropole (6-9 November 1984). Compares it with Vito Acconci's videotape *Theme Song*. Both works are discussed in relation to the feminine position on pleasure and its neglect in postmodernist discourse. Tuer argues that Coleman has forged the beginnings of a strategy to represent a specifically feminine pleasure.

1032 TUFTS, ELEANOR. "First International Festival for Women in the Arts." *Arts Magazine* 55, no. 2 (October 1980): 136-37, 12 illus.

Women from all over the world assembled in Copenhagen in July 1980, to honor the World Conference of the United Nations Decade for Women through the first International Festival for Women in the Arts. The great variety of performances of all kinds, exhibitions, and other events organized for the festival and the part played by the American delegation are described and illustrated here. See Judith Wilson.

1033 TUFTS, ELEANOR. "Beyond Gardner, Gombrich, and Janson: Towards a Total History of Art." *Arts Magazine* 55, no. 8 (April 1981): 150-54, 13 illus.

Tufts is highly critical of the art-historical establishment's double standards when it comes to women artists. She notes that we've come a long way since the all-male apprentices of the Renaissance atelier but she not only calls for art-history books that include women artists such as Sofonisba Anguisciola, Artemisia Gentileschi, Clara Peeters, Rachel Ruysch, Kathe Kollwitz, Remedios Varo, and Leonora Carrington but also demands that the "insulting familiarity" implied by using women's first names, which belittles them, be set aside. Her major focus throughout is how we go beyond the patriarchal canon to a total history of art that includes the contributions of the "backward," such as women of surrealism and American nineteenth-century women sculptors, including Harriet Hosmer, Emma Stebbins, and Anne Whitney. And Tufts strongly recommends that revisionists do away with tokenism, which solves nothing. See Hills; Moore; Orenstein.

1034 TULLY, JUDD. "In Homage to Ana Mendieta." *New Art Examiner*, May 1986, 59.

One of the few articles by a white male to address the art world's baffling silence regarding the outcome of the Mendieta trial and its possible moral implications for a community that likes to pride itself on its ethics and humanity.

1035 TWEEDY-HOLMES, KAREN. "A Curious Occupation: Or Why Does a Nice Girl Like You Take Pictures of Naked Men?" *Feminist Art Journal* 2, no. 3 (Fall 1973): 12-13, 22, 4 illus.

Artist Karen Tweedy-Holmes thinks male nudes are as cryptic, divergent, and absorbing as female nudes. She shuns professional models, coaxing friends to pose, thus establishing a warm, informal atmosphere that produces humorous and familiar pictures as opposed to classical Greek poses. Audience reaction runs the gamut from revulsion to appreciation. Tweedy-Holmes is struggling to cut down the imagined pornographic information contained in her photos of naked men so they can be valued for their artistic worth.

1036 UNGAR, NANCY. "Tenth Street Revisited: Another Look at New York's Cooperative Galleries of the 1950s." *Womanart* 2, no. 3 (Spring 1978): 15-18, 27-30.

A wealth of information on women artists, machismo, and the 1950s.

1037 VAN VECHTEN, CARL. "The World of Florine Stettheimer." *Harper's Bazaar* 79 (October 1946): 238, 354-57, 1 illus.

Van Vechten discusses his perceptions, recounting an engagement in 1915 with Ettie Stettheimer and subsequently meeting her sisters, Florine and Carrie. The ladies and their mother were an inseparable

quartet. Each of the sisters was a professional. Van Vechten discusses Carrie's *Doll House*, which is on permanent exhibit at the Museum of the City of New York. He then goes on to describe Florine's studio overlooking Bryant Park as a nest of white-draped cellophane, red rugs, and carved white and gold furniture. What emerges is a portrait of Florine Stettheimer's own special brand of feminine energy, not unlike that of Marie Laurencin, and her documentary commentaries on contemporary New York life. Mentions *Heat, Asbury Park South*, and his own portrait to illustrate his points.

1038 VAN WYCK, M. E. "Artfemme: Women at Work." *Atlantis* 9, no. 2 (1984): 61-68, 3 illus.
 Describes the "Artfemme" exhibition in Ottawa (1983), which focused on Canadian women artists and was sponsored by the Canadian Advisory Council on the Status of Women.

1039 VERGINE, LEA. "From Italy." *Art and Artists* 12, no. 4 (August 1977): 38-41, 4 illus.
 Examines recent trends in Italian art, concentrating on the interaction of theater and the visual arts and the work of women artists. Vergine looks at the work of Italian women artists and how today women in the arts "do not believe in remaining isolated from other women and their problems, but stand firmly with the movement, less afraid of damaging their own professional status and reputation."

1040 VICUNA, CECILIA. "The Coup Came to Kill What I Loved." *Spare Rib*, no. 28 (November 1974): 36-38, 5 illus.
 Cecilia Vicuna, painter and poet, traces her own development, as well as the cultural development of her people, in the context of the history of Chile. Working women carried on the crafts of weaving, ceramics, and basket weaving. The upper-class women had to demand education to become artists; Vicuna's generation rejected elitist concepts of art as a purely aesthetic phenomenon. While still at school, Vicuna wrote poetry and essays, contributed to left-wing events, and painted with oil and acrylic. "Art for Everyone," the national plan for allied arts and centers of popular culture, coincided with the Allende victory in 1970. Since the coup of September 1973, Vicuna has been a refugee, prevented from returning to Chile with her plan of painting murals about the history of women. She held an exhibit in New York in 1991.

1041 VOGEL, LISE. "Erotica, the Academy, and Art Publishing: A Review of Woman as Sex Object. Studies in Erotic Art, 1730-1970, New York, 1972." *Art Journal* 35, no. 4 (Summer 1972): 378-85.

Vogel is critical of the superficiality of John L. Connolly's article on J.A.D. Ingres's *Antiochus and Stratonice*, of the inaccuracy of Marcia Allentuck's theories about Henry Fuseli's *Nightmare*, of the insensitivity of Gert Schiff's study of Pablo Picasso's *Suite 347*; she deplores the unscholarly approach of Robert Rosenblum's study of the many representations of a woman suckling an adult man and David Kunzle's survey of French and English corset fetishism. She discusses favorably Beatrice Farwell's essay on Gustave Courbet's *Baigneuses*; Gerald Needham's "Manet's *Olympia* and Pornographic Photography"; Alessandra Comini's "Vampires, Virgins, and Voyeurs in Imperial Vienna"; Barbara White's "Renoir's Sensuous Women"; and Linda Nochlin's "Of Eroticism and Female Imagery in Nineteenth Century Art." See Allentuck; Kunzle; Nochlin.

1042 VOGEL, LISE. "Fine Arts and Feminism: The Awakening Consciousness." *Feminist Studies* 2, no. 1 (1974): 3-37.
 The article has a Marxist slant and asks why, when the women's liberation movement has explored issues touching on all areas of human experience, we have heard so little about it in art. "Why are there so few feminist art historians and critics and what is a feminist point of view in the visual arts?" Vogel correctly asserts that it is only in the last few years that women in the arts have turned their attention to the problem. First she explains the apparent backwardness of the art world with respect to all social issues and claims that it is no accident, then she evaluates the book *Woman as Sex Object* (entry 235), and finally she discusses the direction in which she thinks a truly feminist involvement of women in the arts should go. She is insightfully critical of Linda Nochlin's position, which she argues maintains the status quo, and of the lack of development of a truly independent feminist art criticism; affirms the necessity of including issues of race and class. See Nochlin's "Why Have There Been No Great Women Artists?" (entry 842).

1043 VOIGT, DAISY. "Lowery Sims." *Hatch Billops Collection, Inc.* 5, (Visual Arts): 66-74.
 Interview in which Sims describes her job, the projects she is working on, activities outside the Metropolitan Museum, her educational development, travel, race, sex, and political influences.

1044 WAGENER, MARY L. "Fashion and Feminism in Fin de Siecle Vienna." *Women's Art Journal* 10, no. 2 (Fall-Winter 1989): 29-33, 4 illus.
 Considers the impact of feminism on dress reform in turn-of-the-century Vienna in terms of health, class, and aesthetics. Mentions the complex attitudes women had toward the corset and architect Adolf Loos's legitimation of simplicity in women's fashions. Discusses

Gustav Klimt and Emille Floge in the context of the Wiener Werkstatte (Viennese Workshops for Arts and Crafts).

1045 WAGNER, ANNE M. "Lee Krasner as L. K." *Representations*, no. 25 (Winter 1989): 42-56.

Considers Krasner's rehabilitation as an artist from a feminist perspective and in relation to French poet Rimbaud's poem "A Season in Hell," the artist as a "young man/woman" in culture, psychoanalytical discourse, and marriage. Explores issues of creative self and gender in the establishment art world. Krasner died in 1984. See Rose (entries 309, 313); Marcia Tucker (entry 312).

1046 WALKER, K. "Feministo: A Portrait of the Artist as a Young Housewife." *Heresies* 4, no. 1 (1980): 34.

An account of the origins, development, and events associated with this British "Postal Event," established in 1975 by two artists, mothers, and housewives who aimed at communication with other women and the creation of a female/feminist "image-language." At least one exhibition has resulted from this long-term project, which is still continuing and which has made a positive and creative contribution to both consciousness-raising and the development of solidarity among women – artists and otherwise.

1047 WALLACE, MICHELE. "Reading 1968 and the Great American Whitewash." In *Remaking History*, edited by Barbara Kruger and Phil Mariani. Dia Art Foundation, no. 4. Seattle: Bay Press, 1989.

Wallace refers to "Global Retrospective" in relation to the underlying coherence in African-American intellectual and cultural development. Considers this in the context of literature, film, and art, citing her mother Faith Ringgold and the formation of WSABAL (Women Students and Artists for Black Art Liberation) as an activist association. She points out that "a white cultural avant-garde, here and abroad, has always believed it possible to make an oppositional art without fundamentally challenging hegemonic notions of race, sexuality, and even class." This is a cop-out. The Great American Whitewash trivializes the true breadth of the African-American cultural presence and contributions so that we can hardly see it.

1048 WALLACE, MICHELE. "Variations on Negation and the Heresy of Black Feminist Creativity." *Heresies* 6, no. 4 [Issue 24: 12 Years] (1989): 69-75, 4 illus.

Laments the fact that black women writers have not been able to truly challenge "the exclusionary parlor games of knowledge production." Examines tropes as road maps where the bodies of those who have been excluded are buried. Argues for a coherent history of black feminist creativity as a continuous visible discourse.

Stresses that it is essential to speak of its inadequacies and failures – to be self-critical. Refers to her mother Faith Ringgold's feminism as a basis for her own political engagement. Addresses sexism and self-negation within the black community. Wallace cries out for the inclusion of a variety of voices in order for black women to transform and grapple with control of their own lives.

1049 WALLER, SUSAN. "The Artist, the Writer, and the Queen: Hosmer, Jameson, and Zenobia." *Woman's Art Journal* 4, no. 1 (Spring-Summer 1983): 21-28, 4 illus.

An in-depth feminist analysis of the genesis of Harriet Hosmer's *Zenobia* (1859) as an expression of Hosmer's own sympathy with the women's rights movement. Waller effectively argues that it is the artist's treatment, rather than her choice of subject, that reveals her attitudes. Notes that Hosmer was harassed because of her sex and her work was said to have been executed by an Italian workman in Rome. Compares and contrasts English and European attitudes toward women artists with American ones, pointing out that Hosmer's Queen of Palmyra was transformed by the sculptor into a symbol of woman's courage and wisdom rather than of woman's failings.

1050 WALLER, SUSAN. "Strong-Minded Critics: Feminist Art Criticism in the Nineteenth Century." *Women Artists News* 10, no. 5-6 (September 1985): 12-13, 23, 1 illus.

There were female art critics in the nineteenth century whose views and writings were precursors of modern feminist criticism, although many of their attitudes differed from those of today's feminist critics. Waller explores some of these writings, which were published in England, France, and the United States. Many women critics of this period supported separate art exhibitions for women so they would be able to develop the skills and experience necessary to succeed in the art world. By recognizing the handicaps under which women worked, they were able to effect changes in many art institutions.

1051 WAUGH, PHYLLIS. "Feminist Art in Toronto, 1984: A Survey." *RFR/DRF* 13, no. 4 (December 1984-January 1985): 29, 1 illus.

Criticizes the Toronto feminist art scene for its lack of lesbian visibility. Includes comments on performance, video, and women of color.

1052 WAYNE, JUNE. "The Male Artist as a Stereotypical Female." *Art Journal* 32, no. 4 (Summer 1973): 414-16, 1 illus.

1053 WAYNE, JUNE. "The Male Artist as a Stereotypical Female, or Picasso as Scarlett O'Hara to Joseph Hirshhorn's Rhett Butler." *Artnews* 72, no. 10 (December 1973): 41-44.

 Variation of the article published in *Art Journal* 32, no. 4 (Summer 1973) (entry 1052).

 Wayne argues that society's stereotype of the artist is very similar to that of the woman: inchoate, intuitive, emotional, romantic, born rather than made; in short, of biologically-determined creative irrationality. She believes that artists unconsciously accept this role; collectors and dealers exploit artists rather like men exploit women. Hence the pervasive suspicion that male artists are homosexual. Female artists are discriminated against because their art is seen only as a boring accentuation of their femininity. Wayne proposes an artists' guild to fight this problem. See Garrard; Springer.

1054 WEIN, JO ANN. "The Parisian Training of American Women Artists." *Woman's Art Journal* 2, no. 1 (Spring-Summer 1981): 41-44.

 In the nineteenth century, women were not admitted to the École des Beaux-Arts, Paris. Considers the impact of this on American women, who were taught privately by the French academic masters.

1055 WEINSTOCK, JANE. "Interview with Martha Rosler." *October*, no. 17 (Summer 1981): 77-98, 6 illus.

 Rosler is a feminist artist who works in a variety of media: films, performance, photography, video, and installations. She states that the physical medium is in itself unimportant: she chooses a suitable form in which to express her meaning, which, although didactic, is not pushy. Most of the discussion centers on three of her videos, including *Losing* and *Semiotics of the Kitchen*.

1056 WEISBERG, RUTH. "June Wayne's Quantum Aesthetic." *Woman's Art Journal* 11, no. 1 (Spring-Summer 1990): 3-8, 4 illus.

 A personal overview of June Wayne, founder of Tamarind Lithography Workshop and a practicing artist for more than fifty years. Traces the artist's life and development from her birth in 1918 through 1990. Pays particular attention to Wayne's awareness of the problems faced by women artists. See Elizabeth Popescu Jones, "American Lithography and the Tamarind Lithography Workshop/Tamarind Institute, 1960-1980." Ph.D. diss., University of New Mexico, 1980.

1057 WEISBORD, M. "Women Artists of the Fifties: Artists-Talk-on-Art March 4." *Women Artists Newsletter* 3, no. 2 (June 1977): 1, 6, 5 illus.

 Report of a discussion at the Soho Center, New York (4 March 1977), with panelists Anne Arnold, Louise Bourgeois, Gretna Campbell, Marisol, Marcia Marcus, and Pat Passlof. It was felt that

the 1950s was an exciting period, and despite discrimination against them women were very much involved in the art scene because they were more willing than men to help in the day-to-day running of galleries. The artists on the panel described their struggles to become accepted and the importance of patience and perseverance in the struggle.

1058 WEISMAN, CELIA. "O'Keeffe's Art: Sacred Symbols and Spiritual Quest." *Woman's Art Journal* 3 (Fall 1982-Winter 1983): 10-14.

Considers the collective and private symbolism of O'Keeffe's objects and how she incorporates that into her paintings. See "Letters," Eleanor Munro, *Woman's Art Journal* 61 (Spring/Summer 1983).

1059 WELSH, MARJORIE. "Pattern Painting: A New Flowering of the Decorative?" *Art Criticism* 1, no. 4 (1981): 68-79.

The art world has traditionally regarded the decorative arts as an inferior form. Recently, however, pattern painting has been receiving greater recognition and acceptance. Stating that two trends account for this, the use of decorative elements by abstract expressionists and the mass-produced images of pop art, the author discusses Clement Greenberg's views on whether decoration weakens or vitalizes abstraction and also the role played by women in the revival of interest in decoration.

1060 WEYERGRAF, CLARA. "The Holy Alliance: Populism and Feminism." *October*, no. 16 (Spring 1981): 23-34, 2 illus.

Weyergraf is highly critical of ideological approaches to art and of "humanist aesthetics" as represented by Donald Kuspit's demand for socially responsible and accessible art and Lucy Lippard's claim that a new, feminist art is needed to change the world. Kuspit and Lippard are described as apologists for populist humanism and its variant, feminism. Analyzes the political nature of Lippard's call for a new feminist art to affect those whom contemporary art has failed to reach.

1061 "What Is It Like to Be a Woman in Art?" *Arts Magazine* 5, no. 15 (Fall 1973): 10-15, 11 illus.

Consists of the replies of ten women artists (and one male gallery director) to questions about women artists and their place in the art world. Confronts such issues as women's liberation, the combined role of wife and artist, whether women's art is taken seriously by galleries or by men artists, and women artists' chances for "making good" in the future.

1062 WHELAN, R. "Are Women Better Photographers Than Men?" *Artnews* 79, no. 8 (October 1980): 80-88, 23 illus.

A survey of the work of women photographers in the twentieth century shows how bad the economic discrimination against them was when it came to earning a living. Whelan makes the unsubstantiated claim that today things have improved, and women may even have a positive advantage in some situations; for example, when photographing people they may be more able to put their subjects at ease and establish better rapport with them more immediately than male photographers are generally able to do.

1063 WHITE, BARBARA E., and WHITE, L. S. "Survey on the Status of Women in College Art Departments." *Art Journal* 32, no. 4 (Summer 1973): 420-22.

Data obtained through a questionnaire sent out by the College Art Association Committee on the Status of Women to women faculty members in American colleges and universities resulted in the following: 164 questionnaires were analyzed. Of 2,465 positions, 20.5 percent were held by women. Women tended to hold lower positions despite equal or superior qualifications and to be more numerous and more successful in smaller and less prestigious schools and departments. See also Barbara Ehrlich White's "A 1974 Perspective: Why Women's Studies in Art and Art History?" in *Art Journal* 35, no. 4 (Summer 1976): 340-44.

1064 WHITE, BARBARA EHRLICH. "Women's Studies in Art and Art History: Different Points of View about Women's Studies in Art and Art History." *Feminist Art Journal* 3, no. 1 (Spring 1974): 20-21.

Report on the session on women's studies in art history at the College Art Association meeting in Detroit in January of 1974. Various teachers described their courses. Linda Nochlin's course included three areas of investigation: the imagery of women by both male and female artists at certain times and within certain contexts of the history of art; women artists in the nineteenth and twentieth centuries; and the issue of "feminine" or "women's" style in art. Ellen C. Oppler's seminar had as its main themes attitudes towards women; problems of the woman artist; and feminist subject matter and the possibility of a feminist style. Peter Walch taught a lecture course in the histories of female subject matter in art; female artists; and female critics, dealers, curators and historians. While the art historians tended to agree on most issues, the two artist-teachers had conflicting opinions. Rita Yokoi feels that the need for women's studio courses is over and that women can now be absorbed back into the system. Betsy Damon insists on the increasing need for all-women feminist studio courses within the university.

1065 WHITESEL, L. S. "Scale Construction for the Measurement of Women Art Students' Career Commitments." *Studies in Art Education* 17, no. 1 (1975): 47-53.

An account of a study to assess attitudes and goals of women graduate students in various media of the visual arts. The focus is upon the scale construction, item scoring, and analysis of the instrument used to measure the subjects' career commitments. The importance of planning for financial support and of reconciling sex-role and career demands led to the suggestion that courses should be offered in these areas.

1066 WHITESEL, L. S. "Personalities of Women Art Students." *Studies in Art Education* 20, no. 1 (1978): 56-63, illus.

A description of a study undertaken to learn about the self-perceived personalities of women graduate studio-art students and to look for differences between their personalities and those of women students in two other academic fields, medicine and psychology. The Gough Adjective test list (ACL) was used for assessing the subjects' personalities, and analysis of the results suggests the possible value of the women art students' self-perceived personality traits in their future work.

1067 WHITWORTH, SARAH. "The Lesbian Image in Eve." In *The Lavender Herring: Lesbian Essays from the Ladder*, edited by Barbara Grier and Coletta Reid. Baltimore: Diana Press, 1976, pp. 284-357.

Selection of eight essays showing the importance of cultural studies in the construction and depiction of lesbianism.

1068 "Who's Holding the Baby?" *Heresies* 4, no. 1 (1980): 88-89, 3 illus.

Sketches the history and aims of a London collective, the Hackney Flashers, formed of women working in education or the media and sharing a variety of skills including design, illustration, and photography. Several of their exhibitions, including *Women and Work* and *Who's Holding the Baby*, are discussed, and the article, which is written by the Hackney Flashers Collective, includes two illustrations of posters made specifically to address issues raised by these exhibitions.

1069 WILDING, FAITH. "How the West Was Won: Feminist Art in California." *Women Artists News* 6, no. 2-3 (Summer 1980): 14-15, 1 illus.

Outlines the history of the feminist art movement in California. In 1973, a body of feminist groups founded the Los Angeles Woman's Building, which calls itself an "experimental program in female art education." Although Californian women artists are more visible in

galleries, they are still not properly represented in university art departments.

1070 WILLARD, JANICE. "An International Sampling of the Visual Arts." *Women Artists News* 6, no. 4 (September-October 1980): 8-9, 1 illus.

Describes the International Festival of Women Artists, held in Copenhagen (14-30 July 1980). There was a variety of events during the festival, including slide shows, an international mini-art show, performances, exhibitions, and video presentations. The variety of material displayed permitted people to see how women throughout the world have integrated their existence. See Tufts.

1071 WILSON, JUDITH. "Alma Thomas." *Ms. Magazine*, February 1979, 59-61, 90-91, 6 illus.

Discusses Thomas's evolution as an African-American woman and painter. Traces the artist's career from high school teacher to respected abstract painter during the 1960s after she had retired. Despite arthritis, Thomas got up and painted every morning of her life. During the 1970s her work was praised by Hilton Kramer, and she was included in the Whitney Museum's "Contemporary Black Artists in America." In 1972, the mayor of Washington, D.C., declared September 9 "Alma Thomas Day." Thomas was a woman who didn't believe there was such a thing as "black art" and who was very clear about her own direction in art.

1072 WILSON, JUDITH. "Howardena Pindell." *Ms. Magazine*, May 1980, 67-70, 3 illus.

Pindell's art is serious, witty, spiritual, sensual, precise, and spontaneous. It embraces all these oppositions and more. During the 1970s, her art became progressively more political and activist, culminating in the videotape performance piece *Free, White, and 21.* Her work has been described by psychologists as demonstrating a kind of "compulsion" as a way of dealing with "rage."

1073 WILSON, JUDITH. "Ana Mendieta Plants Her Garden." *Village Voice*, 13-19 August 1980, 71.

Discusses Mendieta's art as memories of growing up in Cuba. The ideological content of her work focuses more on sexual politics, power, and magic.

1074 WILSON, JUDITH. "Advance Placement Texts." *Village Voice*, 24-30 December 1980, 79.

Reviews Brenda Milla and Maren Hassinger's work, asserting the two artists cross some of the same borders. Both evoke

environmental, real-life space. Comments on Hassinger's "deft double-talk."

1075 WILSON, JUDITH. "Coming of Age: Look at Three Contemporary Artists." *Essence*, May 1986, 120-24.

Wilson looks at Howardena Pindell, Jeanne Moutoussamy-Ashe, and Beverly Buchanan, artists who work in painting, sculpture, and photography. Stresses that all these women are only children whose creativity was encouraged by their parents. Wilson discusses the development of each artist's work, her political commitments, and her personal iconography.

1076 WILSON, JUDITH. "Candace Hill-Montgomery." *Hatch Billops Collection, Inc.* 5 (Visual Arts): 48-55.

Interview discusses Hill-Montgomery's upbringing and career, black people's perceptions of art history, John Ahern, Joe Louis, performance art, installations, and the Mandella bathing suit.

1077 WILSON, JUDITH. "Judith Wilson." *Hatch-Billops Collection, Inc.* 5 (Visual Arts): 102-10.

Wilson discusses her background, racism in the arts, working at *Ms.*, Alma Thomas, and bridging the gaps between the histories of white and black American art. Talks about becoming a critic with reviews like "Afro-American Abstraction" and how slippery the term "art criticism" is. For her it is a range of commentary that extends from short, descriptive reviews through longer, analytical essays to book-length explorations of aesthetic theory. She calls for art journalism that "approaches the vigor, the subtlety, the depth of modern African-American art itself."

1078 WILSON, JUDITH. "*Ndebele: The Art of an African Tribe*, photographs and text by Margaret Courtney-Clark; foreword by David Goldblatt." *Woman's Art Journal* 9, no. 1 (Spring-Summer 1988): 47.

Wilson reviews a significant collection of photographs of South African artistry. She comments on the ramifications of wall painting as a gendered art. It is an art form that celebrates the Ndebele women's pride in the coming-of-age of their male offspring, advertises their ethnic identity, and provides a fair avenue of self-expression. The review is amply supported by extensive footnotes.

1079 WILSON, JUDITH. "Hexes, Totems, and Necessary Saints: A Conversation with Alison Saar." *Real Life*, Winter 1988-89, 36-41, 4 illus.

Sets Saar's work in the context of artists such as Melvin Edwards, Sam Gilliam, Maren Hassinger, Richard Hunt, and Martin Puryear.

This conversation took place in Saar's Chelsea loft. Alison Saar was influenced by her painter/conservator father and her mother, Betye Saar. Samella Lewis stimulated her interest in black American folk art. She also liked Joseph Albers's ideas of color and spiritualism and Mark Rothko's abstract, ephemeral, spirit-type things. She wanted to make un-precious objects. Saar talks about the development of a personal iconography, altars, ensembles, love potions, AIDS, the Bible, pop music, and totems.

1080 WITHERS, JOSEPHINE. "Meret Oppenheim." *Womansphere*, May-June 1975, 8-9, 7 illus.
 A short biographical essay on Meret Oppenheim, discussing her status as the "fairy princess" of surrealism. Concludes it is difficult to know whether her invisibility was self-imposed or circumstantial.

1081 WITHERS, JOSEPHINE. "Artistic Women and Women Artists." *Art Journal* 35, no. 4 (Summer 1976): 330-36, 8 illus.
 Discusses the durability of such notions as women's creativity but the fact that there haven't been any great women artists and that male artists are pretty effeminate, which explains why art is seen, to use June Wayne's phrase, as "stereotypical[ly] female." Explains how this relates to "first wave feminism" in the nineteenth century. Cites women who did not conform totally to the model (i.e., Sophia Hawthorne, Mary Cassatt, Harriet Hosmer, and Lilly Martin Spencer). Concludes that these women exposed the myth of the creative feminine, which for them was more of a hindrance than a help; even today it continues to limit how women artists and critics are seen.

1082 WITHERS, JOSEPHINE. "Faith Ringgold." *Feminist Studies* 6, no. 1 (1980): 207-11, 3 illus.
 Introduces three soft-sculpture art works by Faith Ringgold, an African-American feminist artist living in Harlem, New York, whose work incorporates elements of black American history, African culture, and feminism.

1083 WITHERS, JOSEPHINE. "Judy Chicago's *Dinner Party*: A Personal Vision of Women's History." In *Art the Ape of Nature: Studies in Honor of H. W. Janson*, edited by Moshe Barasch, Lucy Sandler Freeman, and Patricia Egan. New York: Abrams; Englewood Cliffs, N.J.: Prentice-Hall, 1981, pp. 789-803, 11 illus.
 The Dinner Party, first exhibited 16 March-17 June 1979 at the Museum of Modern Art, San Francisco, is a multimedia environment that presents in metaphorical form a vision of women's history, culture, and aspirations. It is an imaginative response to the sort of ideal *Cité des dames* imagined by Christine de Pisan in the fifteenth

century. Two of the major themes of *The Dinner Party* are the ideal or imaginary gathering and the ritual of sacrifice. *The Dinner Party* presents women both as heroines and as sacrificial victims. Chicago has synthesized two of the principal strains in the current debate over women's historical roles: that women's achievements must be studied separately, by way of compensation (Mary Beard, *Woman As a Force in History*), and that women's history is a continuous chain of unmitigated oppressions and victimizations (Simone de Beauvoir, *Le deuxième sexe*). An appendix provides a list of the thirty-nine women of *The Dinner Party*. See Chicago; Lippard.

1084 WITTIG, MONIQUE. "The Straight Mind." *Feminist Issues*, Summer 1980, 103-11.
Considers who and what a lesbian might be and argues for the destruction of gender classifications of all kinds, since they obscure the real gender politics of patriarchal systems with their compulsory heterosexism and marginalization of those who are classified as outsiders. See Hammond; Langer; Rich; and *Frontiers* 4, no. 3 [Lesbian History Issue] (Fall 1979).

1085 WOLVERTON, TERRY. "An Oral Herstory of Lesbianism." *Frontiers* 4, no. 3 [Lesbian History Issue] (Fall 1979): 52-53.
Describes an experimental theater-art work collaboratively created by thirteen lesbians and performed for thirteen nights at the Woman's Building in Los Angeles in May 1979. The project was inspired and supported by Wolverton's work with Arlene Raven in the Lesbian Art Project (LAP).

1086 WOLVERTON, TERRY. "Generations of Lesbian Art." *High Performance* (#53) 14, no. 1 (Spring 1991):10-11.
Wolverton reviews "*All But the Obvious*: A Program of Lesbian Art," an exhibit at Los Angeles Contemporary Exhibitions (LACE). This is the second major lesbian art show to be mounted in Los Angeles—the first was "The Great American Lesbian Art Show" [GALAS] at the Woman's Building in 1980. Compares and contrasts the two exhibitions, commenting on the generational differences, particularly regarding the construction of sexuality. Argues that there is a curious "homogeneity" to the show. Wolverton asserts that she "misses the emotion that fueled" lesbian art of the 1980s. She notes that the invisibility of lesbians of color is still a problem, and she rightly chastises the curators for their throwing-the-baby-out-with-the-bath attitude. "Without a grounding in history [sic], we have no place to stand at all."

1087 "Women's Art 1977: Momentum and Responses." *Women Artists Newsletter* 3, no. 4 (September-October 1977): 4.

Account of a panel on women's art held at the Aldrich Museum, Ridgefield, Connecticut, on 11 August 1977. The panel included Donna Byars, Carol Kreeger-Davidson, Patsy Norvell, Therese Schwartz, Phyllis Thompson, and Judy Seigel. These artists theorized that women sought other female company because their working relationships with male artists were severely circumscribed by art-world politics and because they felt there was no patronage for women in the art world. They associated with other women for criticism, feedback, and networking opportunities. The women's movement, some believed, gave some women artists the confidence to work on a completely different scale.

1088 "The Women's Movement in Art, 1986: Applebroog, Carvalho, Gill, Heindl, Hodes, Kreloff, Lerman, Moore, Semmel, Snyder, Spero." *Arts Magazine* 61, no. 1 (September 1986): 54-57.
 Transcript of a discussion among eleven woman panelists at a meeting of the Women's Caucus for Art Conference in New York (April 1986) on the women's art movement today.

1089 WOOSTER, ANN SARGENT. "Images of Women's Work: A National Collection of Video." *Woman's Art Journal* 3, no. 1 (Spring-Summer 1982): 25-27, 1 illus.
 Sargent's account of putting on an exhibition of video art by contemporary American women artists. Discusses the issues raised by the experience.

1090 WYE, PAMELA. "Florine Stettheimer: Eccentric Power, Invisible Tradition." *Meaning*, no. 3 (May 1988): 3-17.
 Discusses Stettheimer's career and her campy and bizarre vision of life in relation to her "ultra-feminine stance." Wye describes the *Cathedral* series to illustrate her points. Using Sontag's definition of camp, Wye creates a critical framework for the voluptuousness of feeling, satire, and lyricism that energizes Stettheimer's art. See Nochlin; Zucker.

1091 WYE, PAMELA. "Nancy Spero: Speaking in Tongues." *Meaning*, no. 4 (November 1988): 33-41.
 An "abundance of tongues exist" in Spero's art. Wye discusses their meanings in relation to body language, myth, literature, and feminism. See Kuspit.

1092 WYNER, R. "Jacki Clipsham: A Study in Determination." *Women Artists News* 6, no. 1 (May 1980): 12, 2 illus.
 Describes the career of ceramic artist Jacqueline Ann Clipsham, who was born in London but now lives in New Jersey. The author describes the artist's views on the value to artists of the women's

movement, her work with senior citizens (especially former garment workers) in ceramics, and comments on her current work (especially that inspired by jazz). The conversation revolves around the problems raised in museum visits by Clipsham's diminutive height and her future advisory capacity on how to eliminate architectural barriers for the handicapped.

1093 ZACK, B. "*The Dinner Party* by Judy Chicago." *Arts Magazine* 14, no. 60 (September-October 1982): 25-28, 4 illus.

Examines Judy Chicago's installation *The Dinner Party* from a patronizing patriarchal perspective. Zack expresses a deceptive regard for the monumentality of Chicago's task, the size of the work, and the corporation required to complete it. Asserts a belief that the value of the work rests on its role as a consciousness-raising device of the feminist movement. Despite this it is simplistic and, like most political works, never rises above its original purpose. One wonders if Zack would have criticized political work done by males or addressing another topic differently? See Withers; Zana.

1094 ZANA, D. "*The Dinner Party*: An Epic Representation of the History of Womankind." *Cahiers des arts visuels au Québec* 4, no. 14 (Autumn 1982): 7-8.

Argues that *The Dinner Party* by Judy Chicago should not be judged from a preconceived male viewpoint but should be welcomed, as it allows for the feminine vision of the world. Quoting Bertold Brecht's view that the best type of theater should be more divisive than unifying, Zana explains that the "guests" at this dinner party were mainly involved in a struggle against injustice towards women that itself changed the course of history.

1095 ZASTRO, LEONA M. "American Indian Women as Art Educators." *Journal of American Indian Education* 18 (October 1978): 6-10.

Considers Pima, Papago, and Pueblo women as art educators, teaching their children traditional arts and a spiritual way of life.

1096 ZEMANS, J. "Inuit Women in Transition: Arctic Provinces." *Art Magazine* 7, no. 24 (December 1975): 52-53, 3 illus.

This exhibition, the result of a conference of Arctic craftswomen held in Toronto, derives from the desire of the Inuit women to preserve their cultural heritage without reverting to a way of life that has all but disappeared. Zemans criticizes the exhibit for ignoring the conflicts that must have occurred during the relegation of a culture from a way of life to a business proposition.

1097 ZEMEL, CAROL. "Postmodern Pictures of Erotic Fantasy and Social Space." *Genders* 4 (March 1989): 26-49, illus.

Postmodern pictures by David Salle, Eric Fischl, and Cindy Sherman draw on mass culture figures of sexuality–from film to pornography–to lodge a cultural and social critique. Zemel considers the impact of such imagery in high-culture museums and academic spaces. An analysis of the pictures' formal structures and their appeal to a gendered spectator discloses how provocative erotic imagery is deployed to challenge (Fischl, Sherman) or to reinscribe (Salle) conventional gender relations and pleasures. The article argues for the importance of "conditions of spectatorship" in assessing a picture's subversive effect. The question that remains for feminist art critics is whether these women artists' works achieve the ends with which Zemel credits them.

1098 ZUCKER, BARBARA, and KOZLOFF, JOYCE. "The Women's Movement: Still a Source of Strength or One Big Bore?" *Artnews* 75, no. 4 (April 1976): 48-50.

A conversation in which Zucker takes the extreme posture that women's shows, galleries, and panels are dull and unable to really dig into the issues that need to be addressed with vitality and effective political strategies. She argues for protecting the diversity of feminism. Kozloff, by contrast, although agreeing with Zucker that current practices are tired and unimaginative, reaches the conclusion that feminist artists' ideas are at least five years in advance of the present discourse about art. Implicit in these ideas are challenges to assumptions that culture is genderless and that art is universal. Kozloff quotes from a stereotypic dialogue she often has with hostile male students (why are they so hostile, one wonders; what threatens them in this idea?). She concludes that if one is a feminist, one can expect one's statements to routinely be undermined or circumvented by those who feel their values are threatened. She asks us to keep in mind the long-term goals and not become frustrated along the way.

1099 ZUCKER, BARBARA. "An Autobiography of Visual Poems." *Artnews* 76, no. 2 (February 1977): 68-73, 4 illus.

Addresses the life and work of Florine Stettheimer (1877-1944), listing the artists who attended the salon run by Stettheimer and her sisters in New York City after 1915. Stettheimer had only one solo exhibition during her lifetime, and the issue of whether or not its relative failure was a tragic disappointment is evaluated. Zucker looks at Stettheimer as an "environmental feminist" who evoked the feeling of her boudoir. Zucker argues that the artist looked on her work as "an autobiography of visual poems" that she could not bear to have separated one from another. In some pictures, the artist's manner is to shift from realistic space to a cerebral dream space in which characters and events move through walls and time without regard for facts. In Stettheimer's mature style after 1918, the images

have coalesced into pictures that are witty and curiously sensual and express her fascination with language as information and structure. Zucker comments on Stettheimer's inclusion of African Americans as a vital part of American culture as if it were remarkable, but the truth is that among intellectual and artistic circles of the period such interaction was common.

1100 ZUCKER, BARBARA. "Florine Stettheimer: A Private Vision." *Women's Studies* 6, no. 1 (1978): 89-106, 9 illus.

Florine Stettheimer, an original, hedonistic, eccentric painter, lived at the hub of the artistic market of New York City. Her early works (still life, landscapes, and portraits) reflected elements of impressionism, fauvism, the Nabis, and Chinese and Japanese art. After 1915 Stettheimer pursued autobiographical subjects, and in 1929 she began her series of cathedral paintings: *Cathedral of Broadway, Cathedral of Fifth Avenue, Cathedral of Wall Street*, and *Cathedral of Art*. Her works were shunned because of their freedom and feminism and because she wanted her painting to be buried with her in her mausoleum. See Nochlin; Wye.

Author Index

Note: References are to entry numbers, not pages.

271

Subject Index

Note: References are to entry numbers, not pages.